CHRIST TO COKE

Christ to Coke

HOW IMAGE BECOMES ICON

MARTIN KEMP

OXFORD

UNIVERSITY PRESS

OXFORD

UNIVERSITY PRESS

Great Clarendon Street, Oxford OX2 6DP

Oxford University Press is a department of the University of Oxford.
It furthers the University's objective of excellence in research, scholarship,
and education by publishing worldwide in

Oxford New York

Auckland Cape Town Dar es Salaam Hong Kong Karachi
Kuala Lumpur Madrid Melbourne Mexico City Nairobi
New Delhi Shanghai Taipei Toronto

With offices in

Argentina Austria Brazil Chile Czech Republic France Greece
Guatemala Hungary Italy Japan Poland Portugal Singapore
South Korea Switzerland Thailand Turkey Ukraine Vietnam

Oxford is a registered trade mark of Oxford University Press
in the UK and in certain other countries

Published in the United States
by Oxford University Press Inc., New York

British Library Cataloguing in Publication Data

Data available

Library of Congress Cataloging in Publication Data

Data available

Typeset by Sparks—www.sparkspublishing.com
Printed in Europe
on acid-free paper by
Grafos

ISBN 978–0–19–958111–5

1 3 5 7 9 10 8 6 4 2

PRAISE FOR BOOKS BY MARTIN KEMP

Leonardo

'Excellent'

Sunday Telegraph

'Leonardo seen from the inside out'

The New Yorker

'Orchestrates the available information effortlessly . . . [a] magisterial text'

Lisa Jardine, *Guardian*

'Illuminating'

Peter Ackroyd, *The Times*

'A succinct introduction . . . by one of the world's foremost authorities.'

Independent

'Filled with fresh thought . . . Kemp has succeeded at something that is possible only after years of reflection.'

Los Angeles Times

'Excites the reader's admiration for the restless vitality of the man and his ideas . . .'

Washington Post Book World

Leonardo: The Marvellous Works of Nature and Man

'This is a masterly book with no equal on its subject.'

<div align="right">Byron Ireland, Day by Day</div>

'Sensitive and original descriptions of the master's paintings ... combining the achievements of Kenneth Clark's classic on the artist with V. P. Zubov's unsurpassed account of the scientist in the context of his age.'

<div align="right">E. H. Gombrich, The Times Literary Supplement</div>

'The student of Leonardo, it seems to me, could not have the field more elegantly and scrupulously ordered.' <div align="right">The Burlington Magazine</div>

'Here happily is a scholar who has found Leonardo the whole man, and given him to us.' <div align="right">British Journal for the History of Science</div>

Seen/Unseen: Art, Science, and Intuition from Leonardo to the Hubble Telescope

'This is a major book on an important theme ... Seen/Unseen is massively well-informed.' <div align="right">Piers Bizony, BBC Focus</div>

'Dive in: the swim is bound to be rewarding ... This is a mature book written by a scholar who has meditated for decades on the false dichotomy between scientific and artistic representations of nature.' <div align="right">Bart Kahr, Nature</div>

'There is much to treasure here. Those ... looking for a handsome and beguiling study of different ways, scientific or artistic, in which we can mirror nature, will find much to enjoy.' <div align="right">Charlie Gere, TLS</div>

'What emerges from this multi-faceted closely argued *tour de force* is a conviction that the real excitement begins where the knowledge breaks down: in the visual institutions that give us the freedom and insight to "feel our way into the unknown". It is a tantalising conclusion to an exhilarating ride.'

<div align="right">Ariane Bankes, Financial Times</div>

ACKNOWLEDGEMENTS

F OR REASONS THAT WILL BECOME CLEAR, my first thanks go to those who collectively contributed to the advent of the internet and to Sir Tim Berners-Lee, the inventor of the worldwide web. These thanks are coupled with gratitude to all those who have subsequently placed such rich bodies of source material within the reach of those who for practical or other reasons cannot hope to visit the repositories of sources all in their varied locations. We hear a great deal about the amount of pernicious rubbish on the net—and there is more than enough of that—but there is an incredible quantity of very high-quality sources, often placed there by people or organizations who have nothing to gain financially from doing so. It is customary for historians to thank librarians, archivists, curators, and other holders of material for their assistance. To their numbers now have to be added the countless 'librarians', 'archivists', and 'curators' of written and visual documents on the web. In the present book, even the rubbish has played its role, since one of the features of iconic images is that they are enriched by the aura of myth and untruths that helps cement their public reputation. The book could not have been written if I had needed to visit all the places and to meet all the people that were essential to its compilation. It is a book of the internet era.

A number of friends and colleagues played key roles either throughout or at various stages. Joe and Francine Connors hosted me for two months

at the Harvard villa, I Tatti, just outside Florence. Joe cheerfully accepted that I spent at least half my time on a topic that neither centred on the Renaissance nor on Italy. It was a time when the nature and shape of the book was formed. Louis Waldman, the accomplished Deputy Director of I Tatti, was willing to accept some of the material in the COCA-COLA chapter for a volume of essays in honour of Joe.

Happily, my time in Florence coincided with one of Karin Leonard's periods of work at the Kunsthistorisches Institut. She shared in shaping the book's thinking, and in some of expeditions connected with it, helping in ways that she would not guess. We also remember little Lisa, a puppy not a painting. Marie Boyle, Samantha Jessel, and my long-standing friend and colleague Marina Wallace stayed in the guest rooms in my apartment at various points, bringing company and fun into my non-working hours. They patiently endured my repetition of stories from the book. Marie as an artist herself was a perceptive reader of the chapters as they came forth.

My family have played their role, not just as family but helping in specific matters. Jonathan, my son, has a degree and doctorate in physics with music, and looked for obvious mistakes in the Einstein chapter. Any that I hid too well and that have survived are not his fault. He also provided the 'snapshot' of my grandchildren which is illustrated and manipulated in the conclusion. Benoit Demars, Joanna's husband, a biologist as is Joanna herself, gave the DNA chapter the once-over.

Kate Oliver, who has a very wide knowledge of photographs of all kinds and an incredible memory-store of images, supplied me with regular items that bore in upon the subject matter of the chapters. That I myself own the card showing Christ as Che (or is it the other way round?) is an indication of her generosity as a friend and companion. She was also a dedicated reader of what I was writing.

When I strayed into historical and geographical territories in which I am a stranger, I encountered many acts of generous advice. I should mention in particular Sarah Ng, a postgraduate at Oxford, who assisted with incredible enthusiasm in my quest to make sense of the Chinese lions, for which obvious answers are often not available even in the Chinese literature, and on which much basic research remains to be done.

More people than I can readily recall have played a role in my researching, writing, and revising the chapters. One advantage of dealing with such popular images is that everyone is their own kind of expert witness. All the chapters have been read by more than one person, and

a few have stoically read the whole book. I have received help and not least encouragement all the way. Some of those listed will be recognizable as actors in the dramas that gave birth to some of the images. If I list my 'helpers' alphabetically, this is because I am resorting to convention in the face of not being able for practical reasons to list each individual kindness. They will have an idea why I mention them in the stark list that follows: Horst Bredekamp, Philip Campbell, Craig Clunas, Pascal Cotte, Mark Curtis, Aqsa Dar, Robert Devčić, Clare Farago, Stephanie Fischer, Jim Fitzpatrick, Nathan Flis, Milton Glaser, Richard Gott, Anthony Griffiths, Richard Howells, Mengfei Huang, Geraldine Johnson, Andrew Krasnow, Harry Kroto, David Kunzle, Matt Landrus, Marta de Menezes, Tim Page, Donald Preziosi, Jürgen Renn, Scarlett Rigby, Emily Roberts, Gervase Rosser, Pierre Rosenburg, Gheri Sackler, Robert Simon, Armin Schlechter, Vycki Sparkes, Chris Taft, Margareta Tillberg, and Bruce Weigl. Others go unnamed not because of lesser contributions but due to my erratic memory. None of course shares any responsibility for mistakes or misconceptions that have slipped into the final version.

I should also like to thank Maximillian Schich, not so much for what he has done so far, which has been very supportive, but for the future promise of a statistical analysis in collaboration with a colleague from Google, Diego Puppin. We intend to look at the occurrence of my chosen images via Google books. Since they are not of the same type and bear varied relationships to their titles and descriptions, this is a non-trivial problem. We hope to publish a detailed study in due course.

The job of bringing the book into print involved the close engagement and skill of valued colleagues. Caroline Dawnay, my agent, provides a service at a very high level that I do not take for granted, even after many years. During the later stages, Judith Flogdell, who has been serving as my PA, has played a vital role, both in organizational terms and in the matter of preparing the book for publication, not least with respect to the illustrations. She has also taken on the important task of assembling the index. It has been a pleasure to work again with the editorial and picture research teams at Oxford University Press. Luciana O'Flaherty has been supportive from the beginning and hugely encouraging as the final text assumed its publishable state. Matthew Cotton has worked closely on the book throughout with unstinted commitment, and its final appearance, in all senses of this term, owes much to his collaboration. Deborah Protheroe oversaw the picture research, and Sandra Assersohn,

with the assistance of Liz Heasman and Caroline Thompson, undertook sterling work tracking down a very widely scattered body of illustrative material. The picture research and the acquiring of permissions proved to be notably taxing, especially when dealing with large commercial rights-holders. Phil Henderson and Coleen Hatrick have worked enthusiastically to ensure that the book becomes known in the public domain. Emma Barber skilfully took the book through to production. Jackie Pritchard has brought her copy-editing skills to bear on the text to good effect. Clare Hoffman's cover design has captured the diversity and flavour of the book very skilfully. Jonathan Bargus's text design is elegant, spacious, and engaging. For all involved at the Press, beyond those named, the book set some unusually demanding tasks, and I am most grateful that they have been undertaken with such friendly professionalism.

CONTENTS

Acknowledgements *ix*
List of Illustrations *xv*

Introduction 1
1 Christ: The True Icon 13
2 The Cross 45
3 The Heart 81
4 The Lion 113
5 *Mona Lisa* 141
6 Che 167
7 Napalmed and Naked 197
8 Stars and Stripes 225
9 COKE: The Bottle 253
10 DNA 279
11 $E = mc^2$ 307
12 Fuzzy Formulas 339

Picture Acknowledgements *355*
Index *359*

LIST OF ILLUSTRATIONS

Christ as Pantokrator, detail, 6th century (?), encaustic on panel, Mount Sinai, St Catherine's Monastery. — **Ch 1 opener**

1.1 Alfred Leete, 'Your Country Needs You', cover of *London Opinion*, 5 September 1914.

1.2 *Mosaic floor with roundel of Christ* (from Hinton St Mary, Dorset), 4th century, London, British Museum.

1.3 *Solidus of Justinian* (obverse and reverse), 685–95, London, British Museum.

1.4 *Christ with the Virgin and Angels and Saints*, 12th-century apse mosaic, Cefalù, Cathedral.

1.5 *Holy Face*, canvas with silver casing, 6th (?) and 11th–15th (?) century, Genoa, S. Bartolomeo degli Armeni.

1.6 Matthew Paris, *The Sudarium of St Veronica*, after 1245, illumination on parchment, from Chronica majora. Corpus Christi College, Cambridge.

1.7 *The Sudarium of St Veronica*, German (?), 17th century (?), private collection.

1.8 Master of St Veronica, *St Veronica with the Sudarium*, c.1420–30, oil on panel, London, National Gallery.

1.9 Jan van Eyck (after), *Christ*, (original from 1438), oil on panel, Berlin, Gemäldegalerie, Staatliche Museen zu Berlin.

1.10 Petrus Christus, *Young Man with a Book*, c.1450–60, London, National Gallery.

1.11 Andrei Rublev, *Christ*, c.1410, tempera on panel, Moscow, Tretyakov Gallery.

1.12 Leonardo da Vinci, *Salvator mundi*, c.1505–9, oil on panel, private collection.

1.13 *The Turin Shroud*, c.1300, linen, Turin, Cathedral, original and reversed appearance.

1.14 Georges Roualt, *Head of Christ*, c.1937, The Cleveland Museum of Art.

Ch 2 opener *Descanso* (temporary resting place for coffins), near Santa Fe, El Rancho de las Golodrinas.

2.1 The 'Hand of God': Diego Maradona scores for Argentina against England in the 1986 football World Cup.

2.2 Piero della Francesca, *Constantine's Dream of the Cross*, c.1460–6, Arezzo, Church of San Francesco.

2.3 Piero della Francesca, *Constantine's Victory over Maxentius*, c.1460–6, Arezzo, Church of San Francesco.

2.4 Sarcophagus with the cross and scenes from the Passion, mid-4th century, Rome, Vatican, Museo Pio Christiano.

2.5 Reading stand (?) with the lamb, crosses, doves, and the symbols of the Evangelists, 6th century (?), Lectern of Sainte Radegonde. Musée de la Ville de Poitiers et de la Société des Antiquaires de l'Ouest.

2.6 *Descanso* (temporary resting place for coffins), near Santa Fe, El Rancho de las Golodrinas.

2.7 Cross of Muiredach, c.920, Ireland, Monasterboice.

2.8 *Il Volto Santo di Lucca*, early 13th-century replacement of 9th-century original (?), with gold vestments, crown, shoes, mace, and keys from the 15th–19th centuries, Lucca, Cathedral of S. Martino.

2.9 Matteo Civitali, *Tempietto* to house the *Volto Santo*, 1484, Lucca, Cathedral of S. Martino.

2.10 Giotto di Bondone, *The Stigmatization of St Francis with Scenes from his Life*, c.1300, Paris, Louvre.

2.11 Matthias Grünewald (Matthis Neithardt?), *The Isenheim Altarpiece* closed, c.1512–16, Colmar, Museum Unterdenlinden.

2.12 Family assembly of the Ku Klux Klan at Macon, Georgia, 27 April 1956.

2.13 Terracotta funerary jar, from Lamba Teye, Kinshasa, Institut des Musées Nationaux du Zaïre.

2.14 Wooden cross with brass insert of St Anthony, 20th century. New York, Metropolitan Museum of Art. Brass, gift of Ernst Anspach, 1999.

2.15 The swastika flag, private collection.

2.16 Leni Riefenstahl, *The Sea of Flags*, still from *Triumph of the Will*, 1934.

2.17 John Heartfield (Helmut Herzfeld), *As in the Middle Ages . . . so in the Third Reich* (with St George tortured on the wheel of swords, from the Collegiate Church, Tübingen), 1934.

Puzzle Valentine card, in its fully folded state, detail, 1790, London, British Postal Museum. **Ch 3 opener**

3.1 Giotto di Bondone, *Charity*, c.1305, Padua, Scrovegni Chapel.

3.2 The heart of a pig (with a lateral puncture).

3.3 Leonardo da Vinci, *Vessels of the Thorax and Upper Abdomen with Demonstration of the Heart as Seed*, c.1507, Windsor Castle, Royal Library 12597.

3.4 Anatomy of a pregnant woman, from Johannes de Ketham, *Fasciculus medicinae*, Venice, 1491. Wellcome Library, London.

3.5 Govard Bidloo, 'The Heart, Whole and Dissected', from *Anatomia humani corporis*, Amsterdam, 1685.

3.6 Donatello, *Miracle of the Miser's Heart*, c.1447–50, Padua, Basilica of Il Santo.

3.7 Detail of Fig. 3.6 showing the discovery of the miser's heart. Padua, Basilica of Il Santo.

3.8 Casket with armorial shield and two scenes of a young man as the victim of love, *c*.1330, New York, Metropolitan Museum. Oak, inlay, and tempera; wrought-iron mounts.

3.9 Knave of hearts and diamonds, uncut cards, French, *c*.1490–1500, London, Victoria and Albert Museum.

3.10 *Friendship*, from Gregor Reisch, *Margarita philosophica*, Freiberg, 1503.

3.11 *The Heart of St Clare of the Cross with the Symbols of the Passion*, woodcut, *c*.1600.

3.12 Barthélemy d'Eyck, 'Contrition and Fear of God Return a Purified Heart to Soul', from René d'Anjou, *Le Mortifiement of vaine plaisance*, 1455.

3.13 The Sacred Heart from a Book of Hours, *c*.1490, New York, Pierpont Morgan Library.

3.14 Antonius Wierix, *On Other Side of the Door Beats the Heart of JESUS*, *c*.1600.

3.15 Peace of Concrete Company, *The Sacred Heart*, concrete, handpainted, 2010.

3.16 Puzzle Valentine card, in its fully unfolded state, 1790, London, British Postal Museum.

3.17 Milton Glaser, *I Love New York*, 1977.

Ch 4 opener Guardian lion at the Gate of Heavenly Purity, *c*.1655, Beijing, Royal Palace.

4.1 Metro Goldwyn Meyer logo, 1950s.

4.2 Slats the lion being recorded for MGM.

4.3 Ancient Egyptian statues of Sekhmet at Louvre, Paris, France.

4.4 Guardian lions at the Gate of Heavenly Purity, *c*.1655, Beijing, Royal Palace.

4.5 Lion capital of Ashoka, *c*.250 BC, Sarnath Archaeological Museum, Uttar Pradesh, India.

4.6 A lion with a cart and cockerel, from a 13th-century miscellany, including a bestiary in Anglo-Norman verse, Oxford, Merton College.

4.7 Johannes de Ketham, 'Zodiac Man', from *Fasciculo de medicina*, Venice, 1493.

4.8 Giambattista dell Porta, heads of lion and leonine man, from *De humana physiognomia*, Vico Equense, 1586.

4.9 Lion mauling a man, 12th century, from the portico of St Trophime Cathedral, Arles.

4.10 Donatello, *Marzocco*, *c.*1419, Florence, Museo Nazionale del Bargello.

4.11 Henry Shrady, Grant on horseback and lion, from the Ulysses S. Grant Memorial, bronze, 1902–22, Washington.

4.12 Sir Edwin Landseer, lion from the base of Nelson's Column, bronze, finished 1867, London, Trafalgar Square.

 Leonardo da Vinci, *Portrait of Lisa Gherardini; the 'Mona Lisa'*, 1503– **Ch 5 opener**
 *c.*1516, Paris, Louvre.

5.1 Pascal Cotte, *Mona Lisa Digitally Restored*, 2009.

5.2 Leonardo da Vinci, *Map of the Arno Valley West of Florence Showing the Projected Canal*, Windsor, Royal Library.

5.3 Jean-Auguste Dominique Ingres, *Leonardo Dying in the Arms of Francis I*, 1818, Paris, Musée de la Ville de Paris.

5.4 The *Mona Lisa* vanished.

5.5 Aderans Hair Goods Inc., *The Mona Lisa*, 2010.

5.6 Leonardo Studio, *Madonna Vanna*, cartoon, *c.*1518, Chantilly, Musée Condé.

5.7 Unknown artist, *Madonna Vanna*, *c.*1520, St Petersburg, Hermitage Museum.

5.8 Marcel Duchamp *L.H.O.O.Q.*, 1919, New York, private collection.

5.9 *Mona an Icon*, René Design.

5.10 Andy Warhol, *Thirty are Better than One*, private collection.

5.11 Robert Knudsen, *President Kennedy, Mme Malraux, André Malraux, Jackie Kennedy and Vice-President Johnson at the Unveiling of the Mona Lisa, National Gallery of Art, Washington, 8 January 1963*, Boston, John Fitzgerald Kennedy Presidential Library.

Ch 6 opener Jim Fitzpatrick, *Che Guevara*, 1968.

6.1 Alberto Korda, *Guerillo heroico*, 5 March 1960.

6.2 Alberto Korda, *Norka Modelling a Hat*, 1957.

6.3 Raúl Corrales, *Caballería*, 1960.

6.4 Alberto Korda, contact sheet of 28 frames shot at the rally of 5 March 1960.

6.5 Alan Oxley, *Che Guevara Helping Workers on a Government Housing Project*, no. 7 in the *Cuban Revolution Collection*, 1962.

6.6 Frémez (José Gómez Fresquet), *Hasta la victoria sempre*, 1967. Photographer Alberto Korda, offset, 1967, Cuba.

6.7 Enrique Avila González, *Che Guevara*, Havana, Ministry of the Interior, Plaza Revolución.

6.8 Jim Fitzpatrick, *Che Guevara*, 1968.

6.9 A Republican mural painted with a portrait of Che Guevara, Shiels Street, Belfast, Northern Ireland, 25 August 1998.

6.10 Freddy Alborta, *Che Guevara Dead*, 1967.

6.11 Andrea Mantegna, *Dead Christ*, c.1500, Milan, Pinacoteca di Brera.

6.12 Chas Bayfield and Martin Casson, *Meek Mild As If*, for the Churches Advertising Network, 1999.

6.13 *Christ/Che Crucified*, postcard, author's collection.

6.14 Military shirt/jacket, 2010, Dragonfly Clothing Company, via the Che Store, author's collection.

Ch 7 opener Nick Ut, *Villagers Fleeing along Route I*, detail, 1972.

7.1 Nick Ut, *Grandmother Flees with Dying Grandson*, 1972.

7.2 Nick Ut, *Villagers Fleeing along Route I*, 1972.

7.3 Richard Peter, *Dresden Bombed, Viewed from the Tower of the Town Hall*, 1945.

7.4 Horst Faas 'Why?' (father, child, and South Vietnamese soldiers), 1965.

7.5 Edward Adams, *General Nguyen Ngoc Loan Executing a Viet Cong Prisoner in Saigon*, 1968.

7.6 Raphael, *Massacre of the Innocents*, engraved by Marcantonio Raimondi, *c.*1510. British Museum.

7.7 Pablo Picasso, *Guernica*, 1937, Madrid, Museo Nacional Centro de Arte Reina Sofia.

7.8 Nick Ut, *Kim's Aunt Carrying a Baby*, 1972.

7.9 Tim Page, *Nun and Corpse*, 1969.

7.10 Robert Capa, *Loyalist Militiaman at the Moment of Death, Cerro Muriano, September 5, 1936*.

Andrew Krasnow, *The Flag from Flag Poll*, detail, 1990, human skin and dye, collection of the artist. **Ch 8 opener**

8.1 Felix de Weldon, *Marines Raising the Flag at Iwo Jima*, Virginia, Marine Corps War Memorial, Arlington National Cemetery.

8.2 Betsy Ross Bunnykins by Royal Doulton, 2004.

8.3 The 'Francis Hopkinson' Stars and Stripes.

8.4 Dread Scott, *What is the Proper Way to Display a U.S. Flag?*, 1989, displayed in the School of the Art Institute, Chicago.

8.5 Joe Rosenthal, *Flag Raising on Mount Suribachi on Iwo Jima*, 1945.

8.6 Théodore Géricault, *Raft of the Medusa*, 1819, Paris, Musée du Louvre.

8.7 Felix de Weldon, *Marines Raising the Flag at Iwo Jima*, Virginia, Marine Corps War Memorial, Arlington National Cemetery.

8.8 Felix de Weldon working on the clay model for the head of Rene Gagnon.

8.9 Felix de Weldon, *Marines Raising the Flag at Iwo Jima*, detail.

8.10 Thomas Franklin, *Flag Raising at Ground Zero (Ground Zero Spirit)*, *New York*, 11 September 2001.

8.11 Jasper Johns, *Flag*, encaustic, oil, and collage on fabric mounted on plywood, 42 1/4 × 60 5/8' (107.3 × 153.8 cm). 1954–5, New York, Museum of Modern Art.

8.12 Andrew Krasnow, *The Flag from Flag Poll*, 1990, human skin and dye, collection of the artist.

Ch 9 opener COCA-COLA bottle, 2010. Contours of the bottle, designed by Earl Dean et al.

9.1 Logo of the Ford Motor Company.

9.2 Ai Weiwei, *Han Dynasty Urn with COCA-COLA Logo*, paint/Han dynasty urn (206 BC to AD 24) 1994.

9.3 Bottle from the Birmingham COCA-COLA Bottling Company, Alabama (bottle designer unknown).

9.4 Earl Dean, drawing for the COCA-COLA bottle, 1915. Courtesy of Norman and Linda Dean.

9.5 Earl Dean, COCA-COLA bottle prototype, 1915.

9.6 COCA-COLA bottle patent, named 'inventor' Alexander Samuelson, 16 November 1915.

9.7 Man with cocoa pod, *c.*1440–1521, Volcanic stone, traces of red pigment, Brooklyn Museum.

9.8 The cocoa pod, from volume vi of the 11th edition of the *Encyclopaedia Britannica*, 1911.

9.9 Green vase by the Teco Company, *c.*1910.

9.10 Haddon Sundblom, *My Hat's Off*, 1944. Publicity of Christmas for the soda COCA-COLA.

9.11 L. Roberty, *Hobbled by the Hobble Skirt*, postcard from the series 'Les Entravées', *c.*1910.

9.12 Second COCA-COLA bottle patent, 25 December 1923, named 'inventor' Chapman Root.

9.13 Third COCA-COLA bottle patent, 3 August, 1937, named 'inventor' Eugene Kelly.

9.14 Pepsi-Cola 'swirl bottle', 1970s.

Ch 10 opener Eric Lander and Darryl Lea, cover for *Nature*, 15 February 2001.

10.1 Odile Crick, diagram of the proposed structure of DNA, from James Watson and Francis Crick, 'Molecular Structure of Nucleic Acids: A Structure for Deoxyribose Nucleic Acid', *Nature*, 25 April 1953, p. 737.

10.2 The structure of DNA rendered as a space-filling molecular model.

10.3 Max Perutz with his model of haemoglobin and John Kendrew with his model of myoglobin, 1962.

10.4 Rosalind Franklin and Raymond Gosling, crystallographic photo of Sodium Thymonucleate, Type B, 'Photo 51', 1–2 May 1952.

10.5 Linus Pauling's passport ban, *Los Angeles Examiner*, 12 May 1952, showing Pauling with his alpha-helix model of proteins.

10.6 Antony Barrington Brown, *Watson and Crick with their Model of DNA*, 21 May 1953.

10.7 Bruno Strasser, English language citation of record of Watson's and Crick's 1953 paper on DNA to 2003.

10.8 Francis Collins, Eric Green, Alan Guttmacher, and Mark Guyer, 'The Future of Genomics Rests on the Foundation of the Human Genome Project', *Nature*, 422, 2003, p. 836.

10.9 Eric Lander and Darryl Lea, cover of *Nature*, 15 February 2001.

10.10 Buckminster fullerene (Carbon$_{60}$).

10.11 BFF Architects and Izé, DNA door handles, London, Royal Society, 2003.

10.12 Mark Curtis, *The Double Helix Unzipping*, collection of the artist.

10.13 Robertson's DNA golly brooch, the 1950s, 2001.

 Baloo (Rex F. May), 'You think you're pretty smart, don't you?' **Ch 11 opener**

11.1 Oren Turner, *Albert Einstein*, 1947.

11.2 Grave marker for Erwin Schrödinger, 1965, Austria, Alpach, churchyard of St Oswald.

11.3 The energy/mass/light equation in Einstein's manuscript on relativity, 1912, The Israel Museum, Jerusalem.

11.4 Photograph of the total eclipse of the sun (positive version) as taken on the 1919 Expedition to Sobral, Brazil. Science Museum.

11.5 Eric Mendelsohn, the Einstein Tower, 1917–21, Potsdam.

11.6 Ernest Hamlin Baker, *Cosmoclast Einstein*, cover of *Time* magazine, 1 July 1946.

11.7 Lucien Chavan, *Einstein, 1906–7*. Hebrew University of Jerusalem, Albert Einstein Archives.

11.8 Julia Margaret Cameron, *Sir John Herschel*, 1867. National Media Museum.

11.9 Philippe Halsman, *Albert Einstein*, 1947.

11.10 Arthur Sasse, *Albert Einstein Sticking his Tongue Out*, 1 March 1951.

11.11 Einstein's blackboard, 1931, Oxford, Museum of the History of Science.

11.12 Photographs of Einstein's brain, as published by Sandra Witelson et al., *The Lancet* in 1999.

12.1 Matthew Landrus, *Mona Lisa under Siege*, 2001.

12.2 The 'Venus' of Willendorf, *c.*23,000 BC, Vienna, Naturhistorisches Museum.

12.3 Andy Warhol, *Twelve White Mona Lisas*, 1980, private collection.

12.4 Nick Ut's photograph of the napalmed girl, transformed by the Stamp feature in Adobe Photoshop.

12.5 Kim Phuc in the Stamp version, cropped.

12.6 Jonathan Kemp, *Etienne, Louis, and Alice*, May 2008.

12.7 The Stamp version of *Etienne, Louis, and Alice*, May 2010.

12.8 Louis in the Stamp version, cropped, 2010.

12.9 Fuzzy category field, with green, blue, and red groups, 2010.

Introduction

Origins

THE IDEA FOR THIS BOOK can be dated to 2003 and, more specifically, to the fiftieth anniversary of the publication in *Nature* of a proposed structure for DNA by James Watson and Francis Crick. I had been asked by the science journal *Nature* to provide an essay on the double helix's remarkable visual history for their free-standing publication *50 Years of DNA*. My contribution was entitled 'The *Mona Lisa* of Modern Science'. The original *Mona Lisa* had much occupied me over the years. I have been researching, teaching, writing, broadcasting, and curating exhibitions about Leonardo da Vinci since the late 1960s. Of course there are also Leonardo's *Last Supper* and his 'Vitruvian Man' (the nude man tracing the circle and square with his extended arms and legs), which have achieved

a status only a little less lofty in the pantheon of icons. Teaching first-year classes in Glasgow and St Andrew's I had inevitably grappled with other canonical works in the history of European art: Jan van Eyck's *Arnolfini Wedding*, Michelangelo's *David*, Velázquez's *Las Meninas*, Rembrandt's *The Night Watch*, Constable's *Hay Wain* (perhaps rather an English choice), Rodin's *Thinker*, Van Gogh's *Sunflowers*, Munch's *Scream*, Picasso's *Guernica*, and so on. Readers can readily add to this slim list of examples. This is to say nothing of images outside this European mainstream, such as the Egyptian *Queen Nefertiti* in Berlin and the prehistoric *Willendorf Venus* in Vienna.

After moving to Oxford, I have been giving talks about Leonardo to various leadership seminars, looking at his ways of thinking and representing—under the general banner of lateral thinking. Most were given under the aegis of the Saïd Business School. I suggested that I might develop a lecture or workshop in iconic images, on the basis that I already have two of them under my belt, and thinking that they are very relevant to the 'branding' concerns that have come to loom so large for all private and public bodies. After all, the COCA-COLA bottle and the Nike 'Swoosh' are iconic images *par excellence*, and any company would give much to achieve such universal brand identity. Furthermore, the mega-famous works of art have been adopted and adapted ceaselessly in commercial advertising. As it happens the offer of the lecture was not taken up in the face of the seductions of Leonardo's 'universal genius'. Perhaps it will be after the publication of this book.

Anyway, I began to think about the obvious questions. Why have iconic images achieved their status? Do they have anything in common? A tidy answer to the second of these questions has remained elusive, not least because it is founded on a false premise, as I hope to show in due course. The first question becomes more tractable if it is asked in terms of 'how?'; that is to say if we plot the key moves through which each image has risen to extravagant levels of fame. I am not promising to narrate the life histories of each of the selected images, as I rashly claimed to friends at the outset. Rather I will be looking at the origins of each and picking out some of the most notable and curious steps along the course of their ascent. Each has promiscuously spawned such a huge number of progeny that only a few will have to stand for the many, for obvious practical reasons. I have concentrated particularly on notable, significant, idiosyncratic, and (often) bizarre examples amongst the legions of copies,

reproductions, versions, variants, pastiches, and parodies. Once alerted, we see them everywhere and begin to realize their ubiquity.

There is also the obvious question of how to define an iconic image. I would prefer in some ways not to give a definition, since this suggests some clear and definable boundary that the image crosses when it moves from being very famous to fully iconic. The problem is compounded by the tendency of the modern media to downgrade such terms as genius and icon and by applying them to too many examples. Elvis Presley, The Beatles, Marilyn Monroe, and Muhammad Ali (Cassius Clay) are undoubtedly icons in their popular domains and even beyond, particularly to my generation. However the term iconic is now scattered around so liberally and applied to figures or things of passing and local celebrity that it has tended to become debased. By contrast, the eleven images here are as secure and universal in their iconic status as any cultural products can ever claim to be.

If I have to give a definition of a visual icon, let me suggest the following. An iconic image is one that has achieved wholly exceptional levels of widespread recognizability and has come to carry a rich series of varied associations for very large numbers of people across time and cultures, such that it has to a greater or lesser degree transgressed the parameters of its initial making, function, context, and meaning. I am aware that this is a bit ponderous. I have developed my own rule-of-thumb instinct for when an image is simply very famous, not least on the basis that the very famous still tends to reside within the parameters of reference that governed its original making. But absolute tests are not to be applied with any degree of confidence.

One striking characteristic of truly iconic images is that they accrue legends to a prodigious degree that is largely independent of how long they have been around. Once one of them crosses a certain boundary, the bald historical facts and the original zone of function and meaning seem inadequate. An extraordinary image demands an extraordinary explanation, ideally involving some kind of 'secret', especially when the actual historical evidence points to quite prosaic origins. Over the years I have come to recognize this seemingly insatiable demand with respect to the *Mona Lisa*. None of the images here is immune from the need for legends. Indeed, they seem actively to incite them.

Even participants in the actual making of the images and their propagation can all too readily become caught up in the myths, becoming

honestly convinced in retrospect of something that seems not to have been the case. We all tend to do this with our own lives. A few of the contemporary witnesses I consulted for the various chapters presented these kinds of problems, and their evidence needs to be evaluated carefully, as with all historical sources from any era.

Choices and Chapters

The examples included here are all static, and even those that are three-dimensional work at high levels of efficacy even in flat representations. Moving into architecture and engineering (e.g. the Forth Rail Bridge) would have expanded the brief too far and introduced too many extra criteria. It is arguable that moving images never become truly iconic without crystallizing into a memorable still. I think this continues to apply even in the age of clips on YouTube. In any case, film and video also would have stretched my brief beyond any practical limits. The still, flat image clearly carries a special cognitive potency, working in a particularly effective way with our perception and memory.

An inevitable early stage in my project involved compiling lists, often with the help of friends. One of the nice things about writing and discussing this book is that everyone has a pointed opinion on what warrants inclusion. Given my working definition, all opinions deserve respect, and I cannot claim to be more of an expert than the next person as to whether this or that image should elbow its way in. I can at least say that I have given the matter a lot of thought and canvassed a wide range of opinions.

The lists, as they rapidly grew, demanded some kind of ranking, ordering, and classification if they were to make much sense. It rapidly became clear that there are two basic categories, general and specific. The general ones represent an entity that can be recognized and expressed in terms that are noun-like—like a lion or a heart. They do not rely for their basic potency on their identity with this or that individual lion or heart, although they may be represented by specific individuals. The specific examples are recognizable in terms of known individuals and therefore share the properties of proper names—like Christ and Che. But the categories are not watertight. The generic becomes specific as soon as it is materialized in a given context, and the individual comes to stand for something general enough if it is to achieve its very wide reach. DNA and $E = mc^2$, my two last examples, do not quite fit into either category with

comfort, since their relationships between form and content are different from the other examples. The molecule of DNA features as diagrams and models but is never literally 'seen' in itself, while Einstein's formula is a concept that assumes visual form only when written down.

A more differentiated classification gradually emerged, and was by *type*. The types came and went, but eventually crystallized into the current eleven chapters. I like eleven rather than the tidier twelve. Eleven is a good prime number and resists regular sub-division. However, the number has no rationale beyond its utility to me and, I hope, the reader.

Where to begin was not the biggest problem. The term 'icon' (from *eikon*, Greek for image) has come to be applied specifically to devotional images characteristic of Greek and Russian Orthodox Christian traditions. We have no difficulty in conjuring up a typical Russian-style icon—a highly formalized and standardized flat representation of Christ or the Virgin Mary or a saint in rich pigments on a tooled gold background. Large eyes, emphatically almond-shaped, stare unblinkingly at us. The eyes, as the cliché goes, 'follow us round the room'. The icon of Christ serves to define the iconic species in its own right. It is what biologists call the 'type specimen'.

The cross or cross-shape seemed to follow naturally, given its Christian prominence. It represents the simplest kind of formal or graphic device. It can function in contexts in which figurative images are unwelcome or impractical, and can be drawn or constructed with great ease in almost any medium. The cross also provides opportunities to reach out into another cultural framework, and into a variant form that carries stark implications, the Nazi swastika. The cross exhibits extraordinary elasticity of meaning in different contexts, but tends to have predominantly severe connotations.

The heart refers to something complicated in its original bodily form but has come to assume a special schematic shape—the heart-shape—that carries a wide range of meanings, almost always positive. It functions across the religious and secular with equal potency. It has also come to function as a hieroglyphic word, as in Milton Glaser's famous slogan, 'I ♥ NY'. It helps if the heart is blood red.

Animals and to a lesser degree plants have come to signify almost universal meanings or characteristics, and none to a greater degree than the lion. Its designation as the 'king of the jungle' crosses cultures and times to an unrivalled degree. The eagle is also strongly present across cultures,

but not to the same extent. From children's books to political symbols, the animal often does a job in conveying a general meaning or significance which a representation of a particular person somehow fails to do.

When it comes to selecting an example of 'high art', there really is no contest. I would have been happy to avoid the *Mona Lisa*, given the fact that I have already written extensively on it (or 'her'). However, as it happened, writing about it in the present context—having left this chapter until last—presented unexpectedly fresh opportunities. Recent claims have been made that Munch's *Scream* has supplanted Leonardo's icon, most notably as an angst-ridden symbol of our age, but I do not think it is a serious competitor.

A modern, popular, and 'posterized' *Mona Lisa* also more or less selected itself, namely the head of Che (Guevara). A lumbering sports utility vehicle (a 'Chelsea tractor' in the UK) disgorges a posh family in Sloane Square in London with two kids wearing T-shirts that carry a highly simplified rendition of the face, hair, and beret of Che, the communist revolutionary. We may wonder how image, social communication, and original subject have become almost totally dislocated.

The schematic picture of Che depended on a photograph by Alberto Korda, and the photograph itself is famous in its own right. However, I selected as my leader amongst famous photographs the incredibly moving snapshot by Nick Ut of a naked Vietnamese girl running down a road after being hideously napalmed. In my taking of soundings amongst acquaintances, there was probably more diversity of choice in the photographic category than any other. This is in part due to the sheer numbers of works from which to choose. No one thought that my choice was misguided, but some would have selected a different one. At least Joe Rosenthal's famed photograph of the raising of the American flag on Iwo Jima and Robert Cappa's notorious shot infantryman feature in the next chapter.

For the national or political emblem, the Stars and Stripes has the prime claim, as well as presenting a livelier visual image than many flags. Some years ago the British Union Jack would have been the obvious choice, but the current realities of worldwide power have prevailed. The American flag is also hedged around with mythology and law in a way that was probably only rivalled by the symbol SPQR that dominated the ancient Roman empire (*Senatus Populusque Romanorum*—the Senate and People of Rome), and the Nazi banners of the last century.

Selecting a commercial emblem or logo obviously presented a wide range of possibilities. The Nike 'Swoosh' has already been mentioned. There is also the 'M' of McDonald's—and many others. However, the COCA-COLA bottle, coupled with the cursive script of its logo, seemed to be without a really close rival. Disliking COKE (and Pepsi), even as a teenager, I would have been happy to make another choice, but the myths proved exceptionally lively once I looked into some more-or-less suppressed aspects of its history.

In the twentieth century images specific to science have emerged as a specific visual genre in its own right. The double helix of DNA was a fairly easy choice. It has come to symbolize the human quest to understand what makes us tick, often in a bowdlerized manner. Its fascinating shape has been transferred into areas of art and decoration as a familiar cipher that confers status on its user, even in the most generalized way. Many of its users would be hard-pressed to explain what DNA is and how it works.

It could be objected that $E = mc^2$, based on Einstein's theories, is not a visual image at all. It certainly does not have the pictorial qualities of all the preceding examples, since it does not signify by *visual resemblance*. However, in its written or printed form, it has assumed a ubiquitous visual presence in the imagery of science, not only when theoretical physics is involved but also more generally to represent scientific endeavour—with powerful hints of mysterious conceptual realms into which the ordinary person cannot readily venture. It is also indelibly linked with the person of Einstein himself, the supreme modern exemplar of genius, and the nuclear bomb.

Obviously it would be wrong to insist that my choices are definitive. I am conscious that they are those of a British man of a certain age and background (and political conviction). I am prepared to argue that within their defined types each of the chosen images has an arguable case to be the most famous, and would deserve serious consideration in anyone's list. I am not getting into the game of arguing that there are good reasons for *excluding* a particular example, say the Nike 'Swoosh'. I am only claiming that amongst brand images the COKE bottle is in its own right incontestably iconic. I am prepared to stand by each inclusion but I am not aspiring to support exclusions on the basis that they are somehow deficient according to my criteria for an iconic image. Above all, since I am dealing with representatives of types, my list is not an all-time 'top

eleven' and is certainly not in ranking order. But if anyone wants to play the ranking game, they are welcome to do so.

The actual order of the chapters is determined by chronologies (that inevitably overlap) and by what seems to me to a reasonably natural progression through the types. I did toy with the idea that I might reverse the order of the chapters, or even, in a moment of non-commercial fantasy, publish it in two versions, one of which would have the chapters in reverse order. In reality, the chapters can be read in any order that makes sense to the reader.

Looking over the chapters during and after their composition I am fully alert to the 'Western' slant of the enterprise, and indeed to the heavy representation of American material. This is in part because of my areas of cultural knowledge, but it does reflect a modern reality. The reality is that Western and Western-style media have come to dominate the making and dissemination of images on a worldwide basis. American commercial imperialism has transformed the COKE and Pepsi bottles into the most successful international invaders there have ever been. Even Einstein, a German-speaking Jew, was transformed into a figurehead of American freedom. The major twentieth-century wars that have spawned great war photographs have all involved America.

At one time the Buddha was on my list. The prophet Muhammad clearly was not, since representations of him are prohibited, as are 'graven images' of God in Judaism. I lost the Buddha partly because even the very familiar seated image of the portly divine did not seem quite to have achieved the same level of worldwide recognizability as Christ. I am not now quite so confident about this. I also had to admit to myself that anything I wrote on the Buddha would have been cannibalized from secondary literature rather than gaining the potential freshness that comes from my having confronted primary sources. Of 'non-Western' artworks, I thought longest about Hokusai's renowned coloured woodcut of *The Great Wave*, but decided that its fame resided largely within the world of art, even if it has achieved very wide recognizability. Another significant factor in skewing any choice is that there is more recorded evidence about the generation of images in Western cultures than in any other, with the possible exceptions of China and modern Japan.

In China, an image-making society second to none before the nineteenth century, the most famous painting is *Qingming shanghe tu* (*Along the River During the Qing Ming Festival* or *Spring Festival on the River*) by Zhang

Zeduan, an artist working in the eleventh to twelfth century. It consists of a handscroll over 17 feet long across which unfolds a wonderful panorama of countryside and town, populated with different types of people who are busily engaged in delightfully varied activities during the course of a day from morning to evening. Sections of the panorama have become notably popular through derivations in almost every kind of medium and in restaurant décor. I needed to look it up when Craig Clunas, my successor as Professor at Oxford, patiently answered my importunate question as to which is the most famous painting in China. This testifies to my (and I think our) general ignorance of Chinese culture. With the rebirth of China as a political, economic, and cultural power, it may be that Zhang Zeduan's masterpiece will assume its warranted prominence on a worldwide basis.

Even without venturing into what for me would be exotic territories, the range covered by the chapters is very wide, from early Christian evidence of the appearance of Christ to the abstract and counter-intuitive complexities of twentieth-century relativity. Inevitably I am more secure in my knowledge and understanding of some of my topics than others. I have been fortunate that friends with special expertise have been willing to look at the whole or parts of chapters. It would, however, be surprising if some bloomers have not crept through, but I hope that none undermines the arguments of each chapter and of the book as a whole.

The range of material would not have been manageable in practice during the era before the internet. I can, for instance, search the US Patents Office on-line for COCA-COLA bottle designs without the expense, time, and rigours of a journey to Washington. Major archives are increasingly appearing on-line, like the excellent and freely accessible records of the Ava Helen and Linus Pauling papers in Oregon State University, the generous accessibility of which stands in contrast to the more prescriptive and commercial management of the Einstein archive at the Hebrew University in Jerusalem.

Separating the wheat from the chaff on the internet involves much the same skills of evaluation that the historian has always needed, but these skills need refining and fortifying in the face of the apparently authentic rubbish that looks so plausible in many websites. It seems to me that one of the biggest jobs for education today is to educate everyone, young people in particular, about the necessary skills in questioning and evaluation in the digital age. Spurious material can now be readily and freely

presented with a visual and verbal conviction that is hugely dangerous. My own widespread use of internet sources accounts for the cluster of links to websites at the start of each chapter's list of reading. Academics still tend to be rather sniffy about citing such sources. If they are good and provide access to something special, they deserve to be credited.

One of the hazards in writing about such famous images is that media 'stories' erupt so frequently that the book can all too easily appear to be outdated before it is published. During advanced stages in the production of the book the 'original recipe' for COCA-COLA appeared, accompanied by much media excitement. Typically, the scoop was not all it seemed. The list of ingredients was written by a friend of the inventor and had appeared, obscurely published, some years before. It is unclear if it was the definitive recipe for the original drink. It certainly is not the formula used in the present concoction. With iconic images even damp squibs tend to become jumping firecrackers.

I am conscious that the approach and style is not always that expected of a sober university professor, especially one who is now retired from a full-time post. There is an overtly personal dimension to the book, not least in the opening sections of each chapter, which consciously exploit an 'eyewitness' dimension. This seemed appropriate and felt right as I was drafting the chapters, not least because the images are very close to us and are living components of the visual fabric of our contemporary world, even if they originated a long ago. They evoke personal reactions and associations often of a powerful kind, sometimes positive, sometimes negative. Indeed they would not be iconic if they failed to engage us. The subject of some of the episodes, most notably those involved with war but also those that concern overly funny incidents, involve reactions that it would have seemed stilted to suppress. My prose has been stretched into realms of potential expression into which it has not ventured on previous occasions. Only the reader can decide if it has been stretched beyond its breaking point.

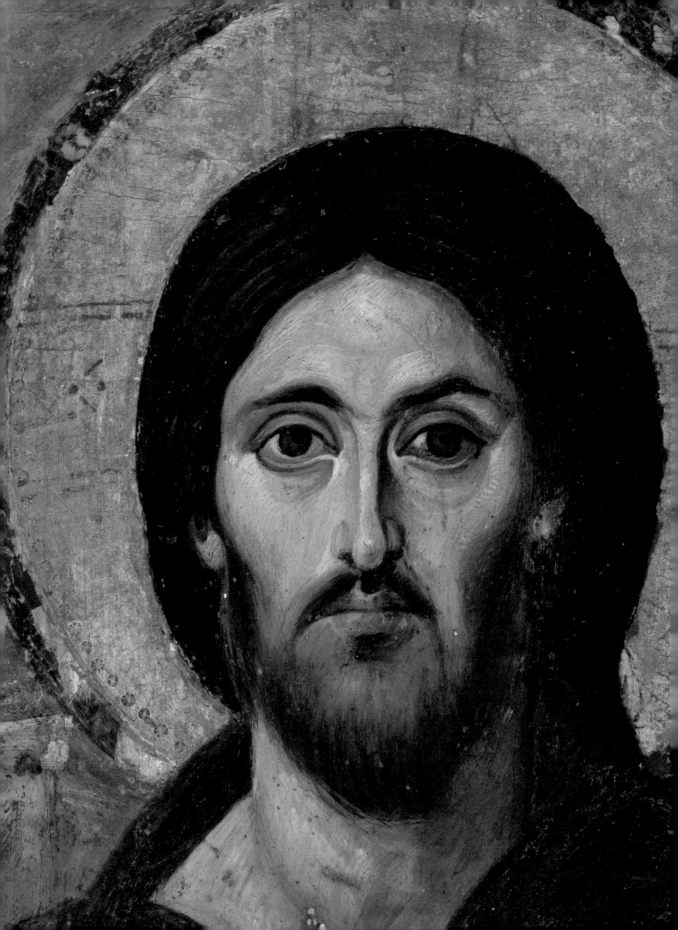

Christic

THE TRUE ICON

T HE GUIDE AT WINDSOR CASTLE spits out gobbets of routine history to fidgeting schoolboys. Neither she nor they seem particularly interested. Then something catches her eye and engages theirs. Somewhere on a stone wall behind St George's Chapel is a simple painted image of a man's head. It is entirely frontal, and lacks any details beyond the basic outlines of eyes, nose, mouth, beard, and long curling hair. The eyes are staring out, straight ahead.

'See how the eyes follow you wherever you are,' she says, moving a few steps from side to side to prove her point. The boys follow suit, reluctant to demonstrate genuine engagement but fascinated enough to murmur assent. Is this some mysterious magic of art from a far off era, lost to us today?

■ *Christ as Pantokrator*, detail, 6th century (?), encaustic on panel, Mount Sinai, St Catherine's Monastery.

This is an imperfectly recalled memory from my schooldays. I am not even sure whether the image was meant to be Christ, a saint, an ancient king, or someone else. I think it was at Windsor Castle. The details of the incident may be wrong, but the image itself made a lasting impression, and (to use the cliché) I can still see it today. I wonder how many guides in historic buildings over the years have been relieved to conjure up this bit of magic. It will, after all, work with any image of an entirely frontal human head with staring gaze, and works best with relatively rudimentary images.

As adults we know of course that such tricks involve no lost magic from the age of Merlin. The eyes that follow us are a consequence of the peculiar way that we are able to work with images on flat surfaces that purport to represent real things with even a modest level of naturalistic resemblance. The naturalistic illusions, even quite simple ones, remain remarkably robust when viewing the surfaces from quite oblique angles. Equally, if the eyes in a portrayed face seem to be glancing to the side when viewed from the front, there is no way that we can move laterally to make the eyes look at us.

It was this peculiarity of a representation on a flat surface that Alfred Leete brilliantly exploited in his visual admonition to the young men of Britain at the start of the Great War in 1914 (Fig. 1.1). Not only do Lord Kitchener's eyes stare commandingly at the potential recruit but his pointing index finger also 'follows us around' whether we like it or not.

There is something disconcerting about the riveting stare from which we cannot escape. It is something we rarely experience in real life, since our eye contact with others is generally less insistent and more intermittent. Infants tend to stare disconcertingly. But we are told as older children that it is rude to stare. 'Looking somebody in the eye' is an assertive act, either to indicate that the starer is registering an important truth or implicitly scolding the recipient for being evasive. The full frontal view of a forward-looking face often exhibits a certain emotional starkness. The stock mug-shots of criminals, which involve a profile and full face, tend to carry unpleasant connotations that all too readily transfer to own frontal portraits on passports and security cards.

The frontal view is also the first kind of face drawn by children. Our early perceptual system is designed to pick out the salient shape of a face together with its eyes, mouth, and nose. This propensity is retained in a more developed way into adulthood. Eye movements tracked in the laboratory have confirmed the amount of perceptual attention that we

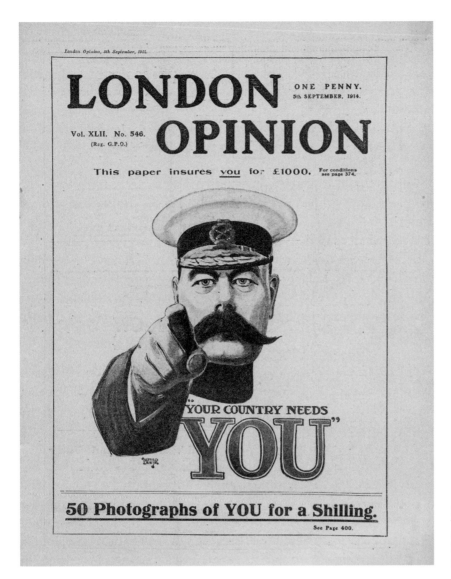

Fig. 1.1

Alfred Leete, 'Your Country
Needs You', cover of *London
Opinion*, 5 September 1914.

lavish on those features of someone that both identify them and declare
their emotional state. We focus especially on eyes. Not for nothing have
they been called 'the windows of the soul' (by Leonardo amongst others).
Even in eras of art during which very sophisticated techniques have been
developed to portray faces at almost every conceivable angle, the frontal
stare has continued to play a key role. In this sense, we never cast off our
childish things.

CHRIST: THE TRUE ICON | 15

The primitive potency of the full face, frontally staring, has been utilized insistently in political and religious arenas over the ages. It is obligatory in passports and police photographs. It is perfectly adapted to giving visual form to the concept of the all-seeing God or ruler who wishes to transcend the normal limits of material vision. There was a relatively well-known image of Christ in profile which was claimed to be authentic in the fifteenth century, but it never gained a comparable purchase on worshippers' imaginations.

This all-seeing quality is precisely the sense in which an image of Christ was glossed by Nicholas of Cusa (Cusanus), the much travelled German cardinal who was probably the most profound philosopher-theologian of the fifteenth century. When Cusanus sent a copy of his treatise *De visione Dei* (On the Vision of God) to the monks of Tegernsee, the leading Benedictine abbey in Bavaria, he accompanied it with a painted 'Icon of God'—almost certainly the face of Christ, a famous and popular subject for small-scale panel painting. Cusanus, like the Windsor Castle guide, pointed out that

> Regardless from the place from which each of you looks at it, each will have the impression that he alone is being looked at by it . . . If while fixing his sight upon the icon he walks from west to east, he will find that the icon's gaze proceeds continually with him.

This is more than an optical curiosity. Cusanus draws an analogy between the tracking stare of the painted Christ and the 'Absolute Sight' of God. He stresses, however, that the earth-bound sense with which we view the painted image is but a feeble reflection of the inner vision that might aspire to imagine the 'invisible Truth of Your Face'. He invites the monks to compose their own *speculatio* (meditation) on spiritual truth when looking at the image. For his own part, Cusanus goes on to meditate about our act of looking in a mirror and God as the mirror of eternity. An image that uses basically primitive means leads to thoughts of great profundity.

We can readily imagine the kind of icon sent to his fellow monks. It would have shown the 'Holy Face' of Jesus that had long been established as a standard type. An oval face with almond-shaped eyes, longish nose, and firm lips is to be symmetrically framed by long hair parted in the

middle, and a neat beard. We all know the type. It is familiar through countless pictures, old and new. Whatever the vicissitudes of pictorial style, the basic physiognomy of Christ has persisted. The archetypal form appears in what we now call 'icons', that is to say the highly formal images produced in Byzantine and Eastern Orthodox Church cultures. An early example before the genre had assumed stock rigidity survives from the monastery of St Catherine in Sinai. Christ is in the guise of 'Pantokrator'—he who rules over everything—with a golden halo, blessing and holding a lavishly bound book of Gospels. The painting may date from as early as the sixth century, though it has been subject to successive restorations. As we will see, it is likely that Cusanus' painted gift showed Christ in the 'modern' fifteenth-century manner pioneered by Jan van Eyck (Fig. 1.9).

The term icon comes from the Greek word *eikon* that refers to any image or portrait, but it came to be associated specifically with the hieratic and largely invariant paintings produced over the centuries in Eastern churches and favoured by Orthodox Christianity to this day. It is of course the term that we use today for everything from pop stars to DNA. In this broader and later sense, it is the subject of this book. It also provides, more or less inevitably, the book's first chapter, though it is not the simplest point at which to begin. It will entail aspects of theology of the kind with which we are now longer conversant.

The standard form of Christ's frontally portrayed features serves an important function. It grants the image recognizability wherever and in whatever medium it appears, whenever in history. If, as is frequently the case, the viewer takes it that the image somehow embodies some aspect of the 'presence' of the holy figure, it follows that the presence is most likely to be convincing when the image looks right. There is a persistent sense, not wholly in line with standard theology, that Christ is present in his iconic image in a way that is similar to the embodiment of his flesh and blood in the bread and wine at the Catholic and Orthodox Churches' ritual of the Eucharist. For most believers, a blond Christ with upturned nose and receding chin would not work at all well to summon the spiritual presence of Christ in his painted face.

When artists in the Renaissance began to vary the stock appearance of Christ and the saints, aspiring for a more varied sense of humanity and personality, something was lost as well as gained. A delegate from the

Eastern Church at the momentous Council of the Eastern and Western Churches in Ferrara and Florence in 1438–9, also attended by Cusanus, expressed this feeling very clearly. Gregory Melissenos, 'the Confessor', was a representative of the court of the Holy Roman Emperor in Constantinople (now Istanbul), and was later to become the Patriarch of the church in exile after the fall of the holy capital to the Turks in 1453. He was disconcerted by the results of the pictorial revolution that had been wrought by European artists in the fourteenth and fifteenth centuries. He reported that 'when I enter a Latin church, I can pray to none of the saints depicted there because I recognise none of them. Although I do recognise Christ, I cannot even pray to him because I do not recognise the manner in which he is depicted.'

As Gregory from Constantinople recognized, the Italian artists did not assume the same liberty with Christ's appearance as they did with the saints, but they were no longer making recognizable 'icons' and their images did not function in the spiritual and liturgical way that Gregory required. For many worshippers, even in the West, traditional-looking images of Christ and the saints have continued to serve their devotional function better than the 'arty' works of Raphael and Co. The presence of Greek lettering also helps to convey an air of ancient spiritual mystery. The stock 'icons' seem to be more spiritual and other-worldly, attracting serried ranks of lit candles, and are more likely to be endowed with miracle-working powers. Making Christ look like an ordinary man, albeit a very beautiful one, has its down side for a worshipper who wants to be confident that Jesus differs from us in essential respects of time and space. Christ in an Eastern Orthodox icon belongs in an eternal realm of an absolute presence rather than in the here and now of a portrait.

Not Made by Human Hand

To see what Christ actually looked like is potentially a very big deal for the worshipper. But where did the stock image come from? How do we know what Christ looked like?

The answer is that we have no early evidence, either from his own lifetime or from the years immediately following his death. There was no conviction in the early Church that Christ's physical appearance really mattered in the context of spiritual truth. Indeed, the Church maintained

a traditional prohibition of 'graven images', in keeping with Moses' command in the Old Testament and the Jewish rejection of images of the deity.

Words and letters served as visual signs for the early Church. The Hebrew YHWH (Yahweh), the 'tetragrammaton', was God's name, and served as the permitted image of his presence. For early Christians, XP (*chi ro*), IHC or IHS, or ICXC, variant abbreviations from Jesus Christ's Greek name, were widely used in the same way, as 'christograms'. A schematic cross could be built effectively into the initials, as we will see in Chapter 2. Jesus could also be signalled by the alpha and omega, α and Ω, the first and last letters in the Ionic alphabet. 'I am alpha and omega, the first and the last', as God declared to St John in the Book of Revelation in the Bible. An acrostic of the description as 'Jesus Christ Son of God Saviour' formed the Greek *Ichthys* or 'fish', and a simply outlined fish became a symbol of the Christian faith. But for a long time there were no direct visual representations of Jesus himself.

These now arcane letter-signs had a persistent and fervent history. In the fifteenth century, St Bernard of Siena widely promoted the image of the IHS set within a blazing sun as the proper logo of a Christian society. The Jesuits of the sixteenth-century Counter-Reformation adopted Bernard's preferred device, glossing it as *Iesus hominem salvator* (Jesus saviour of mankind) and *Iesus humilis societas* (the Humble Society of Jesus). IHS became a very early instance of letters serving as a visual icon. Its most notable predecessor was the Roman SPQR, *Senatus populusque Romanorum* (the Senate and People of Rome), which still serves at the emblem of the modern city.

As figurative images of Christ seeped into being during the third century, a youthful beardless Jesus, reminiscent of a classical Apollo or Orpheus, seemed to have been favoured, particularly in his guise as the good shepherd. This beardless image was exported to the colonies, to appear with the *chi ro* at the centre of the fourth-century mosaic floor discovered in the English village of St Mary Hinton and now in the British Museum (Fig. 1.2).

The bearded Christ gradually assumed ascendancy. In this guise he looked graver and more authoritative, more like a fitting successor to Zeus (Jupiter). Unsurprisingly it was this image that was adopted as a symbol of God-given authority by the Holy Roman emperors in the wake of Constantine. In the seventh century Justinian II during his first reign specifically placed this Christ-as-ruler on the front of his coins, blessing

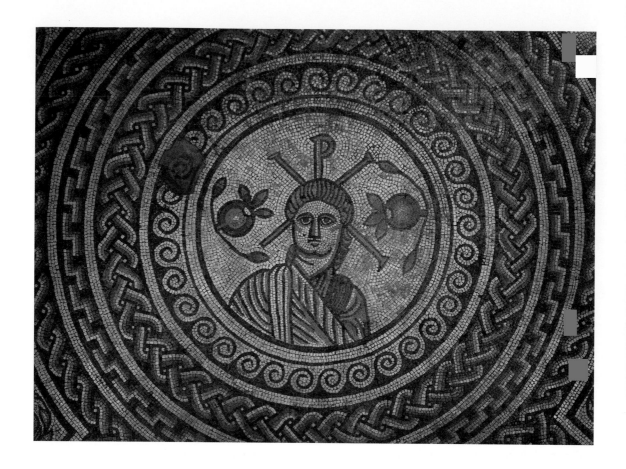

Fig. 1.2

Mosaic floor with roundel of Christ (from Hinton St Mary, Dorset), 4th century, London, British Museum.

and holding a book, with the arms of the cross visible behind him (Fig. 1.3). On the reverse, the emperor stands in a jewelled gown holding a ceremonial cross on a stepped plinth. Justinian's *Christus Rex* is fully recognizable as what became the authorized image.

The bearded Christ stood in a very special if unclear relationship to a body of miraculous 'portraits' that could hardly have been more important to the broader issue of the role of representations in the Christian Church. These representations were known as *acheiropoieta* (αχειροποίητα) in Greek. An *acheiropoietos* or *non manufactum* (not made by any hand) was an image that had appeared miraculously, without any intervention by a human maker. No painting or other artifice was involved. The *artifex* (maker) was Christ himself. The Greek and Latin terms are important here, and are not readily translatable. They recur as crucial referents throughout the centuries of debate about the role of images in Christianity.

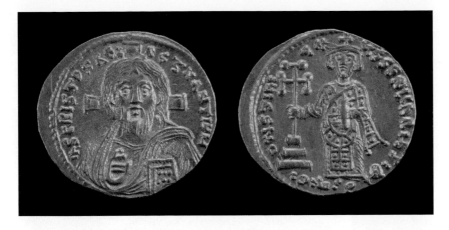

The *acheiropoietos* that comes most readily to mind is the cloth of St Veronica, proffered by the young woman to Christ on the Via Dolorosa, the agonizing road along which he was dragging his cross to Mount Calvary. Mopping his sweaty face, he left a lasting imprint of his divine features on the veil or *sudarium* (from the Latin for sweat, *suder*). However, although the legend credits the *sudarium* as originating within Christ's own lifetime, it actually made its historical debut quite late, and the story itself is essentially a medieval invention. It was preceded by two earlier 'portraits', one known as the Mandylion, and the other originating in Camulia, in Asia Minor. They both appear in the historical records in the sixth century.

The first of the 'portraits', like the Veronica, is credited to the living Christ. Agbar, the king ruling Edessa, was mortally ill. Having heard of Christ's power as a healer, he wrote soliciting Jesus' intervention. Different versions of the story tell of a letter accompanied by a painted portrait or, as became progressively accepted, an image of Christ's features formed when he dried his face on a towel. Evagrius, Bishop of Edessa in the sixth century, asserts specifically that the face was miraculous imprinted and not 'made by hand': 'the saviour washed his face in water, wiped off the moisture that was left on the towel that was given to him, and in some divine and inexpressible manner had his own likeness impressed on it.' Agbar was, of course, cured by his sight of Jesus' true image.

The 'portrait' was not only miraculously formed but also possessed miraculous powers in its own right, later intervening to repel invading Persians and imprinting its own image on a tile behind which it had been placed for safe keeping, in a niche over the city gate. Constantinople

claimed to own the image from Edessa in the tenth century, and it was adorned with a lavish gold casing. The Mandylion (from the Arabic *mandil*, veil or kerchief) assumed great authority in the Byzantine empire as a true image of Christ and became one of the main prototypes for images in a wide variety of media, small and very large. The glowing apse mosaic in the Cathedral at Cefalù in Sicily from the twelfth century testifies to the power and geographical spread of this stock likeness of Christ (Fig. 1.4). He holds open the Gospel of St John at the passage that reads, 'I am the

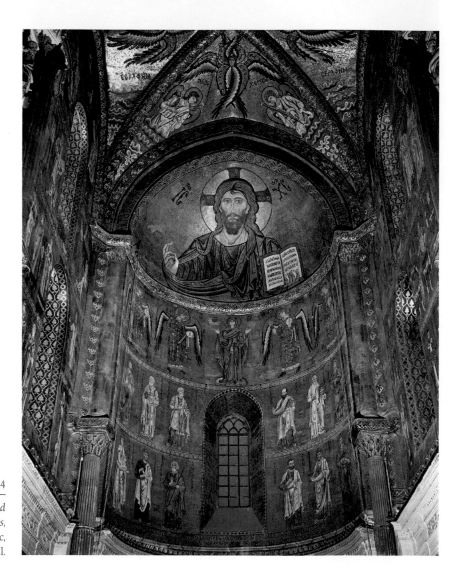

Fig. 1.4

Christ with the Virgin and Angels and Saints, 12th-century apse mosaic, Cefalù, Cathedral.

light of the world, who follows me will not wander in the darkness but will have the light of life'. The text is rendered in both Latin and Greek.

The fate of the Constantinople Mandylion after 1204, when the city was sacked by Crusaders, is disputed. The most prominent claim was that it came to be housed in Sainte Chapelle in Paris, but this French contender disappeared during the secular ravages of the French Revolution. There have also been arguments that the Mandylion is identical with the Shroud of Turin, about which more in due course.

Such a fragmented history, typical of early images, leaves plenty of room for competing claims. The most picturesque story is that attached to the *Volto Santo* in Genoa, which is said to have been presented by the Byzantine emperor John V Palaeologus to Leonardo Montaldo, a Genoese captain, in 1384 (Fig. 1.5). Darkened, severe, hieratic, evidently old, and ex- uding mystery, it is set within a later case of gilded silver with small *niello* reliefs depicting the narrative of the Mandylion's origins and miracles. It is certainly not an orthodox painting, with a palette largely limited to a reddish colour and brown. It is noticeable that all the images of Christ's face 'not made by hand' seem to have been quite dark in character. There is a double sense that images take the form of an elusive 'stain' and that Christ's true features are visible to us only as if 'through a glass in a dark manner' (to quote St Paul). Regardless of the potential historical status of the Genoa Holy Face as the Edessa image, it is consistent enough in its mysterious appearance with other miraculous 'portraits' to play its role in confirming what Christ actually looked like.

Also known from sixth-century accounts is another portrait with mi- raculously moist origins. The story tells how a sceptical woman in Hypa- tia, living in Asia Minor, could not believe without actually seeing Christ. While drawing water from a well she discovered a cloth on which was rendered the face of Jesus. It was not of human manufacture. Such was its prestige that the great warrior emperor Heraclius carried it with him into battle in 622, confident in its protective potency. As with the Mandylion, its history was fractured during the turbulent history of the Holy Roman empire. A number of surviving candidates without secure lines of descent have striven to step into the breach. And there are other legends of mi- raculous 'portraits', too many to be told here. We will encounter another miraculous 'Holy Face' in the next chapter.

The *acheiropoieta* were of a significance far beyond their obvious role as depictions of Christ's face. It was crucial that they were *images*. They were

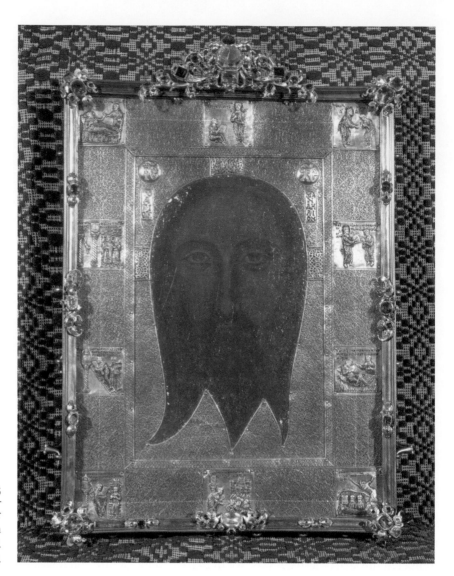

Fig. 1.5

Holy Face, canvas with silver casing, 6th (?) and 11th–15th (?) centuries, Genoa, S. Bartolomeo degli Armeni.

not humanly 'graven' (as forbidden in the Bible) but divinely imprinted. This divine origin could be and was taken as sanctioning devotional images per se. If Christ himself was an active agent in giving us 'pictorial' representations, we could hardly deny that images of him (or of other divine figures) were permissible. During the iconoclast controversies that beset the Byzantine empire, the images not made by hand were important witnesses. They also bore theologically significant witness to the appearance of Christ as a real man in a fleshly body—as fully incarnate. They

therefore lent support to the doctrine of the *corpus domini*, the reconstituted body of Christ as manifest in the ritual of the Eucharist. The theological stakes were very high.

The Veronica

These three miraculously formed images, and others that claimed similar origins, were progressively overtaken in the Western Middle Ages by the legend of St Veronica and by the *sudarium* housed in St Peter's. Not only was the story vivid and deeply appealing but it also became integral to the role of papal Rome as a centre for pilgrimage. Its significance was enhanced by the notion that her name signalled the image; that is to say, Veronica gives us the *ver icon* (*veram iconam*). Her *sudarium* also became central to the practice of obtaining remissions from the sentence that repentant sinners are condemned to spend in Purgatory.

The earliest secure record of the veil's existence dates from as late as the tenth century. During the next hundred years it became the subject of great devotion. Petrus Mallus in his twelfth-century *History of St Peters* describes the image as 'without doubt, the genuine *sudarium* of Christ, the cloth into which he pressed His most holy Face before his Passion, when His sweat ran in drops of blood to the earth'.

The remarkable English chronicler and artist Matthew Paris described a key event in the history of Veronica's veil. In 1216 Innocent III conducted it on its now customary procession to the Ospedale di S. Spirito in Rome. Alarmingly, the image suddenly turned itself upside down, which was taken as an unfavourable sign. To offset the warning, the Pope 'composed an elegant prayer', as Paris testifies, and had it illustrated as a 'framed miniature on a gold ground'. On his own account, the English artist later included a powerfully engaging illumination in his *Chronica majora*, his Great Chronicle (Fig. 1.6). He explained that 'to attune the reader's mind to prayer, the redeemer's face is honoured by the maker's workmanship [*industriam artificicis*]'—in contrast to the *sudarium* itself which involved no human *artifex*, as Innocent's prayer attested. The original, as Paris emphasizes, was not 'depicted by hand, sculpted or refined'.

Innocent's prayer, which begins 'Greetings Holy Face of our Redeemer . . .', together with a second prayer, 'Hail radiant Face . . .', became popular across Europe, particularly if a copy of the Veronica was available for worship. Specific painters in Rome were licensed as *pictores veronicarum* (painters

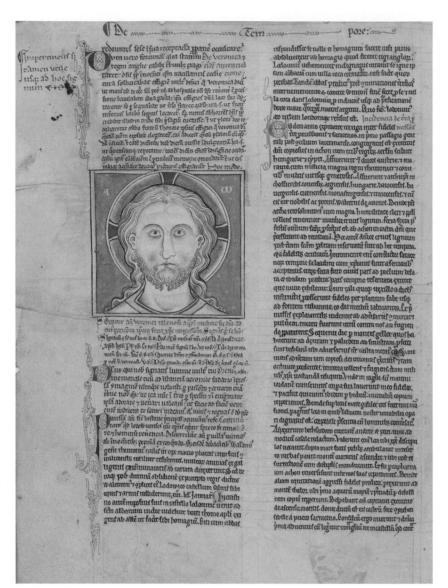

Fig. 1.6

Matthew Paris, *The Sudarium of St Veronica*, after 1245, illumination on parchment, from *Chronica majora*, Cambridge, Corpus Christi College, MS 26, f.VII 2.

of Veronicas) to replicate the Holy Face for pilgrims. Most importantly for its fame, the relic became the focus of the new system of indulgences. Initially the Pope decreed that those lucky enough to go to Purgatory rather than Hell could subtract forty days from their sentence before passing to Paradise. Subsequent inflationary pressure led to the granting of as many as 20,000 days for devotions in the presence of the actual veil.

The story of the origins of the veil on the Via Dolorosa was not wholly stabilized, however. The extraordinarily popular *Golden Legend* by the Archbishop of Genoa, Jacobus da Voragine, in the thirteenth century, seems to conflate the story with elements of the Mandylion. As we have seen, Genoa claimed to hold the original of the Edessa image. Jacobus tells (quoted here from a version of William Caxton's early translation) how

> Tiberius the Emperor fell into a grievous malady. And it was told to him that there was one in Jerusalem that cured all manner maladies. And he knew not that Pilate and the Jews had slain him. He said to Volusian . . . : Go into the parts over sea, and say to Pilate that he send to me the leech or master in medicine for to heal me of my malady. . . . Volusian found an old woman named Veronica which had been familiar and devout with Jesu Christ.

Veronica recounted how she

> bare a linen kerchief in my bosom, our Lord met me, and demanded whither I went, and when I told him whither I went and the cause, he demanded my kerchief, and anon he emprinted his face and figured it therein. . . . Then went Volusian with Veronica to Rome and said to the Emperor . . . : A matron, a widow, is come with me which bringeth the image of Jesus, the which if thou with good heart and devoutly wilt behold, and have therein contemplation, thou shalt anon be whole. And when the Emperor had heard this, he did anon make ready the way with cloths of silk, and made the image of Jesus to be brought before him. And anon as he had seen it and worshipped it he was all guerished and whole.

Jacobus adds a cautionary note: 'And hitherto is this story called apocryphum read. They that have read this, let them say and believe as it shall please them.'

Veronica's veil, on its own or being held up by the saint for our devotion became a very popular subject in Renaissance and later art. A host of vernacular Veronicas were produced in paint, print, and other media over the centuries, such as this unsophisticated painting on panel (Fig. 1.7). Identifying the date and place of origin of such paintings is tricky, because continuity is a key factor. The job of such 'icons' was to be instantly recognizable and directly communicative to a lay audience. The emphatic expression, streaming tears, and copious blood do exactly what is required.

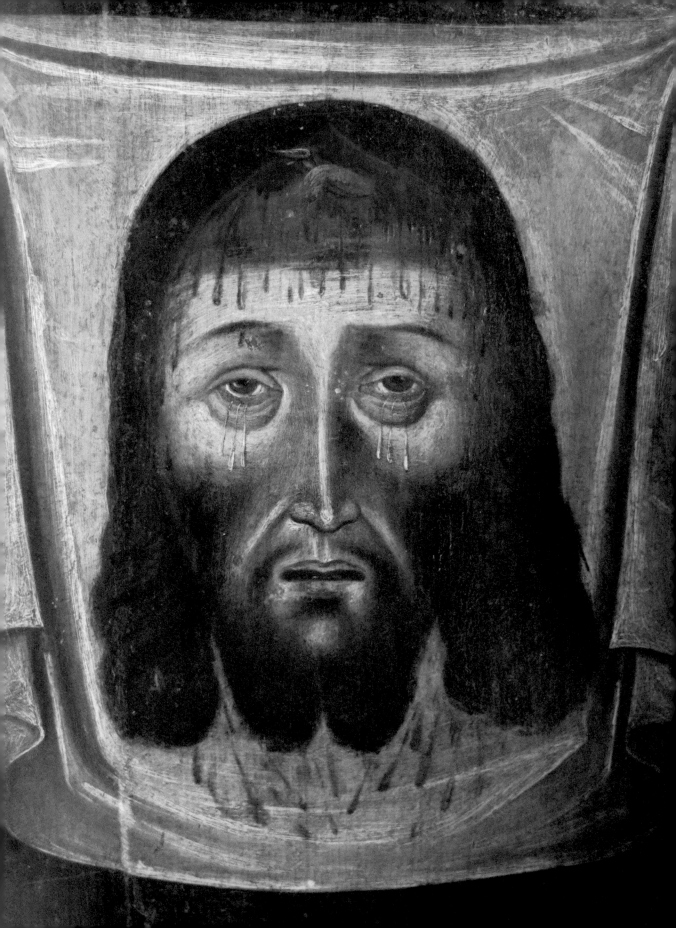

The hole near the top of the panel indicates that it was at one point in its life simply hung over a nail or from a chord, without a frame.

The character of the *sudarium* as a 'portrait' made directly from Christ's own features also presented a special challenge to patrons and painters of 'high art' who delighted in sophisticated lifelike images. Artists in northern Europe took up the task with particular enthusiasm.

An anonymous artist, apparently from Cologne and working in the 1420s, is named after his signal subject as the Master of St Veronica (Fig. 1.8). One version of the subject in London shows the saint in isolation with her vivid 'portrait' of Christ, while that in Munich shows Christ more realistically with his crown of thorns and accompanies her with gently singing angels. It could be that the former corresponds to the story as recounted in the *Golden Legend*, which does involve the crown of thorns. Both paintings are of the utmost refinement. The saint's gilded halo records her name, while Christ's bears the letters IHS.XP.IK.X from his Greek names. In the

Fig. 1.7 (*opposite*)

The Sudarium of St Veronica, German (?), 17th century (?), private collection.

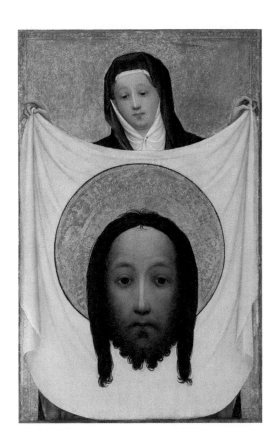

Fig. 1.8

Master of St Veronica, *St Veronica with the Sudarium,* c.1420–30, oil on panel, London, National Gallery.

London icon she stands against a gold background, her delicate fingers and the folded edges of the white veil overlapping the tooled border, so that the image is pressed into our space. The head of Christ seems suspended in an indefinite realm, unrestricted by the actual surface of the *sudarium*, underscoring its miraculous, immaterial nature. The subtly modelled faces of the saint and Christ are affected by gentle melancholy that invites us to meditate on his sweet sacrifice. Jesus' physiognomy conforms to the standard type, but its infusion of naturalism and subtle emotion belongs to a new style of sacred art designed to meet new forms of humanist devotion.

This translation of the stock iconic image into something recognizable as a Renaissance portrait was taken a step further by Jan van Eyck, the greatest of all exploiters of naturalism in the service of Christian meaning. A painting in Berlin, generally regarded as a copy of high quality, exhibits a rich compound of traditional frontality, textual sophistication, human presence, and high illusionism (Fig. 1.9). It will be worth taking some time to detail the inscriptions, since they are crucial to our understanding of Jan's portrayal—although we are not helped by errors the copyist seems to have made.

The Greek alpha and omega and their equivalent in Latin *I(nitium)* and *F(inis)* are portrayed as letters raised on the background. Jesus is designated as King of Kings on the neckband of his garment. The frame, typically for van Eyck, bears other illusionistic inscriptions that look as if they are carved into and painted on its gilded surface. At the top is VIA VERITAS VITA from Christ's pronouncement to Thomas in the Gospel of St John that he is 'the way, the truth and life'. At the bottom is PRIMUS ET NOVISSIM(US) from the first chapter of the Latin Apocalypse, which provided the Greek source for the alpha and omega:

> And when I had seen him, I fell at his feet as dead. And he laid his right hand upon me, saying: Fear not. I am the First and the Last [*primus et novissimus*].

All this is in conformity to tradition. But on the inner face of the lower moulding of the frame declarations are made in a new style. We read that '*Johannes de eyck me fecit & aplevit anno 1438 31 januarii*' (Jan van Eyck made and amplified me in the year 1438 on 31 January). The odd term *aplevit* is generally taken to be a mistake for *complevit* (completed), but I think it should be understood as amplified or magnified (*amplavit*) in the sense that Psalm 34 in English invites us to 'magnify the Lord'. Jan has 'amplified' the tradi-

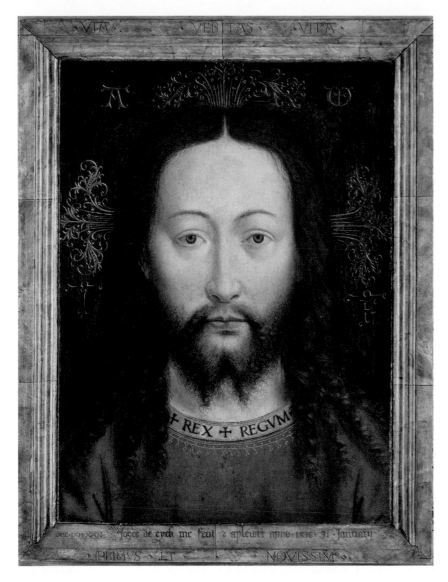

Fig. 1.9

Jan van Eyck (after), *Christ* (original from 1438), oil on panel, Berlin, Staatliche Museen, Gemäldegalerie 528.

tional visual schema to give us a 'true portrait' of Jesus by an act that gives material form to revelation through his incredible artistic skill. To the left of his signature he has unabashedly written, in Greek characters, ALS [actually rendered as AME!] ICH KAN ('As I can'). Indeed! As only he could.

Jan's 'amplification' was highly influential, and is known in a number of versions. One, sold at Christie's in New York in 1994, flanks the image of Christ with two wings on which are inscribed Innocent's hymn to

Veronica. We may wonder if it was an example of this new kind of 'icon' that Cusanus sent to his Bavarian brothers. Cusanus moved in clerical and secular circles where Jan's high skill was internationally renowned. Van Eyck is known to have portrayed Cardinal Albergati, another of the delegates to the 1438–9 church council in Italy, at which Gregory Melissenos from the East expressed discomfort with the new modes of representation that had arisen in Europe.

A very nice testimony to the prominence of the Veronica in everyday devotional practice in the Netherlands in the fifteenth century is provided by Petrus Christus' portrait of a pious young man holding a book in the National Gallery, London (Fig. 1.10). A metal marker is inserted into the young man's book to guide him rapidly to cherished texts. On the wall high behind him is an arched illumination of the Holy Face. Jesus is flanked by the alpha and omega, and gives just the hint of a smile. Below is inscribed Innocent's prayer with its implicit promise of remissions. It is painted on vellum and has been tacked to a board through a ribbon. In the lower right corner the ribbon and parchment have broken away from the board, indicative of the wear and tear of regular use. We may assume that the youthful sitter has already invested regularly in the days he would not need to expend in Purgatory.

Van Eyck has humanized Christ's visage, and Petrus Christus inserts it into a human context. The iconic symmetry is however retained in the service of awe. For all the naturalism and narrative fluency of Renaissance art, we should not forget that artists knew what to do when a stock subject was to serve a specific devotional purpose. Even Leonardo, that great practitioner of the science of art, was fully alert to the power of paintings to move worshippers to extreme reactions:

> Do we not even now see the greatest kings of the Orient going out veiled and concealed, believing their fame to be diminished by showing themselves publicly and divulging their presence? Do we not see pictures representing the divine beings constantly kept under coverlets of the greatest price? And whenever they are unveiled there is first great ecclesiastical solemnity with much hymn singing, and then at the moment of unveiling the great multitude of people who have gathered there immediately throw themselves to the ground, worshipping and praying to the deity, who is presented in the picture, for the repairing of their lost health and their eternal salvation, exactly as if this goddess were there as a living presence.

Fig. 1.10

Petrus Christus, *Young Man
with a Book*, c.1450–60,
London, National Gallery
2593.

Leonardo's allusion to the Orient—'even now'—suggests that he especial-
ly associated such practices with the Byzantine East, where the miracu-
lous 'portraits' originated.

A persistent theme is the awesome experience of coming face to face
with Christ. As Paul wrote to the Corinthians, explaining our transition
from earthly limitations to true grace, 'We see now through a glass in a
dark manner; but then face to face.' In the Apocalypse, St John is actually
faced with the revelation of Christ's visage: 'His head and his hairs were
white like wool, as white as snow; and his eyes were as a flame of fire.' He
tells how 'when I had seen him, I fell at his feet as dead'. The vision was too

much for him to bear. When Dante introduces the *sudarium* in *Paradiso*, towards the end of his long voyage in the *Divina commedia*, it is in the context of the progressive failure of his earth-bound faculty of sight to absorb the radiant vision of the truly divine. Dante has reached the point at which his pilgrimage is to be completed in the company of St Bernard rather than his beloved Beatrice. What Dante witnesses in Canto XXXI, he can best explain by reference to Veronica's veil (here in Longfellow's translation):

> As he who peradventure from Croatia
> Cometh to gaze at our Veronica,
> Who through its ancient fame is never sated,
> But says in thought, the while it is displayed,
> 'My Lord, Jesus Christ, God of every God,
> Now was your semblance made like unto this?'

The Croatian pilgrim could hardly believe his eyes faced with the *sudarium*.

An image of Jesus in the chapel of S. Lorenzo in the Lateran in Rome, reputedly painted by St Luke, so overwhelmed the sight of those who beheld it that Pope Alexander in the mid-twelfth century had it veiled in layers of translucent silk.

We should not ignore the other side of the coin, namely the awe of the actual painter faced with this supreme task of visualization. For a pious artist, probably the great majority, the task must have evoked feelings of great intensity, even in the most professional of contexts. St Luke was supposed to have been a painter, famously depicting the Virgin, and, according to some accounts, Christ himself, as in the Lateran portrait. Painters across Europe traditionally belonged to a guild or confraternity of St Luke, being expected to perform devotions to their divine predecessor. It was no little thing to follow St Luke in making a 'portrait' of Christ.

This is a central theme of Andrei Tarkovsky's epic film of the life of the great Russian painter of icons Andrei Rublev, which was first released in 1966. Tarkovsky's narrative tells of Rublev's terrible struggles as a monk to visualize an image worthy of his divine subject. Faced simultaneously with the dreadful events that were ravaging the Russia of his time and with the task of realizing a sublime image of the Last Judgement, Rublev's creativity undergoes creeping paralysis. The film's enigmatic epilogue involves a rather fragmented montage of known icons by the great master (Fig. 1.11). Already battered by time, Rublev's images are finally inundated

by insistent rain, in what seems to be an oblique commentary on the impossibility of realizing in material and enduring form the kind of visionary truth to which he aspired. In a comparable way to Tarkovsky's Rublev, Michelangelo, towards the end of his career, found the material realization of Jesus' face increasingly impossible in his sculpture and drawings.

Even the highly self-conscious, ambitious, and unconventional Leonardo seems to have reacted with special intensity and conservatism when portraying Christ. It has long been known that Leonardo had designed a *Salvator mundi*, an image of Christ specifically as saviour, a well-known variant of the iconic type. A series of copies recorded Leonardo's composition. Recently the original has come to light, having passed in the seventeenth century through the collection of Charles I and Henrietta Maria in England (Fig. 1.12).

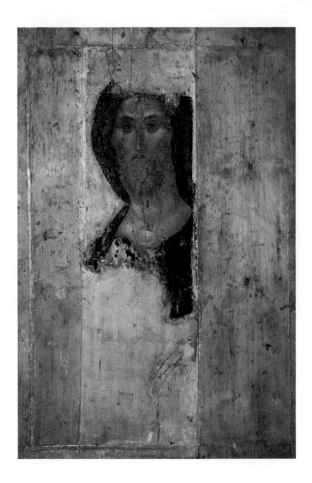

Fig. 1.11

Andrei Rublev, *Christ*, c.1410, tempera on panel, Moscow, Tretyakov Gallery.

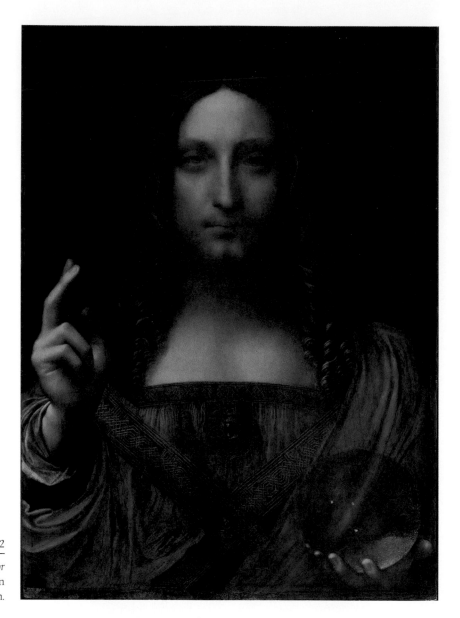

Leonardo has retained the traditional frontality, aware both of what was expected and of the potency of the 'windows of the soul' when they are seen face to face. He would have been aware of the legends of the miraculous images and undoubtedly knew one or more of the Netherlandish depictions in the manner of Jan van Eyck. He has followed Jan in presenting a convincing 'portrait' of Jesus in addition to manufacturing an icon.

He uses oil painting as magically as van Eyck. But, whereas his Netherlandish predecessor had clarified Christ's human features, Leonardo exploits artful ambiguity, not least in the eyes, just as he was doing in his *Mona Lisa*. Through a use of subtle glazes that leaves the precise contours of the face elusive, he invites us to meditate—compose a *speculatio* as Cusanus had suggested. In this instance, Leonardo's elusive portrayal leaves us psychological room to speculate about Christ's unspoken message as our saviour.

The crossed bands or yokes on Christ's chest refer to his pronouncement in St Matthew's Gospel: 'Take my yoke upon you, and learn of me; for I am meek and lowly in heart: and ye shall find rest unto your souls. For my yoke is easy, and my burden is light.' His right hand is raised in blessing, while his left bears a globe, signalling his role as saviour of the world. The orb, in this instance, is made from rock crystal, and sparkles with a series of internal inclusions (or pockets of air). Leonardo seems less to be portraying the conventional terrestrial globe than summoning up an image of the 'crystalline sphere' of the heavens, as it was understood in his time. His Christ is conjointly saviour of mankind and master of the cosmos. Leonardo allows us to see Christ in a more benign and less judgemental mode than was traditional in icons of the *Pantokrator*.

Leonardo would have known of the famous Veronica in Rome and might even have seen it in person. The dusky obscurity of the ancient Holy Faces could well have affected his own portrayal. The Roman *sudarium* was about to disappear, however. When Rome was invaded in 1527 by the rampaging troops of the Holy Roman emperor, the Vatican was sacked. One account tells how the Veronica was bartered in the city pubs and was eventually destroyed. On the other hand, an image claiming to be the surviving original was still present in St Peter's later in the century and came to be housed in a shrine marked by Francesco's Mocchi's statue of St Veronica. Copies were forbidden by Pope Urban VIII in 1629, and the image itself has subsequently disappeared from general view. At present, the story ends in confusion, just as it had begun.

In later centuries attention has shifted from the *sudarium* to the Holy Shroud in Turin (Fig. 1.13). Interest in the Turinese relic has escalated recently as the result of its unprecedented scientific examination, beginning with carbon dating undertaken by three international laboratories in 1988. In the ensuing controversy, supporters and denigrators of the

Shroud have cited contradictory 'scientific' and other 'evidence' in a myopic and unsystematic way that obscures any clear judgement.

The long linen sheet, bearing ghostly images of the front and back of a recumbent man, has been the subject of dispute from the time of its discovery. Its first documented appearance was at Lirey in France in the 1350s, when the Lord of Savoy founded a collegiate church for its veneration. In 1389 the Bishop of Troyes, Pierre d'Arcis, petitioned Pope Clement VII in Avignon to declare that the Shroud was a false relic. He cited his predecessor, Henri de Poitiers, who 'eventually, after diligent inquiry and examination', discovered how the 'said cloth had been cunningly painted, the truth being attested by the artist who had painted it, to wit, that it was a work of human skill and not miraculously wrought or bestowed'. Nevertheless, it attracted a fervent following. Via the House of Savoy, the Shroud moved to Turin in 1578, where it has since remained.

Ian Wilson, one of the most fervent advocates of the antiquity of the Shroud, proposes that it is the long-lost Mandylion. A full body image would not correspond to the early legend, but early descriptions refer to it as an 'image' and can be reconciled with the idea that the Shroud was once folded (as we can see it was) and mounted in such a way that only the head and shoulders were visible. In this case, it is strange that it was not explicitly identified as the Shroud from the outset. The fractured histories of both the Mandylion and Shroud leave huge gaps to be bridged, and the mystery certainly has not been 'solved', as the subtitle of Wilson's latest book proclaims.

Given the loud public debates, and the disappearance from view of the Vatican Veronica, the Turin Shroud is now the most famous of the αχειροποίητα. The fact that the image is far more apparent in a photographic negative than in the original has served to enhance its magical status. For the enthusiastic seeker of evidence, its elusiveness as a picture allows the viewer to 'see' details that may not be there. It has occasioned its own recent pseudo-histories, often of such an extravagant and fanciful nature as to rival any medieval legend. Even Leonardo, as a proto-photographer, has been pressed into service as its forger.

If we are to look analytically at the image on the shroud as a picture (however it was made), it exhibits clear visual features that point to its painterly origins. The first thing to say is that it bears few of the physical characteristics needed for an imprint made by a cloth wrapped around a

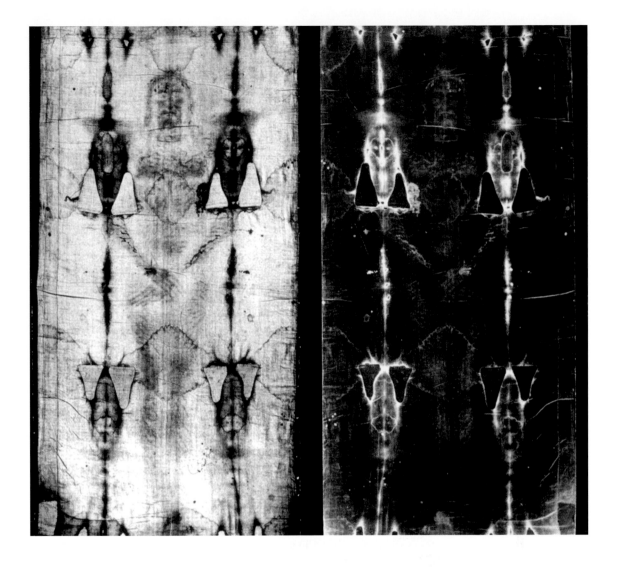

body. Even if the linen was initially laid flat on the corpse, it would have sunk softly around it, and any imprint would have registered aspects of the top and side of the head and some portion of the flanks of the whole body. The bony prominences of the hands, knees, and feet would have come into particularly direct contact with the cloth, but there is no evidence of their having done so. The attenuated proportions, stick-like nature of the folded arms and straight legs, and the long, thin, unmodelled fingers are all consistent with both medieval and Byzantine figure styles, just as the existing Holy Faces all betray their Byzantine origins. If I were

Fig. 1.13

The Turin Shroud, c.1300, linen, Turin, Cathedral, original and reversed appearance.

asked to provide an art-historical date for the portrayal of Christ on the Shroud, I would estimate it have been made in the later thirteenth or first half of the fourteenth century in Italy or southern France. This is consistent with the much denigrated carbon dating. The other possibility is that it is of Byzantine manufacture. Were the various bodies of evidence ever to converge consistently on a date in the first century AD, there will still be a lot of visual explaining to do. It seems to me to be evidently 'made by hand'.

One visual advantage the Shroud does possess for believers is that it exhibits the same kind of archaic other-worldliness as the earlier images said to be made by no hand. The face is a rather unlovely version of the stock physiognomy, manifesting the severity of the medieval *Pantokrator* rather than the human gentility of the Renaissance *Salvator mundi*. We have already noted that the archaic images generally do a better job for the pious worshipper than very naturalistic representations. When the French twentieth-century expressionist painter Georges Rouault strove for a style that expressed his piety and rejection of material values he turned not to the Renaissance but to the more 'primitive' styles of the Middle Ages and Byzantium. His *Christ* in Cleveland picks up many of the physiognomic traits of the traditional Holy Faces, not least in its large, strongly outlined eyes, and it openly evokes the colours of stained glass (Fig. 1.14). However, Rouault's Christ does not quite look at us.

Modern images of Jesus available in apparently unlimited numbers over the internet tend uneasily to combine the symmetrical physiognomy sanctioned by long tradition with a Hollywood soft-focus effect, typically used for female film stars in the pre-digital era. The emotional connotations of the modern confections lean to the potential sweetness of the *Salvator mundi* rather than the stern ruler guise of the *Pantokrator*.

And, of course, miraculously formed images of Jesus continue to be appear, and not only in Catholic countries. On 29 May 2009 *The Sun* newspaper in Britain carried the following story, accompanied by a smeared brown image from inside the cap of a jar:

MUM Claire Allen opened a jar of Marmite—and was stunned to see Jesus staring back at her

Claire, 36, saw the blobs of yeast extract under the lid had mysteriously formed the shape of a familiar bearded face. The mum of three said: 'I opened

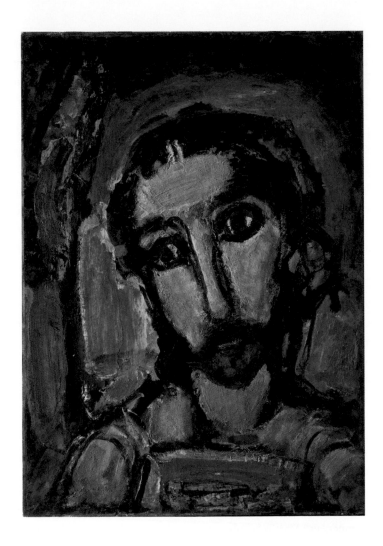

Fig. 1.14

Georges Roualt. *Head of
Christ*, c.1937. Cleveland,
Cleveland Museum of Art
1950.399.

the Marmite jar, put it on the breakfast bar and the lid caught my eye. I just
looked at it and immediately thought, "That's Jesus Christ".' It wasn't a new jar,
but I had never noticed it before.' Claire's sons Jamie, 14, Tomas, 11, and four-
year-old Robbie are big fans of the pungent brown spread—known for the
slogan: 'You either love it or hate it.' The company boss said: 'I was about to do
some Marmite on toast for Robbie's breakfast when I saw the face. I showed
it to my two eldest boys and straight away they could see a face. They thought
it looked like the images of Jesus you see in paintings and stained glass win-
dows.' Claire and husband Gareth, of Ystrad, Rhondda, South Wales, now hope
the apparition means that the son of God is looking out for their family. She

said: *'I'm not particularly religious—but we've had a tough couple of months and it's comforting to think that if he is there, he's watching over us.'* A spokesman for Marmite maker Unilever said: 'While we know many people have a Marmite passion, we can't promise a representation from Jesus in all of our jars.'

Reading

I have concentrated on more recent texts that provide authoritative guidance, full references to sources, and extensive bibliographies. The major tradition of scholarship in this area is German. The exhibition catalogue *Il volto di Cristo* contains a large selection of images with excellent commentaries. The extensive and often strange literature on the Turin Shroud is represented by two sample books.

C. Antonova, *Space, Time, and Presence in the Icon*, Farnham, 2010.

H. Belting, *Likeness and Presence: A History of the Image Before the Era of Art*, trans. Edmund Jephcott, Chicago, 1997.

H. Bredekamp, 'Bilderkult aus Bildkritic', in R. Schröder and J. Zachuber (eds), *Was hat uns das Christentum gebracht?*, vol. ii, Münster, 2003, pp. 201–17.

R. Cormack, *Writing in Gold: Byzantine Society and its Icons*, London, 1985.

G. Finaldi et al., *The Image of Christ*, ex. cat. (London, National Gallery), London, 2000.

G. F. Hill, *The Medallic Portraits of Christ. The False Shekels. The Thirty Pieces of Silver*, Oxford, 1920.

J. Koerner, *The Moment of Self-Portraiture in German Renaissance Art*, Chicago, 1996.

C. Kruse, 'Vera Icon—oder die Leerstellen des Bildes', in Hans Belting, Dietmar Kamper, and Martin Schulz (eds), Quel corps? Eine Frage der Representation, Munich, 2002, pp. 105–29.

G. Morello and G. Wolf, *Il volto di Cristo*, ex. cat. (Rome, Palazzo delle Esposizioni), Milan, 2000.

L. and C. Prince, *Turin Shroud: In Whose Image? The Shocking Truth Unveiled*, London, 1994.

Jacobus da Voragine, *Golden Legend*, 'Englished' by Willam Caxton, 1493, updated by Fredrick Ellis, London, 1900.

I. Wilson. *The Shroud*, London, 2010; see also the substantial bibliography at http://www.shroud.com/library.htm, including other contributions by Wilson.

G. Wolf, *Traditionen des Christusbildes und die Bildkonzepte der Renaissance*, Munich, 2002.

G. Wolf, Anna Rosa Calderoni Masetti, and Colette Dufour Bozzo, *Intorno al sacro volto: Genova, Bisanzio e il Mediterraneo (secoli XI–XIV)*, Venice, 2007.

The Cross

THE EXTRAORDINARILY TALENTED and mercurial Argentinian football-er Diego Maradona crosses himself before the start of the game. That is to say he touches the top, bottom, and tips of two lateral arms of an imaginary cross that lies over his torso. The full version of the sign reaches up to the forehead, down to the navel, and across to the tips of the shoulders. Maradona's version seems to be a bit abbreviated. The quarter-finals of the World Cup of 1986 in Mexico are about to begin. The opposition is England. During the course of the game, we witness one of the most notorious incidents in the history of world football.

The ball is lofted high in the air towards the England goal. Maradona rushes after it, and Peter Shilton, the experienced English goalkeeper,

■ *Descanso* (temporary resting place for coffins), near Santa Fe, El Rancho de las Golondrinas..

runs from his goal area intending to punch the ball clear. It should be no contest. Maradona is heavily muscled but short in stature, while Shilton is very tall and can use his hands. Astonishingly, as Shilton rises to punch the ball, the diminutive Maradona makes contact and diverts it into the net. Maradona wheels away shouting 'Goal!' The referee agrees. The score is decisive and Argentina reach the semi-finals.

Photographs and later replays reveal that Maradona had raised his arm to fist the ball past Shilton (Fig. 2.1). A blatant and intentional foul. Accused of cheating by the irate English fans and media, Maradona 'credits the hand of God'.

The English, with their predominantly secular brand of religion, never quite grasped the cultural resonances of Maradona's pronouncement. Few English sportsmen and -women confidently expect God to be wholly on their side rather than that of their competitors, and, if they do hope that he is helping them specifically, they are unlikely to make much of a public show of divine assistance. North American winners are far more

Fig. 2.1

The 'Hand of God': Diego Maradona scores for Argentina against England in the 1986 football World Cup.

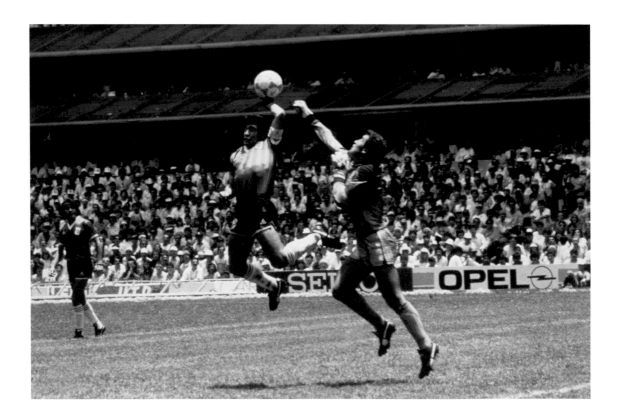

likely to thank God publicly, and South American victors are even more prone to do so.

Maradona was in effect implying that Argentina was somehow 'destined' to win the game, and that his handball and the referee's mistake were part of this greater scheme of things. All is apparently fair in this version of divine love and sporting war. Interviewed later by the English striker Gary Lineker, who has become a media pundit, Maradona laughingly admitted that it actually was his hand. During the interview he was conspicuously wearing a pendant cross on his chest outside his blue T-shirt.

Had this been an incident recorded by a Byzantine chronicler, we can imagine how his name might be glossed by medieval commentators. Diego = Dio; Maradona = Madonna, all of which adds up to goal by divine assistance. The final score of 2–1 to Argentina clearly refers to the Trinity. And so on. A modern pseudo-historical novelist would no doubt travel along a similar road. Leonardo's *Last Supper* does after all portray a team of eleven disciples, with one manager and a malcontent substitute. And there are no less than two hands of God visible.

Under The Sign of the Cross

'The sign of the cross' had a long and substantial history. It is strongly identified with the Christian West but is not exclusive to it. Since we have begun with the proxy hand of the Christian God in a football stadium, let us first look at this tradition, which is, in any event, much more heavily documented.

The stage was set by Constantine, the first Holy Roman emperor. It was he who was responsible for taking the once dissident Christian religion and identifying it officially with the state militant. The key moment in the political-cum-military history of the cross came before and during the battle of the Milvian Bridge in 312.

Maxentius and Constantine, both sons of emperors, became locked into a large-scale struggle for supreme power. The decisive battle occurred near the bridge over the Tiber and resulted in a conclusive triumph for Constantine's smaller forces. Accounts of the battle by the contemporary Christian authors Lanctantius and Eusebius differ in their details but concur about the key role played by Constantine's vision of the cross. He was instructed in a vision to go into battle under the sign of the cross: *in hoc signo vinces* (in this sign you will conquer). This later became the motto

of the Knights Templar and the Masons. The version of the cross used by Constantine was the *labarum,* a logo that comprised the *chi ro,* as in the Hinton St Mary mosaic and the *Passion Sarcophagus* (Figs. 1.2 and 2.4). The ensuing victory resulted in Constantine's full conversion to Christianity.

The story of Constantine is effectively narrated in its fully elaborated later form by Jacobus da Voragine in the *Golden Legend,* when he tells of the 'Invention of the Holy Cross' (invention here meaning discovery). The supreme visual account of key events in the narrative is provided by Piero della Francesca's radiant frescoes on three walls of the choir of S. Francesco, Arezzo, painted during the period 1452–66.

Jacobus recounts that when Constantine was asleep on the night before the battle,

> an angel awoke him, and showed to him the sign of the cross in heaven, and said to him: Behold on high in heaven. Then saw he the cross made of right clear light, and was written thereupon with letters of gold: In this sign thou shalt overcome the battle. Then was he all comforted of this vision and on the morn he put in his banner the cross and made it to be borne tofore him and his host, and after, smote in the host of his enemies and slew and chased great plenty. After this he did do call the bishops of the idols, and demanded them to what God the sign of the cross appertained. And when they could not answer, some Christian men that were there told to him the mystery of the cross, and informed him in the faith of the Trinity. Then anon he believed perfectly in God and did do baptize him.

Piero della Francesca portrays the vital moments in this story in two adjacent frescoes on the lowest of his three tiers of paintings, one on the altar wall to the right of the window and the other on the right lateral wall (Figs. 2.2–3). We first see Constantine asleep in his battle tent, attended by a manservant and guarded by two soldiers. An angel, his robes fringed by light, arrives abruptly on the scene as a heavenly missile. One of his fingers points towards the sleeping emperor, and we can just discern an upright cross, fragile but glowing, above the angel's hand. A burst of miraculous light gleams on the cylindrical tent. No one seems aware of the luminous apparition, and no one reacts. However, the vision is seen—by the emperor with his eyes closed. Those with their eyes open do not see it. The light is visionary not natural and is seen in the mind's eye—and by the spectator.

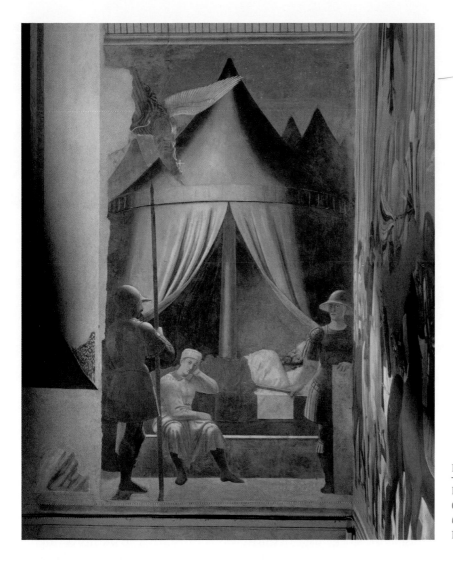

Fig. 2.2

Piero della Francesca, Constantine's *Dream of the Cross*, c.1460–6, Arezzo, S. Francesco.

Next comes the battle, although in Piero's hands it is less a battle than an irresistible march of triumph. In a badly damaged area of the mural to the left of the centre Constantine can be recognized, since he is wearing an Eastern emperor's hat taken from Pisanello's medal of the contemporary emperor, John VIII Palaeologus, made at the time of the 1438–9 church council. Constantine holds before him the slim cross of light that the angel had carried. It is this frail spiritual weapon that confounds his enemy as they stumble into disorderly retreat to the right. One of their number is struggling to drive his horse up the bank of the river. Piero has not so

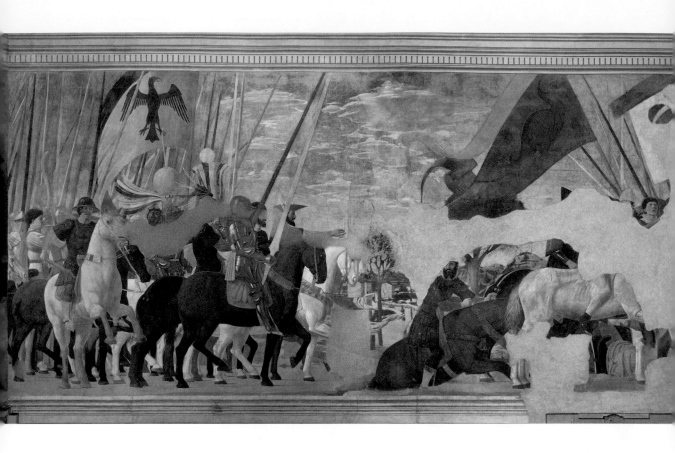

much followed the documentary accounts as distilled the essence of their meaning into narratives of superb doctrinal clarity. The cross, now in its canonical Latin form with a tall upright and shorter arms, is at the centre of the spiritual action.

Just as the stock image of Christ was late to emerge in the history of the early Church, so the cross only slowly assumed the symbolic centrality that it now possesses for believers. The evidence before the fourth century is very scattered and in a large part uncertain. This is hardly surprising. Early Christianity, as a minority sect, was not part of a power structure that led to large-scale expenditure on building, furnishings, decoration, and collecting. We should also remember that early Christianity was reluctant to proliferate graven images and displays of ostentation.

Let us begin at a firm point, rather than becoming involved with any of the contentious candidates claiming to be the earliest crosses identifiable specifically as Christian symbols.

The greatest number of early Christian images have been found in the Roman catacombs, extensive underground burial chambers tunnelled out of volcanic tufa. The biggest network of tunnels and larger spaces is the Catacomb named after St Domitilla, a first-century convert from the imperial family. It was probably from her catacomb that the so-called *Passion Sarcophagus* originated (Fig. 2.4). Designed and sculpted in a quite accomplished late Roman manner, some three or more centuries after her death, it centres on the Passion of Christ. On the far right, Pilate 'washes his hands' after failing to placate those who were demanding the death of Christ, watched by the figure of Christ in the next compartment accompanied by one of the arresting soldiers. Christ is unbearded in the manner that we have seen is characteristic of early representations. At the far left, a soldier forces Simon of Cyrene (as the Bible narrates) to carry the cross. Then we see a soldier crowning Christ, not apparently with the mocking crown of thorns but with the laurel wreath accorded to Roman victors. Christ's victory is registered in the centre. A cross bears a grand version of the *chi ro* monogram, encircled by a large victory wreath. Wreaths also hang from the triangular pediments in the lateral spaces. Two birds, probably doves of peace, stand in adoration on the arms of the cross, while the sleeping Roman soldiers who were guarding Christ's tomb continue to slumber in ignorance. The cross, represented both symbolically as a sign and figuratively in a narrative, thus becomes the object around which Christ's triumph revolves.

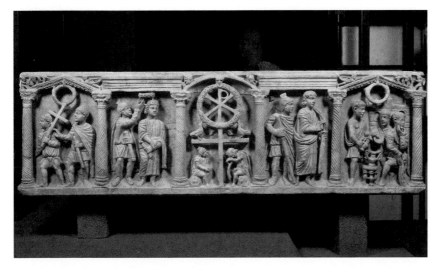

Fig. 2.4

Sarcophagus with the cross and scenes from the Passion, mid-4th century, Rome, Vatican, Museo Pio Christiano.

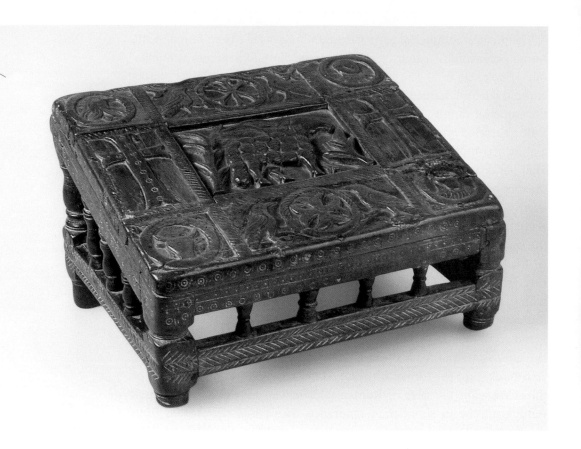

The portrayal of Christ himself was by no means obligatory or even customary in the early imagery of the cross. On a beautiful wood carving on the sloping face of a box-like structure in the Musée de Sainte-Croix in Poitiers, presumably a very small reading stand or lectern (Fig. 2.5), Christ is represented by the sacrificial lamb. Pairs of doves above and below the lamb hold roundels with different cross-forms, while Latin crosses occupy the lateral panels. The corners are marked by the symbols of the four Evangelists—St John's eagle, St Matthew's angel, St Mark's lion, and St Luke's bull. There is still clearly a sentiment abroad that the use of symbols avoids the contentious portrayal of the holy figures themselves.

Of all the main Christian symbols, the cross lent itself best to physical representation, ranging from the most elaborate sculpted crucifixes showing Christ at various stages in his pain, despair, death, and release to the simplest wooden structures. Simple examples abound. A tight cluster of rocks and rudimentary crosses beside a gravel road in New Mexico

Fig. 2.6

Descanso (temporary resting place for coffins), near Santa Fe, El Rancho de las Golondrinas.

marks the resting place (*descanso*) where the coffin was temporarily set down by the bearers on the wearisome journey to the burial ground (Fig. 2.6). The tradition of *descansos* is now expressed in roadside shrines marking the location of a fatal motoring accident.

During the Middle Ages, large-scale sculpted and painted crucifixes became dominant features in church decoration. Typically they were placed centrally over the aperture in the rood screen that separated the lay nave from the privileged chancel. The English term, rood, comes from the

Saxon *rode* or 'cross'. Crucifixes often pulled no punches. The nails that pierce his hands and feet drip blood. The jagged crown of thorns tears at the skin of his forehead. The lance wound in his side also seeps blood. The worshipper is vividly confronted by the agonies of Jesus' sacrifice, splayed and hanging on the wooden cross. They made the events in the Holy Land, remote geographically and chronologically, become urgent and real. The bloody body also resonated powerfully with the wine and bread of the Eucharist.

The form of the cross could also serve as the frame for the telling of narratives and the signalling of sophisticated theologies. The example I have selected, not least because it is a personal favourite, comes from the remote country of Ireland—remote at least from papal Rome and even more remote from imperial Constantinople. The Celtic Church in Ireland, centred around the fifth century St Patrick, produced some truly remarkable Christian art, above all its manuscripts and standing stone crosses. The Cross of Muiredach at Monasterboice, one of three within the ruins of a countryside monastery in County Louth (Fig. 2.7), is an astonishing object to encounter in a rural setting. An inscription at its base solicits 'a prayer for Muiredach, who had the cross erected', probably the abbot of that name who died in 923. In the characteristic form of Celtic cross, in which the concave arms are linked by a circular band or wheel, it stands over five metres tall and is richly carved on all four faces.

One of the main faces shows the crucified Christ being wounded by two lance bearers, while other compartments are filled with further New Testament scenes. At the centre of the opposite face stands Christ the resurrected judge with a flowering rod and cross, over a compartment showing St Michael weighing souls and fending off an interfering demon. On Christ's left side condemned souls are expelled from his company, while on his right the elect are serenaded by David on his harp. In the roofed tabernacle at the top are two saints, perhaps Paul and Peter. The compartments on the shaft contain the *Adoration of the Kings*, *Moses Drawing Water from the Rock*, *David and Goliath*, and two scenes from Genesis, *The Fall of Adam and Eve* and *Cain's Murder of Abel*. These diverse stories can be glossed in relation to issues of sin, punishment, atonement, and redemption, and are therefore, according to the elaborate forms of allegorical interpretation practised by medieval theologians, all germane to the final judgement made on mankind. The advent of Christ's birth brings us reason to hope.

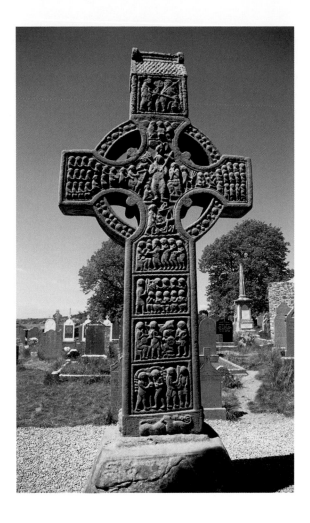

Fig. 2.7

Cross of Muiredach, c.920,
Ireland, Monasterboice.

On one of the narrower lateral faces are the *Entry into Jerusalem* and
Pilate Washing his Hands, located on the gable end of the tabernacle and
the end of the arm of the cross respectively. On the opposite narrow face
are two saints and *Christ Mocked*. Other lateral panels contain elaborate
interlaces and decorative motifs comparable to those in manuscripts,
including vines, bosses, heads, and snakes. The arm of the cross that
terminates with *Christ Mocked* is supported from underneath by a firm
hand of God against a roundel. Any direct connection with Maradona
should be resisted.

The figure style is very basic and the narratives are highly compressed,
even elemental. Yet it would be wrong to characterize such Celtic crosses

as rude or primitive. They stand at the peak of a long development and are highly original in form and format. Each field is tightly packed with robust forms disposed in thumping rhythms that are as deeply affecting as a great blues by Robert Johnson or the Kyrie from a powerful mass. The overall shape and the blunt narratives are designed to stamp the essentials of the events and their doctrinal significance on the minds of the faithful, just as the learned leaders of the Church would have done in their sermons. For the monks or the laity the great stone crosses must have seemed awesome in scale, visual authority, and doctrinal compunction.

The shape of the Celtic cross has itself become iconic within the field of the basic icon, much favoured by makers of silver pendants. A Google search for 'Celtic crosses silver' produced 432,000 hits. 'Gold' rather than 'silver' delivered 451,000 sites offering Celtic crosses for sale.

Against the narrative and doctrinal complexity of crosses that serve to carry multiple narratives, we can set the basic cross that only bears the figure of Christ. They do a quite different kind of job. The simple crucifix could raise quite complex issues about such things as the number of nails and their placement. But their fundamental role is to impress the reality of Christ's sacrifice on the spectator, above all in the naves of churches.

One of the most renowned of the devotional crucifixes, the *Volto Santo* (Holy Face) in Lucca, takes us back to the images 'not made by hand' (Fig. 2.8). Like other such *acheiropoieta*, it is supported by an elaborate legend, in this case involving Nicodemus, a senior Jew who had come to play a vital role in the recovery of Jesus' body from the cross.

In the legend Nicodemus was credited with being a sculptor. He set out to sculpt Christ on the cross using wood from a cedar of Lebanon tree. The divine face of Christ proved to be the stumbling block. Nicodemus fell asleep for a while and awoke to find that the elusive face had been completed by an angel.

According to Deacon Leboino, writing in the early twelfth century, the crucifix was discovered in 742 in a cave in the Holy Land and taken by boat to the Tuscan port of Luni. The men of Luni were however unable to take charge of the sculpture, since it continually evaded their grasp. Meanwhile in Lucca Bishop Johannes had been informed about events by an angel, and went with a substantial entourage to the port, where the boat and the crucifix were laid open to him. The translation of the cross to Lucca was accomplished by an ox cart with no driver. It was installed

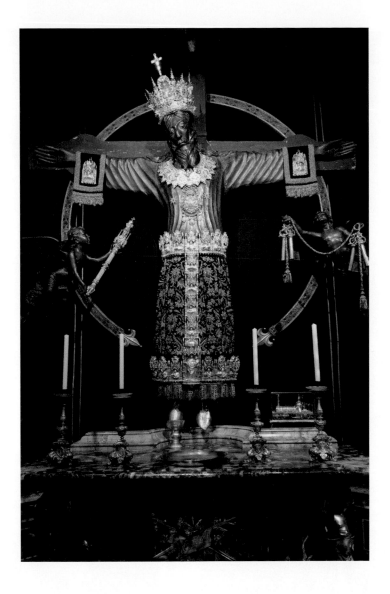

Fig. 2.8

Il Volto Santo di Lucca, early
13th-century replacement
of 9th-century original (?),
with gold vestments, crown,
shoes, mace, and keys from
the 15th–19th centuries,
Lucca, Cathedral of S.
Martino.

with great commotion in the Lucchese church of S. Frediano and was
transferred to the new cathedral of S. Martino in 1070, where it remains
today.

It is housed in a beautiful Tempietto erected in 1484 by the leading
Renaissance artist in Lucca, Matteo Civitali (Fig. 2.9). At the rear is
Civitali's statue of St Sebastian, a portion of whose pelvis is held in a
Cathedral reliquary. The Tempietto's extensive gilding, patterned roof of
coloured tiles, and elaborate ironwork grills incorporating nails (referring

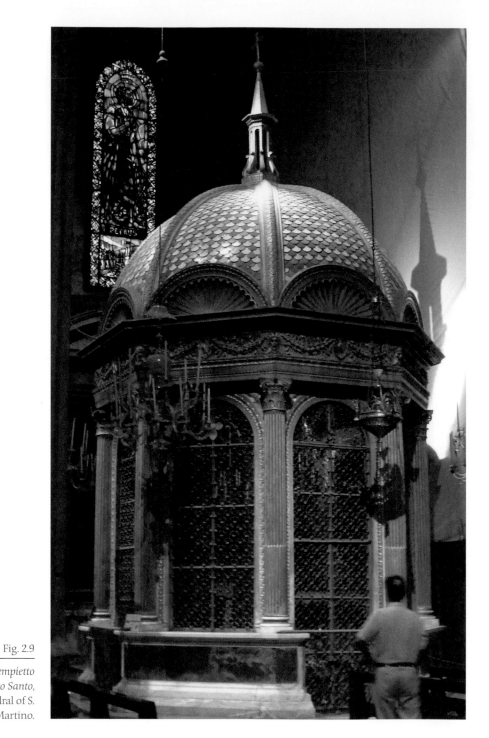

Fig. 2.9

Matteo Civitali, *Tempietto*
to house the *Volto Santo*,
1484, Lucca, Cathedral of S.
Martino.

to the Crucifixion) give it the air of a very large reliquary as much as a small piece of architecture. Over the years Christ was provided with regal adornments of magnificent craftsmanship and great cost, which have now been removed to the Cathedral Museum, to be used only in the annual procession. Today the Tempietto is brightly lit from outside, while an internal spotlight strongly illuminates the dark features of Christ. Originally in the Romanesque Cathedral, with its small windows, the *Volto Santo* would have been but dimly discernible by the flickering light of candles. The current staging seems more designed to satisfy curious visitors than to evoke sacred mystery.

The strategy of housing a major object of devotion in a reserved, mysterious, semi-secret holy of holies is common to many religions. The potency of the relic's aura is enhanced by its only being seen in elusive glimpses, apart perhaps from a very few designated occasions of huge spiritual import when it might be carried in procession or openly displayed. Some revered objects are only ever seen by their select guardian or guardians, like the Veronica in St Peter's. At the same time, copies, variants, and reproductions spread the object's fame, acting as surrogates for devotion. We are, having seen the copies, even keener to come into the presence of the original. We long to catch even a fleeting sight of the subject of our awe, just as a fan delights in a photographer's stolen glimpse of a celebrity in an unguarded moment. The proliferation of copies serves to enhance the aura of the 'real thing', particularly if it is elusive in the original.

The staring face of the carved crucifix is dramatically emphatic and the garments are hewn from the wood in broad sweeps. Jesus is clothed in a robe simply tailored from a single sheet of cloth. It is a *colobium sindonis*—a 'shroud robe'—and often features in early painted crucifixes. It corresponds to the account in St John's Gospel:

> Then the soldiers, when they had crucified Jesus, took his garments, and made four parts, to every soldier a part; and also *his* coat: now the coat was without seam, woven from the top throughout. They said therefore among themselves, Let us not rend it, but cast lots for it, whose it shall be: that the scripture might be fulfilled, which saith, They parted my raiment among them, and for my vesture they did cast lots.

The presence of the robe helped differentiate the *Volto Santo* from the standard Italian crucifixes, as did its 'primitive' style.

The status of what we see is unclear. It is likely to be a replacement, perhaps from the early thirteenth century, which has fully assumed the spiritual properties of the original. In style it is not implausible as a replica of a much earlier original. A related crucifix in Borgo San Sepolchro has been carbon dated to the eighth or ninth century. As with other of the miraculously generated images its archaic style enhances its credibility. It may seem paradoxical that all the images made by spiritual agency as true likenesses are not naturalistic. Rather they are severe and authoritarian. Over the ages viewers have achieved a separation between judgements of naturalism and authentic 'likeness'. The authenticity of the image is not a matter of whether it exploits the tropes of naturalistic art. The issue is one of spiritual essence and embodiment, as witnessed by the object's legend and its own power to perform miraculous acts. The *Volto Santo* of Lucca proved deficient in neither of these respects.

The Cross in Action

The most celebrated example of the miraculous power of an image or vision of the crucified Christ is the much-illustrated incident of St Francis receiving the stigmata. The circumstances of the stigmatization are recounted in the *Fioretti di San Francisco* (The Little Flowers of St Francis), an engaging compilation of stories of the saint's life. While in meditation on the remote slopes of Monte La Verna in 1213, Francis experienced a transformative vision.

The story is worth recounting at some length from the *Fioretti*, since it presents a vivid picture of how the incident was visualized in the circles of his followers, not least by the great painter Giotto.

> He beheld a seraph descending from heaven with six fiery and resplendent wings; and this seraph with rapid flight drew nigh unto St Francis, so that he could plainly discern him, and perceive that he bore the image of one crucified; and the wings were so disposed, that two were spread over the head, two were outstretched in flight, and the other two covered the whole body. And when St Francis beheld it, he was much afraid, and filled at once with joy and grief and wonder . . .

Christ ... spoke to him certain high and secret things, which in his lifetime he would never reveal to any person, but after his death he made them known to one of the brethren, and the words were these: 'Knowest thou,' said Christ, 'what I have done to thee? I have given thee the stigmata which are the insignia of my Passion, that thou mayest be my standard-bearer; ...' Then, after long and secret conference together, that marvellous vision disappeared, leaving in the heart of St Francis an excessive fire and ardour of divine love, and on his flesh a wonderful trace and image of the Passion of Christ. For upon his hands and feet began immediately to appear the figures of the nails, as he had seen them on the Body of Christ crucified, who had appeared to him in the likeness of a seraph. And thus the hands and feet appeared pierced through the midst by the nails, the heads whereof were seen outside the flesh in the palms of the hands and the soles of the feet, and the points of the nails stood out at the back of the hands, and the feet in such wise that they appeared to be twisted and bent back upon themselves, and the portion thereof that was bent back or twisted stood out free from the flesh, so that one could put a finger through the same as through a ring; and the heads of the nails were round and black. In like manner, on the right side appeared the image of an unhealed wound, as if made by a lance, and still red and bleeding, from which drops of blood often flowed from the holy breast of St Francis, staining his tunic and his drawers.

The representation of the scene on the mountain that works most effectively with the account in the *Fioretti* is the large painting in the Louvre signed OPUS IOCTI FLORENTINI (the work of Giotto the Florentine). It is over 3 metres tall and about half as wide (Fig. 2.10). The large panel places an event in the position normally occupied by static images of holy figures, but it is not really a narrative as would be a cycle of paintings of the saint's life. It is an image of the *Stigmatization* presented as a devotional subject—'St Francis Stigmatised', like the 'Virgin Annunciate'. Below, smaller square fields tell of Pope Innocent III's dream of St Francis holding up the tottering church, the Pope's inauguration of the Franciscan Rule, and the saint preaching to the birds. Now in the Louvre, it was painted for S. Francesco in Pisa.

The main scene captures the searing intensity of the dialogue between Jesus and Francis. It is an essay in concentrated directness. Rays dart from Christ's wounds, piercing the saint's flesh. The ray from the lance wound moves across so that it will register correctly on the right of the saint's

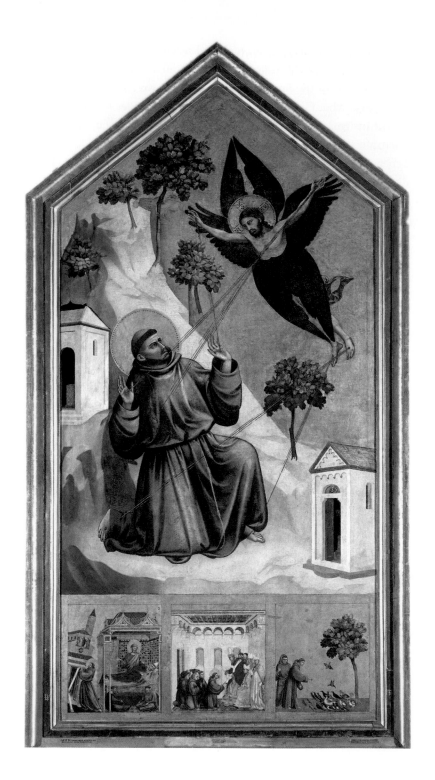

body. The looming seraph, with the crucified Christ enwrapped in its wings, is exactly as in the *Fioretti*.

The painting is signed on its frame, as we have noted. But is it actually by the great Florentine master? The composition stands in a close relationship to the famous fresco in the upper church of S. Francesco in Francis's home town of Assisi. Giotto also painted the narrative again in the Bardi Chapel in Florence. Whether Giotto masterminded or participated in the St Francis narratives in the upper church is one of the most sustained bones of contention in the history of art. If, as seems plausible, the Louvre painting dates from before Giotto's work in Padua, that is to say from about 1300, the Assisi fresco could be dependent on it, whether painted by Giotto or not. In any event, there seems no reason to doubt that the signature means that Giotto and Co. produced it, probably with assistants heavily involved in the smaller scenes.

From our point of view, it is more important that the Louvre *Stigmatization* perfectly expresses the new devotional sensibilities inculcated by St Francis, above all the affecting of pious visualization of sacred events in human and humble terms. In the early 1300s, eighty years or so after the saint's death, painters in a number of Italian centres were working intensively on new pictorial means to give external visual form to Franciscan internal visualization. The style they devised may be described as a compact and selective naturalism, and is manifested at its strongest in the *Stigmatization*.

St Francis, from a wealthy and educated family, had renounced his worldly goods, embracing poverty and humility. But what of worshippers who actually came from the lower echelons of society, who were unlikely to have left articulate records of their devotion? What did the crucifix mean for them? Fortunately we do have an exceptional witness, the English visionary Margery Kempe. Born in Norfolk around 1373, she was the daughter of a former mayor and parliamentary representative in King's Lynn. She was very definitely not working class, but neither was she the kind of person who would be expected to leave an extensive written legacy, let alone a ghost-written 'autobiography'.

After producing no less than fourteen children, she renegotiated a 'chaste' marriage with her husband. Intensely devout, impassioned, and subject to visions, she undertook a daunting series of pilgrimages, ranging from Santiago de Compostela in Spain to Jerusalem. Hers was a truly remarkable life, and it was laid down in her *Book*, produced just before

her death in collaboration with one or more of her family members, who acted as scribes.

The envisioning of Christ crucified played an especially intense role on her pilgrimage to Jerusalem in 1414, where her guides were the Franciscans resident in the Church of the Holy Sepulchre. A short excerpt (rendered into modern English) will give a good flavour of Kempe's blending of the seen with the visionary. We may note that she calls herself 'this creature'.

> And when this creature saw Jerusalem, riding on an ass, she thanked God with all her heart . . . When they came up on to the Mount of Calvary, she fell down because she could not stand or kneel, and rolled and wrested with her body, spreading her arms abroad, and cried with a loud voice as though her heart would have burst asunder; for, in the city of her soul, she saw verily and clearly how Our Lord was crucified.

Back in England, the image remained vividly with her.

> Thus she had as very contemplation in the sight of her soul, as if Christ had hung before her bodily eye in His Manhood. And when through the dispensation of the high mercy of Our Sovereign Saviour Christ Jesus, it was granted to this creature to behold so verily His precious tender body, all rent and torn with scourges, fuller of wounds than ever was a dove-house of holes hanging on the cross with the crown of thorns upon His head, His beautiful hands, His tender feet nailed to the hard tree, the river of blood flowing out plenteously from every member, the grisly and grievous wound in His precious side shedding blood and water for her love and her salvation, then she fell down and cried with a loud voice, wonderfully turning and wresting her body on every side, spreading her arms abroad as if she would have died and could not keep herself from crying, and from these bodily movements for the fire of love that burnt so fervently in her soul with pure pity and compassion.

Margery Kempe can hardly be regarded as 'typical', but she is a wonderful witness to what religious visualization (shaped inevitably by images made by artists) could accomplish at its most intense. Her actions and reactions might have been exceptional, but her emotional engagement with religious visualization was not. We might envisage in her mind's eye a late medieval polychromed sculpture, perhaps over the screen separating

the congregation from the clergy. Pale skin seeping dark red blood. Unfortunately we can only envisage this in our own mind's eye, since the English Reformation swept away or defaced most of the rood screens of the type Margery would have known best. Margery had visited Assisi, where, amongst the affecting images, she would have seen the majestic fresco of the Crucifixion by Cimabue. She wept copiously in Assisi, as was her habit.

If, considering at the other side of the picture, we look to art for a figure comparable to Margery, one image springs to mind above all others, even though it is a century or so later: the frantically distraught Mary Magdalene in Matthias Grünewald's *Isenheim Altarpiece* in Colmar (Fig. 2.11). Mary's entwined fingers are racked with emotional and physical pain. Her luxuriant hair and drapery cascade in grief. Her face is a cry of emotional desolation. Christ himself is portrayed with a ravaging force that has never been equalled. A grief-stricken St John the Evangelist supports the collapsing Virgin, while St John the Baptist points insistently at the ghastly body of Jesus. The inscription beside the Baptist declares, 'he must increase while I decrease'. Below, Christ's lamented body, the *corpus domini*, is laid out beside his tomb. On the wing to the left is *St Sebastian*, tied to a column as was Christ for his flagellation. The right shows a calm St Anthony with a tau cross (with no arm above the cross bar), which had become especially associated with him.

St Anthony provides the key to the altarpiece's function. His intervention was particularly sought in connection with degenerative skin diseases. Most notable of these was ergot poisoning, resulting from a fungal infection of rye and other cereals. It caused severe convulsive reactions, hallucinations, and gangrenous degeneration of fingers, toes, and limbs. Skin blistered and blackened, and the worst affected parts rotted away. The monks of St Anthony famously strove to alleviate the suffering, and the disease came to be known as 'St Anthony's fire'. Although we should not see Christ as literally suffering from ergot poisoning, the spasms of his nailed hands, the marks of the thorny scourges on his lacerated skin, and his wrenched feet oozing glutinous blood would all have possessed huge resonance for someone afflicted with St Anthony's fire.

The great painted and sculpted altarpiece, of which these four panels comprise its closed state, was commissioned for the church of an Antonite monastery hospital near Colmar in Alsace. It was not unusual for altarpieces and other religious art to be involved in the medical treatment

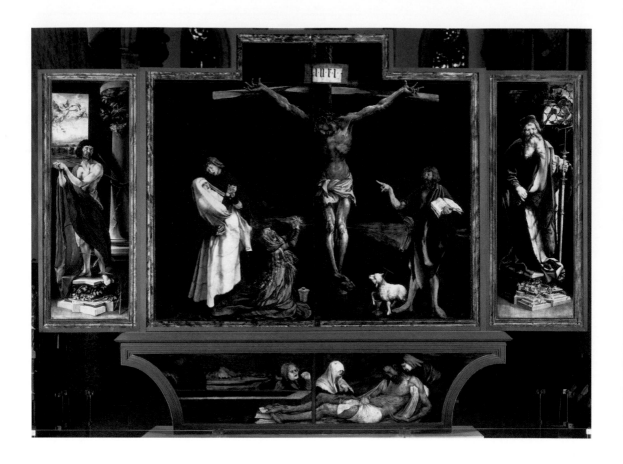

of the sick and the comforting of the dying. But nowhere was the sufferer presented with such a compelling image of how Christ their saviour had born afflictions of a comparable savagery.

The cross progressively became a standard part of the furnishings of an altar to accompany the saying of masses. Its type could vary from elaborately figurative, with a realistic figure of Christ, to a simple structure of an upright and a horizontal. Some crosses were enriched with subsidiary structures to support other holy figures, symbolic motifs, and elaborate decorations.

At its most basic, the cross could be made from two pieces of wood, plus a nail or piece of string. The plain, unadorned cross became ubiquitous in societies that espoused Christianity, not only in religious buildings but also many secular settings, such as schools and hospitals. It has served as the standard three-dimensional sign of belief in the redemptive power

of Christ's sacrifice. Deep faith is not always involved. A simple pendant gold cross on a fine chain has become widely used as a standard piece of jewellery. The Egyptian Ankh cross with its looped upper arm, which we will encounter briefly in Chapter 4, has similarly become a decorative object largely divorced from its meaning of eternal life.

Crosses of many different kinds have proliferated over the centuries, many endowed with different kinds of secondary meanings—far too many to be enumerated here. The two basic forms are the Latin, with one long and three shorter arms, and the Greek, with arms of equal length. Some variants are better known than others. A number spring readily to mind: the cross of St Peter, inverted because of his upside-down crucifixion; the diagonal cross of St Andrew, also referring to his mode of crucifixion; the tau cross of St Anthony as in the Grünewald altarpiece; the red cross of St George; the Celtic ring-headed crosses; the three-barred papal crosses; the two-barred cross of Lorraine; the Crusaders' or Jerusalem cross, with smaller crosses set in the spaces between its arms; and the Maltese cross, with its pointed triangular arms. There are many more, not least in heraldry. The cross is probably the most familiar symbol on flags worldwide, though it does not seem to feature outside a Christian context.

Like all simple motifs adopted as 'badges', a cross serves bluntly to identify insiders and outsiders, members and non-members. It is rarely neutral, as even the International Red Cross has discovered. Its mission statement declares that is 'the world's largest humanitarian organization, providing assistance without discrimination as to nationality, race, religious beliefs, class or political opinions'. Under the sign of the red cross on a white background it has become renowned for bringing succour to the afflicted across the world. But the blood-red cross can be identified with the Church militant, the Church of the crusades. Thus it has come about that 'the Red Crescent is used in place of the Red Cross in many Islamic countries', as their statement explains. But, in turn, the Red Crescent may be seen as hostile by those who distrust Islam. Hence the recent moves to adopt the 'red crystal', a diamond-shaped logo, to signal universal humanitarian efforts in an entirely neutral way. In the British House of Commons a minister at the Foreign Office reported that

the reference to the Crusades is . . . not lost to some people which, of course, anybody involved in the Red Cross would wholly deprecate. The truth of the

matter is that it has been difficult in some places for us to ensure that these connotations of a religious war or a religious crusade don't undermine the work that the Red Cross or Red Crescent is able to do.

Opponents in Parliament argued that this is 'political correctness' gone mad. It seems likely that the red diamond will seep increasingly into widespread use.

Crosses can be inflammatory in a wholly deliberate manner. The most notorious of the deviant versions is the fiery cross adopted by the American white supremacist organization the Ku Klux Klan (Fig. 2.12). Inspired by the D. W. Griffith silent film *The Birth of a Nation* (called *the Clansman* at its premiere in 1915), Klan members assumed a uniform of white robes with conical hoods. Fiery crosses were held aloft in ritual circles, and carried in night-time paramilitary parades. The sign was overtly designed to intimidate, and, at its most extreme, to signal acts of violence and killing. At the organization's peak in 1928, when it numbered some millions of supporters, it felt strong enough to mount a large parade with flags and crosses along Pennsylvania Avenue from the Capitol to the White House. After a sharp decline, it continues to survive in a diminished and superficially legitimate manner. To become a current member of the 'Brotherhood of Klans',

an applicant must be a white Gentile person, a native-born citizen of the United States of America who owes no allegiance of any nature or degree whatsoever to any foreign government, nation, institution, ruler, sect, prince, potentate, people or person; one must have attained the age of eighteen years, be of sound mind, good character, of commendable reputation and respectable vocation, a believer in the tenets of the Christian Religion, and one whose allegiance, loyalty and devotion to the Government of the United States of America in all things is unquestionable.

We know that the 'tenets of the Christian Religion' have been defined in wildly contradictory ways by different sects.

The dominant Christian message of the militant cross, in the wake of Constantine's victory, has become heavily connected in political rhetoric to the defeat of 'evil', in whatever form 'evil' is defined by the definer. The cross famously plays this role in Bram Stoker's *Dracula*, both in his 1897 novel and its many filmed variations. During a terrifying skirmish with

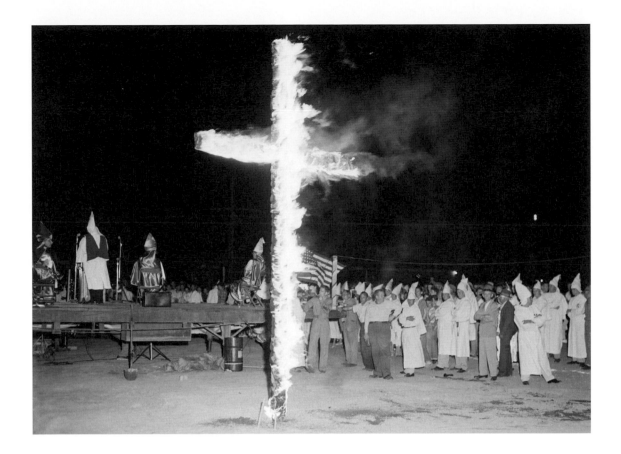

the vampire count, Jonathan Harker's 'great Kukri knife' was of little avail. Dr Seward instinctively raised a cross and the host:

> Instinctively I moved forward with a protective impulse, holding the crucifix and wafer in my left hand. I felt a mighty power fly along my arm; and it was without surprise I saw the monster cower back before a similar movement made spontaneously by each one of us. It would be impossible to describe the expression of hate and baffled malignity—of anger and hellish rage—which came over the Count's face.

Throwing himself precipitately through a window 'amid the crash and glitter of the falling glass', Dracula stumbles away from the hateful sight of the cross to bite another day.

Fig. 2.12

Family assembly of the Ku Klux Klan at Macon, Georgia, 27 April 1956.

As I am writing this, a flyer from the local Baptist Church pops through my letterbox. 'Does God Exist?' it asks, with three boxes to tick: yes, no, and probably. The cruciform letterhead consists of WOODSTOCK BAPTIST CHURCH across a single vertical line.

Cardinal Directions

The cross is one of the most basic of graphic marks. It is the sign traditionally used as a signature by those who have not learnt to write. It is what we place on ballot papers when voting at elections. We are very accustomed to placing a cross in relevant boxes on official forms, and during transactions on the internet.

It appears very early in children's drawings, which are characterized by two dominant motions, the whirling scribble and lines that cross more or less at right angles. These marks are fundamental descriptors of space: round and round; and along the four cardinal axes of front, side, and rear. The cross develops in adult societies into the basic means of mapping territory. Placed horizontally, the cross signals the four points of the compass, or less abstractly sunrise, midday, sunset, and midnight. Oriented vertically the cross can signal above ground, ground level, and underground. A complete coordinate system is thus in place—and provides the system with which the virtual space in computer graphics is organized.

A cross can also be used to mark a spot definitively. A chalk cross on the floor tells us where to stand when being filmed for television. The point at which two lines cross promises precision. In 'spot-the-ball' competitions in newspapers, in which we have to locate the football that has been removed from the photograph of an incident, we are told to make a cross at the chosen point, The sights attached to military weapons very often use a very fine cross—crossed hairs traditionally—so that the aim may be as accurate as possible.

In cultures for which no written documentation survives, such as the Pueblo Indian societies in northern Mexico (now New Mexico) before the Spanish conquest, it is probable that the cross (and the related diamond) denoted the four cardinal directions, perhaps with spiritual connotations. However, when the cross appears in later Navajo weaving as a regular motif in a decorative repertoire, it is seemingly devoid of developed symbolic content—at least as far as anthropologists have been able to tell.

As a highly developed example of the coordinate cross as a symbol of articulated space, I have chosen one from the Kongo culture in Africa. I then end this chapter with the notorious *Hakenkreuz* (hooked cross) of the Nazis, more widely known as the swastika. The contrast could hardly be sharper.

The Bakongo people and the Kongo culture extended across a large territory that includes some of the present lands of the Congo, Zaire, and Angola. Christianity arrived as early as the late fifteenth century, bringing its own special version of the cross. However, the Bakongo were already using a cross of a very different kind—less a material symbol and more of a mental concept, used to denote cosmological and spiritual directions. The four points of the cross are marked by orbs, signalling the 'four moments of the sun' in the southern hemisphere, that is to say the four cardinal directions of sunrise (east), noon (north), sunset (west), and midnight (south). The basic disposition of the 'four moments' could also be expressed by the points of a diamond. The points of the cross or diamond also denote an 'upper' world (north) and the 'lower' world (south), divided horizontally by a boundary, associated with water or other barriers, such as a dense forest. The 'upper' world was characterized by earth, the living, male, strength, and ultimately with god; the 'lower' with white clay, the dead, female, otherworldly strength, and wholeness. Life and death, like the rising and setting sun, was cyclical, with a spiral configuration (as in shells) serving as an ideogram of spiritual motion. Those in our realm who have lived a good life can aspire to return, while those who were truly exceptional would die twice to be reborn in immortal guise as enduring features of the visible world, such as rocks, waterfalls, and shells. This cosmos was to be understood by adherents as a continuous, cyclical whole.

The Kongo cross and diamond in their various dispositions can best be regarded as conceptual arrays of qualities and entities expressive of the metaphysics of life and death under the rule of God rather than as a symbolic image or emblem realized in a fixed graphic or sculptural form. The graphic expressions were more flexible than was the case with symbols that relate to a substantial body of written doctrine.

The Kongo cross did find physical expression, as in crosses marked on the ground or dug as trenches during ritual acts, most notably during the 'drawing of a point' in an act of oath-taking. It is also found in a variety of objects that have funerary associations. A notable example

is the ceramic jar from the village cemetery at Lamba Teye (Fig. 2.13), said to be a cooking vessel for sacred medicines. Diamonds feature conspicuously, some with central voids indicative of death, while the round openings are surrounded by orbiting circles denoting the cyclical nature of life and death. The markings are typical of those featuring on Kongo artefacts in that the diamond (or crossed diagonal incisions) predominates, confirming that it is not so much the upright cross that is the obligatory sign, but that the graphic marks signal the cosmological array in ways appropriate to each manifestation—whether marked on the ground for a ritual or carved into a ceramic vessel for funerary purposes.

The relationship between the graphic sign and its function as an expression of belief is therefore quite different from the Christian cross, with its more literal correspondence between object and devotion. This is not to say that the two belief systems could not merge in a particular Kongolese way. The cross of Christ was readily assimilable. A particularly nice instance is a wooden cross in the Metropolitan Museum (Fig.

Fig. 2.13

Terracotta funerary jar, from Lamba Teye, Kinshasa, Institut des Musées Nationaux du Zaïre.

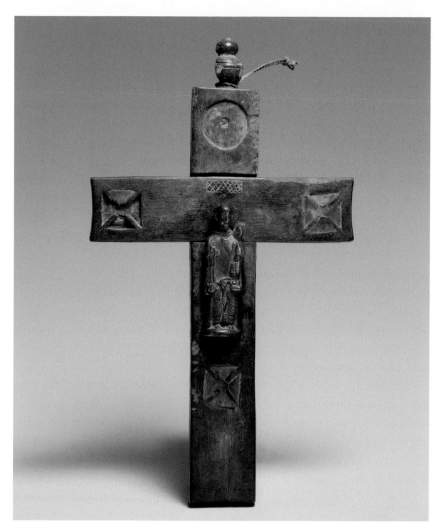

Fig. 2.14

Wooden cross with brass
insert of St Anthony,
20th century, New York,
Metropolitan Museum.

2.14), in which is embedded a brass figure of St Anthony, who was the
subject of particular devotion in Kongo culture following the activities
of missionaries. The cross bar and lower arm of the wooden cross are
adorned with the diagonal motifs familiar from other Kongo artefacts,
while the upper arm bears a circle orbiting a round central mark, which
presumably has a similar cyclical meaning to the round motifs on the
funerary jar.

The Hooked Cross

In its origins the now-repulsive swastika or 'hooked cross' (the *hakenkreuz*) was as spiritually benign as the Kongo cross. It is a basic and primitive variation on the cross, dating back to prehistoric eras and used commonly as a decorative and symbolic motif in many cultures, most conspicuously in the Indian sub-continent. Indeed, its name comes from the Sanskrit *svástika*, and it features conspicuously in both Hinduism and Buddhism as signalling well-being. In 1894 Thomas Wilson, curator in the Department of Pre-Historic Anthropology in the US National Museum, produced a report for the Smithsonian on the *Swastika the Earliest Known Symbol and its Migrations* detailing the wide chronological and cultural spread of the motif in a wide range of variants on all manner of artefacts. His aim was anthropological and taxonomic.

Already, however, the swastika was being pressed into the service of a particular racial theory, namely the quest for the prehistoric Aryan ancestors who first began to drive the Indo-European cultures towards the heights of 'true' civilization. The quest was nourished by a mish-mash of linguistic theory, anthropology, archaeology, and prejudice. A key player was the wealthy German businessman Heinrich Schliemann who conducted highly productive excavations at Hisarlik in Turkey, the site of ancient Troy. In his 1875 book *Troy and its Ruins* he interpreted the many varieties of swastika he unearthed on his 'Trojan treasures' as emblems of Aryan identity. A further step was taken by Michael Zmigrodski, the Polish librarian and archaeologist, who exhibited 300 drawings based on a wide variety of swastikas at the Paris Exposition of 1889. These he refined down to sixty-five 'pure' Aryan swastikas. When Gustaf Kossinna, in his *German Prehistory: A Pre-eminently National Discipline* in 1914, expounded the idea that the founding Aryans from whom the Indo-European culture diffused were northern and Teutonic, the components were in place for the swastika to become the loaded Aryan symbol that Hitler adopted as perhaps the most potent graphic emblem ever devised. Such was his success in marrying sign to meaning that it is has become virtually impossible to look in an untainted way at swastikas that carry absolutely no Nazi connotations.

Hitler tells the story in *Mein Kampf*.

I had to discard all the innumerable suggestions and designs which had been proposed for the new movement, among which were many that had incorporated the swastika into the old colours. I, as leader, was unwilling to make public my own design, as it was possible that someone else could come forward with a design just as good, if not better, than my own. As a matter of fact, a dental surgeon from Starnberg submitted a good design very similar to mine, with only one mistake, in that his swastika with curved corners was set upon a white background.

After innumerable trials I decided upon a final form—a flag of red material with a white disc bearing in its centre a black swastika. After many trials I obtained the correct proportions between the dimensions of the flag and of the white central disc, as well as that of the swastika. And this is how it has remained ever since . . .

The new flag appeared in public in the midsummer of 1920. It suited our movement admirably, both being new and young. Not a soul had seen this flag before; its effect at that time was something akin to that of a blazing torch . . .

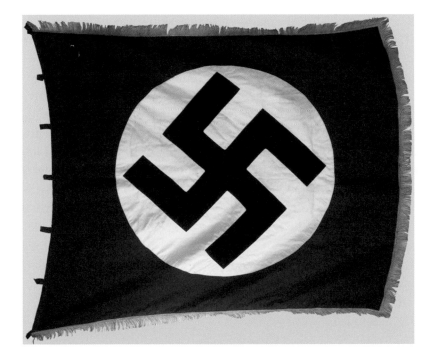

Fig. 2.15

The swastika flag,
private collection.

The red expressed the social thought underlying the movement. White the national thought. And the swastika signified the mission allotted to us— the struggle for the victory of Aryan mankind and at the same time the triumph of the ideal of creative work which is in itself and always will be anti-Semitic.

The visual impact of the design is attuned with precision to its bluntly assertive purpose. Uncompromisingly rectilinear, compared to the curvaceous versions that were common in earlier cultures, it is turned through 45 degrees, which endows it with a rotational dynamism. The ratio of the breath of the arms: the gap between them: the inner length of the arms, the outer length of the arms, and the side of the square within which it can be inscribed is $1:1:2:3:5$. The numbers are familiar as the start of the Fibonacci series ($1 + 1 = 2, 1 + 2 = 3, 2 + 3 = 5$), and are closely related to the golden section. Given Hitler's ambitions as an artist and his classicizing sympathies, it is entirely possible that he was alert to how the 'correct proportions' of his design related to the proportional series that had come to be seen as holding the mystical key to cosmic harmony. The black *hakenkreuz* was then set tensely almost touching the circumference of white circle within the assertive red rectangle. It is (though it is hideously difficult to acknowledge) a masterpiece of design (Fig. 2.15).

The Nazi flag was exploited like no other before or since, with the possible exception of the American Stars and Stripes. Lauded in Horst Wessel's Nazi anthem—'Raise the flag high! The ranks tightly closed . . .'—its insistent visual drum was banged cacophonously at every National Socialist event. The flag is the star performer in Leni Riefenstahl's remarkable and gripping film *Triumph of the Will*, centred on the huge Nuremberg Rally of 1934. A high point is the 'sea of flags' orchestrated by Albert Speer, Hitler's architect, in which wave after wave of banners surge along the great central avenue between the massed ranks of the Nazi youth (Fig. 2.16). A key moment was the consecration of flags by their touching against the *Blutfahne* (the Blood Flag), which had been stained by the blood of Nazi party members shot by the police during the attempted Beer Hall Putsch in 1923. The *Blutfahne* was a kind of holy relic. It seems to have disappeared with the death of its designer in 1945.

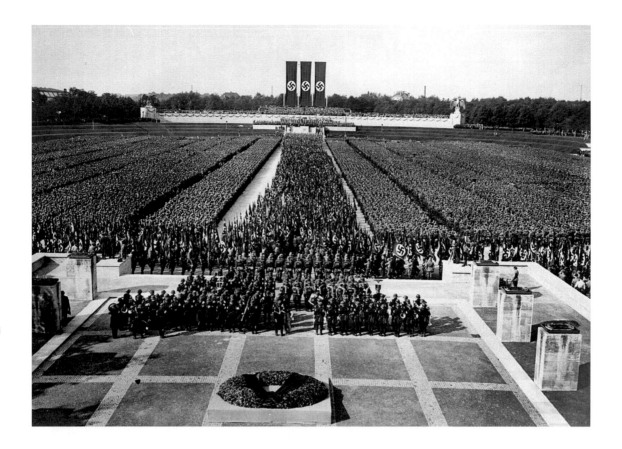

It is fitting, I think, to leave the last word to the artist who represented the most telling visual negation of Hitler's emblem, the master of photomontage, John Heartfield. He reconstituted the swastika as a cross composed of battle-axes dripping blood. He portrayed a Nazi callously screwing heavy extra arms to the cross in a sweetly traditional image of *Christ Bearing the Cross.* And he drew upon medieval precedent to portray the body of humanity broken, Christ-like, on the *hakenkreuz* (Fig. 2.17). Heartfield was fully able to exploit the extraordinary power of the icon of the cross, turning Hitler's swastika against itself. The Nazi emblem and image of Christian suffering are brought together in a deadly combat that exemplifies the searing power of visual signs.

Fig. 2.16

Leni Riefenstahl, *The Sea of Flags,* still from *Triumph of the Will,* 1934.

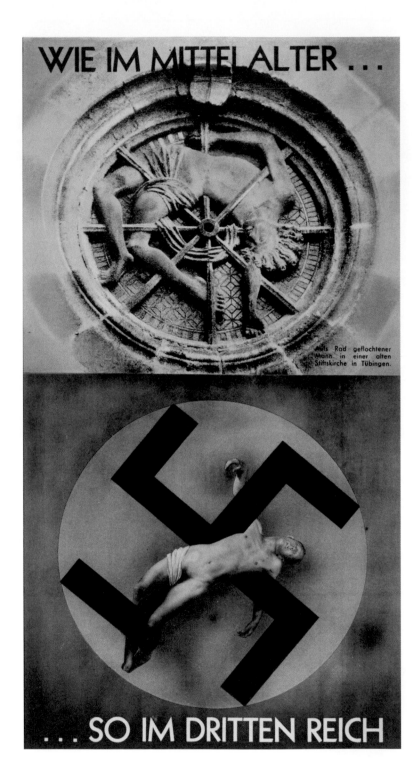

Fig. 2.17

John Hartfield (Helmut Herzfeld), *As in the Middle Ages . . . so in the Third Reich* (with St George tortured on the wheel of swords, from the Collegiate Church, Tübingen), 1934.

Reading

The books by Belting and Wolf in the reading for Chapter 1 contain much germane material.

A. Andreopoulos, *The Sign of the Cross: The Gesture, the Mystery, the History*, Orleans, Mass., 2006.

H. Bredekamp, 'Bilderkult aus Bildkritic', in R. Schröder and J. Zachuber (eds), *Was hat uns das Christentum gebracht?*, vol. ii, Münster, 2003, pp. 201–17.

E. Dinkler, *Signum crucis: Aufsätze zum Neuen Testament und zur christlichen Archäologie*, Tübingen, 1967.

R. Harries, *The Passion in Art*, Farnham, 2004.

A. Hayum, *The Isenheim Altarpiece: God's Medicine and the Painter's Vision*, Princeton, 1990.

S. Heller, *The Swastika: Symbol beyond Redemption?*, New York, 2000.

Il Volto Santo. La Santa Croce di Lucca: Storia, tradizione, immagini, Atti del Convegno, Lucca, 2001.

Margery Kempe, *The Book of Margery Kempe 1436*, a modern English version, trans. W. Butler-Bowdon, Oxford, 1954.

R. Lightbown, *Piero della Francesca*, New York, 1992.

W. MacGaffey, *Religion and Society in Central Africa: The BaKongo of Lower Zaire*, Chicago, 1986.

M. Quinn, *The Swastika: Constructing the Symbol*, London, 1994.

H. Richardson and J. Scarry, *An Introduction to Irish High Crosses*, Blackrock, 1990.

J. Taylor, *Journey through the Afterlife: Ancient Egyptian Book of the Dead*, London, 2010.

R. F. Thompson and J. Cornet, *The Four Moments of the Sun: Kongo Art in Two Worlds*, ex. cat., Washington, National Gallery of Art, 1981.

D. Wood (ed.), *Women and Religion in Medieval England*, Oxford, 2003.

dear the heart which you behol

do my heart with love tick sweet

3

The Heart

LET ME TELL YOU A STORY ABOUT A FAITHLESS HEART (♥)—a variant on a famous one. Don Juan was a hard-♥ed man, renowned for his stony ♥, always unmoved by the most ♥-rending emotions experienced by others. He had left a trail of ♥-broken women in his wake. A woman who wore her ♥ on her sleeve left herself vulnerable to his ♥lessness. He learnt by ♥ his skilled speeches of seduction. His warm-♥ed friends witnessed each new romance with a ♥-sinking feeling. Here we go again, another sweet♥ who has lost her ♥, queuing up to have her ♥-strings plucked. However, they were ♥ened to think that his new conquest might actually prove as cold-♥ed as him. They began to take ♥. She was not at all faint-♥ed when confronted with the Don's ♥-stirring charm. He was utterly

■ Puzzle Valentine card, in its fully folded state, detail, 1790, London, British Postal Museum.

confident that he could flutter her ♥ to his ♥'s content. But she closed her ♥ to him. She seemed to be reacting half-♥edly to his advances, even after a ♥-to-♥ conversation. Was he beginning to feel pain in his own ♥, or was it just ♥-burn after too lavish a meal the night before? His ♥ was pounding. Could he really be experiencing a change of ♥? The ♥ of the matter was that he was actually being made to eat his ♥ out with unrequited love. The emotion, entirely new to him, was ♥-stopping. From the bottom of his ♥, he declared his love, to no avail. All was lost.

My mini-story contains a lot of clichés to be sure, but that is par for the course when love and the heart loom into view. I subsequently find that one website lists sixty-one words that start with heart and six that end with it, although some of them have a tenuous existence. Readers might well be able to do better than me, even before looking at one of the websites dedicated to helping with word-games such as crossword puzzles.

English, not conventionally renowned as a romantic language, is particularly rich in heart-words. *Cœur* in French and the Italian *cuore* are ubiquitous in matters of love and the human spirit, but do not feature so abundantly in compound words or familiar phrases. The Latin languages are differently structured, but even other northern European languages seem hard-pressed to rival English. German is probably most comparable, compounding many *herz*-words, such as 'herzzerreißend' (heart-rending). Even allowing for the fact that English is what linguistic specialists term an 'analytical' language—prone to make compound words—the number of words and phrases is remarkable. Hand-words, like handmade, are the heart-words' most obvious rival. Making lists is a game we can all play.

Obviously it would be unwise to conclude that English speakers are more full of heart than others. In all cultures, heart plays a central role in the human system of values. The meaning of 'heart' in most world cultures extends far beyond a reference to a particular organ in the body. Heart often refers in the broadest manner to the innermost nature of someone's character, 'spirit', or 'soul'. A spectacular manifestation of this sense of heart-as-spirit occurs in the prophecies of Jeremiah in the Old Testament. In his famed lamentations, heart is invoked no less than sixty-six times.

Jeremiah does convey a positive sense that God is looking to receive our hearts. 'I will give them an heart to know me, that I am the LORD: and they shall be my people, and I will be their God: for they shall return

unto me with their whole heart' (24: 7). However, the dominant concern of the severe prophet is the evil nature of the citizen's hearts. In general he believes that 'The heart is deceitful above all things, and desperately wicked' (17: 9). On more than one occasion Jeremiah berates the Israelites for 'the imagination of their evil heart' (3: 10 and 3: 17). His is a literally visceral vision: 'My bowels, my bowels! I am pained at my very heart; my heart maketh a noise in me; I cannot hold my peace, because thou hast heard, O my soul, the sound of the trumpet, the alarm of war.' And in a remarkable piece of imagery, which he uses twice, he instructs his people, 'circumcise yourselves to the Lord, and take away the foreskins of your heart' (4: 4 and 9: 26).

Heart is here virtually synonymous with soul, to be weighed in the balance at the time of judgement, both earthly and eternal. In Egypt the weighing had adopted a very specific form. Although the viscera were generally removed from the dead before embalming, the heart was retained in the mummified body, so that each person's organ could be weighed against the feather of truth and justice, symbol of the God Maat. If the heart was unburdened by sin, it would potentially possess the lightness to withstand such a severe test. It is clear that lightness is less a literal matter of physical mass than of spiritual buoyancy.

Chapter 30 of the Egyptian *Book of the Dead* expresses concern that the heart should act loyally in front of the tribunal of the gods:

> O my heart that I received from my mother, my heart that I have had since birth, my heart that was with me through all the stages of my life, do not stand up against me as a witness! Do not oppose me at the tribunal! Do not tip the scales against me in the presence of the Keeper of the Balance!

This text, often in variant form, might be inscribed on a scarab placed over or even within the heart of the deceased.

These witnesses from Israel and Egypt belong to a worldwide history of the heart as embodying the innermost nature of a person. This history reaches back to the earliest recorded literature. However, before we assume that this chapter is committed to a breathless tour of the heart in world culture, we should remind ourselves that we are dealing specifically with what has become the stock visual image—the icon that I am calling the 'heart-shape'. It does not adopt this specific shape in either the ancient Israeli or Egyptian cultures.

Although the heart-shape is now universal, having become a hiero-glyph or pictogram as much as a direct visual representation, it made a surprisingly late appearance and is of somewhat uncertain origins. When we find Giotto's *Charity* (Fig. 3.1) in the Scrovegni Chapel in Padua present-ing her heart to Christ, we may be surprised to find that it does not con-form to our schema. She holds her heart 'upside down' with the traces of the aorta protruding from her palm. Our convention is clearly not yet in place.

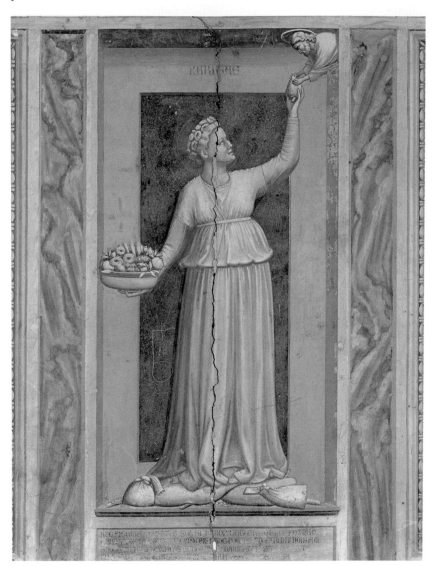

Fig. 3.1

Giotto di Bondone, *Charity*, c.1305, Padua, Scrovegni Chapel.

The Anatomical Heart

It would be good to tell a tidy story of the origins and rise of the heart-shape, but I am not convinced that it can be done. A number of claims have been made that the heart-shape as a symbol of love originated with ancient plant symbolism. Stylized ivy leaves in various decorative contexts assumed the heart-shape to greater or lesser degrees. Ivy, tenaciously adhesive, was regularly associated with fidelity and enduring love. And the seeds of the extinct silphium plant, which served a contraceptive function, are distinctly heart-shaped. But it is difficult to establish how our stock hieroglyph of the human heart originated directly from any ancient or Medieval associations of botanical form with amatory meaning. For our present purposes, we can most securely begin with anatomical science in the late Middle Ages and Renaissance, subsequently looking at courtly poetry and Christian devotion.

Before we do so, it is worth tackling the question of the resemblance of the heart-shape to an actual heart. The literature on the stock image insistently emphasizes how unlike it is to a real heart. This lack of resemblance is considerably overplayed. First, what a heart looks like depends on what kind of heart is being studied, human or animal, and what we count as the main body of the heart. Let us say we cut out a pig's heart, severing the aorta, pulmonary artery, and vena cava. We then cut away the untidy bits at the top that seem not to belong to the main muscly mass of the heart (though leaving the two auricles in place), and we end up with something that can, in its untidy, fleshy, and rather asymmetrical way, be reconciled without too much special pleading with the heart-shape (Fig. 3.2). Secondly, the resemblance of the heart-shape is no more remote from the real thing than the popular icon of a smiley face. We have no trouble in seeing two dots, a vertical line, and a curved one within a perfect circle as the head of a happy person. We know by perceptual instinct and pictographic custom how such schematized visual signs function. A minimal level of resemblance is enough, as we see repeatedly with other iconic images. Thirdly, there was a somewhat confused written tradition, stemming from the writings of Aristotle and the ancient Alexandrian philosopher-anatomist Galen, which described a *fovea* (small pit or depression) between the main chambers of the heart. As we will see, it is this written tradition that results in the earliest of the heart-shaped images that are definitely intended to represent the heart as a human organ.

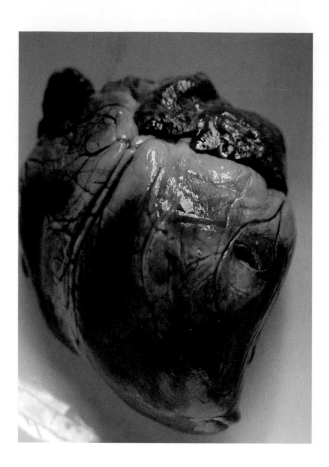

Fig. 3.2

The heart of a pig (with a lateral puncture).

Galen set the terms of the anatomical debate, particularly with respect to the earlier and rather different views of Aristotle. Galen viewed the heart, in the memorable formulation of Jonathan Miller, as 'an industrial plant half-way between a brewery and a blast furnace'. Galen claimed that 'the heart is, as it were, the hearthstone and source of the innate heat by which the animal is governed'. He recognized its extraordinary power and endurance. It is composed of 'hard flesh, not easily injured. In hardness, tension, general strength, and resistance to injury, the fibres of the heart far surpass all others, for no other instrument performs such continuous, hard work as the heart.' However, as a specialist pump, it was secondary to the liver, which was responsible for the production of the venous blood and most significantly of the four humours that dominate the human constitution.

For Aristotle, by contrast, the heart is 'the very starting-point of the vessels, and the actual seat of the force by which the blood is first fabricated'. He emphasizes in his treatise *On the Parts of Animals* that

> the primary source of the vessels is the heart. For the vessels manifestly issue from it and do not go through it. Moreover, being as it is homogeneous, it has the character of a blood-vessel. Again its position is that of a primary or dominating part. For nature, when no other more important purpose stands in her way, places the more honourable part in the more honourable position; and the heart lies about the centre of the body, but rather in its upper than its lower half, and also more in front than behind. This is most evident in the case of man.

Looking at the formation of the heart and vessels in the embryo in a hen's egg, Aristotle concluded that 'the heart is the first of all the parts to be formed; and no sooner is it formed than it contains blood. Moreover, the motions of pain and pleasure, and generally of all sensation, plainly have their source in the heart, and find in it their ultimate termination.'

This historic divergence of views between Galen and Aristotle was still a matter of contention in the Renaissance. Leonardo da Vinci resolved the question in his own mind by the force of analogy. His mode of argument was founded on his cherished notion that the human body, as a microcosm, was a 'model for the world', reflecting the universal macrocosm in its forms and functions. After performing a dissection on a man who claimed to be 100 years old, he argued that the vessels originated from the heart just as the trunk, branches, and roots originated from a seed. The microcosm of the 'tree of the vessels' in the human body must obey the same principles of universal design as are apparent in plants. Beside the main demonstration of the vessels of the thorax and upper abdomen, he made a small sketch of a 'nocciolo' (nut or stone) germinating into a plant, with branches above and roots below (Fig. 3.3). The other sketch shows a heart, 'core', thrusting the 'roots' of its branching vascular system into what he picturesquely terms the 'dung of the liver'. As is customary, the form of the heart in Leonardo's drawings is neither very like nor very different from the heart-shape, which was clearly not a significant point of reference for him, even though it had already made its debut in anatomical illustration.

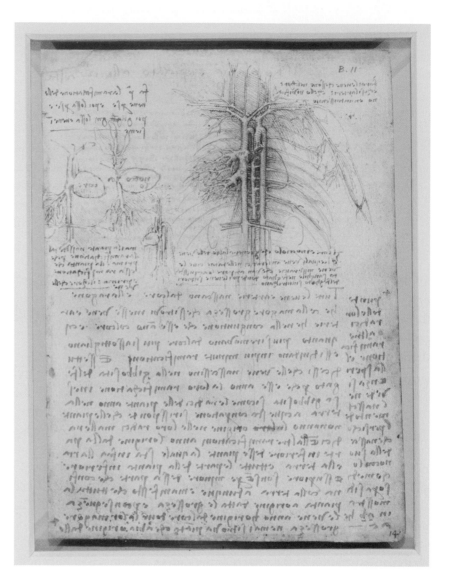

Fig. 3.3

Leonardo da Vinci,
*Vessels of the Thorax and
Upper Abdomen with
Demonstration of the Heart
as Seed*, c.1507, Windsor
Castle, Royal Library 12597.

What may be the earliest example of the heart-shape in an anatomical context occurs in a diagrammatic illustration of the main internal organs in a manuscript of the *Anothomia* (1345) by Guido da Vigevano, which displays a small-scale heart with Galen's central *fovea*. More conspicuously, amongst the unprecedented set of printed illustrations in Johannes de Ketham's *Fasciculus medicinae*, first published in Venice in 1491, a diagrammatic woodcut of the anatomy of a pregnant woman displays the heart in its classic form, with a curved line dividing it into left and right halves

(Fig. 3.4). The squatting pose and general disposition of the organs derives from a medieval tradition, but the heart reflects a shape that was beginning to become more common in the later fifteenth century, as we will see. Even so, we are still some way from the heart-shape assuming its iconic form on a more widespread basis.

Later, more naturalistic illustrations of the heart, taking their cue from Andreas Vesalius' *Fabrica* in 1543, might be expected to provide no

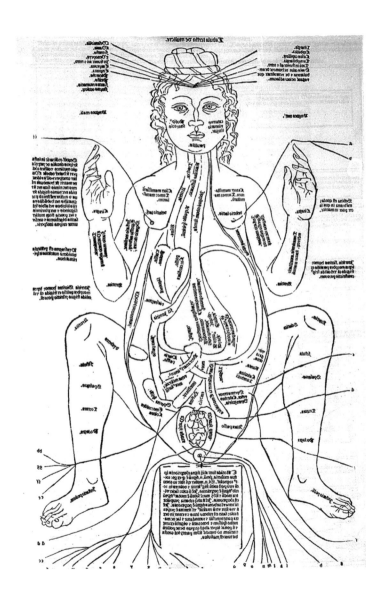

Fig. 3.4

Anatomy of a pregnant woman, from Johannes de Ketham, *Fasciculus medicinae*, Venice, 1491.

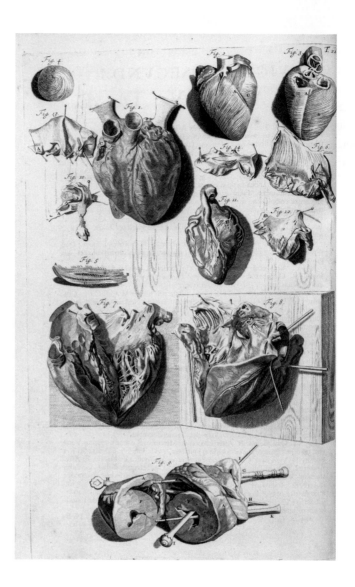

Fig. 3.5

Govard Bidloo, 'The Heart, Whole and Dissected', from *Anatomia humani corporis*, Amsterdam, 1685.

encouragement for thinking that the human heart is really heart-shaped, but they are often more compatible with the iconic image than has been recognized. The notably fleshy heart in Govard Bidloo's magnificent 1685 treatise on human anatomy (Fig. 3.5) is not so remote from the iconic form, particularly in the first figure at the top of the page.

It would be easy to assume that advancing anatomical knowledge of the heart's external appearance and internal structure, together with a growing awareness of its function as a pulsing muscle, would result in

the discarding of the 'passionate' view of the heart expressed by Aristotle and of Leonardo's microcosmic context. However, even William Harvey, who first clearly explicated its function as a circulatory pump, expresses what may be regarded as an almost ecstatic attitude to this most central of anatomical organs.

In his epochal treatise of 1628, *Exercitatio anatomica de motu cordis et sanguinis in animalibus* (*An Anatomical Investigation of the Movement of the Heart and Blood in Animals*), Harvey relies very much upon contemporary engineering, particularly that of pumps and canals, for his thinking about the role of the heart, the vessels, and the valves. His essentially mechanical analysis leads him to conclude that 'there must be a motion, as it were, in a circle'. This conclusion, though he could adduce some powerful evidence, required a degree of faith, since the capillaries needed to complete the circle were not visible to him.

For all his mechanistic notions of the physical performance of the heart, Harvey characterized its philosophical-cum-theological status within a microcosmic framework of an entirely traditional nature. In his dedicatory letter to 'To The Most Illustrious and Indomitable Prince Charles King of Great Britain, France, and Ireland Defender of the Faith', he declares that,

> The heart of animals is the foundation of their life, the sovereign of everything within them, the sun of their microcosm, that upon which all growth depends, from which all power proceeds. The King, in like manner, is the foundation of his kingdom, the sun of the world around him, the heart of the republic, the fountain whence all power, all grace doth flow.

In case we should imagine that such rhetoric is limited to the necessarily flowery letter of dedication, the same tone is expressed deep in his treatise, at the start of chapter VII:

> The heart, consequently, is the beginning of life; the sun of the microcosm, even as the sun in his turn might well be designated the heart of the world; for it is the heart by whose virtue and pulse the blood is moved, perfected, and made nutrient, and is preserved from corruption and coagulation; it is the household divinity which, discharging its function, nourishes, cherishes, quickens the whole body, and is indeed the foundation of life, the source of all action.

The notion of the heart as a 'household divinity' is particularly nice.

Even in the most technical modern medicine, performed by the most apparently detached of surgeons, the traditional connotations of the heart as the organ central to someone's emotional being remain very much in patients' minds. The first heart transplant, performed on 3 December 1967 by Christiaan Barnard in the Groote Schuur Hospital in Cape Town, attracted huge public interest—not just because it was a remarkable operation but because it involved a new heart rather than, say, a new liver. The fact that the recipient, Louis Washkansky, a male Jew, received the heart of a 26-year-old gentile woman, Denise Darvall, served to heighten the sense of frisson—something the press did not fail to exploit. Mrs Washkansky was worried on other grounds: 'I was petrified at what I'd find. Like everyone else, I thought the heart controls your emotions and your personality.' She was relieved to find that her husband's emotions had emerged unscathed. When, in a country divided along racial lines, Barnard's second transplant involved the replacing of the heart of a white recipient with one from someone designated as 'coloured', the emotive implications of transplanting hearts were even more evident.

However, we are again being drawn into the wider issue of the cultural significance of the heart and away from our quest to understand how the heart-shape assumed its ubiquitous presence. Anatomy has not really solved the problem. Let us return to Italy in the fifteenth century.

Hearts in Chests

The most compelling portrayal of the heart in Renaissance art occurs in Donatello's bronze relief of the *Miracle of the Miser's Heart* for the high altar of St Anthony in Padua, on which he was working during the late 1440s (Fig. 3.6). The great basilica dedicated to S. Antonio was then as now an important site of pilgrimage. Donatello's narrative is drawn from the *Life of St Anthony* by the Paduan author Sicco Polenton (or Polentone).

The miracle occurred when a miserly rich man was being buried with lavish ceremony. St Anthony was moved by a spiritual impulse to shout aloud that the man should not be buried in a sacred place, but outside the city walls like a dog. Citing Christ's words, 'For where your treasure is, there will your heart be also' (Luke 12: 34), he declared that the miser's body was without a heart. When, after much debate, surgeons opened the

miser's chest, they found that his heart was missing. As prophesied by the saint, the miser's heart was duly found with his hoard of money in a chest of the wooden variety.

The story is narrated with Donatello's typically cacophonous urgency. The central event of the opening of the miser's thorax, revealing only a void where the heart should be, is accompanied by an agitated chorus of seething witness, and, to the right, terrified innocents fleeing into their mothers' embraces. The frieze of actors is set within a complex and restless architectural structure that is further agitated by a scattering of gilded and coloured surfaces. The dead man's heart is discovered in a substantial treasure chest. The miser's heart is distinctly heart-shaped in its basic outlines, but Donatello was clearly aware of its asymmetry (Fig. 3.7). At the top are indications of severed vessels and it is suspended from the hand of the saint by a thick tube, presumably the aorta. The sculptor has acquired some knowledge of anatomy perhaps from the witnessing of a public dissection. It is worth recalling that Padua was a leading centre for medical studies.

Fig. 3.6

Donatello, *Miracle of the Miser's Heart*, c.1447–50, Padua, S. Antonio.

Hearts removed from human chests and placed in receptacles of human manufacture had featured prominently in the popular genre of love poetry in the Middle Ages and early Renaissance. One famed author was himself the subject of such a narrative. The Catalan poet Guillem de Cabestan, who died in 1212, was a prominent amongst the *troubadours* whose

stock-in-trade was the affairs of the heart, frequently with much lamenting over the sweet agonies of impossible love. In one poem he evokes the 'lance of love', openly echoing the lance that pierced the side of Christ on the crucifix.

> Let all desire what I wish always,
> The lance of love for the joyous
> That wounds the unprotected heart
> With friendship's pleasant pleasing;
> Yet I have felt such blow's assailing,
> That from the deepest sleep I start.
>
> Let her then show me mercy
> And welcome, despite her grandeur,
> Let me reveal the ill that pains me,
> And how she adds to my dolour,
> Into my heart now drives it further.

In the written account of his life, as much legendary as biographical, his death is attributed to his requited love for Seremonda, wife of the nobleman Raimon of Castel Rossillon. Raimon killed Cabestan in revenge, removing his heart, which he then tricked his wife into eating. Discovering the horror that had transpired, the distraught Seremonda leapt to her death from a high window.

In Boccaccio's *Decameron*, two of the stories told on the fourth day feature hearts removed from the bodies of errant lovers, one of which depends directly on the tale of Guillem. The first tells the story of Tancred, Prince of Salerno, who killed his daughter's lover and presented her with her beloved's heart in a silver bowl. She poured poisoned water over the heart, which she fatally drank.

The ninth story of the fourth day recounts the tale of the troubadour. Boccaccio tells how

> Messer Guiglielmo de Rossilione, had to wife a very gallant beautifull Lady, of whom Messer Guardastagno (forgetting the lawes of respect and loyall friendship) became overfondly enamoured, expressing the same by such outward meanes, that the Lady her selfe tooke knowledge thereof, and not with any dislike, as it seemed, but rather lovingly entertained.

Once Guiglielmo became aware of their love, he killed this friend, and, 'having a keene knife ready drawne in his hand, opened therewith the brest of dead Guardastagno, and taking foorth his heart with his owne hands'.

Guigliemo had his cook prepare a tasty dish from the heart:

> The Lady having a good appetite indeede, when she had first tasted it, fed afterward so heartily thereon, that she left very little, or none at all remaining. When he perceived that all was eaten, he said unto her: Tell me Madame, how you do like this delicate kinde of meate? In good faith Sir (quoth she) in all my life I was never better pleased. Now trust mee Madame, answered the Knight, I do verily beleeve you, nor do I greatly wonder thereat, if you like that dead, which you loved so dearly being alive. When she heard these words, a long while she sate silent, but afterward saide. I pray you tell me Sir; what meate was this which you have made me to eate? Muse no longer (saide he) for therein I will quickly resolve thee. Thou hast eaten the heart of Messer Guiglielmo Guardastagno, whose love was so deare and precious to thee, thou false, perfidious, and disloyall Lady: I pluckt it out of his vile body with mine owne hands, and made my Cooke to dresse it for thy diet.

We know the consequences of the knight's dreadful deed.

An early example of a heart in an actual casket survives in the Cloisters of the Metropolitan Museum in New York—albeit one that is painted rather than flesh-and-blood (Fig. 3.8). It was made in Germany and dates from the early to mid-fourteenth century. The inner surface of its lid exhibits a central heraldic crest flanked by scenes of a pretty young man whose heart has been conquered by an elegant lady, probably Frau Minne, the German Goddess of Love. On the left she wounds the young man with an arrow from Cupid's bow, while on the right he presents her with his comprehensively pierced heart. An inscription records his lament that 'my heart is wounded'. The casket was probably made as a gift on the occasion of a betrothal or marriage. It is not too hard to imagine a courtly viewer sensing uneasy parallels with poetic hearts removed from dead lovers' bodies. The top of the heart itself is gently concave rather than pronouncedly indented. Representations of lovers presenting their disembodied hearts seem to have become common in the fourteenth and fifteenth centuries, although secular objects and decorations only survive

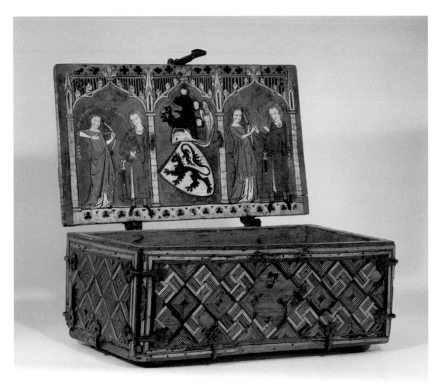

Fig. 3.8

Casket with armorial
shield and two scenes of a
young man as the victim
of love, c.1330, New York,
Metropolitan Museum.

in relatively few numbers. The depicted hearts, like that on the German
casket, do not infallibly adopt the heart-shape as the standard form.

The social and literary contexts of courtly love, which came to be cen-
tred upon a series of chivalric narratives—not least the extraordinarily
widespread legends of the English King Arthur and his valiant knights—
also provided the earliest setting for Western playing cards, with their
now famous suits of hearts, diamonds, clubs, and spades. Early cards were
not the mass-produced printed commodities with which we are familiar
today, but were hand-drawn, hand-coloured, and costly. The 'face' cards
came to represent courtly subjects—kings, queens, knaves (male courti-
ers), and jokers—and the early players belonged to the upper stratum of
society.

The earliest definite references to playing cards in Europe, following
their apparent introduction from the Middle East, date from the 1370s. An
account by a German monk, Johannes, apparently dating from 1377, tells
us that 'the game of cards came to us in this year ... In which the game

the state of the world as it is now is excellently described and figured'. There were wide national and regional variations in the number of cards, the names and symbols of the suits, and the figurative images. By the late fifteenth century the French suits had become those with which we are familiar—hearts, diamonds, spades, and clubs—all of which have courtly or chivalric connotations. Spades, for example, were named from the Italian *spada* (sword). The court or face cards were sometimes inscribed with the names of famous men and women from classical antiquity (such as Pallas, Alexander, and Caesar), from the Bible (such as David and Judith), and from more recent history (such as Charlemagne and Lancelot). Early

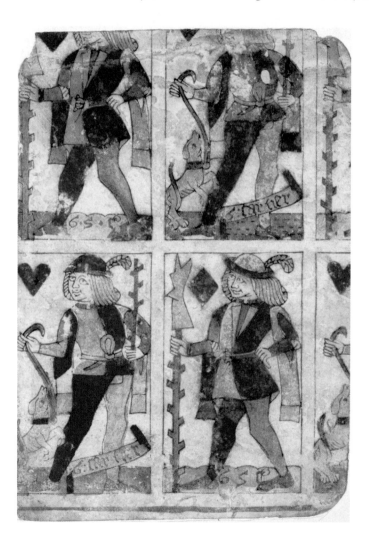

Fig. 3.9

Knaves of hearts and diamonds, uncut cards, French, c.1490–1500, London, Victoria and Albert Museum.

packs of cards or even incomplete packs rarely survive, and, if they do, their dating is problematic. Knaves of hearts and diamonds (later called Jacks) from an uncut French printed and hand-coloured set probably from the late fifteenth century are depicted as dashing young courtiers (sometimes identified with the French fifteenth-century military leader La Hire) (Fig. 3.9). The jack of hearts is labelled 'G: Cartier', probably indicating the card maker, Gilles Savouré. The advent of printed cards of this kind certainly played a role in the schematizing and standardizing of the heart symbol, not only within the card games themselves but also more generally in promoting the heart-shape as the stock pictogram, especially in France, Germany, and Britain.

Again we are faced with a situation in which the codification of the heart-shape is of a less certain date than we might like, but the evidence of the playing cards points to the later fifteenth century. The story of the Sacred Heart, as we will see, points in a similar direction.

Sacred Hearts and Wounded Virgins

Shortly after 1500, one extraordinary philosophical text brings together the literary, chivalric, medical, and religious traditions to produce what is the most telling of the early heart-shaped hearts within a human chest. This occurs in Gregor Reisch's popular compendium of universal wisdom the *Margarita philosphica* (Philosophical Pearl), published in 1503. Reisch was a prominent Carthusian monk who served as confessor to the Emperor Maximilan. His 'encyclopedia' aspires to embrace a notably extensive range of learning across the liberal arts and natural philosophy as taught in the universities. In the section on 'Friendship', quoting such authorities as Plato and Cicero, he shows a man demonstrating the seat of his loving feelings (Fig. 3.10). The smiling protagonist gestures to his open chest which contains a pretty little heart located on his right rather than his left—probably in deference to conventional location of the lance-wound inflicted on Christ at his crucifixion. The wound had come to be interpreted as piercing Christ's heart, releasing a fountain of sacred fluids, as we will see.

It was the Christian tradition of the worship of Christ's loving and re-demptive heart that became decisive in consolidating the iconic shape that we now take for granted. Christ's 'Sacred Heart' became one of the most central images in Christian devotion, particularly in popular

pponenda eſt/nihil em eſt tam naturæ aptū tamꝗ cōueniens ad res ſe
cundas vel aduerſas ꝗ amicitia. Illas ac pleraſꝗ alias amicitiæ ꝓprie
tates antiquius apud Romanos pictura amicitiæ demōſtrabat. DI.
Cuiuſmodi꞉ MAG.Depingebat iuuenis forma/diſcoopta capite ꝷꝑꝰ amí
ꝗ erat tunica rudi induta:in cuiꝰ fimbria ſcriptū erat Mors & Vita:in ꝗuæ
fronte ꝑ ſtas & hyems꞉habebatꝗ latus aptū uſꝗ ad cor:& brachiū in
clinatū/digito cor oſtendens.ibi ſcriptū erat lōge & ꝓpe. DI.Ediſſere
ꝗueſo ſingulorū ſignificationē. MAG.Forma iuuenilis indicat ami
citiam ſemꝑ recentē꞉nullaꝗ tꝓis diuturnitate tepeſcentē.Nudū caput
ut oībus pateat/& amicus nullo unꝗ tꝑe amicū ſuū publice cōfiteri
erubeat. Rude aūt indumentū/oſtendit ut amicus nulla ardua/extre
maꝗ inopiam pro amico ſubire nō recuſet. Vita & mors in veſtimē
to ſcribunt/nam qui vere diligit uſꝗ ad morte amat. Eſtas & hyems
quia & in proſperis & in aduerſis eque Amicitiā ſeruat.Latus apertū
habet uſꝗ ad cor ꝗa ni
hil amico celat.Brachiū
inclinat & digito cor oſt
endit: ut opus cordi/&
cor Ꝫbis correſpōdeat.
longe & prope ſcriptū
eſt ꝗa vera amicitia nul
lo tꝑe aboleſ / nullaꝺe
locoꝛꝯ intercapedine ami
cū ſeparat. DI. Brūs ꝗ
per ome viuendi ſpaciū
ꝛaliuſmodi amicus ade
ꝛit. MAG.Eregione
vero miſer ſolus ab om
ni fideli ſocietate alienꝯ
nam ut ait Valeriꝯ ma/
ximus.li.4.Deſerta eſt
vta hoıs꞉nullius amicı
ꝛiæ cincta ꝓſidio.& Se/
neca ad Lucillū.Nulliꝰ
boni ſine ſocio iocūda
eſt poſſeſſio. DI.ma
nifeſta ſunt hæc꞉ad reli
qua ꝓꝑemus. MA
Affabilitati vicina eſt.
Eutropelia꞉medium in
iocoſis verbis vel factis
cōſtitues . magis tamē
ꝓprie tēperāꝷ coheret
ideo tractatū illius in eū

Valerius

Seneca

Fig. 3.10

Friendship, from Gregor Reisch, *Margarita philosophica*, Freiburg, 1503.

Catholic depictions of Christ in the printed media. It was complemented by devotion to the Virgin Mary's 'Immaculate Heart', which followed in its train. Christ's heart provided the titular dedication of numerous churches across the world, most famously that of the monumental Sacré Cœur that plays such a notable role in the skyline of Paris.

The origins of the cult lie with a series of mystical texts from the eleventh century onwards, best exemplified by the *Vitis mystica* (the *True* or Mystic *Vine*), formerly attributed to St Bernard of Clairaux but now generally ascribed to the Franciscan St Bonaventure. Christ's heart is one of the ecstatic high points in the author's spiritual journey.

> 'Thou hast wounded', says the Spouse in the Canticles of love, 'thou hast wounded my Heart, my sister, my spouse'. O Lord Jesus; Thy spouse, Thy love, Thy sister has wounded Thy Heart. Why then was it necessary that that Heart should be wounded further by Thine enemies? What do ye, O enemies? If the Heart of our sweet Jesus is wounded, yea because it is wounded, why do ye add a second wound? Know ye not that a heart touched with a single wound dies and becomes insensible, and the Heart of our Lord Jesus is dead because it is wounded? The wound of love, the death of love has taken full possession of Jesus, our Lord and Spouse. How shall a second death find entrance? Strong as death, yea, even stronger than death, is love. For the first death, that is, the love which puts to death deadly evils, cannot be driven out of the citadel of the heart which He hath purchased for Himself by an inviolable right with His own Blood.

The physical wound inflicted in Christ's side by Longinus' thrusting lance becomes the portal through which we enter into his love: 'For this cause was Thy side pierced, that an entrance might be opened for us. For this was Thy Heart wounded, that in it and in Thee we might dwell secure from exterior troubles.' The gash also becomes the source for the fountain of blood and sustaining water that was described as emanating from Christ's side. A legend of St Catherine of Siena, one of whose visions described her mystic marriage to the Saviour, recounts how Jesus instructed her to

> 'drink . . . from the liquid of my side, and it will fill your soul with such sweetness that its wonderful effects will be felt even by the body which for my sake you despised'. And she, finding herself thus near to the fountain of life, put the lips of her soul, over the most holy wound, and long and eagerly and abundantly drank that indescribable and unfathomable liquid.

This remarkable episode, with an unmistakable erotic charge, seems to have been so extreme as to make its way into art only rarely, although in

a panel painted in 1460–1 by Giovanni di Paolo in the Metropolitan Museum in New York the saint dramatically presents her own bleeding heart to Jesus.

St Catherine is one of a series of holy virgins whose miracles played a major role in the cult of Christ's heart. A particularly good example is St Clare of the Cross (Sta. Chiara of Montefalco), a deeply pious abbess who experienced a vision in which Christ agonizingly implanted his cross in her heart. After her death in August 1308, her corpse remained unputrefied for five days, and the nuns decided that her body should be embalmed. In preparation they removed the viscera, and placed Chiara's cherished heart in a casket. A day later Sister Francesca of Foligno opened both the casket and the heart, finding within it a small crucifix formed from her heart muscle. Subsequent dissections revealed other tiny representations of the symbols of the Passion: the crown of thorns, whip, column, rod, sponge, and nails. News spread rapidly and the heart and its miraculous contents became objects of fervent devotion. They were recorded in a simple print as a memento for pilgrims (Fig. 3.11), and are now splendidly housed in a baroque reliquary.

The holy virgin who played the most significant role in the consolidation of the cult in its modern form was the French nun Marguerite Marie Alacoque, who died in 1690. Marguerite, racked with guilt about the sins

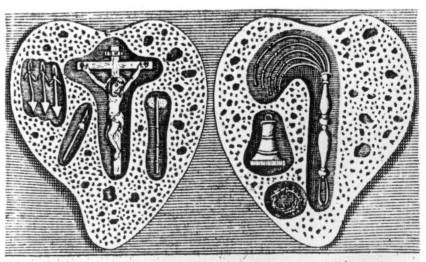

Fig. 3.11

The Heart of St Clare of the Cross with the Symbols of the Passion, woodcut, c.1600.

Cum Clara pectus explicat.
Fulget Crucis myfterium.

of her flesh, scourged her body and humiliated her soul in ways that are terrible to describe. She experienced a series of visions of Christ in which he required her to promote the true worship of his heart.

Her fraught communions with Jesus were recorded by Father de la Colombière, who effectively promoted her fame and advocated worship of the Sacred Heart. On one occasion in 1673, Margeurite recounted that

> Jesus Christ, my sweet master, showed himself to me, shining with glory. His five wounds were brilliant like suns, and flames burst forth, on all sides from this sacred humanity, but especially from his adorable breast; and it opened and I beheld his most loving and most beloved heart, which was the living fountain of his flames.

Christ takes Marguerite's heart and places it within his own, where it is transformed into 'a little heart-shaped flame'. Replaced in her body, her heart consumes her perpetually with sacred fire. The Sacred Heart emitting flames of holy fire became a standard motif.

The renown of Marguerite Marie and the cult of the Sacred Heart spread irresistibly in the domain of popular devotion, but was rather reluctantly given fully official status by the Vatican. The culmination of the campaign to promote the cult only came in 1899 when Leo XIII consecrated every person to the Sacred Heart.

The standard form for the heart in religious art from the fifteenth century was heart-shaped. One remarkable manuscript illumination shows not the crucified heart of Christ but of a woman who represents 'vain pleasure' and whose soul is subject to extreme mortification (Fig. 3.12). As such it provides an early visual counterpart to Marguerite's self-scourging. The sword of 'Divine Justice' presides over the presentation of the woman's nailed heart by ladies representing Fear of God and Contrition (who holds a birch-brush scourge). The author, René d'Anjou, recounts how the woman, Soul, witnessed 'her evil heart' nailed to the cross and bleeding profusely. She cries out, 'What is this that you have brought me, stretched here on this cross, bleeding thus, dejected and beaten, bare and quiet. Is it my heart?'

More usually the red and bleeding heart is that of Christ. A French Book of Hours displays the crucified heart of Christ surrounded by a crown of thorns and brutally wounded by what appear to be three nails and the head of a spear. The image is designed to provoke meditation on

Fig. 3.12

Barthélemy d'Eyck,
'Contrition and Fear of
God Return a Purified
Heart to Soul', from René
d'Anjou, *Le Mortifiement
de vaine plaisance*,
1455, Bibliothèques,
Médiathèques de Metz.

the nature of Jesus' suffering on behalf of mankind and the supreme love of his sacred heart (Fig. 3.13). It depends on the kind of mystic imaginings that we encountered in the *Holy Vine*.

As devotion to the Sacred Heart grew with a popular life of its own, so imagery appeared in every kind of medium. Particularly inventive is Antonius Wierix's suite of engravings of a human heart with a stylized aorta that acts as a divine chimney for the entry of the Holy Spirit. Wierix was working in Catholic Antwerp. At the start of the series we see the child Jesus, spiritually radiant, seeking entry through the portal of the believer's heart (Fig. 3.14), which in a subsequent print he subjects to a thorough cleansing. He also sleeps in the heart as the *Salvator mundi* waiting to perform his role as the believer's spouse. The heart, thus fortified, then resists the assaults of devils and worldly ostentation. With Jesus' help, the believer's heart models itself on that of the Saviour in an act of holy imitation.

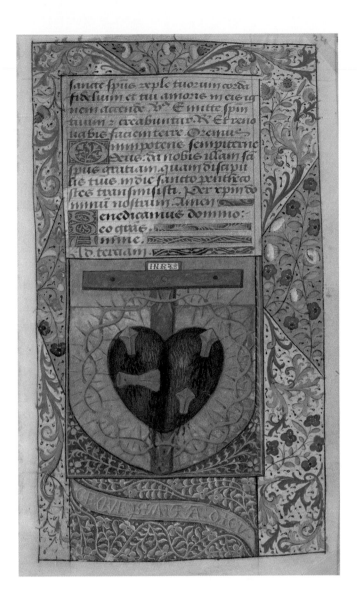

Fig. 3.13

The Sacred Heart from a
Book of Hours, c.1490, New
York, Pierpont Morgan
Library, MS M.7, fo. 24r.

During the course of the eighteenth, nineteenth, and twentieth centu-
ries the Sacred Heart displayed in or on Christ's breast has become one of
the most popular of all devotional images. It appears in almost every con-
ceivable form. We can, for instance, arrange for our 'yard' to be decorated
by the company Peace of Concrete with a series of predominantly Chris-
tian garden sculptures and accessories. A hand-painted concrete sculpture
of the Sacred Heart, 26 inches high, is available for $128.00. Jesus points

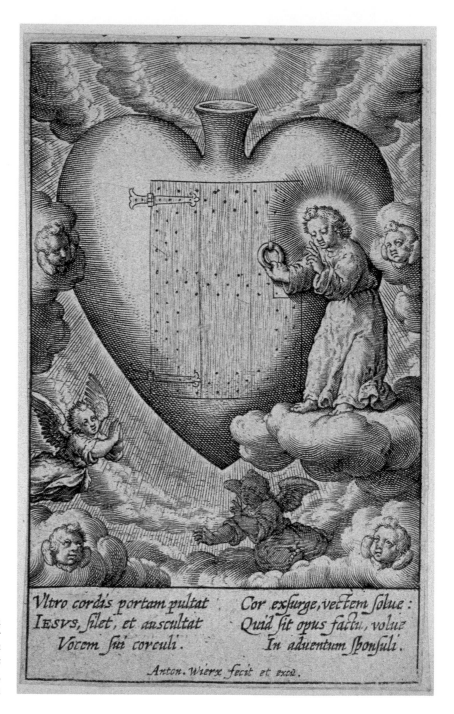

Vltro cordis portam pultat
IESVS, silet, et auscultat
Vocem sui corculi.

Cor exsurge, vectem solue:
Quid sit opus factu, voluz
In aduentum sponsuli.

Anton. Wierx fecit et exca.

Fig. 3.14

Antonius Wierix, *On
Other Side of the Door Beats
the Heart of Jesus*, c.1600,
London, Wellcome Library.

emphatically to his vivid red heart, fringed with rays of light and emitting holy fire. The heart is perhaps less overtly heart-shaped than we might expect, but at this late date approximation will work well enough.

Love Hearts

Even more ubiquitous today than the Sacred Heart is the secular heart of love associated with Valentine's Day on 14 February. Although the day is that of the Christian saint Valentine, the sending of 'Valentines' has become a huge popular and commercial bonanza that has largely lost any religious dimension. That dimension was always obscure in any event.

Valentine is supposed to have been a martyr of the early Roman Church, but hard evidence is absent. This did not stop the later construction of a skeletal 'biography'. The *Golden Legend* tells us that St Valentine was 'a friend of our Lord and priest of great authority' who deeply impressed the Emperor Claudius in Rome before he was martyred by his enemies. Even Jacobus da Voragine could make little out of Valentine's thin legend. And there is no reason to associate him with romantic love.

The earliest clear associations take us back to familiar chronological territory in the late Middle Ages, and most specifically to Geoffrey Chaucer in England in the fourteenth century. In his lyrical *Parliament of Foules* (or *Fowls*), written about 1382, Chaucer tells us that St Valentine's Day held a special significance for birds. 'Nature' addresses her feathered flocks: 'Birds, take heed of what I say; and for your welfare and to further your needs I will hasten as fast as I can speak. You well know how on Saint Valentine's Day, by my statute and through my ordinance, you come to choose your mates, as I prick you with sweet pain, and then fly on your way.' Chaucer implies that this was an annual tradition—at least in the world of birds—but the notion of a regular annual celebration may be more of a literary device than a reality.

Whether traditional or not, the association of St. Valentine's Day with the finding of a mate entered into wider currency. On 14 February 1477 Margery Brews wrote to her 'right well-beloved Valentine John Paston squire'. Her fiancée belonged to a prominent Norfolk family, whose early correspondence has exceptionally survived. Margery begins, 'Right reverent and worshipful and my right well-beloved valentine, I recommend me unto you full heartedly, desiring to hear of your welfare, which I beseech Almighty God long for to preserve unto his pleasure and your hearts

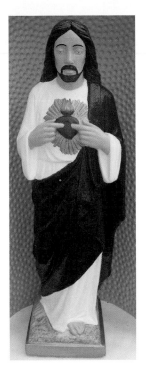

Fig. 3.15

Peace of Concrete Company, *The Sacred Heart*, concrete, hand-painted, 2010.

desire'. There follow a few fervent lines, and she expresses her regret that her dowry will not be increased by her father. She ends, 'And this letter was written at Topcroft with a full heavy heart'. Topcroft Hall, an important Norfolk house with a double courtyard, no longer exists.

So 14 February became a day for presenting gifts and flowers to one's beloved, but the sending of cards specifically adorned with heart-shapes seems not to have become an annual practice until the later eighteenth century. An early and delightful hand-made example is in the British Postal Museum (Figs. 3 and 3.16). Dating from 1790, inscriptions run around a bold red heart: 'My dear the Heart which you behold, | Will break when you the same unfold, | Even so my heart with lovesick pain, | Sore wounded is and breaks in twain.' The card unfolds in a complex sequence of moves, literally breaking the red heart to reveal more extensive versifying within, beginning, 'My dearest dear and blest divine, I've pictured here thy heart & mine'. Such wonderfully basic rhymes suggest that a professional poet was not involved.

During the next century both printed and hand-made cards escalated in numbers and elaboration—becoming ever more florid, ever more lacy, ever more lavish in materials (either real or illusory), and ever more cliched in poetic sentiment. Real, or more often pretend anonymity was the name of the game, providing a covert strategy for those who were too shy, too nervous, or too lacking in confidence to declare their sentiments openly to the subject of their affections. Anonymity also potentially facilitated declarations of love across class or racial boundaries, often in the realization of the hopelessness of the situation. Hearts were not obligatory on Valentine cards—and have become increasingly redundant in the kind of joke cards that have proliferated in recent years—but they have been the stock-in-trade of the designer's art. Countless millions of disembodied hearts have been gifted to lovers over the years in much the same spirit as the young man handing over his heart on the lid of the Medieval German casket. The basic instincts of love and our sense of the somatic centre of our feelings goes beyond cultural specifics.

The heart-shape as a logo has also invaded graphic art worldwide via the famous promotion campaign 'I ♥ NY—'I love New York'—initiated in 1977. The New York State Department of Economic Development commissioned the Wells Rich Greene advertising agency to mount a promotional campaign for the city. The simple rebus—which like many of the most compelling pieces of invention seems obvious after the event—was

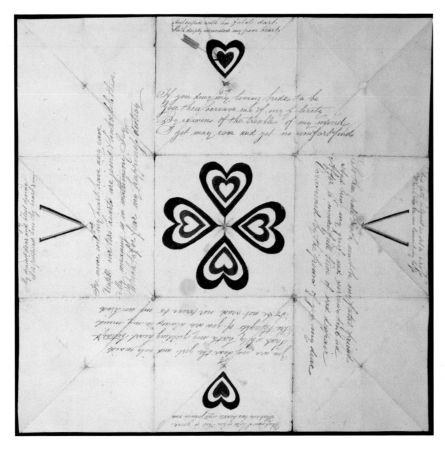

Fig. 3. 16

Puzzle Valentine card, in
its fully unfolded state,
1790, London, British Postal
Museum.

conceived by Milton Glaser, the truly great and humane graphic designer
(Fig. 3.17). The round ends of the serifs of the slab typeface perfectly com-
plement the heart-shape, while the boldness of the body of the letters is
playfully assertive without being overtly aggressive. Working to a budget
of about $1,500, Glaser handed over his invention with no idea that it
would enjoy such an enduring life—both in New York and more widely as
a prototype for innumerable 'I ♥ . . .' this or that. New York has taken legal
action to protect its logo from plagiarism, but the design has irrevocably
escaped into the public domain. In one guise or another it has adorned
T-shirts and various kinds of merchandise to such an extent that it can be
considered the COKE bottle of graphic design.

Walking in Blenheim park I saw a man wearing a T-shirt that stated, 'I ♣
Boston.' 'I club Boston'? This is just a bit too smart. I cannot make out what
it means. 'Ah', a friend remarks, 'I wonder if it is a shamrock and related

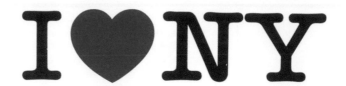

to the Basketball team, the Boston Celtics.' I find that the Celtics have a 'Shamrock Foundation' for community activities. The three leaves of the shamrock are lobed in a way that the club symbol is not, but I imagine the Boston-Irish shamrock is the answer to the iconographical puzzle.

What we have witnessed in our survey of heart-shapes in medical, poetic, religious, and commercial contexts is a picture of unclear, untidy, and multiple origins in the late Middle Ages, followed by an irresistible if gradual ascent from the seventeenth century onwards. It may be the hybrid origins that have helped to give the heart-shape its genetic stamina over the long term. It is also, of course, a shape that is appealing in its simple yet seductive rhythm, and once seen it is difficult to forget. It is like the melody of a great pop song.

The Tin Man

Talking of pop melodies . . . I think it will be fun to end by reminding ourselves of one of the classic heart songs. It comes from *The Wizard of Oz* in 1939, the American musical directed by Victor Fleming and based on the children's novel by L. Frank Baum. The story concerns the 12-year-old Dorothy Gale who is knocked unconscious by a tornado. She awakes in the Land of Oz, where she meets a heartless Tin Man, a brainless Scarecrow, and a timid Lion. She leads them on a quest to the Wizard of Oz to find a heart for the Tin Man, a brain for the Scarecrow, courage for the Lion, and a way home for Dorothy herself. Along the Yellow Brick Road, the Tin Man, looking like a cross between a knight in armour and an assemblage of baked-bean cans, clanks his way through his big number, 'If I Only Had a Heart'. It begins, 'When a man's an empty kettle, | He should be on his mettle . . .' He ends by yearning 'Just to register emotion, jealousy, devotion . . . If I only had a heart.'

The Tin Man does, of course, after sundry adventures and alarming excursions, receive his cherished heart, which is red, shiny, and heart-shaped.

Inset within it is a clock. With his new 'ticker' he can now be human, for better or for worse.

Reading

The bibliography for the cultural history of the heart is vast. The books by Bound Alberti, Dietz, Høystad, Peto, Vinken, and Young will serve as ways into the range of literature.

http://postalheritage.org.uk/ no. OB1995.263, for the Valentine card.

For the early poetry see A. S. Kline's website: http://www.poetryintranslation.com

'Vitis mystica', or, the True Vine, ascr. to S. Bernard. trans. W. R. Bernard Brownlow, London, 1873.

F. Bound Alberti, *Matters of the Heart: Locating Emotions in Medical and Cultural History*, Oxford, 2010.

S. and T. Amidon, *The Sublime Engine: A Biography of the Human Heart*, New York, 2011.

G. Beale, *Playing Cards and their Story*, London, 1975.

G. Boccaccio, *The Decameron*, trans. J. Payne, New York, 1895.

A. Dietz, *Eine Kulturgeschichte des menschlichen Herzens*, Munich, 1998.

M. Glaser, *Art is Work*, Woodstock, NY, 2000.

O. Høystad, *A History of the Heart*, London, 2007.

G. Johnson, 'Approaching the Altar: Donatello's Sculpture in the Santo', *Renaissance Quarterly*, 52, 1999, pp. 624–66.

J. Oruch, 'St. Valentine, Chaucer, and Spring in February', *Speculum*, 56, 1981, pp. 534–65.

K. Park, 'The Criminal and the Saintly Body: Autopsy and Dissection in Renaissance Italy', *Renaissance Quarterly*, 47, 1994, pp. 1–33.

J. Peto (ed.), *The Heart*, London, 2007.

K. Roberts and J. Tomlinson, *The Fabric of the Body*, Oxford, 1992.

J. Taylor (ed.), *Journey through the Afterlife: Ancient Egyptian Book of the Dead*, London, 2010.

P. J. Vinken, *The Shape of the Heart: A Contribution to the Iconology of the Heart*, Amsterdam, 2000.

Paul Watson, *The Garden of Love in Tuscan Art of the Early Renaissance*, Philadelphia, 1979.

L. Young, *The Book of the Heart*, London, 2002.

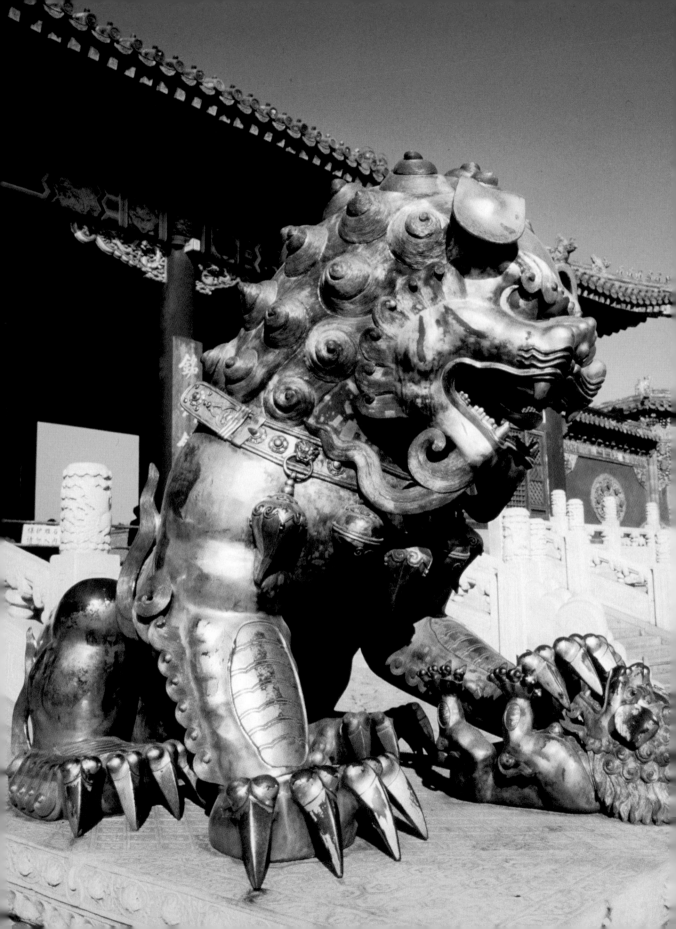

4

The Lion

CLUTCHING OUR LITTLE TICKETS OF STIFFISH PAPER, my schoolfriend and I file past soft-focus posters of screen lovelies with 'authentic' signatures and into the narrow stairwell with its frayed carpet. A uniformed attendant neatly halves the tickets with a twist of thumb and finger, and we step gingerly into the gloom of the auditorium—there is that familiar perfume of dust and farts, with a hint of metal polish. The B movie, in black and white, is already playing. Some kind of police story with a posh detective and chirpy cockney criminals. A cockerel then crows about the news, brought to us by Pathé. Next comes Pearl and Dean. A large totalitarian temple-cum-portico atop a mighty bank of steps looms up, accompanied by trumpeting music of a bombastic confidence that would

■ Guardian lion at the Gate of Heavenly Purity, c.1655, Beijing, Royal Palace.

have suited Hitler as much as it now suits John Wayne. A series of short commercials follows, ranging from fancy ones about Coca-Cola to homemade plugs for Imperial Buses of Windsor. The build-up is as thrilling as, perhaps more so than, the main feature that is shortly to come. Will it be the sweaty man with a big gong or the snarling lion?

The lion's maned head appears, in a roundel of film strips that float away left and right in the scrolled form of cartouches (Fig. 4.1). Below the lion is an African-style mask with a heart-shaped mouth and some vaguely exotic vegetation. 'Metro Goldwyn Meyer'; the name is the very essence of Hollywood. 'ARS GRATIA ARTIS'; that is a puzzle for a 10-year-old who has yet to encounter schoolboy Latin. The mighty lion turns its head and snarls, not quite a full roar. The second of the three snarls is only a little more emphatic. I am a little disappointed that the lion's demeanour is not more savage.

The enduring MGM logo had been designed for Sam Goldwyn by Howard Dietz, publicist and prolific writer of lyrics. Dietz was an alumnus of Columbia University in New York, whose sports teams had adopted a lion as their logo. The Latin motto means 'art for art's sake', and had served as a slogan for a nineteenth-century art movement dedicated to the autonomous worth of art as elevating ideal in its own right. The apparent aesthetic idealism is rendered ironic by the bold letters asserting that the logo is a 'TRADE MARK'.

Fig. 4.1

Metro Goldwyn Meyer logo, 1950s.

Breaking news in November 2010 tells us that MGM now has debts of over $4 billion, and has come to a bankruptcy agreement with debt holders that is designed to rescue a restructured version of the company. The item on the BBC news specifically refers to the growling lion, no doubt because this is likely to trigger sharper memories than the initials MGM.

It turns out that a good deal of coaching had gone into the snarls of successive lions. It is difficult to reconstruct precisely which of the five successive lions is the one that I recall. Perhaps it was Tanner who was used for the colour films in the 1950s, but there seems to be some confusion about the names of the various lions, and one of Tanner's framed performances involved a fuller roar. Perhaps I have conflated a number of slightly different logos.

The best documented lion was called Slats, who seems to have been the first so employed. Slats made the transition from the silent era to become the first of the 'talkie' lions. He was owned and coached by the famous trainer Volney Phifer, who had specifically orchestrated Slats to emit a growling snarl. Presumably a full-out roar would not have conveyed the air of regal majesty, of authority expressed firmly but with a certain degree of arrogant restraint. Or maybe Phifer judged that it was just too dangerous to record a lion that had been provoked into real anger (Fig. 4.2). After

Fig. 4.2

Slats the lion being recorded for MGM.

a peripatetic career and retirement at the Philadelphia Zoo, Slats was buried in Phifer's garden in Gillette, New Jersey, under a neat headstone (now removed). It seems that before burial in 1936, Slat's pelt was made into a rug, which is now on display in the McPherson Museum in Kansas. The worrying number of 'seems' in this account is symptomatic of a relatively recent history in which hearsay and legends decisively outnumber facts.

My schoolfriend and I had no difficulty in recognizing what the lion meant and why he was there. He was, after all, the 'king of the beasts'. What we did not know was that the notion of the lion's regal status was as old as documented culture itself, and that there have been few regimes that knew (directly or indirectly) of the lion that have not made some use of its image to represent power. The lion has been a very political beast, but he has also been a very metaphysical one, incorporated into systems of astrology and accorded the status of a divinity. Not infrequently the political and the metaphysical have merged. Its only universal rival from the animal kingdom is the eagle, much loved by kings and emperors, but the mighty bird features less regularly in a high metaphysical guise.

Part of the lion's hold on us lies in the facts of its life. It is the second largest of the great cats, after the tiger, and commands its territory without serious rival. It is a great but disciplined hunter. But its true grip on our imaginations comes from something less tangible. Its muscular walk, slow and supple, its luxuriant mane, its shapely head, all strike some kinds of deep-seated chords. We seem to 'feel' its personality. It moves with a swagger, though without excessive arrogance, well aware of its unchallenged status. Its head, which we know is equipped with fearsome teeth, seems when at rest to be endowed with a benign expression suggestive of mature wisdom. Such subjective readings are of course without secure foundation, relying upon what I have called the 'physiognomic fallacy', but it is something that we are equipped automatically to do. There is clearly much evolutionary advantage to be gained from reading the likely behaviour of someone or something we encounter. Perhaps those of us who have over the generations only encountered lions in captivity have lost too much of the frisson of fear that the lion's appearance should trigger. In any event, the meaning of the lion across diverse cultures has depended more commonly upon its air of sage and courageous regality than the reality of its savage wildness.

The very ubiquity of the lion as an iconic beast renders an even-paced survey impossible here. My tactic is to select some international examples

that have in themselves become notably famous outside their immediate cultures. Western uses of the iconic image again predominate, not through force of numbers but through the rich textual sources that document the diversity of meanings.

Mistress of Dread

Ancient Egypt was first visual culture we know to have combined highly developed modes for the representation of nature in diverse ways, elaborate symbolic languages, and intricate visual narratives, placed in the service of complex social and religious structures. Egyptian imagery is replete with lions. Leonine deities played starring roles in the Egyptian pantheon, both in their purely animal form and in the familiar human–lion hybrids. Such fusions of human and animal bodies go back to the very beginnings of image-making in the Palaeolithic period. The sphinx, with the body of a recumbent lion and upright human head, is the best known of the Egyptian hybrids, and the enormous Great Sphinx of Giza is justly an iconic image in its own right. Less well known today but of immense and enduring significance to the Egyptians was the lion-god Aker who guarded the eastern entrance and western exit of the sun. During the night the sun made its underground passage in the reverse direction. Egyptian art presents many choices for a potent image of a lion. The one I have selected is something of an exception in this book as a whole. Sekhmet is female. She is also notably threatening, and her name means 'the powerful one'.

Sekhmet (or Sakhmet) began her divine existence as the military goddess of the triumphant kingdom of Upper Egypt. Over the long course of the dynasties she assumed various roles and aspects, but at heart she was always to be feared. She was the 'Mistress of Dread', to be cultivated by warlike kings and to be propitiated at the end of battles. She exacted punishment and fomented pestilence, but her priests were able to invoke her powers to bring caring medicine to the people. Her dress in paintings was an appropriate blood red. In one of the later transformations of her myth she became associated with a licentious festival driven by the alcohol that had tempered her severity when it looked as if she might destroy all mankind.

Her best-known images are carved in dark stone, and show her majestically enthroned (Fig. 4.3). Above her head she often bears the disc of

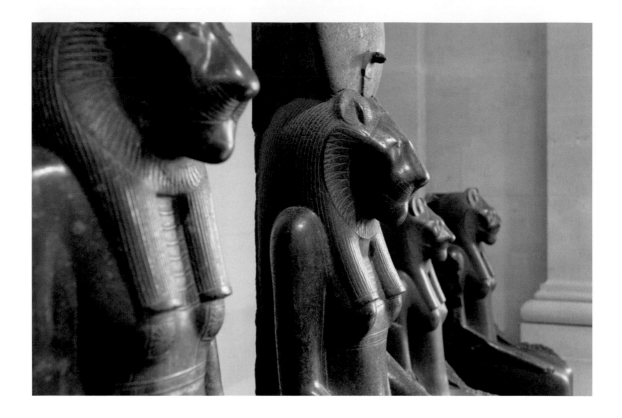

Fig. 4.3

Ancient Eygptian statues of
Sekhmet, from the Temple
of Mut at Thebes, black
granite, c.1400 BC, Paris,
Louvre.

the sun, as a solar deity, together with the cobra emblem that denotes her regal status. In her left hand she typically holds the Ankh cross, with its looped upper arm, which is the famed symbol of eternal life available only to gods. Her head is that of a lion, or perhaps we should say a lioness. However, the mane of hair that effects the transition of the lion's head onto her clearly female torso is closer to that of the male. The biological distinction was probably not of concern to the ancient Egyptians when they were portraying their dangerous goddess. If we play the physiognomic game we might say that she is portrayed in the statues as implacable but perhaps open to propitiation.

A large number of very similar statues survive. Two factors led to this proliferation. One was the requirement that priestesses pay obeisance to a different statue on each day throughout the year. The other was the commission by Amenhotep III of 600 or more statues for the precincts of a temple south of Karnac dedicated to the major goddess Mut. The serial repetition of Sekhmets must itself have been very compelling, possessing

a ritual and incantatory quality. Both individually and collectively the statues of the seated lion goddess possess a haunting power, even for visitors to the museum who know little or nothing of her ancient powers.

Guardians of the Gate

Lions are no less ubiquitous in Chinese visual culture across every kind of medium, including dance. Chinese lions were deeply associated with Buddha as one of his traditional attributes, much as St Mark is often accompanied by or represented by a lion. In a familiar image of Buddha, he is seated on a lion throne that boasts carved lions at the angles of its dais.

It would be a massive task to look at the use of the lion and of leonine creatures in China across the ages in all media and on all scales. My focus will be sculptural and large scale, in keeping with the general strategy in this chapter. The most prestigious of the large Chinese lions were those who performed the role of guardians. Endowed with great protective powers, they appeared early as the third century BC but became especially prominent in the Ming (1368–1644) and later dynasties.

Lions were not native to China but became prized possessions of emperors, often received in tribute. The availability of real lions did not mean Chinese lions were rendered in a naturalistic manner. Rather like Albrecht Dürer's famous woodcut of a rhinoceros, the Chinese images of lions embody the essence of the animal's perceived nature rather than reflecting its literal appearance. The transformative powers of art transport the image of the lion from living nature into the higher realm of concepts. The lion was regarded mythologically as the eighth oldest of the nine sons of the dragon. Dragon-like features were therefore appropriate. Even though their forms and roles varied over the centuries, Chinese sculpted lions were always radically transformed into magnificent heraldic beasts. The most assertive of the lions, like the majority of the others in the chapter, are sculptural, large scale, expensive, and outdoors.

The Ming dynasty undertook huge building campaigns and generated a great deal of large-scale sculpture. Most famously, the Great Wall was consolidated into its definitive form. Successive emperors and their ancestors were buried in tomb complexes resembling walled townships. Approaches to the tombs and key buildings are guarded by impressive arrays of real and mythological beasts—although the distinction between real and mythological is less clear than such a stock classification might

suggest. The taste for guardian lions was established when six pairs of lions were sculpted to protect the tombs of the ancestors of Emperor Hongwu (Zhu Yuanzhang, 1368–98), whose bodies were re-interred in spectacular style, having been removed from their original and less grandiose resting places. Arrays of lions commonly flank the 'Spirit Paths' that lead to the massive mausoleums of successive emperors. Their style during the later Qin dynasty (from 1644) becomes increasingly extravagant.

In the vast complex of the Royal Palace in Beijing (formerly called the 'Forbidden City'), established in the early fifteenth century and subject to sustained building campaigns over successive centuries, there are six pairs of magnificent lions acting as declamatory gate-keepers. They stand guard at the gates of Supreme Harmony, Heavenly Purity, Peace, Longevity, and Mental Repose, and at the Gate of Nourishing that leads to the Hall of Mental Cultivation (the emperor's regular hall) and to the Palace of Eternal Spring (the residence for the queen and concubines). They differ in very subtle ways, according to their location in outer or inner zones of the complex. The innermost ones tend to be somewhat less overtly fierce. The pair in gilded bronze overseeing the triple stairway to the Gate of Heavenly Purity, which serves as the main entrance to the very inner sanctum of the palace, have the floppy ears that signify a lesser degree of alert hostility (Fig. 4.4). The male is to the right and the female to the left, as is customary.

Their bodies and mane declare them to be lions, though they have something of the physique of the Pekingese terrier, the famous lion-dog, bred and prized over the centuries for its leonine look on a miniature scale. We can also believe that the lion is the son of the dragon. The lions' legs are fringed with bold waves of Rococo curls and faced with protective shin pads, recalling the scaly armour of their mythological ancestor. Their manes consist of a dense aggregate of spirals, each like the turbinated shell of a sea creature. As in images of Sekhmet, the female is as maned as the male. The number of spiral clusters signifies the status of the grand person or entity that they are protecting. Their foreheads are adorned with scrolled eyebrows. Seeming to revel in their confident power, they open their mouths in a fearsome grin to reveal their sharp incisors. Around their necks is a thick buckled collar studded with stylized peonies, from which hang bells and massive seed pods (perhaps those of a peony, hugely enlarged). The peony was regarded as the 'queen of flowers'. The collars signal that the lions are owned by the person they are protecting.

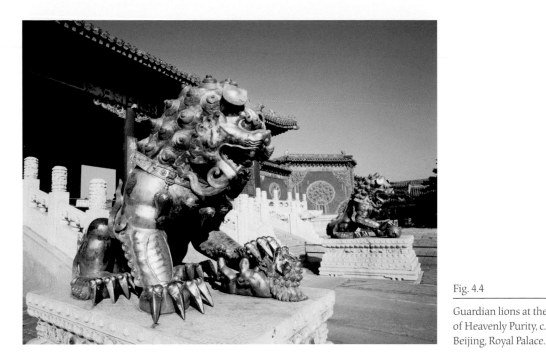

Fig. 4.4

Guardian lions at the Gate
of Heavenly Purity, c.1655,
Beijing, Royal Palace.

Their paws are aggressively armoured, more like savage metallic pros-
theses than organic feet composed of bones, sinew, flesh, and blood. Un-
der each of their inner paws they grasp attributes. The lioness's may be
the easier to read, since we have a possible key. A chubby cub lies on its
back under her foot, not being treated harshly as it looks at first sight, but
probably being nourished with milk from its mother's claws. This motif
appears to refer to an elusive legend of the cub's unorthodox suckling by
its mother. The male grips a 'brocade' ball, the meaning of which is less
wholly clear. The greater part of its surface is knitted together from penta-
gons and hexagons bearing stylized peony flowers. From the ball's later-
ally placed polar regions emerge ribbons or streamers, which traditionally
signify the flight of the spirit. Whatever the detailed meanings, it is clear
that the underfoot sphere conveys the lion's dominant status.

The paired lions serve as belligerent guardians in a theatrical and visu-
ally noisy manner. They are archetypically 'leonine'. By comparison, real
lions—often scruffy-looking in the wild—can disappoint. The bronze
lions are literally super-natural.

They stood at a key point in the palace. Enthroned Qin emperors held
semi-public court on the platform under the Gate of Heavenly Harmony.

The golden lions at the foot of the stairs served to underline the emperors' elevated power and majesty in a way that no supplicant could ignore.

First known in the West via ceramics and textiles, the guardian lion became debased as a decorative motif that signalled the exotic qualities of the Chinese style. Looking at the magnificent originals in the Royal Palace, as many more visitors now have the opportunity to do, we can well envisage the vivid image in the mind of Yu Shinan, the renowned calligrapher, when he wrote his *Ode to the Lions* in the seventh century. He declared that the king of the beasts' 'eyesight is like a shaft of lightning and its roaring, a peal of thunder'. No Western sculpted lion known to me has ever expressed itself in such a buoyantly expressive manner.

Pillars of Power

In India, a lion sculpture, or rather a carving of four conjoined lions, has reached a position of unique eminence. The Lion capital of Ashoka from Sarnath was adopted as the state's national emblem on independence on 26 January 1950 (Fig. 4.5). It is prominently displayed on Indian currency. Indian nationals intending to pass into another county carry passports on the cover of which is a stylized image of the lion capital. Like all such familiar things, the lion capital is rather taken for granted as part of the visual fabric of everyday life in India.

During the period 273–232 BC, the Emperor Ashoka literally marked his power across the extensive territories over which he ruled—comprising much of the Indian sub-continent and Afghanistan—by erecting a series of columns with carved capitals. Some may have already existed but others of the lofty monoliths (i.e. carved from a single piece of stone) were transported over distances of hundreds of miles. Thirty-three of the columns were inscribed with a series of his edicts, promoting his vision of a well-governed kingdom and advocating the *Dharma* (or *Dhamma*— the dutiful path of righteousness) in a predominantly but not exclusively Buddhist manner. Edicts were also carved into the surfaces of strategically located rocks. Rock edict number 13 reads:

> Beloved-of-the-Gods, King Piyadasi [Ashoka], conquered the Kalingas eight years after his coronation. One hundred and fifty thousand were deported, one hundred thousand were killed and many more died (from other causes).

After the Kalingas had been conquered, Beloved-of-the-Gods came to feel a strong inclination towards the Dharma, a love for the Dharma and for instruction in Dharma. Now Beloved-of-the-Gods feels deep remorse for having conquered the Kalingas.

As with all dominant rulers whose power shaped not just history but the writing of it, disentangling fact from myth is not easy, especially when religion is integrally involved. But it does seem that after his notably bloody conquest of Kalinga (Orissa), the destructive results of which appalled him, he strove to adhere to the peaceful tenets of Buddhism. His support extended its reach enormously.

The Sarnath column, over 15 metres high without its capital, may celebrate Ashoka's visit to the site that Buddha had himself designated as holy. The polished capital in exceptionally hard sandstone is now in the Sarnath Museum, founded by the British in 1904 to retain treasures close to their site of origin and excavation. The lions are placed back to back and merged into a single unit. Upright and commanding, with emphatically carved manes and feet, open mouths, and handsome sets of incised whiskers, they survey the four directions in an omnipotent manner. Their stylistic inspiration seems to come from the art of Iran.

The round abacus bears four Dharmachakra (or Dharma Chakra) wheels, each of twenty-four spokes. The wheel can serve as a key symbol of the life cycle and of enlightenment, but here it primarily designates the rule of law. A Dharmachakra wheel is now placed at the centre of the Indian flag. A large wheel was once in place above the heads of the four lions, as is the case with one surviving capital. Between the wheels on the abacus are four animals, beautifully carved with sprightly naturalism and grace. In this case the stylistic inspiration seems to come from Hellenistic art. The animals are the lion of the North, the elephant of the East, the bull of the South, and the horse of the West—or, at least, that is one of the meanings accorded to them. It is in the nature of such symbols that they serve over time as vehicles for varied meanings.

Sarnath in Uttar Pradesh is where Buddha delivered his first sermon, and the animals have also been seen as symbolizing stages in his life. The Elephant alludes to Queen Maya's dream of a white elephant touching her side and rendering her pregnant; the bull symbolizes Buddha's life as a prince, while the horse marks his flight from secular values; and the lion represents his life as the spiritual Buddha. As so often, the lion stands

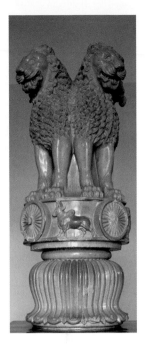

Fig. 4.5

Lion capital of Ashoka, c.250 BC, Sarnath, Archaeological Museum.

for the highest level of achievement. The geographical and biographical interpretations are not mutually exclusive. Symbolism can be a very opportunistic business. The abacus itself is supported by an inverted lotus in full flower, indicative of the fountainhead of life. An inscription asserts that 'truth alone triumphs'.

Each towering column capped by its divine image would have been deeply impressive to Ashoka's subjects, both spiritually and politically. A Chinese Buddhist pilgrim of the seventh century recorded how 'those who pray fervently before it see from time to time, according to their petitions, figures with good or bad signs'. The image of the lions would be seen as embodying divine essence through an act of transubstantiation, like the envisaged presence of the blood and body of Christ in the wine and bread of the Eucharist.

In all this, the regal status of the lion was taken as read, and its equation with Buddha would have been readily understood. The Sarnath capital is a grand emblem not only of India's much admired king and his religious devotion but also of the state that now holds somewhat less of the subcontinent than he once commanded.

Antique Tales

The Western tradition has left plentiful literary tales of lion lore. Like so many other aspects of the Western vision, they have progressively imposed themselves across the world courtesy of the mass media. Lion myth stretches far and wide in the West, embracing the literary genre of fables, the semiotic realm of the bestiary, the scientific territory of zoology, the predictive claims of astrology, and the assertive symbolism of political power. Rarely has one of these aspects been present without at least one of the others. When we look at the greatest of the early 'zoological' compendiums in the age of print, Conrad Gessner's four-volume *History of the Animals* in 1551–8, we find a range of information far wider than we would expect in modern zoology. Gessner extensively reviews the names of each beast in biblical and other languages, tells of its natural history, habits, and geographical distribution, examines its relationship to man, particularly its utility, and records its appearances in many kinds of text. Gessner was at pains to indicate the status of his information, but his science is nowhere separated from meaning, and science itself comprises a more elastic category than it was to become in the eighteenth century.

Let us begin at the literary end of the zoological spectrum, through the writings of an ancient author who enjoyed a particularly constant presence during and after classical antiquity. Surprisingly he did not come from a traditionally educated background and is said to have begun his working career as a slave. A legend also testifies to his misshapen appearance. His name was Aesop, and convention dates his birth to about 620 BC. His moralizing tales of animals, often behaving badly, could be read as satirizing the foibles of powerful and deceitful humans in a way that was not always politically or socially expedient. Nowadays he is perhaps better known to children than to adults.

No less than nine of Aesop's stories feature the lion. One relies on the persistent legend that the lion was afraid of the cockerel, while exhibiting indomitable courage in the face of other beasts. The lion's angst was only tempered when the huge elephant confessed that he was scared that a puny gnat might enter his ear and inflict terminal wounds. Another fable unequivocally demonstrated the lion's supremacy. Having entered into a pact with other animals to hunt for mobile food, the lion apparently agrees to share the resulting catch. In the event he claims all the spoils and his partners are powerless to do anything about it. This is where the expression 'the lion's share' comes from. The lion's aura of invincibility is threatened on occasion in Aesop's fables, but it is taken as read that the regal beast occupies a position of dominance in the animal 'king-dom'.

The massive Roman *omnium gatherum* of received wisdom about the natural and human worlds, Pliny the Elder's *Natural History* from the first century, retails a series of authoritative 'facts' gleaned from a range of sources, including those we would regard as literary as well as scientific. We learn amongst other things about the lion's reproductive and nurturing habits, including the idea that baby lions are inert and unshaped until they are two months old. Cubs are literally licked into shape by their mothers and finally walk at six months. There is a type of lion with curly hair that is relatively timid, compared to the bold, straight-haired variety. As Pliny announces at the start of the chapter dedicated to the lion in his eighth book, 'lions are . . . most strong and courageous when their hair of their mane or collar is so long that it covers both neck and shoulders'. A lion might fast for three days after gorging itself, and can claw excessive food from its stomach. It does not attack people except when provoked or very hungry. To its fear of the cock's crow, Pliny adds turning cart wheels, empty chariots, and fire. Such curious phobias do little overall to reduce the lion's dominant status.

It is the maned male lion's bold character, expressed not only in its behaviour but in its appearance, that features in the ancient formulation of physiognomic theory, in which character is read from appearance. The foundations could not be more philosophically distinguished. It was Aristotle who set the tone.

In his *Prior Analytics* the great Greek philosopher declares in a rather technical manner that

> It is possible to infer character from features, if it is granted that the body and the soul are changed together by the natural affections [or 'traits']: I say 'natural', for though perhaps by learning music a man has made some change in his soul, this is not one of those affections which are natural to us; rather I refer to passions and desires when I speak of natural emotions. If then this were granted and also that for each change there is a corresponding sign, and we could state the affection and sign proper to each kind of animal, *we shall be able to infer character from features.* (my italics)

With characteristic subtlety (and difficulty), Aristotle acknowledges the complexity in reading the outer signs of inner character:

> If the kind [or 'genus'] as a whole has two properties, e.g. if the lion is both brave and generous, how shall we know which of the signs which are its proper concomitants is the sign of a particular affection? Perhaps if both belong to some other kind though not to the whole of it, and if, in those kinds in which each is found though not in the whole of their members, some members possess one of the affections and not the other: e.g. if a man is brave but not generous, but possesses, of the two signs, large extremities, it is clear that this is the sign of courage in the lion also.

The underlying supposition at work here is that the soul is the generating 'form' of the body, with 'form' understood as the shaping virtue rather than the material shape itself, which involves the properties of matter. Soul effectively forms character and dictates the outward signs of that character's traits in the human body. We should therefore be able to read character from the signs.

These ideas were developed in a less elaborately philosophical manner in what became the key text, the *Physiognomics*, long taken to be by the

master himself but now attributed to Theophrastus. The underlying principle is stated at the outset:

> No animal has ever existed such that it has the form of one animal and the disposition of another, but the body and soul of some creature are always such that a given disposition must follow a given form.

The opening section of the text fully acknowledges the complexities of making physiognomic diagnoses and the danger of simple formulas:

> We have to make our selection from a very large number of animals, and from those that have no common characteristic other than that whose character we are considering.

Animal parallels lie at the heart of the enterprise, as two excerpts demonstrate:

> The characteristics of a brave man are stiff hair . . . a strong neck but not very fleshy; a chest fleshy and broad . . . a bright eye, neither too wide opened not half-closed. . . . the forehead is sharp, straight, not large, and lean, neither very smooth nor very wrinkled.

The analogies with a lion are self-evident:

> The lion of all the animals seems to have the most perfect share of the male type. Its mouth is very large, its face is square, not too bony, the upper jaw not overhanging but equally balanced with the lower jaw, a muzzle rather thick than fine, bright, deep-set eyes, neither very round nor very narrow, of moderate size, a large eyebrow, square forehead, rather hollow from the centre, overhanging towards the brow and nostril below the forehead like a cloud . . . a long neck, with corresponding thickness . . . and his chest powerful.

He adds elsewhere that 'the lion and the wild boar are the bravest [of animals] and have very stiff hair'.

The second part of the *Physiognomics* tends to encourage the rather simple one-to-one correspondences between a particular physiognomic feature and a temperamental trait, about which the first part had cautioned.

It was this tendency that came to the fore in the medieval and Renaissance derivations.

Set in the stars

Unsurprisingly, anthropomorphized lions play leading roles in the much copied compilation of animal lore in the Middle Ages, the *Physiologus* (the *Bestiary*). They also feature conspicuously in the fables that were so popular in the post-classical world. Aesop and Pliny were major sources. Pliny was especially important for Isidore of Seville, whose extensive and widely influential encyclopedia, *On Etymology*, was written in the early seventh century. Noting that the lion's name in Greek (*Leo*) means 'king' in Latin, St Isidore explains that the courage of Pliny's straight-haired variety is manifest in its brow and tail. Amongst the stories he retails is its clever erasing of its footprints with its tail so hunters cannot track it. Lions only attack men when they are desperately hungry, and, more generally, they are only aggressive when provoked, and so on. They spare those who prostrate themselves. Their familiar phobias are outlined. Thus it is that a lion in an Anglo-Norman *Bestiary* in Merton College Library, Oxford, is shown in a state of alarm (with its tail between its legs) next to a wheeled cart (Fig. 4.6). To the left of the cart is the feared crowing cock. In the typically inverted world of fables, taking their cue from Aesop, lions are regularly subject to such foibles, in ways that mock their regal pretensions. We may sense that successions of authors were relieved to find that we, as God's humans, know the weak points of the animal king.

Alongside the legends in the bestiary ran the concurrent stream of physiognomics. The medieval science of facial features, represented at its most developed in Michael Scot's *Book of Physiognomics*, written in the early thirteenth century and printed in 1477, relied upon the blending of the Aristotelian tradition with the medical doctrine of the four temperaments. The doctrine relied heavily on the writings of the Alexandrian polymath Galen, whose medical texts set of the tone for Western 'physic' well into the late Renaissance. A series of conjunctions had progressively been forged between the properties of the four elements and the four humours (bodily fluids) that determined health, personality, and illness. The correspondences can most easily be summarized in a table (albeit one that tidies up the variations found in texts by various authors). The

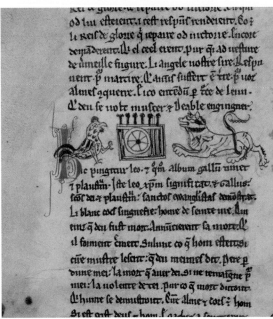

vertical columns designate, respectively, the temperaments, the humours, the elements, the times of day, the seasons, the ages of man, the planets, and the winds.

Each temperament came to be associated with one or more animals. The choleric is of most concern in our present context, since it was indelibly identified with the lion. The choleric is bold and fiery, as befits someone aligned with Mars, the god of war. He (the equations are almost

Sanguine	blood	air: warm-moist	morning	spring	youth	Jupiter	Zephyr
Choleric	yellow gall	fire: warm-dry	midday	summer	maturity	Mars	Eurus
Melancholic	black gall	earth: cold-dry	evening	autumn	later middle age	Saturn	Boreas
Phlegmatic	phlegm	water: cold-moist	night	winter	old age	Venus or Moon	Auster

always made with men not women) is typically endowed with a bright eye, overhanging brow, strong teeth, a wiry mane of vigorous hair, a virile beard, and darkish complexion. The choleric man was thoroughly leonine, just as the lion was manly and martial. The astrological dimension to the scheme of interlocking entities was of considerable significance in the system as a whole.

Astrology was an integral component in what had become a highly developed, deterministic system, which, if fully understood, could provide diagnoses of the nature of every individual. Much the same has been claimed for the human genome today. The most comprehensive and influential of the detailed attempts to integrate the sciences of physiognomy and the signs of the hand with astrological divination occurs in the *Introduction to Horoscopic Matters* of 1522 by the German priest James Rosenbach who wrote under the evocative name of Johannes da Indagine ('John the Hunter'). A year later it was published in German as *The Art of Chiromancy*. It is a notable characteristic of physiognomy that it gained an early prominence amongst popular sciences broadcast in vernacular languages rather than learned Latin, sometimes in anonymous handbooks. One such anonymous German guide, the *Book of Complexions*, appeared in 1511 and went through at least twenty-four editions before the end of the century.

After his comprehensive discussion of the signs of the hand (chiromancy), Johannes opens the second part of his treatise with the eye as a key sign, before exploring other parts of the face. His most substantial branch of physiognomy is devoted to the physical expression of the person's astrological constitution. Thus he explains what happens when 'The Sun is in Leo':

> So in the first face of *Leo*, is the gift of life; and it maketh of them a small comely body, ruddy coloured, mixed with some white, rolling eyes, strait body, full of diseases in their feet, especially in age; famous and notable, simple, and beloved of the Kings and rulers of the Earth.

The astrological Leo exhibits characteristics that can be discerned physiognomically and are for the most part consistent with the choleric humour. According to astrological law, a Leo is typically proud, ardent, ambitious, powerful, brave, and regal, but prone to self-regard, arrogance, irascibility, and an excess of ambition. Leo is the sign that governs

the heart and spine, as graphically demonstrated by the zodiac man in Johannes de Ketham's *Handbook of Medicine* (Fig. 4.7), where it additionally rules over the stomach and lumbar nerves. To 'lack heart' or to be 'spine-less' are not desirable characteristics. Leos are typically not deficient in

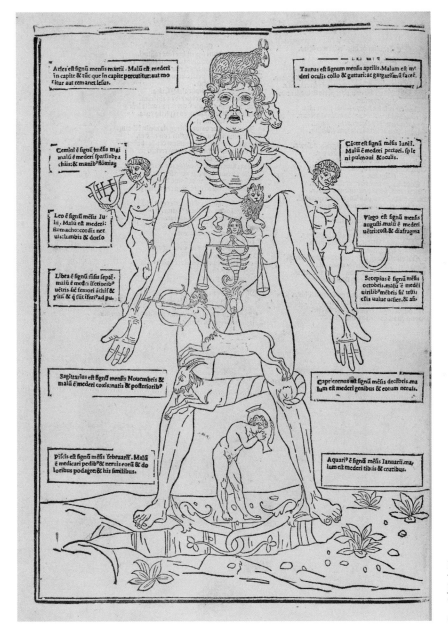

Fig. 4.7

Johannes de Ketham, 'Zodiac Man', from *Fasciculo de medicina*, Venice, 1493.

these respects. As so often, current bodily metaphors have been inherited from early medical doctrines.

We can represent the results of these conjoined traditions at their most schematic and at their most popular in Giambattista della Porta's much translated *On Human Physiognomy* of 1586. In keeping with Theophrastus (or, as he assumed, Aristotle), he begins by equating men for natural boldness with the lion and women with the 'timid' panther. His illustrative technique, widely emulated and equally widely parodied, exploits double plates (Fig. 4.8), sometimes repeated at various points in the text. In order to underline the human–animal analogies, he forces the characterizations of the heads of men and animals, particularly those of the anthropomorphized beasts, to converge in ways that sometimes have comic results—at least in our later eyes. The number of editions over some 200 years testifies to the seriousness with which della Porta was treated.

Fig. 4.8

Giambattista della Porta, heads of lion and leonine man, from *De humana physiognomia*, Vico Equense, 1586.

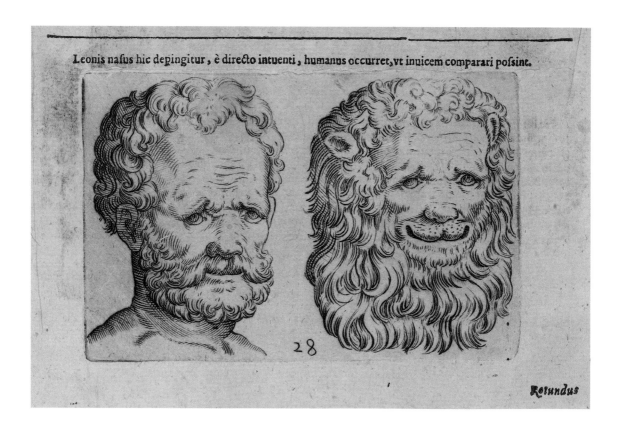

Set in Stone (and Bronze)

Once we are attuned to the sets of leonine signs, we can recognize them on a wide basis in artistic images. I will look highly selectively at a few sculpted examples, not least because they are in the public domain, on a large scale, cost a lot of money, and have played particularly conspicuous roles in shaping our visualization of the king of beasts.

The lion was biblically associated with Christ through the Book of Revelation chapter 5. One of St John's visions involved the lion and the lamb:

> And I saw in the right hand of him that sat on the throne a book written within and on the backside, sealed with seven seals.
>
> And I saw a strong angel proclaiming with a loud voice, Who is worthy to open the book, and to loose the seals thereof?
>
> And no man in heaven, nor in earth, neither under the earth, was able to open the book, neither to look thereon.
>
> And I wept much, because no man was found worthy to open and to read the book, neither to look thereon.
>
> And one of the elders saith unto me, Weep not: behold, the Lion of the tribe of Juda, the Root of David, hath prevailed to open the book, and to loose the seven seals thereof.
>
> And I beheld, and, lo, in the midst of the throne and of the four beasts, and in the midst of the elders, stood a Lamb as it had been slain, having seven horns and seven eyes, which are the seven Spirits of God sent forth into all the earth.

Over the ages, the notion of Christ as the 'Lion of Judah' proved less sympathetic than seeing him as a sacrificial lamb. Of the major biblical figures, it was St Mark the Evangelist who became most closely associated with the lion. Mark was either accompanied by his symbolic lion or actually represented by one. The other prominent saintly lion was the once fierce beast from whose foot St Jerome had removed a thorn and who became the saint's regular companion, often tame and diminutive like a cat. One of the characteristics of the hermit saints was that they tended to prefer animals to humans for company.

The lion also played a prominent role in the Old Testament story of Samson, who as a young man had torn a lion apart by the jaws, and of Daniel, who was protected by God when cast overnight into a pit of lions. The Herculean Samson had been preceded by Hercules himself, who had strangled the Nemean lion as the first of his twelve labours. The lion's pelt was worn by Hercules and those who wished to be identified with his valour.

The most prominent of the early sculpted lions in the Middle Ages seem not to depend upon these associations. Lions appear with remarkable regularity in Romanesque sculptural ensembles, particularly in southern Europe, not always in ways in which their precise meaning is now fully evident to us. They feature most conspicuously in portals, often valiantly supporting columns on their backs—as they sometimes do in pulpits. The one I have selected, on the basis of its powerful and gory portrayal, comes from Arles, the city immortalized by Van Gogh's 'insanity'. It is not now regarded as a major centre, but in the Middle Ages it was the starting point for one of the major pilgrimage routes. The lions appear on either side of the central portal of the beautiful Cathedral of St Trophime. Nearest to the door on the right is St Paul, above an austere lion that is gnawing dispassionately on the left arm of a recumbent man (Fig. 4.9). The lion's claws have bitten harshly into the man's back and cheek. Not a comforting image, but what did it mean to the pious worshipper or departing pilgrim?

The most likely explanation, beyond aligning the Romanesque lions with other elements in medieval decorations that evoke fear and awe, is that their prominence in portals (and perhaps in pulpits) is associated with judgement. As a wise but stern leader and judge, the lion had become identified with legal authority—and, seemingly in the case of the Arles carnivore, with punishment. Portals of churches were used as locations for actual judgements. St Peter, to the left of the Arles portico, was the judgemental doorkeeper who determined which souls were worthy of entrance to paradise, and which were dispatched to the other place. In the central tympanum above, Christ is displayed in judgement, majestically surrounded by the symbols of the Evangelists. Judgement seems to be the order of the day. The main door at St Trophime, flanked by the magisterial figures of St Paul and St Peter, thus becomes a surrogate entrance to heaven. There is an obvious polarization between the spiritual rewards promised by the saints and Christ and the unhappy fate of the lion's bearded victim. Unlike Daniel, who is also sculpted on the façade, God has not spared him from the lions.

Fig. 4.9

Lion mauling a man, 12th
century, from the portico
of St Trophime Cathedral,
Arles.

Unsurprisingly the porch fired Vincent Van Gogh's vivid imagination
when he stayed in Arles. He wrote to his brother Theo on 21 or 22 March
1888,

> There's a Gothic porch here that I'm beginning to think is admirable, the
> porch of St Trophime, but it's so cruel, so monstrous, like a Chinese night-
> mare, that even this beautiful monument in so grand a style seems to me to
> belong to another world, to which I'm as glad not to belong as to the glorious
> world of Nero the Roman.

The greatest of the leonine lions in the Renaissance brings us onto more
secure iconographic territory. Donatello's stone lion is the Florentine *Mar-
zocco*, the familiar lion of St Mark (Fig. 4.10). His powerful paw rests pro-
tectively on a shield bearing Florence's emblematic lily. For years Dona-
tello's lion sat on the platform running along the face of the Palazzo dei
Signori (now the Palazzo Vecchio), seemingly representing the Florentine
republic's stoic ideals as manifestly as Michelangelo's later *David*. But it
was actually commissioned for the column at the base of the stairway to
the Sala del Papa in S. Maria Novella, the large hall erected for the use of

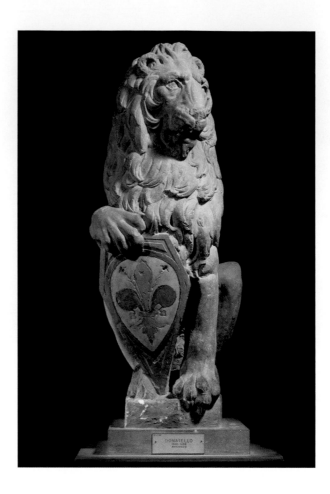

Pope Martin V when he was residing in Florence in 1419. It was designed to remind the successor to St Peter that St Mark was on Florence's side. Donatello's beast is everything we should expect a lion to be—archetypically leonine, upright in demeanour, regal in manner, imperturbably just, and with reserves of martial strength and military valour available to meet every adversity. Donatello's *Marzocco* is a close cousin to the noble but severe prophets that he carved for the free-standing bell tower of Florence Cathedral.

What follows over the centuries is a visual story that can be written in outline by anyone who keeps their eyes open for lions in castles, on knightly shields, heraldic flags, stately houses, parliament buildings, civic halls, urban spaces, and even the gateposts of domestic houses—and in many less probable places. Lions *rampant* (on their hind legs), *passant*

(walking with a raised forepaw), *statant* (standing), *sejant* (sitting), *couchant* (lying but alert), along with other variant types, densely populate heraldic art. Once attuned, the wandering spectator can see lions in virtually every place where some ruler or entity has wished to signal power or status. The lions tend to exhibit specific national characters. French lions tend to display an *hauteur* worthy of Charles de Gaulle. English sculpted lions look imperious but also exhibit a somewhat house-trained air. German ones often growl or are ready to. Those in Russia tend to look uncompromisingly mighty, even when asleep. It is easy to play the physiognomic game in the context of national stereotypes. It seems to work better than it should.

The range of political regimes in which leonine imagery flourishes allows us to pass with no visual strain from republican Florence in the fifteenth century, via an uncited plethora of regimes of diverse kinds, to the republic of America. Washington is no less replete with lions than Florence, Munich, London, or Edinburgh. Standing grandly at the Capitol end of the Mall is the Ulysses S. Grant Memorial, erected between 1902 and 1922 in honour of the Civil War general and later president. Accompanying the second largest equestrian statue in the world, sculpted by Henry Merwin Shrady, are four spectacularly proud lions protecting the standards of the USA and its armies (Fig. 4.11). Shrady's lions exude a rather snooty air of invincible superiority reminiscent of the bronze lions that populate Paris. Given Grant's legendary calmness in battle, which Shrady captures well, it is the alert horse and indomitable lions that convey much of the emotional engagement of the central ensemble.

By comparison, the popular bronze giants sculpted by Edwin Landseer with the assistance of Baron Carlo Marochetti at the foot of Nelson's column in Trafalgar Square, London, temper their obvious sense of pride with a palpable sense of massive cuddliness (Fig. 4.12). As a young painter, Landseer had keenly researched the anatomy of a lion and actually dissected one, but, according to the memoirs of Lord Frederick Hamilton, the artist seems primarily to have relied for his Trafalgar Square model on a docile lion from the zoo which he had transported to his house in a furniture van accompanied by two keepers. There was indeed some contemporary criticism of them because of their lack of lion-ness.

That cheery kids feel comfortable clambering over the lions' bronze backs may in part be due to the lordly but paternal roles that the king of the beasts plays in children's fiction. Amongst the many lion stories, C. S.

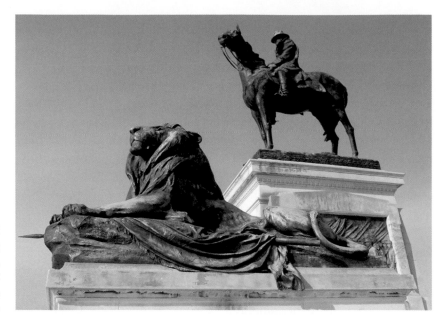

Fig. 4.11

Henry Shrady, Grant on horseback and lion, from the Ulysses S. Grant Memorial, bronze, 1902–22, Washington.

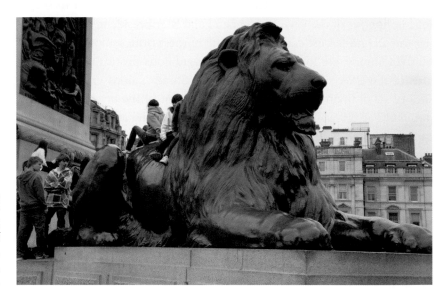

Fig. 4.12

Sir Edwin Landseer, lion from the base of Nelson's Column, bronze, finished 1867, London, Trafalgar Square.

Lewis's *The Lion, the Witch and the Wardrobe* (1950) has proved to be of enduring popularity in both its written and filmed versions. Inevitably, in the kingdom of Narnia that the children enter via the transformative wardrobe, Aslan the lion is the 'true' king. The most notable recent leonine ruler is the *Lion King* in the hugely popular trilogy of films by Disney released

from 1994 onwards, accompanied by the now inevitable torrent of merchandise. I recall going with a friend and her two children to the first of the three films.

This is where we came in, clutching our cinema tickets.

Reading

http://www.closinglogos.com/page/Metro-Goldwyn-Mayer+Pictures

D. Alexander, *Saints and Animals in the Middle Ages*, Woodbridge, 2008.

Aristotle, *Prior Analytics*, trans. A. J. Jenkinson, eBooks@Adelaide, 2007.

K. Ball, *Animal Motifs in Asian Art* (1927), New York, 2004, pp. 53–68.

B. Bryan, 'The Statue Programme for the Mortuary Temple of Amenhotep III', in S. Quirke (ed.), *The Temple in Ancient Egypt: New Discoveries and Recent Research*, London, 1997, pp. 57–81.

G. De Appolonia, 'Judgement and Justice in the Romanesque Column-Bearing Lions of Northern Italy', *Ikon*, 2, 2009, pp. 167–76 (see also the same vol. of *Ikon* for a rich collection of articles on animal symbolism in the Middle Ages).

H. Falk, *Asokan Sites and Artefacts: A Source-Book with Bibliography*, Mainz am Rhein, 2006.

A. Howard et al., *Chinese Sculpture*, New Haven, 2006.

M. Kemp, *The Human Animal in Western Art and Science*, Chicago, 2007.

M. Kemp, 'The Leonine Man: From Metaphysics to MGM', *Bildwelten des Wissens*, Kunsthistorisches Jarbuch für Bildkritik, 6, 2009, pp. 90–102 (see for sources for Western lions).

E. Mitchell, *The Lion-Dog of Buddhist Asia*, New York, 1991.

D. Montagna, 'Henry Merwin Shrady's Ulysses S. Grant Memorial in Washington, D.C.: A Study in Iconography, Content and Patronage', doctoral dissertation, 1987, University Microfilms International Dissertation Services.

R. Ormond, *Sir Edwin Landseer*, London, 1981.

A. Paludan, *Chinese Sculpture: A Great Tradition*, Chicago, 2006.

B. Rowland, *The Art and Architecture of India: Buddhist, Hindu, Jain*, Harmondsworth, 1953.

Chen Shaofeng, *A History of Chinese Sculpture*, Guangzhou, 2003.

Vincent Van Gogh, *The Letters*, no. 588 to Theo Van Gogh, Arles, Wednesday, 21 or Thursday, 22 March 1888, http://vangoghletters.org/vg/letters/let588/letter.html.

5

Mona Lisa

THE SMALL PANEL PAINTING by Leonardo da Vinci known as the *Mona Lisa* or *La Joconde* (the light-hearted or smiling one) is about to emerge from its heavy protective casing for its annual inspection. The date is an unspecified day earlyish in 1994 and the venue is the Salon Carré in the Musée du Louvre in Paris. The man in charge of the momentous yearly operation is Pierre Rosenberg, Président-directeur of the museum since 1992. He is also an Officier de la Légion d'Honneur, Chevalier de l'Ordre National du Mérite, Commandeur des Palmes Académiques, Commandeur des Arts et des Lettres, Grand Officer of the Order of Merit of the Italian Republic, and Commander of the Order of Merit of the Federal Republic of Germany. An elegantly cultivated man of great charm, he is

▪ Leonardo da Vinci, *Portrait of Lisa Gherardini; the 'Mona Lisa'*, 1503–c.1516, Paris, Louvre.

wearing his signature red scarf, draped around his neck and reaching to his thighs. He is rarely without it, whatever the weather, indoors and out.

In attendance are picture handlers, curatorial and conservation staff, together with the leading Leonardo scholar from Milan, Pietro Marani, who is there with a photographer to take new photographs for a monograph on Leonardo for Electa that he is writing. I am also there, courtesy of the Director. I have been hoping for many years to encounter her out of her prison. It is odd, I am thinking, that this picture almost uniquely tends to invoke a 'she' or 'her' rather than 'it' or 'its'.

First the picture has to emerge from a specially constructed, alarmed, and air-conditioned chamber in which there is a window of specially toughened glass, through which the millions of spectators have peered over the years. Sometimes it is said that what is on display is not actually the real thing. It is. The precious masterpiece is laid face down in its gilded and glazed frame on a stout table. Then the panel is removed with great care from the back of its frame and lifted clear of the frame and its glass. It is carried tenderly to an easel on which it is securely mounted.

It is a thrilling and worrying moment—worrying because of the obvious potential for disappointment. It is after all merely a poplar panel on which are some layers of priming, pigments in oil binders, and varnishes. But so much has been invested in the image by centuries of commentators and, in a minor way, by myself in my publications that it is difficult to be sure that the actual experience will match the expectation.

In the event I need not have worried. The result is spine-tingling in a way that is difficult to describe without sounding pretentious. Great art encountered in the flesh can produce sensations that go beyond visual stimulation. Somehow more seems to be involved than the eye and even the mind. The whole mind–body seems to be caught up in the process. The duality of mind and body as advocated in the seventeenth century by Descartes seems quite wrong at such moments. The same thing happens with great music, which has an undoubted somatic dimension, and with great drama and dance in which we seem within ourselves to mirror and ape what we are seeing. For me it also happens with those transcendent moments in sport.

Some artists can make their images live in an uncanny way that transcends the inert material they are using. Donatello and Bernini can do it with marble. Rembrandt and Vermeer can do it with paint—with paint applied in a very different way from Leonardo and from each other. It is a question of working the spectator's mechanisms of perception, of giving

them enough to see what is needed but not giving them so much that they have nothing left to do.

In Leonardo's case, or more specifically the case of the *Mona Lisa*, it involves an incredibly subtle interplay between the painted surface and the incident and reflected light. The tones of the flesh are built up from exceedingly thin layers of pigment in an oil binder—called glazes—and we know from scientific analysis that each glaze contains an exceptionally low quotient of pigment particles in the oil binder. He is in effect applying amazingly fine, tinted films of creamy pink and thin brown shading layer by layer. Not only does this mean that the definition of form is elusive, it also means that the light penetrates to some degree through the pigment layers. In the thinner areas it is reflected back from the white gesso priming and a layer of white lead to pass again through the glazes, before entering the eye. Across the picture and into the depth Leonardo magically exploits paint films of different depth and relative opacity. The different degrees of optical penetration play subtle and elusive games with the spectators' eyes. The soft and translucent warmth of her pale flesh tones stand out against the colder but radiant blues of the distance. The red-green juxtapositions in her draperies, although relatively unemphatic, work to define her closeness to us. In a version restored digitally by Pascal Cotte of Lumière Technology in Paris (Fig. 5.1), we gain some sense of how these effects originally worked in terms of the spatial properties of the colours. The seated Lisa stands forth on her balcony against the middle ground and distance with enhanced clarity.

I have begun with these colouristic/technical/optical effects because these are what first struck me—over and above what I already knew and expected from reproductions and having looked at the picture many times through its layers of protective glass, jostling with other eager spectators.

As the incident light varies on the picture surface—the artificial light of the room, the light from the windows, and the photographer's lamps—the magic of the glazes and the effects of the warm and cold colours vary. There is a sense that the image lives. I recall looking at the great Rembrandt *Self-Portrait* at Kenwood House in London as the sun that was visible though an adjacent window appeared and disappeared behind light clouds. The old devil seemed to be breathing. The Giovanni Bellini portrait of *Doge Leonardo Loredan* in the National Gallery in London also used to do that, before the modern system of lighting largely evened out the level and spectral composition of the incident light.

Fig. 5.1

Pascal Cotte, *Mona Lisa*
Digitally Restored, 2009.

As I begin to turn my attention to a more detailed scrutiny, it is difficult
to know where to look, such is the pressure of this opportunity to spend
intimate time with the world's most famous picture. I decide to concen-
trate on those aspects that I can less readily scrutinize even in the best re-
productions. Remember that this is before the era of very high-resolution

digital images. I look at the surface, its erratic pattern of cracks (including the vertical split in the panel visible above the sitter's head), the evidence of surface damage, the discoloured varnish, signs of overpaint, elusive details in the shadows, the magical delicacy of the brushwork in her hair and in the gathered neck of her dress and in the spiral of the veil over her shoulder, and the delicate touches of a small brush in the hazy blues of the distance . . . I use a magnifying glass to look for traces of the handprint and fingerprint technique we have observed in other Leonardo paintings, but I cannot detect any. I think they should be there. Not least I look at the left and right edges of the paint surface. They terminate clearly within the edges of the wood panel, showing definitively that the thin slivers of columns and their bases visible on the left and right were always as slight as they are now. The painting has not been trimmed past the natural edge of the paint layer, as has often been asserted, not least in relation to copies that felt obliged to include more of the columns. The daring of the hinted columns is just one of the many innovative aspects of the picture.

And, of course, there is always her uncanny presence. I have never experienced a stronger feeling of presence in a work of art. The closest parallel is Donatello's ravaged *Mary Magdalene* in the cathedral museum in Florence. I would not care to be in the dark with her. Lisa's eyes, like those in the frontal images in the first chapter, will not leave us alone. Unlike most Christs, she is not just looking. She is overtly reacting, smiling with a knowingness that is perpetually engaging and even disconcerting. It is often said that her expression is so elusive that we cannot be sure that she is smiling. Such doubts seem to me to be a product of poor reproductions, dirty varnish, and poor viewing conditions rather than inherent in how Leonardo has characterized his sitter. As the wife of Francesco del Giocondo, she is *La Gioconda* or *La Joconde*. As we will see when we turn to the historical evidence, this name in its Italian form seems to have been accorded to Lisa at an early date. The smile is her emblem as Mrs del Giocondo, just as the juniper (*ginepro*) is the emblem of *Ginevra de' Benci* in Leonardo's early portrait in the National Gallery in Washington.

Bare Facts

I have been calling her Lisa del Giocondo because it seems to me that there is now little doubt as to the identity of Leonardo's sitter. Lisa Gherardini was born in Florence on 15 June 1479 to an old Tuscan land-owning

family, no longer at the height of their political and financial power. The Gherardini properties near Greve in Chianti were and are renowned for their fine wines. On 5 March 1494 before she was 15 years old she married an ambitious and rising silk merchant, Francesco del Giocondo. She was Francesco's second wife. Leonardo's father, the important notary Ser Piero da Vinci, knew Francesco and had acted on more than one occasion to settle legal issues that had arisen between the silk merchant and the Servites of SS. Annunziata. The trust that developed between the notary and merchant probably lies behind the agreement that Leonardo should make a portrait of Francesco's wife. This relationship probably explains why Ser Piero's son should have been willing to take on this job when more powerful figures and entities were pressing Leonardo to execute works for them, including Isabella d'Este the Marchioness of Mantua and the Florentine government.

Lisa has left no independent record of her personality (beyond the portrait), but she seems to have been much loved. Francesco's will, written in 1537 two years before his death, testifies to 'the affection and love of the testator towards his beloved wife and daughter of Antonmaria di Noldo Gherardini'. She is bequeathed her dowry, which comprised a property in Chianti, and all the clothes and jewels that she has in her possession. Furthermore, 'in consideration of the fact that Lisa has always acted with a noble spirit and as a faithful wife', Francesco decrees that his children should ensure that 'that she shall have all she needs'. Not least Lisa had accomplished what wives were then expected to do. She gave birth to a son in 1496, with two further sons and two daughters to follow over the course of the next dozen years.

Contemporary confirmation that Leonardo was indeed painting a portrait of Lisa del Giocondo comes from a recently discovered annotation in an early edition of Cicero's *Letters to his Friends*. A copy of Cicero's *Epistulae ad familiares* printed in Bologna in 1477 was owned by Agostino Vespucci, a humanist from the leading family, who was colleague of Niccolo Machiavelli in the Florentine administration. He added a series of marginal annotations, and when he came across a mention of 'Appelles' the Greek painter (which he corrected to 'Apelles'), his thoughts turned to Leonardo. Cicero tells us that 'Apelles . . . completed the head and the bust [head and shoulders] of Venus with the most perfect art, but left the rest of the body inchoate'. It is unclear if 'inchoate' means less highly finished or actually unfinished. His marginal note reads,

Apelles the painter. That is the way Leonardo da Vinci works when paint-
ing all his pictures, for example the head of Lisa del Giocondo, and Anne, the
mother of Mary. We will see what he will do in the hall of the great council,
about which he has already made an agreement with the standard-bearer.
1503. in October.

Agostino was in a position to know, since he had prepared the Italian nar-
rative of the battle at Anghiari that was given to Leonardo to guide his
painting of the Florentine victory over the Milanese on a wall in the Sala
del Gran Consilgio in Florence. Agostino's tone of foreboding was justi-
fied, since Leonardo never brought the whole of the large mural of the
Battle of Anghiari to completion.

The significance of the annotation in our present context is that it con-
firms Leonardo as having begun a portrait of Lisa del Giocondo by Octo-
ber 1503 and that the head was sufficiently advanced to be seen by Agos-
tino as essentially complete. In spite of this good beginning, the finished
portrait was never handed over to Francesco and Lisa. It seems likely that
its completion was very protracted, as was generally the case with Leo-
nardo. Close examination of the paint in the head, in which the glazes are
laboriously built up to make quite a thick layer, with that in the hands,
which are much more thinly painted in Leonardo's late manner, suggests
that the execution may have taken ten years or more.

The next we know of Lisa's portrait are two legal documents, one a
draft, from 21 April 1525, which lists the Milanese possessions of Giangia-
como Caprotti after his death. It was drawn up to facilitate the division of
his property between his two sisters. Giangiacomo is better known to us
as Salaí, Leonardo's rascally but cherished pupil and companion, whose
nickname means 'little Satan'. In the list of paintings complied some six
years after Leonardo's death we find 'a picture named la Ioconda' cor-
rected from 'la Honda' (in the Tuscan dialect form). It was valued at 100
scudi, a high price for a second-hand painting, as was a picture of St Anne
with the Virgin and Child, which may have been the one mentioned by
Agostino Vespucci.

It is clear, therefore, that Francis I, the French king, who employed Leo-
nardo during the last three years of the painter-engineer's life, did not ac-
quire the picture directly from Leonardo. It is likely that Leonardo had the
portrait with him when he was resident in the manor house of Clos Lucé
near Amboise between 1516 and 1519. In 1517 a visitor described seeing a

portrait of a 'certain Florentine lady, made from nature at the instigation of the late Magnificent Guiliano de' Medici'. If this is the *Mona Lisa*, either the patron has been misidentified or Giuliano had expressed interest in having the portrait completed for him rather than for Francesco. In any event, the painting did not stay in France after Leonardo's death, and we do not know when King Francis acquired it, together with other Leonardo paintings on the Salaí list. When Giorgio Vasari first published his *Lives* of the artists in 1550 the painting was in the royal chateau of Fontaine-bleau, south of Paris. It had seemingly arrived there in the early 1540s. Its later history is more simple. It remained in the hands of successive French kings and subsequently became one of the treasures of Musée du Louvre, the vast former royal palace in Paris.

There have been, and continue to be, many diverse theories about alternative identities for the sitter, driven not least by an implicit sense that she should be more mysterious, exotic, socially elevated, or even more scandalous than Francesco's blameless and bourgeois wife. But the most straightforward and traditional identity of her as Lisa del Giocondo fits the bare facts with the least strain.

From Poetry to Philosophy

Is the *Mona Lisa* a portrait? This seems a silly question, particularly in the light of what we have said so far. However, if we ask the question in an expanded form, it becomes more taxing. Is the portrait a functional likeness that falls neatly within one of the categories of Renaissance portraits of women? Portraits served clear functions in the Renaissance. Official portraits of aristocratic women observed certain formal rules, and the sitters in the north Italian courts were often shown in decorous profile. Replicas might well be produced for different castles and palaces, and for sending to other courts. They were often occasioned by special events, most commonly marriage. Their task was to show what the sitter looked like in an impressive manner. Private portraits could be more relaxed in mode and more intimate, like Leonardo's image of *Cecilia Gallerani* (the *Lady with the Ermine* in Cracow). Frequently the more intimate portrayals of 'beloved ladies' picked up on the imagery in Renaissance poetry, which in the wake of Dante and Petrarch had developed a set of conventions to praise the lady's looks and virtue.

Leonardo's portraiture of women was closely associated with poetry, not least at the Sforza court. His portraits of *Cecilia Gallerani* and *Lucrezia Crivelli*, earlier and later mistresses of Duke Ludovico, were both subjects of laudatory effusions by court poets. Back in Florence, Leonardo's thoughts seem to have turned to the great Tuscan author Dante. The imagery in the *Mona Lisa* seems deeply infused with Dantesque metaphors drawn from the poet's *Convivio* (his 'Banquet' of knowledge), written early in the fourteenth century. Dante writes of his idealized beloved,

> Such things appear in her aspect
> As show the joys of Paradise,
> I mean in her eyes and her sweet smile,
> For Love draws them there as to his place.
> They overwhelm this intellect of ours,
> As a ray of light does weak vision.

Dante provided a commentary on his own lines.

> Since the soul operates principally in two features of the face—because there all three natures hold sway, each in its own way—that is, in the eyes and the mouth, then that is where it strives for most adornment and it directs its whole attention to creating beauty there, as profoundly as it can. Delight, I maintain, is generated by these two features, when I say: *in her eyes and her sweet smile*. These two features may be called, by way of a pleasant metaphor, the balconies of the edifice of the body, that is, the soul, in which this lady dwells, because there it often reveals itself, though in a veiled manner. It shows itself in the eyes so clearly that the emotion present there may be acknowledged by anyone who gazes at them intently.

Eyes, smiles, delight, the soul, balconies, and veils. This is the territory of Leonardo's visual poetry in the *Mona Lisa*.

So far so good in terms of Renaissance imagery, although we have to admit that Leonardo's visual expression of the poetic tropes has a wholly special and suggestive quality that refreshes what had become rather stale conventions. The sweet eyes and smile may be stock features of Renaissance poetry, but her very direct glance is something that—according to contemporary codes of good manners—could only be tolerated in an

intimate setting. And for a woman to look into our eyes *and* to react so strongly is very daring, both in life and in art.

But Leonardo moves beyond even the most daring poetic dimension. He takes his portrait into entirely new philosophical realms. The most important of these intellectual dimensions involves the body of the woman and the body of the earth. Leonardo subscribed keenly to the ancient notion of the microcosm and macrocosm.

> By the ancients man was termed a lesser world and certainly the use of this name is well bestowed, because, in that man is composed of water, earth, air and fire, his body is an analogue for the world: just as man has in himself bones, the supports and armature of his flesh, the world has the rocks; just as man has in himself the lake of the blood, in which the lungs increase and decrease during breathing, so the body of the earth has its oceanic seas which likewise increase and decrease every six hours with the breathing of the world; just as in that lake of blood the veins originate, which make ramifications throughout the human body, similarly the oceanic sea fills the body of the earth with infinite veins of water.

We can sense the shared dynamics of the greater and lesser worlds. The meandering river and the snaking form of the dry bed find their counterparts in the tumbling rivulets of Lisa's hair, the cascades of fine silk from the gathered neckline of her dress, and the spiral flow of her diaphanous scarf. Her body is by implication vivified by the irrigation system of her blood vessels just as the earth is nourished by what Leonardo called the 'vene d'acqua' ('veins of water') in the 'body of the earth'. These phrases play a central role in the Codex Leicester, owned by Bill Gates, which spells out in the most dramatic manner Leonardo's revolutionary views of the great convulsions that have shaped the 'body of the earth' over vast tracts of time.

One of his most remarkable conclusions, based on his observation of the strata of rocks and shells in the Arno Valley, was that there once had been

> 2 large lakes, the first of which is where now the city of Florence is seen flourishing together with Prato and Pistoia . . . In the upper part of the Arno valley, above here, as far as Arezzo, a second lake was generated, which emptied its waters into the above-mentioned lake, enclosed about where we now see Girone; and it occupied all the mentioned upper valley for a space of 40 miles in length.

Leonardo had become deeply engaged with the geology of the Arno Valley when he was plotting a great arching canal to link the Arno at Florence to the navigable section of the river nearer the sea (Fig. 5.2). It covers the area where the first of the two ancient lakes were once located. His map, with its scale at the bottom, shows the projected canal pursuing a route similar to that of the modern *autostrada* A11, which passes close to Prato and Pistoia. To call the image a map seems inadequate; it conjures up a vision of the extraordinary dynamism that characterizes the living 'body of the earth'. In lectures I have referred to it as 'the Jackson Pollock of the map-maker's art'.

The high lake behind Lisa's head and the lower body of water above her left shoulder show an arrangement analogous to that he describes in prehistoric Tuscany. The landscape is not a literal illustration of his theory. Nor is it a 'portrait' of a specific contemporary location. Rather it is a remaking of the 'body of the earth' informed by Leonardo's deep understanding of how human and geological bodies work.

Fig. 5.2

Leonardo da Vinci, *Map of the Arno Valley West of Florence Showing the Projected Canal*, Windsor, Royal Library 12279.

At one level, Leonardo's picture is a portrait of Francesco's wife. At another it has become a philosophical mediation on the nature of the earth and the nature of a human being.

This is not even to discuss other aspects of 'natural philosophy' that infuse Leonardo's portrayal of Lisa: the optics of the impact of light on the curved surfaces of her facial features; the way that a young woman's flesh lies smoothly over her muscles and bones; the soft atmospheric perspective and blue tinge of the distant mountains; and his notion of the eyes as the 'windows of the soul'. Leonardo developed theories for all such things, and for many others.

In these respects Leonardo has taken his picture out of the territory of functional portraiture and into the realms of human and natural philosophy. It is this profoundly multi-valent quality that viewers have intuited and re-interpreted over the centuries. There is so much that has gone into the image of the woman in a landscape that we can continue without apparent limit to draw nourishment from it, like a deep well of knowledge—or like an endlessly satisfying 'banquet' of human understanding, to use the analogy in the title of Dante's *Convivio*. It is not surprising that Leonardo found it impossible to part with his most visually beguiling and most philosophically profound creation.

The Irresistible Rise of *La Joconde*

There are a good number of early copies of the *Mona Lisa*. This is exceptional for a portrait of someone who was not from the ruling classes. It suggests, as the Salaì inventory confirms, that the portrait was soon valued as a *picture*, not just as a likeness of a particular individual. This would be exceptional for a portrait at this date—with the possible exception of portraits by Giorgione in Venice. This quality may help explain why Giuliano de' Medici wanted it for himself, if the 1517 report is to be believed. Most of the copies seem to come from France or elsewhere in northern Europe, but Leonardo's innovatory portrait exercised a notable impact in Italy. Raphael, who seems to have enjoyed some kind of privileged access to the older master, translated Leonardo's image into a form that worked less eccentrically for 'normal' portraiture. By affecting Raphael, initially in his picture of *Maddalena Doni*, the *Mona Lisa* exercised an impact on the whole of European portraiture.

The picture also lived in the written word courtesy of Giorgio's Vasari's vivid and imaginative account in his *Lives of the Most Excellent Painters, Sculptors and Architects* in 1550 and 1568. The great biographer-painter-architect may never have seen the original, but he knew a good number of people who had, including the Giocondos. He well understood that it had a special life-force.

> Leonardo undertook to make for Francesco del Giocondo, the portrait of Mona Lisa, his wife; and after labouring on it for four years, he left it unfinished; this work is now in the possession of the King Francis of France at Fontainebleau. In this head, anyone who wishes to see how closely art could imitate nature, may comprehend it with ease; for in it were counterfeited all those tiny things that only with subtlety can be painted, seeing that the eyes had that lustre and watery shine which are always seen in life, and around them were all the bright roseate tints of the skin, as well as the eye lashes, which cannot be done without the greatest subtlety. The eyebrows, through his having shown the manner in which the hairs arise from the flesh, where more thick and where more sparse, and curved following the pores of the skin, could not be more natural. The nose, with its beautiful nostrils, rosy and tender, seemed to be alive. The mouth, with its aperture and its ends united by the red of the lips to the flesh-tints of the face, truly seemed to be not colours but flesh. In the pit of the throat, if one gazed upon it intently, one could see the beating of the pulses; in truth it may be said that it was painted in such a manner as to induce trembling and fear in every valiant craftsman, whoever he is. He also made use of this strategy: since Mona Lisa was very beautiful, he always retained, while painting her portrait, persons to play or sing and jesters, who continuously made her cheerful, in order to take away that melancholy that painters often tend to give to the portraits that they make. And in this work of Leonardo's there was a smile so pleasing, that it was a thing more divine than human to witness; and it was held to be something marvellous, since it was not other than alive.

Vasari's estimate of four years for its completion may be a little kind on Leonardo.

During its centuries in the French royal collection it seems to have been just one treasure amongst many. Raphael, Titian, and Rubens, whose works were more plentiful and less puzzling than Leonardo's, were accorded the highest rank, with the great Bolognese painters of the early

Baroque, especially the Carracci family, close behind. An exceptional centre of interest in Leonardo was the English royal court of Charles I and Henrietta Maria. Leonardo's *St John the Baptist* (now in the Louvre) and *Salvator mundi* were amongst their most prized possessions. In 1625 Charles hoped to trade both Hans Holbein's *Erasmus* and a *Holy Family* by Titian for the *Mona Lisa*. Cardinal Richelieu was amongst those who dissuaded Louis XIII from accepting the tempting offer. The British seemed to have retained a soft spot for Leonardo, and the first President of the Royal Academy, Sir Joshua Reynolds, was proud to think that the copy he owned was actually the original. He was not the last to be so deluded by a good copy.

It may have been the picture's relative lack of prominence in the eighteenth century that permitted its escape from the clutches of the royal picture restorers, who embarked on an innovatory but hazardous campaign to transfer the pigment and priming layers of noted paintings from panel to canvas. Leonardo's *Virgin of the Rocks*, a larger and more elaborate painting, was less fortunate.

In 1797, after the execution of the French King, the *Mona Lisa* was included in Jean-Honoré Fragonard's list of works to be transferred from Versailles to the revolutionary regime's new public museum in the Louvre. Interest grew. Leonardo's life itself became the subject of paintings, not least by the aspiring leader of the traditionalist faction, Jean-Auguste-Dominique Ingres, who in 1818 showed the grey-bearded *magus* from Vinci limply exhaling his last breath in the arms of Francis I—based upon the appealing fiction retailed by Vasari (Fig. 5.3). It was Ingres who facilitated the making of a very careful and exceptionally subtle drawing by Luigi Calamatta in 1826. When the resulting mezzotint was eventually published in 1855 it did much to broadcast the extraordinary qualities of Leonardo's picture, alongside the new photographic reproductions that were beginning to diffuse knowledge of famous masterpieces on an international basis.

The mysteries of the *Mona Lisa* struck a chord with a mid-nineteenth-century generation who were preaching the value of aesthetic sensibility as an intangible manifestation of the human spirit at its most refined level. We cannot do better in this respect than look at the account of that notable English aesthete Walter Pater.

What was the relationship of a living Florentine to this creature of his thought? By what strange affinities had the dream and the person grown up thus apart, and yet so closely together? . . .

Hers is the head upon which all 'the ends of the world are come,' and the eye-lids are a little weary. It is a beauty wrought out from within upon the flesh, the deposit, little cell by little cell, of strange thoughts and fantastic reveries and exquisite passions . . .

She is older than the rocks among which she sits; like the vampire, she has been dead many times, and learned the secrets of the grave; and has been a diver in deep seas, and keeps their fallen day about her; and trafficked for strange webs with Eastern merchants; and, as Leda, was the mother of Helen of Troy, and as Saint Anne, the mother of Mary . . .

However much we may smile indulgently at Pater's verbal embroider-ies, excerpted here from a longer account in *The Renaissance* (1869), he

Fig. 5.3

Jean-Auguste Dominique Ingres, *Leonardo Dying in the Arms of Francis I*, 1818, Paris, Musée de la Ville de Paris.

uncannily sensed that the relationship between the woman and the landscape lay at the heart of the picture's deep appeal. He also intuited that it was a philosophical picture not a merely naturalistic one.

The major episode in the painting's ascent to fame in the twentieth century was its theft. On 21 August 1911 Leonardo's masterpiece had been replaced by a grubby space with four vacant hooks on the wall of the Salon Carré (Fig. 5.4). The police responded by rounding up a prominent group of artistic suspects, led by the anarchic poet Guillaume Apollinaire and his close friend Pablo Picasso, who had previously received some pieces of Iberian sculpture stolen from the Louvre. A photograph shows them sitting with other suspects in a glum row, before the police decided to release them. During the next few days, the queues to see the unedifying gap seem to have been longer than those to see the masterpiece while it was still *in situ*.

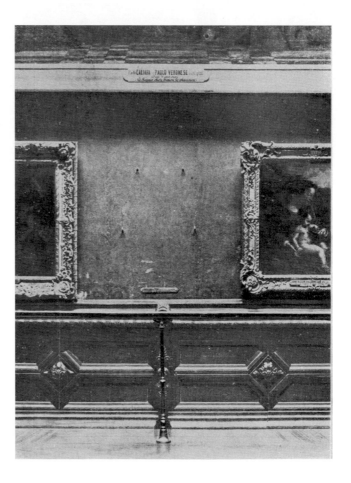

Fig. 5.4

The *Mona Lisa* vanished.

The actual thief, as it transpired over two years later, was an impoverished Italian, Vincenzo Peruggia, who was amongst those being employed to place glass in the frames of important paintings, including of course the *Mona Lisa*. He smuggled the painting out under his coat. His stated motive was the repatriation of a gem of Italian culture. For some time, his restitution of cultural property got no further than his shabby Parisian flat, where he hid it in a cluttered cupboard. Having failed in 1912 to convince the great art merchant Sir Joseph Duveen that he was the 'owner' of the *Mona Lisa*, he contacted the Florentine antique dealer Alfredo Geri, who was intrigued. Having asked for a modest fee, Peruggia travelled to Florence on 12 December 1913 with the painting in a box, and Geri took little time with the Director of the Uffizi to recognize that it was the original. Peruggia was arrested and the picture impounded. The press broadcast the exciting news internationally.

In the face of a perceived threat that the Italian government would not let the painting leave Italy for a third time, it was officially agreed that the *Mona Lisa* would be displayed in Florence, Rome, and Milan before its return to France. On 4 January 1914, after its brief tour of Leonardo venues in Italy, it resumed its place in the Salon Carré.

When the hapless Vincenzo stole it, the *Mona Lisa* was already famous enough (and small enough) for it to be his supreme target. After its theft and return, its fame was ratcheted up to a level achieved by no other painting at that time. It still occupies that supreme position today.

Barefaced Cheek

The now countless reproductions, copies, remakings, versions, parodies, and satires have been the focus of books and large websites. The production of overtly funny *Mona Lisas* has become something of an industry. Famous, infamous, and insignificant people have been 'Lisa-ed', that is to say their own features have been pasted over her face, with varying degrees of success and incongruity. It has happened to me. It rarely happens with portraits by other artists, and not even with other portraits by Leonardo. Merchandise exploiting the *Mona Lisa* embraces an astonishing range of items, worldwide. Some, like the *Mona Lisa* offered by Wilshire Wigs (a discontinued style!), seem not to have even a tangential reference to the original (Fig. 5.5). Lisa's appearances in literature and other artistic media are legion and frequently laughable. Inevitably the painting played a central role in Dan Brown's

Fig. 5.5

Aderans Hair Goods Inc.,
The Mona Lisa, 2010.

popular but deeply deceptive *The Da Vinci Code*, which misleads people into thinking that it is more than a work of fiction. I suspect that if the book had been about *The Michel Angelo Code*, it would have sold fewer copies.

The insistent copying of Leonardo's portrait, as we have noted, began at a surprisingly early date, and one of the most extraordinary variants was probably generated under his own wing. In the Castle of Chantilly is a large drawing (a cartoon), somewhat damaged but of very high quality, which flaunts her bare torso with its neatly domed breasts (Fig. 5.6). It is executed in black chalk and has been pricked for transfer into a painting. The cartoon is of exactly the kind that the studio developed to produce an output of 'Leonardos'. The braided and curling hair comes very close to Leonardo's own graphic style, as does the elusive definition of the facial contours. Her right wrist and hand work nicely in space, and her redrawn index fingers shows the draughtsman searching intelligently for the most convincing position as it rests on her left forearm. There

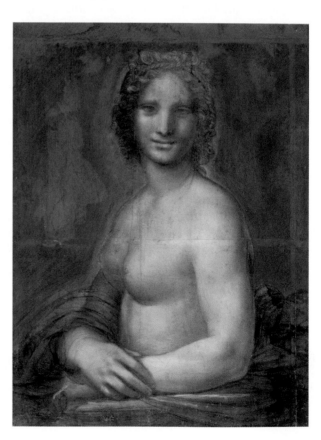

Fig. 5.6

Leonardo Studio,
Madonna Vanna, cartoon,
c.1518, Chantilly,
Musée Condé.

seems every chance that the cartoon was made while Leonardo was alive and with his participation. Indeed it very much has the feel of one of his own *invenzioni*. The main draughtsman would have been someone in Leonardo's inner circle, perhaps Francesco Melzi, the master's most favoured amanuensis.

The invention caught on and provided a starting point for numerous painted variants (Fig. 5.7). The illustrated version from the Hermitage in St Petersburg is close the cartoon and shows the naked sitter in front of a reasonably convincing panorama of blue mountains. It is not too remote from Leonardo. One of the painted versions may be the 'mezza nuda' in

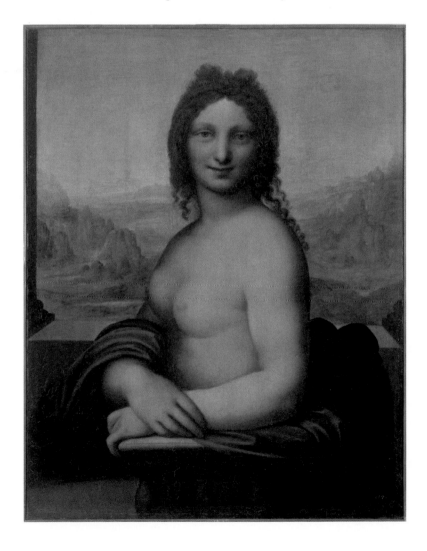

Fig. 5.7

Unknown artist, *Madonna Vanna*, c.1520, St Petersburg, Hermitage Museum.

the Salaì inventory, valued at 25 *scudi*. The nude Lisa later features in the Fontainebleau collection as the *Madonna Vanna* or *Monna Vanna*—a name that features in early Italian love poetry, and may carry the connotation of 'vain'. The lowish value in the Salaí list, one quarter of that of *La Gioconda*, suggests that the painting was not an autograph Leonardo.

The *Monna Vanna*'s direct glance and knowing smile, always challenging in the original portrait, now serve as a conscious provocation, to rival Goya's *Nude Maja* in the Prado (also portrayed clothed) and even Manet's *Olympia*. We certainly cannot think that the *Madonna Vanna* literally shows Mrs del Giocondo smiling at us without any clothes on, and we have seen that the 'portrait' itself seems to have assumed life as a 'picture' independent of any link with the sitter. The naked *Mona* sometimes sits in front of the familiar kind of mountainscape, as in the Hermitage picture, while at others she is accorded a dense backdrop of flowering plants. In the latter case, she may well be assuming the guise of the goddess Flora, which at least provides its owner with a learned excuse for putting the picture on display.

Leonardo's seated and daring nude was highly influential. Raphael's so-called 'Fornarina' (Galleria Nazionale d'Arte Antica, Rome), who softly touches one of her pert breasts, and numerous Venetian paintings of half-length beauties by Titian, Palma Vecchio, and others, stand in line of descent from Leonardo's invention. Most directly in France, the prime painted version (now seemingly lost, unless it is that in the Hermitage) triggered a series of overtly sexy pictures by French painters of Diane de Poitiers, the stylish mistress of Henri II, of other women of the court, and of unspecified beauties. The slender 'ladies' are typically seen from the waist up in baths or behind tables seething with jewels. The visibility of their bodies is frequently emphasized by diaphanous veils that alight wispily on their pearly nipples.

The internet is now rife with more or less pornographic versions of *Mona Lisa* that make the once-extreme *Monna Vanna* seem positively coy. The modern strain of overt vulgarity was set in train by Marcel Duchamp's famous defacing of a card of the Louvre masterpiece (Fig. 5.8). Adorned with a jaunty moustache and goatee beard, she is given the enigmatic inscription 'L.H.O.O.Q.'. If the names of the letters are read out with a degree of elision, we hear *Elle a chaud au cul*, which means 'she has a hot bum [or ass]'. Thus *Mona Lisa* takes her place beside the famed urinal as a sacrilegious ready-made.

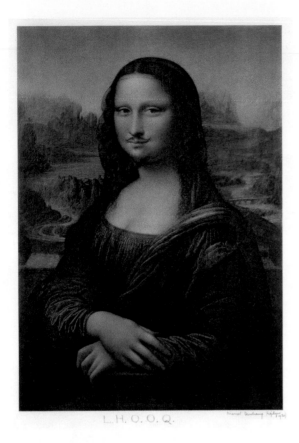

L.H.O.O.Q.

Fig. 5.8

Marcel Duchamp,
L.H.O.O.Q, 1919, New York,
private collection.

One website, megamonalisa.com, boasts almost 50,000 variants at the time of writing, a number that is growing daily. I confess that Kempa Lisa is amongst the massed ranks of horrors. Photoshop makes it all too easy. I particularly like *Mona an Icon* posted by René Design of the Netherlands (Fig. 5.9), along with 264 other René variants ranging from louche to lewd. It serves to demonstrate that the direct glance of Lisa shares much in common with an archetypal icon, even if the edges of her facial contours are a bit too soft to marry with the traditional style.

Inevitably this iconic painting of all iconic paintings attracted the repeated attention of that great 'iconizer' of icons, Andy Warhol. His 1963 silkscreen print (with added paint) *Thirty are Better than One* captures both the remorseless serial repetition of the image and its often debased transmission (Fig. 5.10). Lisa's expression becomes positively sinister in such a sooty mode. Warhol's thirty *Mona Lisas* seems to have been precipitated by the arrival of the celebrity masterpiece in the USA. On a visit to Paris in

Fig. 5.9.

Mona an Icon, René Design.

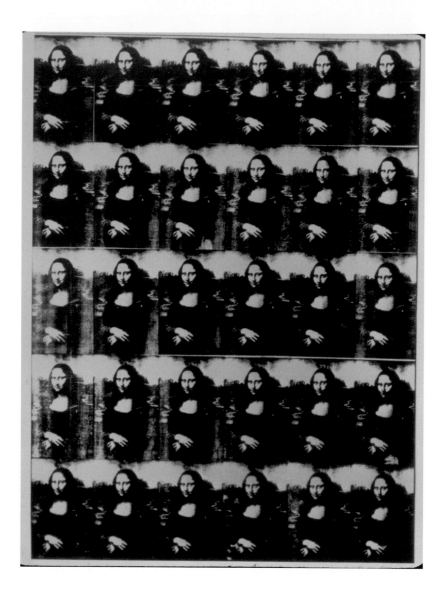

Fig. 5.10

Andy Warhol,
Thirty are Better than One,
private collection.

May 1961, the Francophile Jacqueline Kennedy, who spoke very adequate French, charmed both President de Gaulle and his famed culture minister André Malraux. One consequence of Jackie's personal success was the controversial loan of the *Mona Lisa* for showings in Washington and New York during 1963 (Fig. 5.11). What glittering and courtly company for the wife of a long forgotten Florence silk merchant! In the event, it was clear that Jackie had more than met her match, while Vice-President Johnson seems transfixed. The President himself looks like a bit-player.

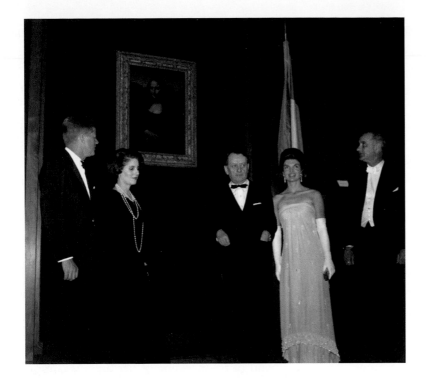

Fig. 5.11

Robert Knudsen, *President Kennedy, Mme Malraux, André Malraux, Jackie Kennedy and Vice-President Johnson at the Unveiling of the Mona Lisa, National Gallery of Art, Washington*, 8 January 1963, Boston, John Fitzgerald Kennedy Presidential Library.

Why?

After lectures and during interviews I am frequently asked, 'Why is *Mona Lisa* so famous?' It is not a question to which I have ever given an entirely satisfactory answer, and I do not realistically expect to do so here. However, we can at least highlight some of the complexly interlocking factors that help us work towards an explanation. Just to say that she is famous for being famous is not enough.

The first and foundational property must be the extraordinary quality of the painting in its own right. The sense of presence that I felt on that early spring day in the Louvre is incredibly strong and somehow survives even debased reproduction. The intensity of human communication between the sitter and the spectator, something that remains a matter of subjective reaction, has undeniably made a powerful impact on very diverse kinds of spectators over the years.

There is also something endlessly enigmatic about an image that hovers between the particularity of a portrait, as a likeness of an individual, and the archetype of woman that operates in some generalized kind of

way. We can, even without analysis, sense that Lisa stands for and has been transmuted into a representative of enduring human qualities.

The interplay between outer glance, communicative smile, and the implied inner motions of thought is also key to her impact. The contours of her outer expression are ultimately elusive, as if under a Dantesque 'veil', and require the spectator to *complete* the definition of the precise form in a non-prescriptive way. There is an essential generosity in letting the spectator in. Great artists know how to do just enough to entice us into the game of completing their image. They know when to stop spelling everything out. There is no set formula for this, and every artist has to discover it on their own terms. It is this lack of absolutely defined form that explains why copies invariably miss the expression of the original.

The microcosmic echoes between the bodies of the woman and the earth also play a large role, as Pater sensed. This sensing is not dependent on actually knowing what Leonardo wrote about the geological and physiological analogies, but knowing certainly helps give substance to the intuition.

We should not overlook the miraculous, singing details. These are now visible to all in the best of the enlarged reproductions. Let us take just one example. The upper band of the neckline of her dress is composed from interlocked golden rings of thread edged with coiled braid. Below it runs a subdued version of one of Leonardo's beloved knot designs, which appears to lie over a finely tucked, subtle, and diaphanous layer of cloth—presumably of the finest silk that ever passed through Francesco's hands. This layer lies over the thicker cloth of the main body of her dress. Leonardo was a slow painter and had an ethical concern to get everything piously right with respect to its material and optical effects. Physics and delectation go hand in hand.

Normally Renaissance sitters were portrayed either in well-observed contemporary costumes or in overtly idealized garments in a Romanizing manner. Lisa's dress and veils, like her very person, seem to hover between the real and the ideal. Here as in the whole the oscillation between the particular and general is crucial to the overall effect. The landscape is both based upon searingly intense observations of geology and is an unabashed product of Leonardo's cherished *fantasia*. The real and the imagined are bridged just as surely as the arched bridge passes over the valley behind her left shoulder. Everything in the picture is passing through the space and time that Leonardo called 'quantita continua' (continuous quantity)—acknowledging that a moment in time has no more material

existence than a mathematical point. The spectator need not invade such recondite areas of Leonardo's thought to feel that the moment of time is both specific and universal, like everything in the picture.

. . . I still doubt that I am quite there in answering the question. And readers can amplify my account. At the end of the day, it is just a truly incredible creation.

Reading

The volume of writing on the *Mona Lisa* is unsurprisingly huge. I have concentrated here on sources that provide: primary evidence; technical analysis; narratives of the later history; and compilations of variants.

http://www.megamonalisa.com/.

http://www.studiolo.org/Mona/MONALIST.htm.

Robert Baron's *Mona Lisa* site.

S. Bramly, *Mona Lisa*, London, 1996.

A. Chastel, *L'Illustre incomprise, Mona Lisa*, Paris, 1988.

K. Clark, Leonardo da Vinci, ed. M. Kemp, London, 1993.

L. de Viguerie, P. Walter, E. Laval, B. Mottin, and V. A. Solé, 'Revealing the Sfumato Technique of Leonardo da Vinci by X-Ray Fluorescence Spectroscopy', *Angewandte Chemie*, International Edition, 49, 2010, 6125–8.

C. Farago (ed.), *Leonardo's Writings and Theory of Art*, 5 vols., London, 1999.

M. Kemp, *Leonardo da Vinci: The Marvellous Works of Nature and Man*, Oxford, 2006.

R. McMullen, *Mona Lisa: The Picture and the Myth*, London, 1976.

P. Marani, *Leonardo da Vinci: The Complete Paintings*, New York, 2003.

J.-P. Mohen, M. Menu, and B. Mottin, *Mona Lisa: Inside the Painting*, New York, 2006.

G. Pallanti, *Mona Lisa Revealed: The True Identity of Leonardo's Model*, Turin, 2006. The key documents for Lisa's life.

D. Sasson, *Becoming Mona Lisa: From Fine Art to Universal Icon—The Incredible Story of the World's Most Famous Painting*, San Diego, 2003.

A. Schlechter, 'Leonardo da Vinci's "Mona Lisa" in a Marginal Note in a Cicero Incunable', in *Early Printed Books as Material Object*, ed. B. Wagner, Berlin and New York, 2011, 151–76.

M. R. Storey and D. Bourdon, *Mona Lisas*, New York, 1980.

A. R. Turner, *Inventing Leonardo*, New York, 1993.

E. Villata, *I documenti e le testimonianze contemporanee*, Milan, 1999.

F. Zöllner, *Leonardo da Vinci, Mona Lisa, das Porträt der Lisa del Giocondo, Legende und Geschichte*, Frankfurt, 1994.

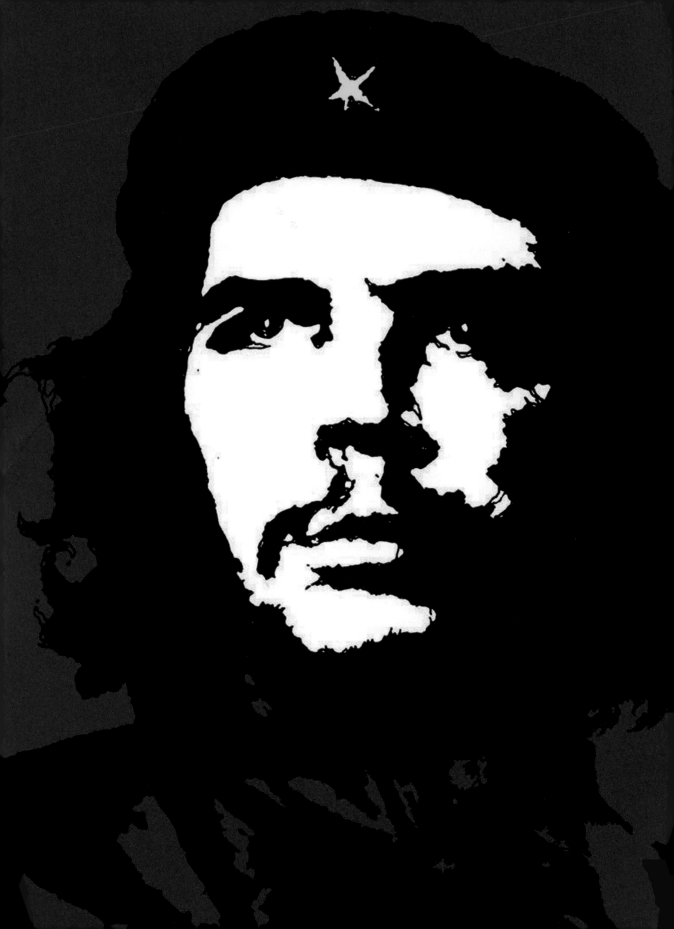

Che

The most complete man of his age; he lived his words, spoke his actions, and his story and the story of the world run parallel.

(Jean Paul Sartre)

CHE GUEVARA HAS BECOME the romantic embodiment of youthful idea-lism and passionate rebellion. He is hailed as a free spirit who committed his life selflessly to the causes of the downtrodden and underprivileged. As the Cuban President Fidel Castro said, 'his ideas, his portrait, and his name are banners in the struggle against injustice by the oppressed and exploited

■ Jim Fitzpatrick, *Che Guevara*, detail, 1978.

and they arouse passionate enthusiasm in students and intellectuals everywhere'. The French philosopher Sartre, whom we quoted at the beginning, was just one of the international intellectuals who were captivated.

Like the movie star James Dean, famed for his role as Jim Stark in Nicholas Ray's *Rebel without a Cause* and who died in a car crash in 1955 at the age of 24, Che attracted a new kind of mass teenage audience. The key difference was that Che was very much a rebel with a cause, and drew in a new generation of students who were being politicized, not least by the unpopular war in Vietnam.

Dying the messy death of a military martyr in Bolivia at the age of 39, fighting for a lost cause, has done Che's legend no harm. Unlike other successful revolutionaries, such as Castro, he avoided the ambiguous fate of turning into the long-term political establishment. Perpetually youthful as a 'saintly' figure, Che in his legendary guise has become detached from the ugly realities of South American politics during the 1950s and 1960s.

The image we have of him is indelibly associated with the photograph by Alberto Díaz Gutiérrez, who called himself Korda, after the famed film director Alexander (Fig. 6.1). The name appealed to Gutiérrez because it sounded like Kodak. Korda's photograph has been reproduced endlessly, often in a very degraded manner, and has provided the basis of huge numbers of derivative images in almost every visual medium. The literature on Korda and Che regularly asserts that it is the world's best-known photograph.

Yet there is another story being told, the story of Che as a doctrinaire communist committed to the achieving of totalitarian control by whatever means were available. It is a story vigorously retailed by the right in America, who are incensed by the ubiquitous diffusion of Che's legend far beyond the narrow confines of American socialism. A Cuban exile, Humberto Fontova, leads the attempts to ferment the counter-legend. On a web journal, *Ruthfully Yours: The Right News, Front and Centre*, he repeats what he has written elsewhere.

'When you saw the beaming look on Che's face as the victims were tied to the stake and blasted apart by the firing squad,' said a former Cuban political prisoner, to your humble servant, 'you saw there was something seriously, seriously wrong with Che Guevara.' As commander of the La Cabana execution yard, Che often shattered the skull of the condemned man (or boy) by firing the coup de grace himself . . .

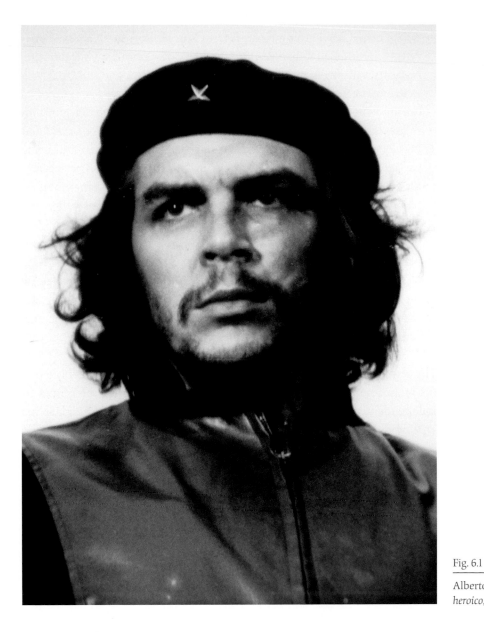

Fig. 6.1

Alberto Korda, *Guerillo
heroico*, 5 March 1960.

Even as a youth, Ernesto Guevara's writings revealed a serious mental
illness. 'My nostrils dilate while savoring the acrid odor of gunpowder and
blood. Crazy with fury I will stain my rifle red while slaughtering any *vencido*
[vanquished person] that falls in my hands! With the deaths of my enemies
I prepare my being for the sacred fight and join the triumphant proletariat

with a bestial howl!' This passage is from Ernesto Guevara's famous *Motorcycle Diaries*, though Robert Redford somehow overlooked it while directing his heart-warming movie . . .

Rigoberto Hernandez was 17 when Che's soldiers dragged him from his cell in La Cabana, jerked his head back to gag him, and started dragging him to the stake. Little 'Rigo' pleaded his innocence to the very bloody end. But his pleas were garbled and difficult to understand. His struggles while being gagged and bound to the stake were also awkward. The boy had been a janitor in a Havana high school and was mentally retarded. His single mother had pleaded his case with hysterical sobs. She had begged, beseeched and finally proven to his 'prosecutors' that it was a case of mistaken identity. Her only son, a boy in such a condition, couldn't possibly have been 'a CIA agent planting bombs.'

'FUEGO!' and the firing squad volley shattered Rigo's little bent body as he moaned and struggled awkwardly against his bonds, blindfold and gag. Remember the gallant Che Guevara's instructions to his revolutionary courts: 'judicial evidence is an archaic bourgeois detail.'

The semi-fictional mode adopted by Fontova, the vitriol of his polemic, his reliance upon jaundiced witnesses, and the dearth of references to independently documented evidence in his two books on Che place his writing outside the category of analytical history—but equally it can be claimed that the popular legend of Che has little to do with an objective history of his life. There are more traditionally academic voices that question the legend. Paul Berman, a respected historian, political commentator, and maverick liberal intellectual with strong hawkish tendencies, reacted adversely to the romantic sweetness of Robert Redford's 2004 film of Che's student expedition, *The Motorcycle Diaries*. Berman declared that 'the cult of Ernesto Che Guevara is an episode in the moral callousness of our time. Che was a totalitarian. He achieved nothing but disaster.'

In this chapter I am not concerned to arbitrate in the often bilious disputes about Che's virtues and vices—both of which are much in evidence in the historical record. Rather I will look at key episodes in how the familiar visual image acquired its extraordinary status. I should say, however, that my personal admiration for his idealism, not least in the context of some poisonous regimes in the Americas of his time, is tempered by a realization that his devotion to the establishing of a Soviet-inspired rule

violates freedoms that I hold dear. I suspect that most of those who wear Che T-shirts and cherish other memorabilia also subscribe to these freedoms.

Not a Cuban but a Che

Che was Argentinian. 'Che' is used in the sense of 'boy' or 'mate', and tends to be applied generically to Argentinians elsewhere in Latin America. Its familiarity became an integral part of Che's personality, and he adopted his nickname with relish. It has a compact informality in its spoken and written forms that makes it much easier to handle on a worldwide basis than long and polysyllabic Spanish names. 'Ernesto' is a less effective rallying cry than 'Che'. It is notable that Guevara is almost always Che, whereas Castro is not routinely Fidel.

The full-dress version of his name was Ernesto Guevara de la Serna. The 'de la Serna' comes from the well-bred Spanish family of his mother Celia. His father's name, Ernesto Guevara Lynch, signals the dual Spanish and Irish components in his ancestry. Che's grandmother was Ana Lynch. Much was later to be made of this Irish dimension. The younger Ernesto was born in Rosario, Santa Fe, in Argentina in 1928. It comes as a something of a shock to realize that he would now be 83. In his student years, before graduating as a doctor he embarked on motorbike journeys through Latin America. The major expedition with his friend Alberto Grandos was immortalized in Redford's film. The existence and nature of Che's diaries indicate that the young Ernesto was already highly self-aware and was gaining a precocious sense that he was destined for something special. His direct experience of deprived communities mingled with his extensive reading in political theory to consolidate his socialist beliefs.

Che was already exhibiting definite literary gifts:

> The huge figure of a stag dashed like a quick breath across the stream and his body, silver by the light of the rising moon, disappeared into the undergrowth. This tremor of nature cut straight through our hearts.

And he emerged with heightened social awareness:

> I have travelled through entire Latin-America and I know this continent very well. I have seen poverty, famine, diseases, the impossibility to cure a child

because of lack of medication, the apathy and dull resignation caused by famine and continuous oppression.

A key moment in his political career came in Mexico in 1954, when he fell in with the Cubans Fidel and Raúl Castro. Two years later, they embarked on the guerrilla campaign that finally resulted in their triumphal entry into Havana on 1 January 1959. Che occupied various key financial and industrial posts in Castro's socialist administration and travelled on behalf of the new regime seeking overseas support in the face of escalating American economic pressure. It was he who spoke on Cuba's behalf at the United Nations. Invasion or American-inspired counter-revolution seemed likely as relations with the USA deteriorated, and the Cubans sought to increase their stock of arms. A freighter, *La Coubre*, carrying 76 tons of ammunition from Belgium, was being unloaded in the harbour on 4 March 1960, when the lethal cargo was detonated in two successive explosions, killing seventy-five or more. American involvement was inevitably assumed. The next day, Castro as President organized a great rally near the Colón Cemetery (named after Christopher Columbus) to mourn the 'martyrs' and to make a political point to the wider world. A platform was erected in the broad street from which Castro was to deliver his lengthy address.

He delivered an extensive account of the circumstances of the explosion and the resulting deaths.

> It was yesterday afternoon when we were all busy doing our work: the blue collar workers, the civil servants, the government officials, the members of the Revolutionary armed forces and the students; in other words, we were all busy, working on our great tasks which we have ahead of us; and then suddenly a gigantic explosion shook our capital . . .

He eulogized the 'ordinary' heroes of Havana.

> Anyone who saw what the Cubans did yesterday; anyone who saw the soldiers, people advance toward danger in order to rescue the injured, in order to rescue the victims from a burning ship, in a zone that was on fire, when nobody knew how many more explosions might occur; anyone who knew of these waves triggered by the explosions, killing more people, not in the first but in the second explosion; anyone who saw how the people behaved

yesterday, anyone who saw the people direct traffic; anyone who saw the people establish order; anyone who saw the people advance toward that explosion which created a tremendous roar, a roar reminiscent of nuclear explosions, anyone who saw the people advance toward that roar without knowing what it was all about—anyone who saw all this can be sure that our people is a people capable of defending itself, a people capable of advancing even into the roar of nuclear bombs.

Castro presented a lengthy forensic analysis of what could have caused the munitions to explode, concluding that it must have been a deliberate act. This act is then attributed to the USA, again at considerable length. Only towards the end does he specifically address the victims.

And as we lower you into your graves at the cemetery, there is one promise that applies to yesterday and today and tomorrow and always: Cuba will not be intimidated, Cuba will not retreat; the revolution will not stop, the revolution will not retreat, the revolution will continue advancing victoriously, the revolution will continue to march irresistibly!

Amongst the platform party were Simone de Beauvoir and Jean Paul Sartre, who were in Cuba to demonstrate French left-wing intellectual support for the revolution. Che, smouldering with rage, was also there, but was only fleetingly visible on the platform. This was the circumstance for Korda's famous portrait.

Seizing the Moment

Before the revolution Alberto Korda had worked his way up from snapping social events to become Cuba's leading fashion photographer. He had an eye for the dramatic shot in natural light and (as he admitted himself) most especially for beautiful women. His second wife, Natalia Menendez known as 'Norka', was his favoured model, and his inspiration as a photographer was Richard Avedon (Fig. 6.2). Korda later visited Avedon in New York and was in effect advised that his photographs of the revolution were likely to be more fashionable than his fashion photography.

Korda was already alert to the savage inequalities in pre-revolutionary Cuba, and when the revolutionaries arrived triumphantly in Havana he turned his skilled lens towards different kind of fashion—the grittier

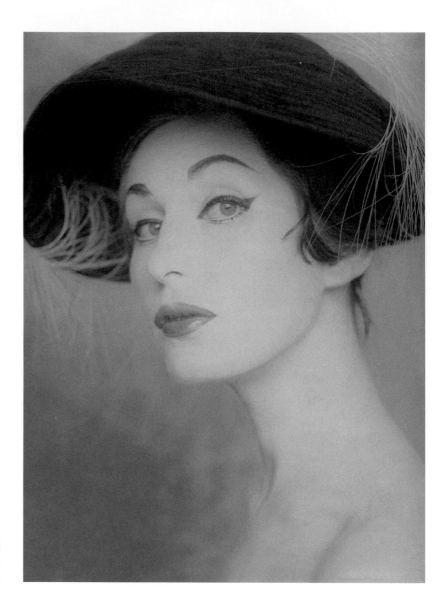

revolutionary mode of battle fatigues, belts, boots, berets, beards, cigars, and guns. Polish was replaced by spit.

The revolutionary leaders became very conscious of the power of photographic images and, not least, their translation into mass-produced posters. The revolutionary leaders, the events, and their social context were immortalized in photography to a notable degree. The major photographer working alongside Korda was Corrales (Raúl Corral Fornos),

who commanded a subtler range of narrative skills than his more direct colleague. A good example of Corrales' sophistication is his stirring 1960 image of the *Cavalry* (Fig. 6.3). Given the historical tradition within which it stands—we may think of Meissonier's heroic paintings of Napoleon and his troops—we may not be surprised to find that it was staged. Not only does the tableau restage the revolutionaries' seizing of a plantation owned by the United Fruit Company a year earlier but it also refers directly to a victory during the Cuban War of Independence in 1895. This kind of photograph works on the principle that it shows the essence and significance of an event rather than recording its precise documentary circumstance. Even in those photographs by Corrales that work as direct documentation, there is very often a sense of implied narrative or allegory.

Compared to Corrales' *Cavalry*, Korda's famed image of Che involved what the photographer himself called 'pure chance'. Korda was at the funerary rally near the cemetery to provide photographs for the newspaper

Fig. 6.3.

Raúl Corrales, *Caballería*, 1960.

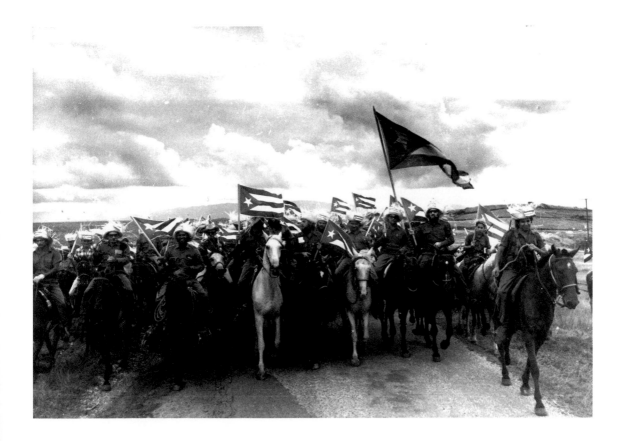

La Revolución. His contact sheet (Fig. 6.4) tells the story rather better than most later accounts. President Fidel Castro, as the prime speaker, was an obvious focus of attention, as were the visiting philosophers de Beauvoir and Sartre. We can see Korda moving in, from relatively distant shots to ones that are more tilted upwards, sometimes framing the heads against the sky. Che is not apparently visible. Then in frame 12 his head is glimpsed elusively behind Sartre. A further eight shots follow before Che reappears as head-and-shoulders between a profile and the fronds of a palm tree. Turning his camera through 90 degrees Korda captured a second image in the 'portrait' rather than 'landscape' format, but an irritating forehead and fringe of hair looms up above Che's right shoulder. Another image of Sartre with a marginal Che is then followed by four night-time frames of Castro. The picture editor of the newspaper decided to run with the images of Castro and the French philosophers.

Such is the obscure, opportunistic, and momentary birth of an iconic image. But can the concept of 'pure chance' be accepted on its legendary terms?

There is a persistent underlying norm or topos in the stories of how the iconic documentary photographs have come about. A key ingredient for the truly 'great' shot is the revered moment of chance, the sudden appearance of a wholly unpredictable picture that the photographer seizes by instinct—even if he or she does not fully realize what has been caught on film. We will see this with many of the photographs in the chapters that follow. Through a mysterious and indefinable act of specifically photographic genius, an iconic image is born, to be recognized either there and then or much later. The stories that surround such 'snaps' involve a strange combination of chance and retrospective inevitability.

Once we start to unpick the circumstances in more detail, the elements of control are clearly greater than the clichéd stories suggest. There are many causes of all kinds—'material', 'formal', 'efficient', and 'final', in Aristotle's terms—that precede and lie behind the shot. There are camera settings, focus, exposure, depth of field, film type and speed, choice of lens, shutter speed, the speed with which successive shots can be made; the photographer's skill, position, the distance from the subject and angle of view, the orientation of the camera to take upright or horizontal (or even tilted) images, the framing, the background, and the foreground. The experienced photographer fully at one with his equipment works rapidly and skilfully within the framework of variables as appropriate in

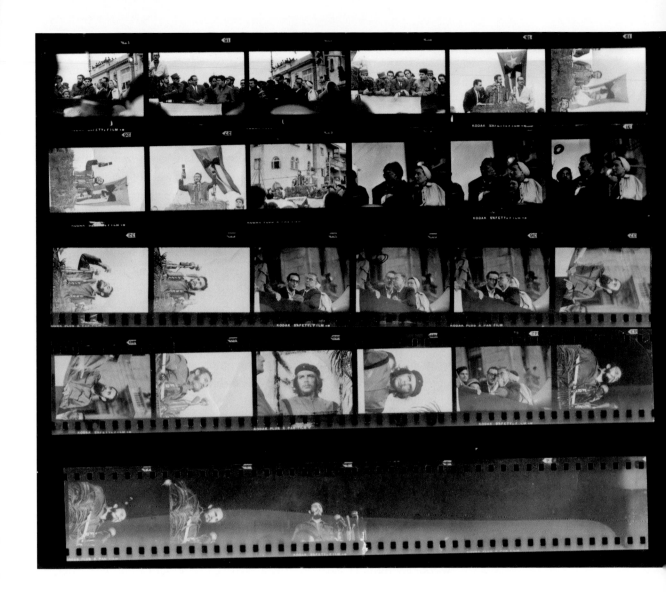

each case. And there are the circumstances of the photographer's engage-ment—what he or she is looking for with respect to their purpose in be-ing there to take photographs. Every act of pointing a camera is literally a pointed act in all kinds of personal and social terms.

 All creative acts involve processes that are apparently instantaneous. At a certain subjective moment Shakespeare must have conceived of writing a play on Hamlet the Prince of Denmark. A moment before, the play was not an idea. A moment later, it begins to develop into a plan. At another

Fig. 6.4

Alberto Korda, contact sheet of 28 frames shot at the rally of 5 March 1960.

time, the playwright decided that a play within a play would serve to tell his stepfather and mother that Hamlet knows the truth. There must have been many such moments in the author's imaginative life during the play's genesis but they are not accessible as a series of staccato decisions when the play becomes a performance, which has a very different temporal base.

The great 'snapshot' is not essentially different from many other creative acts. It is preceded by many decisions—but the act of realization takes place in particular circumstances in which the instantaneous nature of the vision is visibly embedded in the final product, and is understood as such by the viewer. This overt instantaneity gives photography one of its special characteristics. Even so, the final product is often not identical in its positive configuration to the negative image that was inscribed on the film inside the camera. There are all the issues of developing, printing, cropping, reproduction, and copying that transform the image into the one potentially seen by millions. We can see that the portrait with which we are most familiar is not actually the one taken by Korda in the portrait format but is a cropped version of the landscape frame in which Che was originally flanked by the profile and palm.

How the image overlooked for *La Revolución* became so famed will concern us shortly. Before doing so, let us continue exploring the nature of the image. We may recall that Korda first gained a reputation as a fashion photographer. As with any group of people who want to establish an identity, the impact of what was worn by the revolutionaries was highly significant.

Green battle fatigues were paraded in almost all circumstances, most especially in non-military situations that would normally require formal suits with collar and tie (or perhaps a full-dress army uniform). The workaday military garb became a sartorial statement to no less a degree than the glamorous clothes Korda had photographed while working for the pre-revolutionary fashion industry. On the big public occasions the fatigues look more pristine than any that have visited the battlefield. In the standard mode, the trousers were tucked artfully into the high ankles of the boots. Che sometimes let them hang loosely, and he unconventionally wore his shirt outside his belted trousers. His wife said that the loose shirt was better for his asthma. Che was simultaneously able to show that he did not conform to regimentation whilst very much identifying with the fatigue corps of the revolutionaries. On the day of the

speeches Che was also wearing a sleeveless leather jerkin with zip-up front and dark borders at its shoulders. It had been unzipped when he walked through the streets arm in arm with Castro and the other political leaders.

And of course there was the beret with the star. The beret was not standard and became an identifier of Che. Castro favoured a peaked cap. Perhaps the beret carried implications of French bohemia as well as being common enough in armies. In any event, it worked brilliantly in photographs by crowning Che's face, especially if shot slightly from below. It was, as we will see, readily translated into a halo or crown of thorns. The star was that of a *commandante*, the rank accorded to Che by Fidel, who was the supreme commander. Its tiny but insistent brightness became a signal feature of Che's image, particularly in contrast photographs in which the beret serves as a flat black ground. This is the case with Korda's cropped image, though the lowest limb of the star is concealed in a fold in the beret. Every Cuban Catholic knew that Christ was found by following a bright star. The Soviet regime, much admired by Che, adopted a red star as its symbol. And the Cuban flag, indelibly associated with liberation and independence, features at its heart a white star on a red triangle (Figs. 6.3 and 6.7). The associations may be multiple and even contradictory but the mode of triggering potential devotion to a 'shining light' is shared. In the derivative versions of Korda's photograph, the star is normally shown complete and preternaturally bright. Che himself becomes the star in Korda's roll of negatives.

Che also adopted the archetypal Cuban male attribute of the 'Havana' cigar. As a chronic asthmatic he had not smoked before joining Castro. Regular smoking did nothing for his health, and he collapsed with pulmonary emphysema in 1959, after which he seems to have tempered his consumption. But the attribute never lost its potency in images of the Cuban Argentinian. Ironically the image of Che now adorns limited edition cigar boxes, 'humidors', by the Parisian manufacturer Élie Bleu. The asking prices range from £2,000 to £3,250.

Che was very alert to the nature of his appearance in the visual media, exploiting a look that cunningly combined a military aura with sartorial negligence. Like Einstein, who cultivated a similar lack of concern for dressing well, he was sometimes irked at the persistence of photographers' intrusions, but he was fully aware, as was Castro, of the power of photography in conveying his individual image.

A very wide range of those who met Che were deeply impressed by his magnetic beauty and mesmeric eyes. Only the famed Korda image bears this out at the very highest level of visual conviction. His face in other photographs by Korda or those by Raúl Corrales and Alan Oxley tends less unequivocally to confirm Che's famed good looks. We can often see the straggly and sparse nature of his beard, which struggled to achieve the luxuriant coverage of Castro's. The relative thinness of his facial hair tended to sustain a youthful appearance. He did not look like a seasoned fighter. In still and moving images in which we see Che stripped to the waist it is evident that we are not looking at the tautly trained body of a soldier or of a lean and hungry revolutionary—even less that of a leathery peasant who has laboured in the field—as is apparent in one of Alan Oxley's photographs (Fig. 6.5). Che was well aware that he retained something of the look of a university-educated doctor, even though he had undoubtedly endured hard deprivations when fighting valiantly and effectively as a guerrilla commander. In 1957 while in the field, he wrote to his mother

Fig. 6.5.

Alan Oxley, *Che Guevara Helping Workers on a Government Housing Project*, no. 7 in the *Cuban Revolution Collection*, 1962.

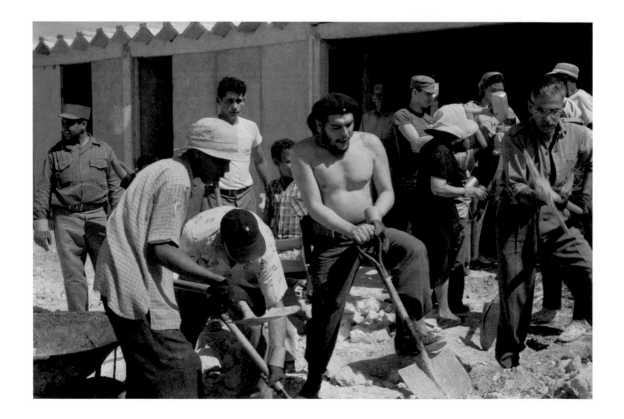

that 'as if I were really a soldier (I'm dirty and ragged at least), I am writing this letter over a tin plate with a gun at my side, and something new, a cigar in my mouth'.

The British-born photographer Alan Oxley was in Cuba for *Life Magazine* in 1962. Arrested on a number of occasions, Oxley was finally imprisoned and accused of espionage. He was released on the intervention of the British government. He had occasion to see a rather different face of the revolution from Korda and Corrales.

The Matrix

How was it that Korda's overlooked frame became what is known as the 'matrix'? The term 'matrix' refers less to Korda's photograph in its own right and more to how its basic configuration has become the template for a range of variants exploiting the key visual signs in the image that stand for 'Che-ness'. Cuba played a key role in the formation of the matrix as we might expect, but Italy and Ireland also contributed significantly to its worldwide diffusion. The political circumstances in Italy and Ireland were important in this respect. The Italian Communist Party was very strong, and there was a good deal of Marxist ferment amongst the radical young, eventually giving birth in 1970 to the Red Brigade, which carried out violent terrorist acts. In Northern Ireland and in Eire there were already signs of the festering discontent in Catholic circles that was to lead to an upsurge in Republican violence in the late 1960s. Italian communism and Irish republicanism both contained strong romantic-heroic dimensions, and a successful revolution in an exotic Latin and Catholic country was deeply appealing at a mythical level. The Cuban context takes priority in our story, even though the Italian and Irish versions arose contemporaneously.

Korda himself valued the shot for its notable expression of visionary resolution, and he produced a 30 × 40 cm print which he kept in his studio. Although it began to appear in the public domain during the next six years, it was Che's Bolivian 'martyrdom' in October 1967 that brought it to full prominence in Cuba. On 18 October Castro mounted a truly massive rally to eulogize Che, whose death was then being formally confirmed. Korda passed the photograph to Frémez (José Gómez Fresquet), the highly inventive and ironic graphic artist, who specialized in using a variety of collage and printing techniques to create posters that scourged capitalist

targets. Frémez worked overnight to produce a screen-printed poster with Che's rallying call: 'hasta la victoria sempre' (ever onward unto victory) (Fig. 6.6). The reduced contrast and the very evident dots of the screen, against the background of the insistently red paper, produce a ghostly effect, evoking a kind of spiritual rather physical presence. At the rally itself a huge, multi-sheet reproduction of Korda's photograph occupied the facade of the Ministry of the Interior, in front of which Castro was to speak. The Ministry now carries a massive metal outline of a more permanent kind by Enrique Avila González (Fig. 6.7). The skilful linear transcription confirms how little of Korda's photograph needs to be retained for Che to be recognized.

Fig. 6.6 Frémez
(José Gómez Fresquet),
Hasta la victoria sempre,
1967.

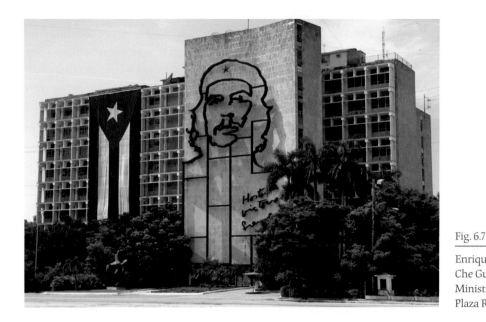

Fig. 6.7

Enrique Avila González,
Che Guevara, Havana,
Ministry of the Interior,
Plaza Revolución.

The Italian propagation of the matrix was the responsibility of Gian-giacomo Feltrinelli, already established as a major left-wing publisher and political activist, who used his personal wealth to help finance the Italian Communist Party. While Che was on his doomed mission in Bolivia, Feltrinelli visited to try to negotiate the release of the French academic and militant left-winger Régis Debray, who was in Bolivia to support the putative revolution. Eventually released in 1970, Debray developed theories about the social consumption and transmission of images, above all in *Transmitting Culture* (2004). Debray's 'mediology', as he called it, is highly relevant to this chapter, and indeed the book as whole, as we will see.

After being expelled from Bolivia, Feltrinelli went to Havana where he sought a good image of Che and was introduced by the authorities to Korda, who showed him the key photograph and gave him two prints. Back in Milan, Feltrinelli produced a photographic poster and began to distribute it in support of Che. In the bottom left-hand corner it carried the copyright legend of the Libreria Feltrinelli but without any mention of Korda. Feltrinelli had seemingly obtained the rights from Castro to Che's *Bolivian Diary*, which he rushed into print following Che's death. The cover of the book used Korda's photograph and the poster was distributed internationally on a massive scale. Figures as high as 2,000,000 have been

mentioned. Korda's subsequent reaction was ambiguous. On one hand he was happy to support the cause and to see his image acquire fame, but he resented its remorseless commercial exploitation by the socialist publisher. Feltrinelli's personal devotion to the extreme socialist cause was not in doubt, however. On 14 March 1972 he died in an explosion at the foot of an electricity pylon near Milan, seemingly killed by the premature detonation of an explosive device that he was himself planting. His publishing house and chain of bookshops outlived him and continue to flourish today.

The originator of the Irish Che could hardly come from a more different background from Feltrinelli. In 1963 Jim Fitzpatrick, its creator, was a teenage barman in the Maritime Hotel in Kilee, County Clare, when Che walked in, on a brief stop-over. This sounds like a legend but Fitzpatrick confirms that it is true. Five years later as an adventurous young graphic artist of radical convictions—'a committed, confused Catholic Marxist hippie', in his own words—he created the three-tone poster of Che that was the precursor of so many others. His first image of the revolutionary, undertaken for but not published in the Irish magazine *Scene*, was in an Art Nouveau-Celtic-psychedelic manner replete with mystic swirls. It was produced in June–July 1967 a few months before Che's death and was based on Korda's photograph. Fitzpatrick recalls that he had obtained a copy of the photograph from the Dutch anarchist group Provo. Korda's photograph was seeping into wider public awareness and was reproduced to accompany an article on *Les Guérilleros* by Jean Larteguy in *Paris Match* in August 1967.

Fitzpatrick printed about 1,000 copies of a poster variation on the swirly image, which he distributed free: 'I mailed it off to every U.K. publication and publisher I could think of.' One was displayed in the offices of the satirical magazine *Private Eye* and came to the notice of the London art world, with the result that he was invited to participate in a London exhibition called *Viva Che*. He produced a poster for the show, a painting (now lost, along with other material sent to the exhibition), and other variants. He distributed his posters via a short-lived company he set up for the purpose—in the face of vicious threats that he believed came from Feltrinelli, who was wrongly claiming copyright in the original Korda photograph. Fitzpatrick himself did not know at that stage who was the photographer of the original.

It was the image that Fitzpatrick produced for the poster of the exhibition held at the Arts Laboratory in London that has proved to be extraordinarily powerful and enduring (Fig. 6.1). It exploited the kind of linear, tonal, and colouristic schematization that had been pioneered by Andy Warhol in his paintings and prints of cultural icons such as Marilyn Monroe.

I re-drew the photograph . . . I wanted it to look photographic but I drew it by hand, on Litho film. I wanted it to look stark so put it on a red background, but if you saw the artwork, all you saw was a flat black with a center cutout for the face . . . you work in black and white and then you print it in any color you like, basically. So that was printed then in one color black and one color red, and I decided that the star should be yellow, so I painted that in [by hand] with a magic marker.

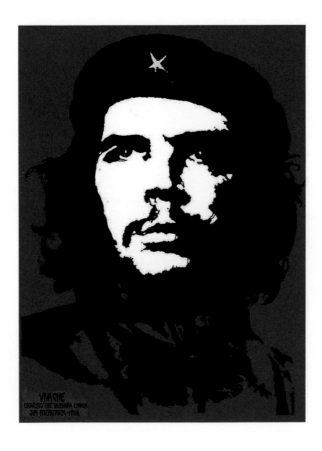

Fig. 6.8

Jim Fitzpatrick,
Che Guevara, 1968.

Frustratingly for its creator, Fitzpatrick's authorial logo had been eliminated in the version that conquered the public imagination—a fate of anonymity he shared with Korda. The icon had become anonymous, like a stock image of Christ on a Catholic postcard available in a local church.

The Irish–Cuban axis has proved to be of considerable romantic potency, not least in Northern Ireland. Che became an almost inevitable hero of the Republican movement, including the radical 'Provos' who perpetrated the most violent of the terrorist acts in Belfast and elsewhere. He featured conspicuously in the murals that were such potent visual weapons for the Republicans and Loyalists alike. In 1998 during the West Belfast Festival the head of the Cuban delegation to the European Union unveiled a Fitzpatrick-style painting on a corner in Shiels Street as part of a mural expressing the Republicans' solidarity with the Cuban revolution (Fig. 6.9). For Che's part he was fascinated by the Irish rebellion that had earlier led to the independence of Eire from British rule.

Fig. 6.9

A Republican mural painted with a portrait of Che Guevara, Shiels Street, Belfast, Northern Ireland, 25th August 1998.

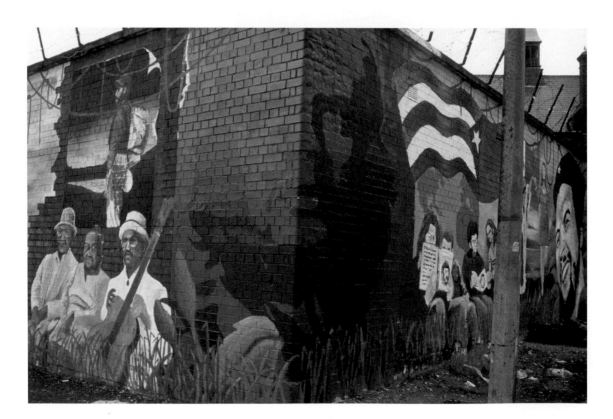

Dead and Deified

Che decided not to remain in Cuba in positions of high authority. He effectively went missing, and after March 1965 his whereabouts were unknown. It transpires that he went to Zaire to foster a Cuban-style regime in the horribly confused and unstable political landscape that prevailed in the years after the Belgian Congo's independence (1960). The following year found him in Bolivia to catalyse a revolution that he hoped would precipitate similar moves across the whole of Latin America. His Bolivian adventure ended after less than a year, and Che was killed.

The manner of Che's death, shot by a Bolivian soldier while wounded and in squalid captivity, with the active connivance of the American CIA, was far from glamorous or even heroic. However, the way that the Bolivians chose to display his corpse and document it proved to act in precisely the opposite way to what they had intended. Richard Gott, journalist for *The Guardian*, recounts powerfully what he saw in Vallegrande on 9 October 1967.

When they carried the body out, and propped it up on a makeshift table in the hut that served as a laundry in less troubled times, I knew for certain that Guevara was dead.

The shape of the beard, the design of the face, and the rich flowing hair were unmistakable. He was wearing olive-green battledress and a jacket with a zippered front. On his feet were faded green socks and a pair of homemade moccasins ...

The two doctors from the hospital were probing the wounds in his neck and my first reaction was to assume that they were searching for the bullet, but in fact they were preparing to put in the tube that would conduct the formalin into his body to preserve it. One of the doctors began cleaning Che's hands, which were covered with blood. But otherwise there was nothing repellent about the body. He looked astonishingly alive. His eyes were open and bright, and when they took his arm out of his jacket, they did so without difficulty ...

The humans round the body were more repellent than the dead: a nun who could not help smiling and sometimes laughed aloud; officers who came with their expensive cameras to record the scene; and the agent from the

CIA, who seemed to be in charge of the operation and looked furious whenever anyone pointed a camera in his direction.

A striking photograph by Freddy Alborta taken the next day shows Che on a crude stretcher laid out across two washtubs (Fig. 6.10). With his propped-up head and open eyes, as described by Gott, he hardly seems dead. The semi-naked corpse displayed and viewed in such a way can hardly avoid comparisons with the *corpus Christi*, the body of the crucified Christ. We may think of the famously stark rendering by Holbein in Basel or, given the foreshortening, of the *Dead Christ* by Mantegna, in which the *corpus* is presented on the stone of unction in dramatic close-up (Fig. 6.11). For good measure the officer who is pointing to one of the fatal bullet holes thrusts his hand towards Che's side like a doubting Thomas confirming Christ's lance wound.

Fig. 6.10

Freddy Alborta,
Che Guevara Dead, 1967.

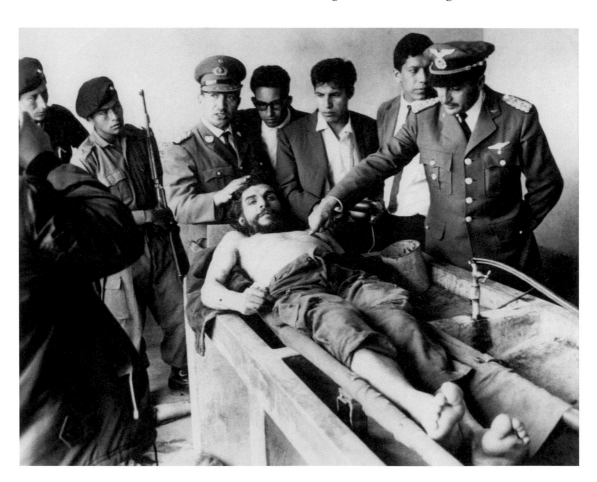

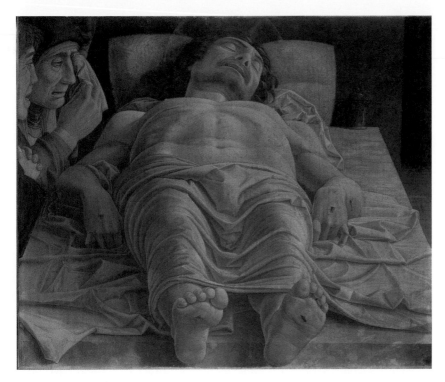

Fig. 6.11

Andrea Mantegna, *Dead Christ*, c.1500, Milan, Pinacoteca di Brera.

The expression in Korda's photograph, to which we have alluded, also carries powerful religious echoes. Korda himself described it as 'enca-bronado y dolente' (angry and pained), speaking also of its special power. 'Angry and pained' is only part of it. Subjectively—and such readings can only be highly subjective—there is a very strong sense of what might be called a 'spiritual stare'. This intense stare seems to be directed towards some great source of inspirational strength, at once within and in some indefinable outer space. This reading, which runs an obvious danger of being overwrought, relies upon a blend of natural and cultural factors. The natural arise from our shared ability to read basic facial expressions independently of race, culture, age, and so on. The cultural dimensions arise from the communicative languages adopted by cultures in all acts of communication, not least visual. The natural never occurs without the cultural filters. In this case most relevant filters are those provided by Christian images over the centuries.

Christian saints, particularly those *in extremis* during martyrdom, are often shown looking intently upwards towards a source, invisible to us, from which they draw their inner strength. Christ himself, on the cross,

is represented either with his head inclined downwards at the moment of bodily death or sometimes with an upward glance toward heaven, as he cries out in agony: 'Eli, Eli, lama sabachthani?', that is to say, 'My God, my God, why hast thou forsaken me?' Korda's 'angry and pained' reading of Che's expression chimes well with this moment, which is invariably depicted in art as a moment of spiritual yearning rather than undignified physical angst. The traditional expression is clearly not built into the photograph as an intentional part of its making but it is integral to its reception, not least by the photographer himself.

Fitzpatrick, for his part, was very alert to the religious dimension when he made his famed poster, making adjustments to the contours of Che's eyebrows and eyes: 'I . . . raised his gaze to give more emphasis to this aspect of his face: perhaps subconsciously I was adding a quasi-religious dimension also. For me the blood sacrifice of Che had a deeply spiritual and mystical dimension and that certainly shows in the finished work.'

The relative openness of Korda's image, effectively inviting the spectator to read *into* it, is essential to its impact. The overtly gruesome photographs taken by Brian Moser, filmmaker from Granada Television, who was with Richard Gott on 9 October, are so direct that they leave little or no room for romanticizing. Moser was in Bolivia hoping to contact Che for a programme he was planning to make for the series *World in Action*. In the event he compiled a revealing documentary in 1968 on the *End of a Revolution*, which opens with his shocking eyewitness account of the mocking treatment of Che's now deteriorating and yellowed corpse, which stank repulsively of formalin.

Amongst the large number of variant images that play on the Che–Christ axis, one will stand excellently for the many. In 1999 the Churches Advertising Network in Great Britain commissioned Chas Bayfield and Martin Casson at short notice to devise a poster for their Easter Campaign. The result is the now-famous *Meek Mild As If* (Fig. 6.12). The commissioners explained their thinking:

> Jesus was not crucified for being meek and mild. He challenged authority. He was given a crown of thorns in a cruel parody of his claims about proclaiming the Kingdom of God. Our poster has the most arresting picture our advertisers could find to convey all this—the image deliberately imitates the style of the well-known poster of Che Guevara.

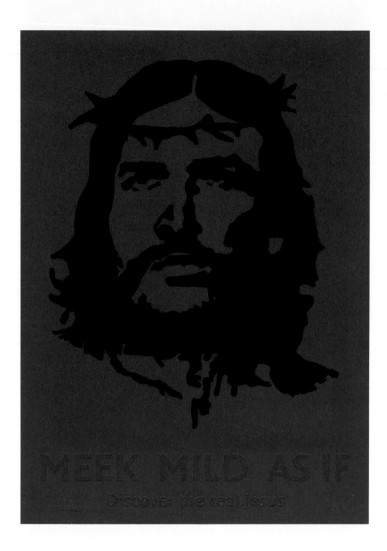

Fig. 6.12.

Chas Bayfield and Martin Casson, *Meek Mild As If*, for the Churches Advertising Network, 1999.

The points of resemblance to Che are stripped down to a few basics, including generic references to his curling hair, which had been played up by Fitzpatrick. The mode of representation, looking back to the earliest posters, plays a key role in the identification. By this time, very little is needed to denote 'Che-ness'. Thus a postcard of the crucified Christ by Velásquez can become Che courtesy of the beret with its star and an angry scattering of bullet holes (Fig. 6.13). The conjoined iconography would I think be readily recognizable even without the famous slogan in six languages: Spanish, French, Italian, English, German, and Danish.

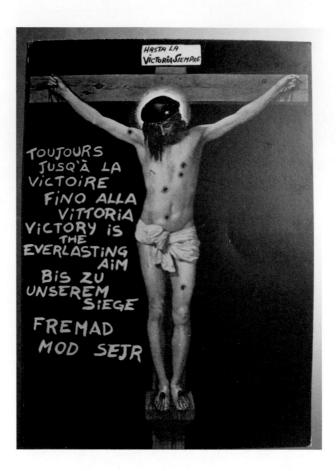

Fig. 6.13.

Christ/Che Crucified,
postcard, author's
collection.

Merchandise, Medium, and Message

Che sells. The matrix appears on all manner of commercial products, like
the luxury humidors for cigars to which we have already referred. His face,
normally in its simple two- or three-tone mode, appears in all kinds of im-
probable places—from lapel buttons to the bikini bottom of a model on a
cat-walk—from Cuban banknotes to Vodka adverts—from the sign of a
café in rural France to students bed-sits—from bottles of beer to cherry-
flavoured ice creams—from the ubiquitous T-shirts to a tattoo on the right
arm of the Argentinian footballer Maradona ('the arm of god' perhaps).

Again, one example can be made to stand for the many, not least since
it keys nicely into a number of themes in this chapter. In the name of re-
search I purchased a Che 'shirt' from the Che Store in the USA (Fig. 6.14).
It is described as a

Men's, long sleeve, olive military-style jacket/shirt, one of the best we have ever seen! This garment is described as a jacket, but is light enough to be worn on its own as a shirt. There are epaulets on the shoulders and every button has 'Che' embossed into it. There is a pocket on the upper-right sleeve and two on the chest, air holes under the armpits just like military-issue shirts, and every star, patch, and 'Che' on front are embroidered. The back has the classic Che image with the caption 'WHEREVER DEATH MAY SURPRISE US, LET IT BE WELCOME.' printed in distressed lettering. There is also a distressed red star and the statement 'It's Better to Die Fighting than it is to Live on your Knees' on the inside back. Made of very heavy cotton for long wear. Available in sizes from medium to 3x-large (3XL).

I ordered the large size to be on the safe side, at $49 with $15.95 postage. On delivery I was unexpectedly charged £5.87 excise duty and £8 Royal Mail International handling fee. A bit steep, but maybe I can wear it to the book launch. I could also have bought a beret with a star, trousers, and boots from Uncle Sam's Army Navy Outfitters. At least one seller offers the beret with attached hair, though disappointingly without a beard.

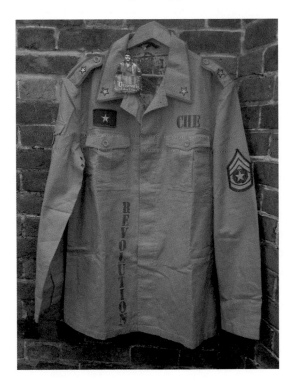

Fig. 6.14

Military shirt/jacket, 2010, Dragonfly Clothing Company, via the Che Store, author's collection.

The 'shirt', as an example of radical chic, retains more tenuous points of contact with the reality of Che than much of the merchandise. To paraphrase the Canadian media guru of the 1960s, Marshall McLuhan, the medium often seems to have become the message. Or rather the stylish trendiness of the schematic matrix has become the visual message. This, as it happens, is where Régis Debray comes back in. We have already encountered him in prison in Bolivia when Feltrinelli visited to try to secure his release.

Debray's notion of 'mediology', to which I do not subscribe as an overarching theory of culture, has a nice local application to iconic images of the Che kind. It is not the easiest of ideas to summarize, but I think it is worth trying. The French philosopher concentrates his cultural analysis on the all media, mechanisms, technologies, institutions, materials, rituals, conventions, and the circumstances of transmission in and across time. Transmission differs from mere communication, which animals can do without the tools of society and culture. The image of Christ or of Che is first and foremost a transmission, which, in Che's case, embodies many of the factors we have seen at work in the transformation of an overlooked photograph into an icon. In this sense it is not the original Che who is somehow communicating across time. Rather we engage with the image transmitted by the media in any particular context, in terms of the nature of the transmission, not its ostensible content. As a historian—and Debray himself is hugely respectful of primary sources—I think that certain dimensions of the original Che are potentially more available and can be seen to a greater extent 'through' the mediations than Debray seems to allow. However, in instances such as the multiple Ches scattered across a bikini bottom we cannot but agree with the 'mediological' interpretation that the main point of Che's 'message' has effectively become obliterated. What the image conveys to us is the mores of our society. A little bit of radical daring, a dash of fashionable irony, and a lot of commercial opportunism are the orders of the day. It also has to be allowed that Che's icon looks very different in the era after the collapse of the Soviet-style regimes in Europe and the mega-capitalist market unleashed by the Chinese communists. Che's image is less hot and inflammatory after the end of the Cold War.

At least, from Che's point of view, the regime he helped establish has survived in Cuba, now under the reins of Raúl rather than his aged brother. For how much longer remains to be seen. The environment in which

Che still survives as something recognizable to himself is now close to a point of inevitable change. In years to come, the message may become even less discernible than the matrix.

Reading

The best of the extensive literature on Che is of higher quality than that on most of the modern iconic images. The worst is very bad. The exhibition-related publications by Kunzle and Ziff contain rich collections of images.

http://www.aleksandramir.info/texts/fitzpatrick.html for a conversation between the author Aleksandra Mir and Jim Fitzpatrick, 2005.

http://www.checulture.com/ for a selection of writings by Che Guevara.

http://www.hfontova.com/ with a feature from Fox News.

http://info.lanic.utexas.edu/project/castro/db/1960/19600307.html for speeches and other resources for Fidel Castro.

http://www.mindfully.org/Reform/2005/Che-Guevara-Gott11aug05.htm for Richard Gott, 'All Right, Let's Get the Hell Out of Here'.

http://www.slate.com/id/2107100 for Paul Berman, 'The Cult of Che: Don't applaud *The Motorcycle Diaries*', 2004.

http://www.snagfilms.com/films/title/kordavision_the_man_who_shot_che_guevara/, 1998 to 2001, a film on Alberto Korda directed by Héctor Cruz Sandoval.

http://il.youtube.com/watch?v=Tn9XRQwnHsM&feature=related for Brian Moser's 1968 documentary, *End of a Revolution*.

J. L. Anderson, *Che Guevara: A Revolutionary Life*, New York, 1998.

M. Casey, *Che's Afterlife: The Legacy of an Image*, New York, 2009.

P. Dosal, *Comandante Che: Guerrilla Soldier, Commander, and Strategist, 1956–1967*, University Park, Pa., 2003.

E. (Che) Guevara, *The Motorcycle Diaries: A Journey around South America*, trans. Ann Wright, London, 1996.

D. Kunzle, *Che Guevara: Icon, Myth, and Message*, UCLA Fowler Museum of Cultural History, Los Angeles, 1998; and *Chesucristo: The Fusion in Word and Image of Jesus Christ and Che Guevara*, forthcoming.

C. Vives and M. Sanders (eds), *Alberto Korda: A Revolutionary Lens*, Göttingen, 2008.

A. Weidinger and C. Skrein, *Korda's Cuba*, Munich, 2009.

T. Ziff (ed.), *Che Guevara: Revolutionary and Icon*, Victoria and Albert Museum, London, 2006.

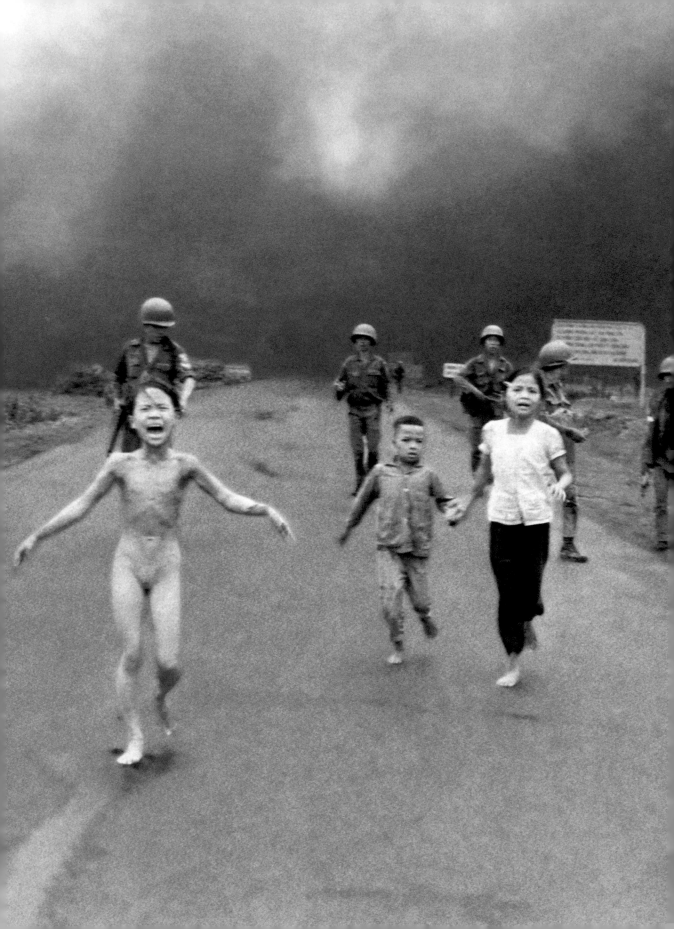

7

Napalmed and Naked

Flying low across the trees,
Pilots doing what they please,
Dropping frags on refugees,
Napalm sticks to kids.

Chorus: Napalm sticks to kids,
Napalm sticks to kids.

Drop some napalm on a farm,
It won't do them any harm,
Just burn off their legs and arms
Napalm sticks to kids.

. . .

■ Nick Ut, *Villagers Fleeing along Route I*, detail, 1972, Associated Press.

Children sucking on a mother's tit,
Wounded gooks down in a pit,
Dow Chemical doesn't give a shit,
Napalm sticks to kids.

. . .

Eighteen kids in a No Fire Zone,
Rooks under arms and going home,
Last in line goes home alone,
Napalm sticks to kids.

. . .

Cobras flying in the sun,
Killing gooks is lots of fun,
Get one pregnant and it's two for one,
Napalm sticks to kids.

. . .

Shoot civilians where they sit,
Take some pictures as you split,
All your life you'll remember it,
Napalm sticks to kids.

. . .

(Verses from one version of the US marching cadence from the Vietnam War,
'Napalm Sticks to Kids')

'Nong qua, nong qua' ('too hot, too hot'), the 9-year-old girl screams as she runs naked from the temple in her flaming village.

South Vietnamese soldiers, some photographers, and reporters, including cameramen from ITN and NBC, have been staring at the village of Trang Bang down the long, straight Route 1, which had been taken over by troops from North Vietnam. It is about 1.00 p.m. Two veteran Skyraider planes of the South Vietnamese Airforce strafe the village, sowing their grim seeds in ragged rows across the green fields, leafy trees, and low houses. First come the thundering bombs; then the fat, gross silver cigars of Napalm. Flames of white and livid orange erupt in a brutal instant, generating temperatures in excess of 1,000 °C. Smoke of

every hue billows feverishly. Everything burns. It is carnage in the most literally fleshy sense. The raging noise subsides into a smouldering quiet of nothingness.

From the suffocating hell a cluster of villagers stumble onto the road, running and walking as best they can towards the group of observers. At the rear of a family group is a grandmother with a child in her arms. The skin of his dangling leg and ankle is hanging in fluttering shreds. He is dead or dying, and she cradles him as she flees. Nick Ut takes a harrowing photograph (Fig. 7.1).

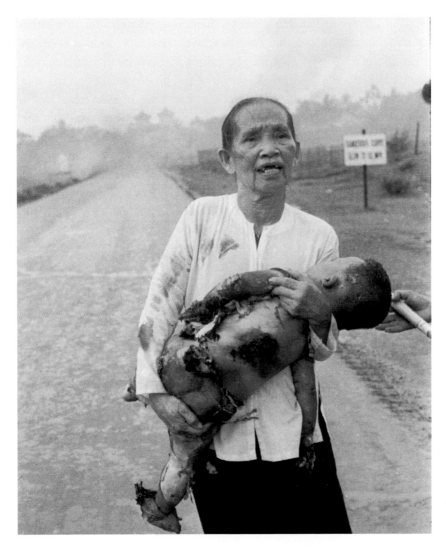

Fig. 7.1

Nick Ut, *Grandmother Flees with Dying Grandson*, 1972.

Three children run close to each other towards Ut who has his camera loaded with film. There is a boy of about 12 or 13 in a neat white shirt and dark shorts, running without shoes. A smaller boy, about 5, presumably his brother, in a grey-blue cotton outfit with long trousers, is trying to keep up. With them is a naked girl, running. Her pace is steady, stoic. 'Nong qua, nong qua' ('too hot, too hot').

As she passes the ITN cameraman, we can see that her back is seared, almost half white and half brown in vertical strips like a grotesque football shirt. She stops and is comforted. Water is instinctively poured on her burnt flesh by Christopher Wain, the journalist who is leading the ITN crew, and she is given a drink, but the helpers are not clear as to whether to drape a garment over her raw shoulders. Her expression is collected much of the time, even tranquil. She calmly inspects her hands and looks down at her body. We can see large white and brown patches on her arm. It looks like the surface of the door that had been blow-torched by the decorator who had come to repaint the exterior of our family home. Classic third degree burns, the epidermis and dermis are gone; the pale subcutaneous fat is exposed, what remains of it. Everyone, whatever their race, is the same colour at that level. She is Phan Thi Kim Phuc and she is recently 9 years old and newly naked. Ut hears her say to her big brother, Phan Thanh Tam, 'I think I am going to die.' This is the most likely outcome.

The Photograph, Taken and Transmitted

Nick Ut had taken a series of shots. In one both Tam and Kim were screaming. Kim's arms were held out wide. It was an exceptional instant in the unfolding narrative. It is immortalized in the iconic photograph (Fig. 7.3).

Nick had been born Huynh Cong Ut, and ended up with two 'first' names. His elder brother had been a photographer but had died a few weeks earlier in the Mekong Delta. Nick had started with menial jobs at the Associated Press office in Saigon, taken on by Horst Faas, who was to play a key role in the story of Kim's photograph and whose accounts provide the most reliable witness to the events before and after its taking. The AP had been founded as a non-profit organization by five New York newspapers in 1848 to share incoming reports. In 1935 it had introduced WirePhoto, the first service that could transmit photographs 'over the wires' (telephone and radio), which initiated the very rapid transmission

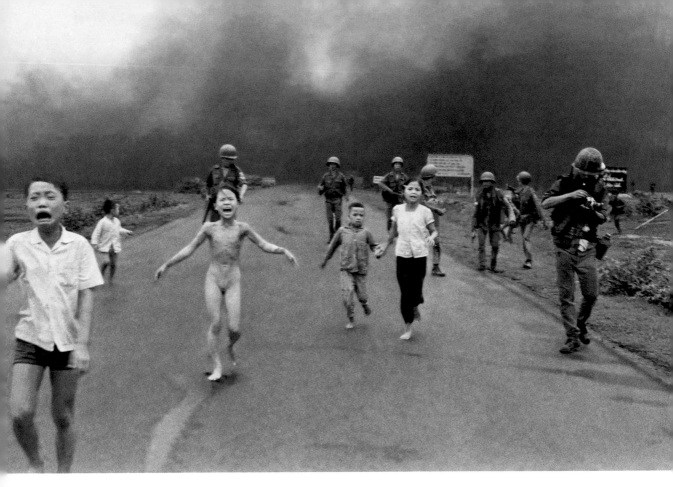

of photographs like Joe Rosenthal's from Iwo Jima, to feature in the next chapter. Ut had learnt his trade in the dark room and on the job. That day was one of many in the Vietnam War scarred by violence and death.

Vietnam was America's longest war and first real defeat. From 1961, successive presidents, beginning with John Kennedy, had been drawn inexorably into an escalating conflict in the belief that if South Vietnam fell to communist invaders from the North and rebels in the South, it would be followed by other states in the region—according to the 'falling domino' principle that had been enunciated by Dwight Eisenhower. By 1967 troop numbers were over 460,000 and the American forces had incurred 16,000 deaths in combat. By 1971 a process of 'Vietnamization' had begun, designed to transfer responsibility to the South Vietnamese forces and to allow the withdrawal of US personnel, but not before their death toll had reached 47,244. Ut's photograph was taken during what was in effect a prolonged end-game, as the South Vietnamese proved

Fig. 7.2

Nick Ut, *Villagers Fleeing along Route 1*, 1972, Associated Press.

NAPALMED AND NAKED | 201

unable to resist in the longer term. A rickety peace settlement with the North was followed by the total collapse of the government and army in the South. America could only watch as the communist troops marched into Saigon.

The chemical player in Ut's drama was the incendiary substance known by its trade name of Napalm. It had been developed in 1942–3 by a team of Harvard chemists. A powdered aluminium soap made from naphthalene and palmitate is used to transform gasoline into a viscous syrup. The 'advantages' are substantial: the mixture burns in a prolonged manner; it generates enormous heat; it spreads out widely; and, not least, it is very sticky. In its first incarnation it was used towards the end of the Second World War. In a more liquid mixture, it fuelled the flame throwers that immolated Japanese defenders on Iwo Jima. The most spectacular demonstration of the potency of incendiary bombs was the destruction of Dresden in February 1945, recorded in an iconic photograph by Richard Peter. Taken from the observation platform on the still-standing tower of the Town Hall, Peter's photograph shows August Schreitmüller's sandstone sculpture, *Die Gute* (Goodness), gesturing impotently above the devastation (Fig. 7.3). This and other photographs by Peter's played a big role in the subsequent debate about the morality of the Allied destruction of the historic city, with around 25,000 dead. The figures become numbing after a while.

By the time of the Vietnam War, Napalm B had been developed, with a much longer burn time and even higher temperatures. The Dow Chemical Company, which featured in the military marching cadence at the start of the chapter, was the sole supplier to the US government during the Vietnam War. Napalm was used to incinerate swathes of jungle (which was providing such a natural home for the elusive Vietcong), to destroy buildings, as a weapon against the communist troops, and ultimately as a more or less indiscriminate destructive agent that took out 'sympathizers' as well. On one of the notorious Nixon Tapes, the President is heard saying to Henry Kissinger, 'I don't give a damn about civilian casualties. I don't care.' Nixon is also heard questioning the veracity of Ut's photograph: 'I'm wondering if that was fixed.' Of course it could have been but wasn't.

The final component in the story of the genesis of the photograph is Ut's camera and the film. The camera consisted of a Leica M-2 body with

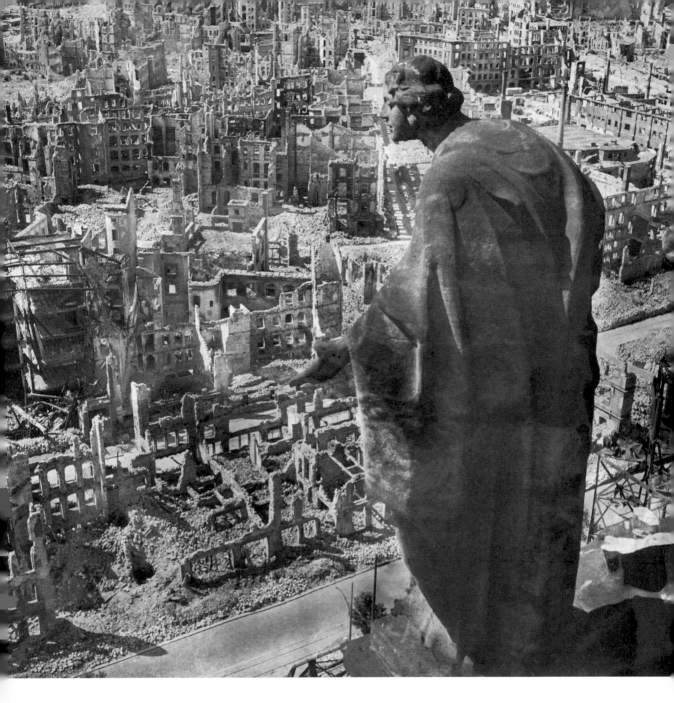

Fig. 7.3

Richard Peter, *Dresden Bombed, Viewed from the Tower of the Town Hall*, 1945.

a 35 mm lens. He also carried a Nikon with 200 and 300 mm lenses, together with a wide-angle lens. The film was Kodak's 400 ASA black and white, a good bread-and-butter film that was fast enough to work in lowish light conditions. It had a slightly grainy quality that works well for war photographs and can be printed to look quite sooty. He took eight rolls to be developed in the AP darkroom in Saigon. Ut and a Japanese photographer, Ishizaki Jackson, then printed up a selection of the most effective shots. Four photographs were slowly scanned and transmitted by radiophone to the Tokyo bureau of AP.

Nick Ut had a good idea that he had something exceptional, and the bureau chief did not doubt that he had. But there was a big problem. A young girl was shown in full frontal nudity. Any full frontal nudity was unlikely to be sanctioned.

The photograph was initially rejected by an AP editor for potential publication, but Horst Faas led an effort to persuade the New York office that an exception should be made, providing no close-up of the naked girl was to be shown. Part of the point was that her clothes had been burnt off her. That was implicit in the image. The New York photographic editor, Hal Buell, agreed. Buell has subsequently published books on Eddie Adams (whom we will encounter shortly) and on Joe Rosenthal's photograph of the flag raising on Iwo Jima. Faas quickly intuited that 'we have another Pulitzer here'—referring to the Pulitzer prize for journalistic ('Spot News') photography. Faas is a major photographer and was a two-times winner of the prize in his own right. His poignant image of a man displaying his dead daughter to a pack of South Vietnamese soldiers was part of his prizewinning photo-essay in 1956 (Fig. 7.4). Faas had an eye for great images. The prize was indeed awarded to Ut in 1973.

Context and rationale count for all, or almost all, in how such an image is used, just as when we planned to exhibit the work of the American photographic artist Nan Goldin in *Seduced: Art and Sex from Antiquity to Now* at the Barbican Art Gallery in London in 2007. Only a few months earlier a photograph of Goldin's owned by the singer/songwriter Elton John had been seized by police from an exhibition at the Baltic Art Gallery in Gateshead. Called *Klara and Edda Belly-Dancing*, the photograph showed two children, one naked and whose genitals were clearly visible. The Crown Prosecution decided not to proceed with charges, citing,

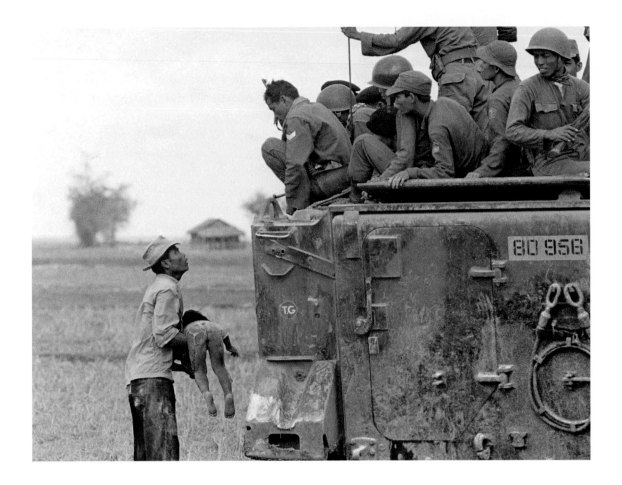

amongst other reasons, the fact that the 'photograph was distributed for the purposes of display in a contemporary art gallery'. We checked with the City of London Police, who concurred. Goldin's images, like Nick Ut's, were to be seen in a specific context which worked powerfully against any pornographic slant. Such a slant can of course never be totally excluded, since images are always potentially open to unintended and even abusive modes of viewing.

One of the reasons why Ut's photograph has proved to exercise such continued power is because its human meaning is fiercely evident, with little ambiguity—even if we do not know the immediate circumstances in which a naked and screaming girl runs down a road peopled with men in military uniforms. It is so powerful that it sets much of its own context.

Fig. 7.4

Horst Faas, 'Why?' (father, child, and South Vietnamese soldiers), 1965.

Kim

A thread of the story has been dropped. Kim did not die, and the photograph may be said to have saved her life. Ut did what photojournalists rarely do or have the opportunity to do. He directly intervened. Unlike the others present he could speak Vietnamese. He rushed Kim, her two brothers, and her aunt by car to a British hospital. How could he persuade the hospital staff to give Kim some kind of precedence over lives more likely to be saved? She was unconscious by this time. Ut told her story, and he emphasized that Kim's picture was likely to wing its way around the world. We may imagine that no doctor would care to be responsible for leaving untreated a girl who might become known in the newspapers. Even so, everyone assumed she would die and she was effectively left as dead. Two days later, Christopher Wain was instrumental in seeking her transfer to an American hospital which was better equipped to treat her savage burns. Wain had the persistence to negotiate his way through a forest of diplomatic niceties before the transfer could be made. The attention she received on multiple visits to the operating table began the long and perilous processes of saving her life and getting her body to work again without wholly excessive pain. As doctors will tell you, in such circumstances, the patient requires exceptional will.

If she had died the photograph would have defined a death. Since she lived, the photograph defined a life. Having been a victim of a capitalist war machine she subsequently became the victim of a communist propaganda machine (and later, as we will see, a victim of the free press). Living in the newly unified communist state of Korea she had no choice but to serve as an image of the righteous war. She came to lament that 'I could not escape the picture'.

Kim went to study in Fidel Castro's Cuba at the University of Havana, where she met her Vietnamese husband. Returning in 1992 from their honeymoon in Moscow via a brief stop in Newfoundland in Canada, they made their escape and managed to establish a quiet life in what was to become their new country. Their Canadian peace did not endure. The Western press wanted to trace her, and inevitably located their quarry. In 1995 she was given front-page treatment by the *Toronto Sun*.

Still not being able to escape the image that both saved and determined her life, she resolved that she would 'take control' of her picture, and use it as 'a powerful gift'. She resolved that she would 'work with it for peace'.

> Now I travel, following my picture around the world as a Goodwill Ambassador for UNESCO. My picture is a symbol of war, but my life is a symbol of love, hope, and forgiveness.

She has also set up the Kim Phuc Foundation to treat war-damaged children. She is a truly remarkable person.

The other mega-famous photograph from the Vietnam War, another Pulitzer prizewinner, also defined a life, this time that of a lofty general not a hapless victim. On 1 February 1968 General Nguyen Gnoc Loan, head of South Vietnam's National Police, was captured by Eddie Adams moments before the general's bullet was to blast through the brains of a captured member of the Vietcong (Fig. 7.5). Adams is quoted in *Time* Magazine as saying,

> The general killed the Viet Cong; I killed the general with my camera. Still photographs are the most powerful weapon in the world. People believe them, but photographs do lie, even without manipulation. They are only half-truths ... What the photograph didn't say was, 'What would you do if you were the general at that time and place on that hot day, and you caught the so-called bad guy after he blew away one, two or three American soldiers?'

The summarily executed man was said to have slaughtered a Vietnamese colonel, wife, and six children. The act may be just understandable, though wholly unjustified if the due and moral process of law is to be respected.

The photographs by Adams and later by Ut played major roles in the USA in fuelling the anti-war protests. The Vietcong and the naked girl, caught in their moments of utter extremis, can both be used to make powerful points. We could, I suppose, see Adams's photograph being used to deter the Vietcong: 'This is what will come to you as well . . .' But a basic human instinct tends to kick in, even in times of war. The executed man is someone's son, maybe someone's father. The way that these photographs

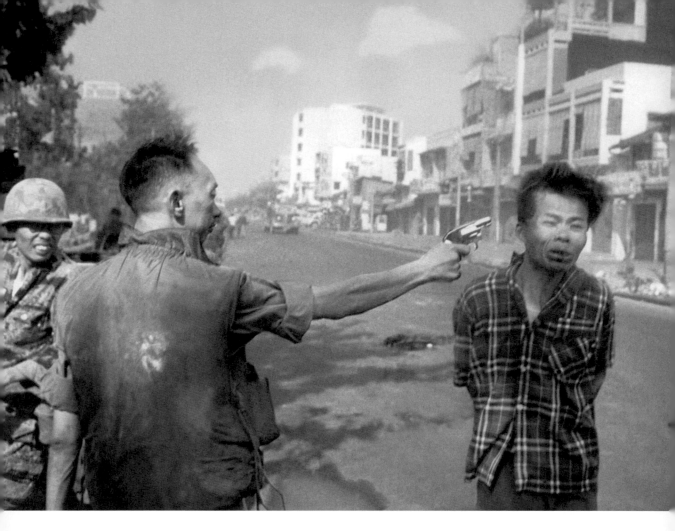

radically effected people's perceptions of the war is one reason why war photography has subsequently been far more rigorously controlled by the military in all conflicts.

The rise of the potent protest movement in America also does something to explain if not justify the repulsive marching cadence that opens this chapter. 'Napalm Sticks to Kids' was first recorded in 1972, and it featured in truncated form in the 1982 film by Taylor Hackford, *An Officer and a Gentleman*. Its origins are far from clear, and it has even been used as an anti-war song.

It arose in a very specific context. Fighting for your country even with its unstinted support is a fearful business, but without its wholehearted backing the warriors need to invent devices that can sustain levels of personal engagement that might well result in death.

A verse in one of the alternative versions specifically alluded to the home-based protesters.

> See the hippies upon the hills
> Smoking grass and popping pills.
> Don't they know that drugs can kill,
> Yo, Oh! Napalm, it sticks to kids.

Looked at from the perspective of a tough, shaven-headed GI, the effete hippies, with their flowing locks, dressed in androgynous robes, consorting in drug-fuelled dazes on flowery hills, were as poisonous as the Vietcong. The extraordinarily potent electronic mangling of the anthem 'The Star-Spangled Banner' by the great guitarist Jimi Hendrix at Woodstock in 1969 seemed designed to shatter American reverence for her flag just as violently as Hendrix smashed screaming guitars during the course of his gigs. The values the GIs were protecting abroad seemed under anarchic assault at home. The soldiers' refrain is a savage riposte to the hippies' mocking chant, 'Hey, hey, LBJ, How many kids did you kill today?' The hippies and soldiers are here caricatured of course, but caricatures turn into reality once political extremes are unleashed.

The Photograph, in Itself

Nick Ut's photograph is remarkable. Its persistent fame does more than enough to testify that it has qualities that distinguish it from the millions of other photographs generated during that most photographed of all wars. But what are those qualities? Are they those of the subject, accidentally caught, or are they identifiable as attributable to an act of 'art'? Of the compelling photographs of war that we are illustrating— the two by Nick Ut, those by Horst Faas, Eddie Adams, Tim Page, Robert Cappa, and Richard Peter, and that by Joe Rosenthal in the next chapter—only that by Peter can be said to have been thoughtfully composed. The others are snapshots, or 'Spot News' photographs, to use the Pulitzer category. There have been accusations that Rosenthal's image was posed, but this seems not to have been the case. Let us begin, as an exercise, by defining what might make Ut's image so compelling in terms of the criteria of art. Surprisingly we can do so in terms of the earliest surviving treatise that talks about how to compose a good painting.

Leon Battista Alberti's *On Painting* was produced in the mid-1430s in two versions, one in Latin and the other in his native Italian. In its three 'books' he talks about how optical truth can be achieved through the use of linear perspective, how a picture can be composed from its component parts, and why painting deserved to be ranked amongst the liberal arts rather than dismissed as a craft. He explains how parallel lines recede to a single point on the horizon line—what we call a vanishing point. In Ut's photograph he is standing close to the centre of the road, having moved across from his earlier position. Perhaps he did this to let the two closest children run to his left. His camera is pointed almost straight down the road and horizontally. Ut is very slightly to the right of the centre line, and we can thus see a bit more of the edge of the road to the right. The heads of the men, as specified by Alberti, are all close or near the horizon line, depending on their height and the level of the place where they are standing. The children are all in graded scales below the horizon line. Alberti specifically recommends this technique for scaling the figures within the depicted space, and for placing the spectator, by implication, at the same level as the depicted figures. With such a dramatically simple space, there is a real sense that we are standing on the road, just as Ut was.

Alberti recommends including not too many people in a narrative (what he calls an *istoria*), just as it is unwise to invite too many people to dinner. Alberti set the number at nine or ten. There are twelve in the photograph, but two of them are partially concealed. He advises us to include a variety of types of people of diverse ages, all appropriately characterized according to their natures and their role in the story. Kim is inevitably the focus, not least because of her nakedness, but the others play their roles. Those dressed in uniforms are relatively anonymous. The children hold centre stage. The older boy's features and stiff arms are the very embodiment of pain and fear, his mouth echoing Kim's, whose limply raised arms speak of despair and of the burning heat that she is trying to cool. Her pale face and shoulders are silhouetted against a man in uniform. A little boy between and behind them looks backwards, linking the fleeing group to the soldiers and burning village. The young woman and boy running hand in hand underscore the flight and provide a mutually tender note. The nearest man is anonymized by his uniform and by the way he looks downwards. He seems to be a cameraman loading his film (and missing the key moment). Alberti also advises that one

figure should look out at the spectator to engage out attention. Kim herself may be doing this, but it is the young woman holding the boy's hand who more obviously does so.

Alberti's rules were followed, repeated, and reworked over the centuries into an academic orthodoxy, followed to greater or lesser degrees by generations of artists who wanted to master the art of 'History Painting'—that is to say the telling of stories that 'signify great things' (to use Leonardo's words). A self-conscious and very poised demonstration of how to create an *istoria* is provided by Raphael's *Massacre of the Innocents*, designed specifically to be engraved by Marcantonio Raimondi (Fig. 7.6). Taking as his subject the slaughter of children ordered by King Herod to forestall the advent of the new 'King of the Jews', whose coming had been announced by the three Magi, Raphael formalizes his composition so that it might serve as an exemplar in its whole and in its parts for an aspiring painter or an ambitious connoisseur. It is full of high artifice. There are more figures than Alberti recommended, to be sure, but this is fitting for the subject

Fig. 7.6

Raphael, *Massacre of the Innocents*, engraved by Marcantonio Raimondi, c.1510.

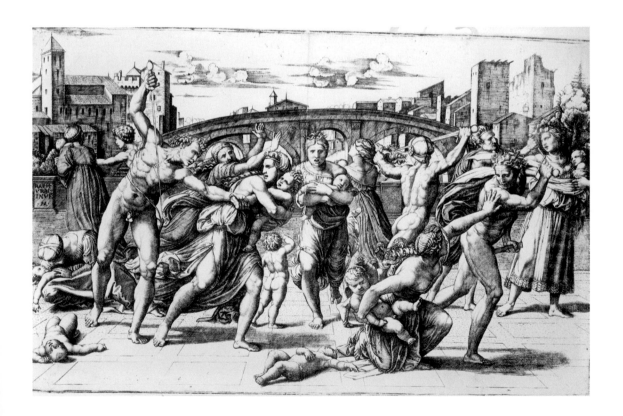

of a mass killing. The central woman is in this case our interlocutor, staring out and running with her dead baby in her arms. The scene, for all its artificial orchestration, does convey the tenor of the mothers' pain in the Gospel of St Matthew: 'A voice is heard in Ramah, weeping and great mourning, Rachel weeping for her children and refusing to be comforted, because they are no more.'

The rules are not absolute of course and were violated over the years. One of the most searing of all war pictures, Picasso's iconic *Guernica*, appears to breaks all the rules (Fig. 7.7). Or does it? There are, as far as one can reliably count, eight victims of the fascist bombs in the Basque town, including two animals, a dismembered man, and three screaming women, one of whom holds a dead child. The space is signalled quite simply, albeit in a characteristically fractured manner. Picasso establishes a demarcated stage for the actors, and there is even a classic passage of tiled floor to the right. In this case it is the bull, that most Spanish of beasts, who looks directly at us. Perhaps Alberti's principles are still at work in some way. They certainly were when Velázquez composed his great late Spanish masterpiece *Las Meninas*. Picasso certainly knew, like Raphael, how to echo screaming mouths.

You may say, this is all very well, but Ut intended none of these things. Is such an elaborate analysis just a bit of art-historical pretension? There

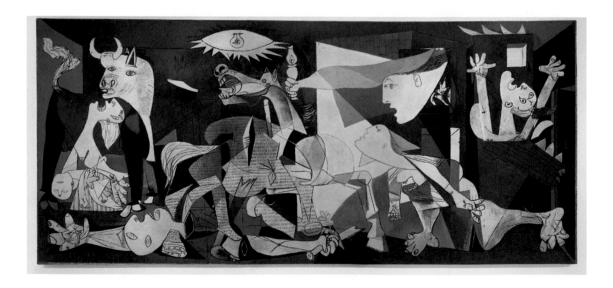

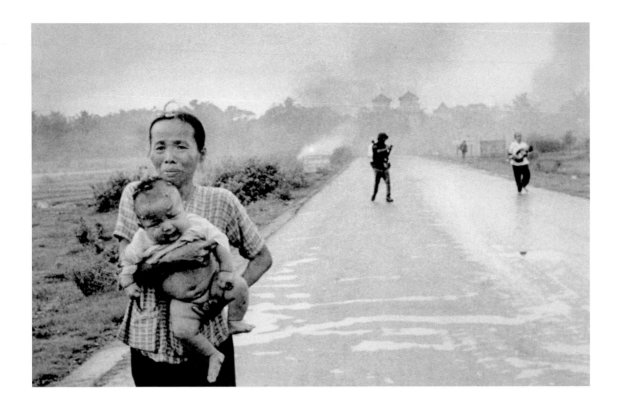

is every reason to think that Ut knew nothing about the academic rules of Western history painting. And, even if he had gained some glimmer of them, they are hardly likely to come into play in the fraught fractional second that belonged to this particular photograph, amongst the others on his four rolls of Kodak ASA 400 film.

These caveats are clearly justified. However, there are two senses in which the analysis may be valid. The first is that Nick Ut clearly has an eye for a good shot, both in taking photographs and in the later selection of which images really work. His career both in Vietnam and later in America testifies to his instinctive ability to spot what might make a really telling picture. There are other photographs in the series that function eloquently and simply in ways that differ from the photograph of Kim (Fig. 7.8). What makes a good shot has changed somewhat over the years. Peter's extreme contrast of scales in the Dresden composition is very much a vision cultivated with the photographic camera. However, new modes do not mean that the old ones do not work any more.

Fig. 7.8

Nick Ut, *Kim's Aunt Carrying a Baby*, 1972.

There is a second sense in which the formal analysis may be valid, and this is with respect to the spectators' attuning to the image. The attuning seems to me to embrace both nature and nurture. We have become accustomed over the years to see things in terms of certain tropes in pictorial culture, though a process of nurture. But the robustness of the tropes over the ages suggests that they play very effectively to certain things that our perceptual and cognitive systems have been designed to do. We bring order out of sensory chaos and bring intelligible emotional sense to what is happening in front of us in more personal terms.

Even though it might yield some of its secrets to art-based analysis, Ut's photograph falls far short of being 'arty'. It has a raw and instantaneous look. The positions of Kim's legs do not conform to the conventional running positions favoured by artists. The cameraman on the right is shown in an ungainly pose that no stylish painter would employ. Historical draughtsmen tended to cultivate 'grace' even in terrible subjects. Part of the image's emotional potency is that it says 'this is the real thing', and its rough edges are vital to this effect. It could of course be contrived, as Nixon recognized, but we instinctively take such rough edges as a guarantor of authenticity. They are part of what I have called the 'rhetoric of reality' in two- and three-dimensional images.

Black and white plays its role as well. Not for nothing did Picasso resort to blacks, whites, and tinted greys in *Guernica*. Picasso's picture is contrasty and grainy, like the published photographs of the gaunt skeletons of bombed buildings in Guernica, looming over piles of rubble. Kodak's black and white film was conveniently versatile, but colour was available to Ut. Photographing in black and white became something different after the widespread availability of colour film. Another of the great photographers to have made their name amidst the carnage of Vietnam, Tim Page, used colour extensively alongside black and white. Page's photographs are of great power, yet they seem almost to belong in a different visual world from Ut's.

Page the Englishman was known as something of a wild man, someone for whom the cliché 'a larger than life character' is actually true. Arriving in Vietnam at the age of 20, he became renowned for taking risks that were both inherent in his personality and blurred by his absorption of substances that were circulating widely amongst the American troops. He seems to have been, to use one of his favourite terms, a bit 'fucking' crazy. He had already experienced something close to death in a motorcycle

accident, which coloured his attitude to the additional time he had been granted on earth.

> I had died. I lived. I had seen the tunnel. It was black. It was nothing. There was no light at the end. There was no afterlife. Nothing religious about any of it. And it did not seem scary. It was a long, flowing, no-colour wave which just disappeared. The mystery was partly resolved, all the fearful church propaganda took on its true, shameful meaning. I was content. I was alive. I was not dead, and it seemed very clear, very free. This was the dawning, the overture to losing a responsible part of my psyche. A liberation happened at that intersection. Anything from here on would be free time, a gift from the gods.

He became a larger than death character as well. His history of erratic daring and the series of severe injuries he suffered to his body and the loss of a portion of brain suggest that he was not reluctant to repeat the experience of dying. The character played by Dennis Hopper in Coppola's 1979 film *Apocalypse Now!* bears a not uncoincidental resemblance to Page. The photographer has told his own story in *Page after Page* in 1988, narrating an extraordinary life and a sequence of near-deaths that would be far-fetched in fiction. He has subsequently been deeply involved with charitable work for journalists and memorializing the heroic photographers of the Vietnam generation. Another remarkable person.

Through all the personal craziness and the madness of war he brought an artist's eye to the terrible beauty of extreme conflict. He is aware that artistry is involved, 'I'm a frustrated painter . . . I see photography as being a bridge between painting and reality'.

There is both an involvement of an intense kind, the buzz that comes with extreme action and risk, yet also a quiet inner distance that allows the photographer's eye to seize the moment: 'Although you're totally integrated to the total insanity of it, the horror, the horror, the horror, you have this ability to pull out whatever you want to, you call the shot.' The great shots, as Horst Faas had said, possess an essentially humane dimension: 'I try to express with the camera what the story is, to get to the heart of the story with picture. In battle I look at things first in terms of people, second in terms of strategies or casualties'. For all his immersion in the violence, Page's photographs frequently have an elegiac quality, seeing the quiet, inner human voice that still speaks through the visual cacophony of war.

And what shots they were. The image of a nun with a corpse will have to stand for many (Fig. 7.9). Page tells how he rushed in his 'Mini-moke' to reach the scene of a reported fight at the village of Dong Latch, which 'was being cooked'. He arrived too late for the action, in which the US gunships had slaughtered the rump of a North Vietnamese battalion who had taken futile refuge in a Catholic church. By the time Page was on the scene 'only the dead protested'. The bullet-riddled corpses were being dragged outside and sprinkled with handfuls of quicklime to arrest putrefaction.

The result was both horrific and pictorial.

Anyway you framed it, you had death. It was starked out by the contrast of the lime retardant. A Surreal black and white concept. A chromatic colourisation of the limes white against the orange backdrop of a departing chopper's rotor wash scrimmed the arrival of a surviving nun, rosary in hand, above an erstwhile enemy. A northerner, A Bo Doi in rigor mortis subject to the benefice of a theoretically free recitation. Liberation receiving the blessing from the liberated.

Fig. 7.9

Tim Page,
Nun and Corpse, 1969.

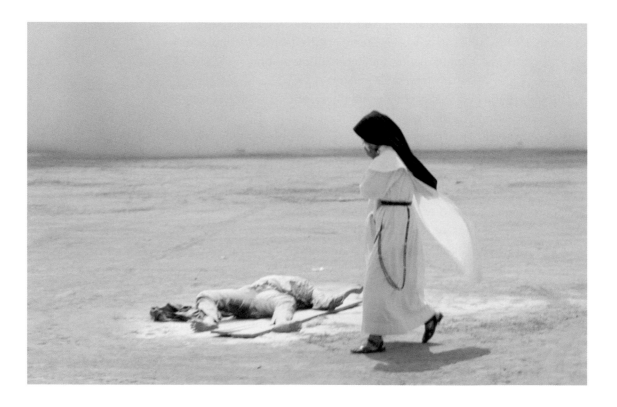

The stench of death was already emanating from the collective cadavers, the final whip of seamless orange froze the image in time.

This is the writing of man who has developed conscious tastes in art and literature, and who inhabits a different imaginative world from Nick Ut.

The photograph of the pristine nun and bespattered soldier is a magnificent image, formally brilliant and emotionally deep. The black and white profile of the human angel; the spread-eagled pose of the soldier within his white aura of lime, a nihilistic version of St Paul collapsed and blinded in the pool of light sent by God to chastise him. He is a more foreshortened and a more dead version of the soldier in Robert's Cappa's ultra-famous photograph of a *Loyalist Militiaman at the Moment of Death, Cerro Muriano, September 5, 1936* (Fig. 7.10). Cappa's photograph comes from the same war as Picasso's painting. Like Rosenthal's photograph, Cappa's image has been haunted by accusations of staging, but the doubts about its 'authenticity' have done nothing to loosen its visual grip.

Fig. 7.10

Robert Capa, *Loyalist Militiaman at the Moment of Death, Cerro Muriano,* September 5, 1936.

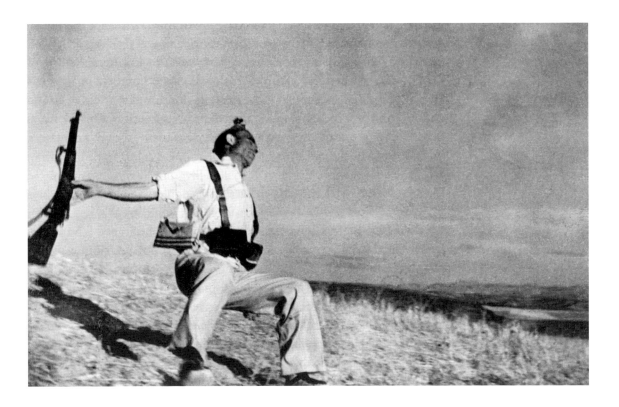

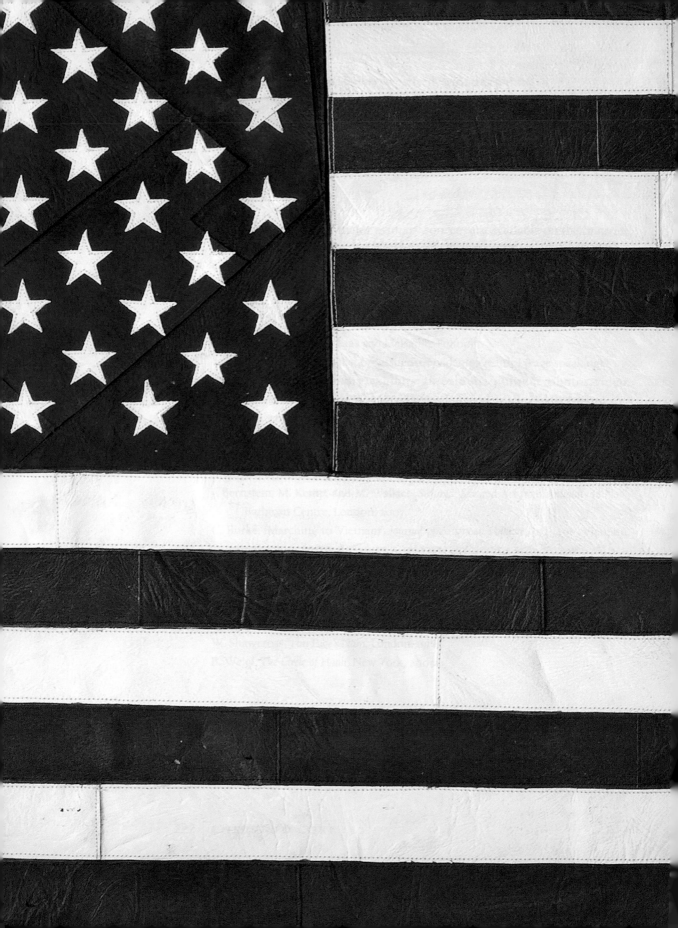

8

Stars and Stripes

T HE HISPANIC DRIVERS at LAX are rushing excitedly between one an-
other on the taxi ranks to pass on the news. 'We are at war. We are at
war.' Immigrants to a man, the 'Latinos' seem to have identified almost
overnight with their adopted country. There are some Eastern European
accents as well. Judging by their fragmentary English, most are recent ar-
rivals. I am taken aback by their automatic and unquestioning 'we'.

It is 2001. I am arriving at Los Angeles Airport at the start of the first
Gulf War—the one that was to liberate Kuwait from the invading Ira-
qis but which left Saddam Hussein in power. My driver's English does
not extend beyond a few bellicose schematics. We are on our way, I
hope, to the scholar housing at the Getty Institute at Brentwood. As we

■ Andrew Krasnow, *The Flag from Flag Poll*, detail, 1990, human skin and dye, collection of
the artist.

eventually leave the choked and choking multi-lane highways and pass along the quiet grids of villa-lined roads near Hollywood I notice that very many houses are boasting at least one fluttering 'Stars and Stripes', far more than when I had left a few days earlier to give a conference paper (I forget where). I am at 'the Getty' for a few months to write my book on *The Human Animal*, some glimmers of which can be discerned in Chapter 4.

I had already been surprised by the number of American flags displayed outside the sprawling houses, luxuriously reclining behind their austere security fences. They seem uneasily like microcosms of the beleaguered US embassies abroad. Now it would seem that those residents who were failing to fly the American flag for whatever reason are laying themselves open to the charge of un-American inactivity. It's obviously a good time to be in the flag business. I have seen nothing comparable in Britain or elsewhere in Europe, other than at times of major football tournaments (or soccer as I have learnt to say in LA). Even then the flags tend to unfurl from cars and pubs rather than private houses.

The flag of the United States of America, the Stars and Stripes, 'Old Glory', or the 'Star-Spangled Banner', has a religious hold on the American imagination. (Should I accord the names of the flag capital letters, I wonder?) Europe, grown weary in conflict and old across passing regimes, has largely lost what we might call the metaphysics of the flag. The Nazi swastika was probably the last European flag to function at full blast. In Los Angeles we seem to be closer to Constantine going into battle under the sign of the cross than to the contemporary cynicism that I have come to take as natural. The majority of the residents of the fortified mansions I have encountered unquestionably see their country as continuously fighting a just defensive war against the 'axis of evil' as defined in George Bush's speech a year later. This is Bush I not Bush II. The wealthy businessmen and their expensively dressed wives are not given to self-doubt and liberal reflection, which they see as sapping Europe's moral fibre. I am disconcerted by their paradoxical combination of personal big-heartedness and international small-mindedness. The flag provides the iconic seal on their American values.

All flags of nations (and of potent smaller entities) are icons, but a few have significantly transcended the necessary level of national identity. The Union Jack, the flag of the United Kingdom, achieved an international reach, not least as the result of the global spread of the old British Empire.

It is one of those flags that has a highly distinctive design. The red flag of the former Union of Soviet Socialist Republics, with its proletarian hammer and sickle, also came to acquire a pan-national meaning and has a highly individual look, but is not now in use. How many people can immediately say what the current Russian flag looks like? (The answer is that it is one of those boring tricolours, with successive white, blue, and red horizontal bands.) The current spread of the American flag now exceeds that of the Union Jack for very apparent political and economic reasons. It has been transfigured into works of art. In the modern world of pop symbols it has also become a jazzy design motif drained to a greater or lesser degree of meaning. As we will see such use of the Stars and Stripes is illegal, according to a code of astonishing complexity and rigidity.

What I propose to do is to look at the origins of the flag, with its wholly inevitable quotients of myth, at the dry but mystical code that governs its use, at a photographed incident that embodies the flag's resonant meaning at its simplest—triggering a remarkable set of progeny—and at two transformations of the flag into high art. The mythical origins involve the homely Philadelphia seamstress and upholsterer Betsy Ross and the mighty George Washington in a story that has become more true than the truth, because it is needed. The Flag Code, which has legally binding status but is honoured more often in the breach than the observance, is contained in the ordinance 'Title 4—Flag and Seal, Seat of Government and the States'. The photographic image, as many will have guessed, is the renowned shot by Joe Rosenthal of the flag raising on Iwo Jima, with its most famous child, Felix de Weldon's *Iwo Jima Memorial* in the Arlington National Cemetery (Fig. 8.1). The two artists are Jasper Johns, whose varied renditions on the surface of his paintings of the Stars and Stripes have brought fame, and Andrew Krasnow, whose stitching of the flag from dyed human skin has unsurprisingly brought notoriety.

Homespun Tales

On 14 June 1777, the Marine Committee of the Second Continental Congress passed the famous Flag Resolution which stated: 'RESOLVED: That the flag of the United States be thirteen stripes, alternate red and white; that the union be thirteen stars, white in a blue field, representing a new Constellation.' The thirteen stripes and stars corresponded to the thirteen

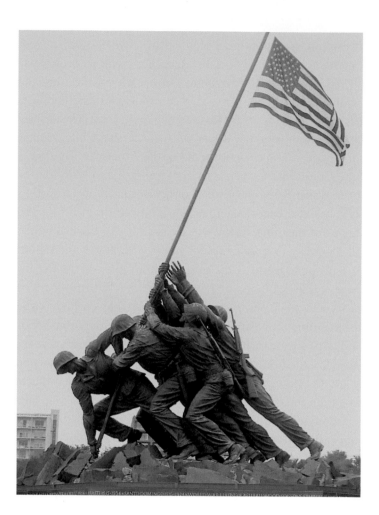

Fig. 8.1

Felix de Weldon, *Marines Raising the Flag at Iwo Jima*, Virginia, Marine Corps War Memorial, Arlington National Cemetery.

founding states of the union. The bald history of the flag thereafter is apparently straightforward and accumulative, as union moved towards its present, numerically satisfying total of fifty. In 1795 the number of stripes increased to fifteen, but reverted to the founding number of thirteen in 1818 when the states came to number an impractical twenty. The accumulation can best be summarized in tabular form. It comes as something of a surprise to find that Oklahoma, as American as apple pie and immortalized in Oscar and Hammerstein's hit musical of 1943, only joined in 1908. The story looks clear enough.

However, in keeping with our law that 'the accumulation of myth is in direct proportion to the fame of the icon', the story is anything but

13	Delaware, Pennsylvania, New Jersey, Georgia, Connecticut, Massachusetts, Maryland, South Carolina, New Hampshire, Virginia, New York, North Carolina, Rhode Island	1777
15	Vermont, Kentucky	1795
20	Indiana, Louisiana, Mississippi, Ohio, Tennessee	1818
21	Illinois	1819
23	Alabama, Maine	1820
24	Missouri	1822
25	Arkansas	1836
26	Michigan	1837
27	Florida	1845
28	Texas	1846
29	Iowa	1847
30	Wisconsin	1848
31	California	1851
32	Minnesota	1858
33	Oregon	1859
34	Kansas	1861
35	West Virginia	1863
36	Nevada	1865
37	Nebraska	1867
38	Colorado	1877
43	Idaho, Montana, North Dakota, South Dakota, Washington	1890
44	Wyoming	1891
45	Utah	1896
46	Oklahoma	1908
48	Arizona, New Mexico	1912
49	Alaska	1959
50	Hawaii	1960

straightforward. There is a living folk history that exists alongside the historical documentation, and has its own kind of emotional reality.

The Philadelphia seamstress and upholsterer 'brave' Betsy Ross, raised a Quaker and thrice widowed, worshipped in the pew next to George

Washington. When a design for the first American flag was mooted, Washington and two Congress representatives took the proposed scheme to Betsy for sewing. The stars in the 'Washington design' were six pointed. With 'a single snip' of her deft scissors, she cut out a five-pointed star.

It is indeed possible (as demonstrated on the internet) to fold a rectangular piece of paper or cloth with the proportion of $1:0.85$ seven times and then with a single cut to produce a five-pointed star. It is the kind of handicraft trick that a seamstress might well have known. The problem with the trick is that the angle of the cut is crucial, and can produce points ranging from very sharp to very blunt. The upper edges of the lateral arms are not necessarily aligned as in the canonical pentagram that is on the flag. A bit more geometry is needed to guarantee success.

We know that Ross, like other seamstresses, was involved in making flags. In 1777 a minute of the meeting of the Board of War on 29 May records 'An Order on William Webb to Elizabeth Ross, for fourteen pounds, twelve shillings, two pence for making ships colours & put into William Richards' stores.' This is a little over two weeks before the key resolution of the Marine Committee.

We can visit Betsy Ross's neat little 'Georgian' house in Pennsylvania. It is decidedly pretty, not grand but quietly gracious. It is both stylish and homely. At least it is *probably* her house, where she practised her skilled trade. There is some dispute about changing house numbers over the years. We can see a flag according to the 'Betsy Ross design', in which the canton (a 'quarter' of a flag) contains a circular 'constellation' of stars. This is consistent with the 1771 resolution. It is difficult to see a grid of stars as a 'constellation' in the heavenly sense. We can buy all sorts of historical reproductions and souvenirs, including a tea-stained (i.e. 'antiqued') Betsy flag and pint glass decorated with a 'distressed' flag, most of which, as will become clear, break the Flag Code. There are lots of Betsies on eBay. I tend to think that the Betsy Ross Bunnykins, issued by Royal Doulton in 2004 in a limited edition of 2,000, is going a bit far (Fig. 8.2).

Betsy's key role was first announced in 1870 by her grandson, William Canby, and was supported by sworn affidavits by other relatives. The story grabbed the public imagination. It played precisely to the American affection for homespun things, for the honest ordinariness of American 'folk', for the simple truths of the fireside reminiscence, for the common or garden basis of the humble Christian might that allowed the plain virtues of the fledgling republic to triumph over the fancy monarchical grandeur of

Fig. 8.2

Betsy Ross Bunnykins, by
Royal Doulton, 2004.

George III. Very rapidly the narrative expanded, like the number of stars of the flag, with 'verbatim' accounts of what Ross said boldly to Washington about his flawed design.

The problem is that there are no contemporary documents or testimony about her production of the first flag. Canby was only 11 years old when Ross died. The only contemporary claimant to be the designer of the flag is someone else altogether, someone who can be documented as at the centre of the events that led to America's independence. He is Francis Hopkinson, lawyer, author, composer, and one of the signatories of the Declaration of Independence in his capacity as a delegate from New Jersey. On 25 May 25 1780, Hopkinson wrote a letter to the Continental Board of Admiralty seeking modest recompense in the form of a 'Quarter cask of the public Wine' for several designs, amongst which was 'the Flag of the United States of America'. A month later Hopkinson submitted a bill for his 'drawings and devices'. 'The Naval Flag of the United States' headed the list and was priced at 9 pounds. It is generally assumed that his design aligned thirteen stars of six points in staggered rows of 3/2/3/2/3, but this is not certain.

It is worth noting that the precise form and distribution of the stars exercises quite an effect on the look of the canton. Many differently-shaped arrays were tried over the years. The six-pointed star has three axes of bilateral symmetry and can be said to 'point' unemphatically in six directions. The five-point star has only one axis of bilateral symmetry but its aligned arms work very well to set up strong horizontal and diagonal alignments in the staggered design. The changing number of states has resulted in various 'constellations' over the years, but the staggered array credited to the schoolboy Bob Heft in 1958 for a forty-nine-star version has endured into the current fifty-star canton. That Heft submitted such a design is certain, but it is highly unlikely that none of the more than 1,500 designs was identical to his. But no other designer could compete with a 17-year-old boy in a provincial town as the natural heir to Betsy (but not to Hopkinson). Incidentally, the state flag of Ohio shows just what a mess can be made of a design with stars and stripes.

Given the circumstances of Hopkinson's claim to have played a decisive role in what became the standard design, it is highly unlikely that the then judge was flying a kite. However, he does not possess the homely charm of Betsy. (The common uses of the sur- and christian- names tell a story in their own right.) But he was quite a picturesque character. His patriotic

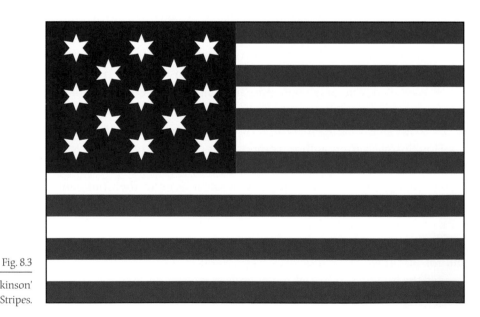

Fig. 8.3

The 'Francis Hopkinson'
Stars and Stripes.

writings and poems are not big on nuanced subtlety but possess a committed directness. One essay is cast in the form of 'A Letter Written by a Foreigner (1776) on the Character of the English Nation'. He had himself been in England ten years earlier. He pulls no punches:

> The general character of the English is certainly the most fantastic and absurd that ever fell to the lot of any known nation. As they are made up of contradictions, it would be unjust to give them any uniform designation. There is scarce a virtue that adorns the mind, or a vice that disgraces human nature, but may be ascribed to them as part of their national character . . . He will brave the utmost hardships and encounter the severest trials with heroic fortitude; and he will drown or hang himself because the wind is in the east.

In his 'Political Catechism Written in 1777', Hopkinson berates George III in no uncertain terms:

> History is filled with the wicked lives and miserable deaths of tyrants. The present King of Great Britain . . . is a living example of such a prince . . . he is now carrying out an offensive war in *America*, without one specious plea of justice for so doing . . . he looks on his fellow-creatures created only for his use, and makes their misery his sport.

A man of impeccable nationalist and republican credentials. But on 27 October 1780, the Treasury Board refused Hopkinson's request, stating that he 'was not the only person consulted on those exhibitions of Fancy, and therefore cannot claim the sole merit of them and not entitled to the full sum charged'. This seems to be exactly right. The design of the flag did not occur at a single moment as a flash of creative genius attributable to a single person. We will encounter a similar situation with the COKE bottle in the next chapter. The Marine Committee's resolution of 1777 may well relate to a national ensign to be deployed on ships rather than saying, in effect, 'this is for now and for ever to be the state flag of our nation'. The stripes seem to have been a reasonably settled feature of early flags, but the stars seem to have been variable in their form and deployment. The key things were that the thirteen states should be clearly signalled and that it should not look like the Union Jack.

Once this historical untidiness is accepted, the question of *the* designer is not the right one. This acceptance also helps potentially to bring Ross back into the story. She may have sewn a very early version of the Stars and Stripes for the Congressional representatives, maybe even the prototype. The Marine Committee might well have wanted to see what an actual flag looked like before committing themselves. But the 'constellation' array of stars did not stick, and Hopkinson's grid may have proved decisive in the final array in the canton. But there could have been other contributors as well. Proof is elusive, but there is something satisfying (and very American) in being able to accommodate both the homely upholsterer, Betsy, and the polemical author, Hopkinson. If this is not literally right there is a bigger sense in which it ought to be.

Precisely 10 Commandments

The United States Code, Title 4, Chapter 1, comprises ten numbered paragraphs, running from number '1. Flag; stripes and stars on', to number '10. Modification of rules and customs by President'. (The President can alter 'any rule or custom pertaining to the display of the flag' but not its design.) Some of the paragraphs are in themselves substantial. No. 7 contains sixteen separate rules. The Code was compiled in 1923 by a conference representing almost seventy organizations—with the kind of results that one might expect. In 1942, during the Second World War, the Code became public law. It has been subject to only minor modification in the following years.

The most controversial paragraph is number 3, which covers the 'use of flag for advertising purposes; mutilation of flag'. It opens,

> Any person who, within the District of Columbia, in any manner, for exhibition or display, shall place or cause to be placed any word, figure, mark, picture, design, drawing, or any advertisement of any nature upon any flag, standard, colors, or ensign of the United States of America; or shall expose or cause to be exposed to public view any such flag, standard, colors, or ensign upon which shall have been printed, painted, or otherwise placed, or to which shall be attached, appended, affixed, or annexed any word, figure, mark, picture, design, or drawing, or any advertisement of any nature . . .

After other such clauses, it warns that any person who transgresses

shall be deemed guilty of a misdemeanor and shall be punished by a fine not exceeding $100 or by imprisonment for not more than thirty days, or both, in the discretion of the court.

Much of the merchandise offered by the Betsy Ross House, along with the majority of the flag-adorned souvenirs at American heritage sites, runs afoul of the rules. Such items as cushions and clothing decorated with flags are prohibited under the rule in number 8 that 'the flag should never be used as wearing apparel, bedding, or drapery' or 'be embroidered on such articles as cushions or handkerchiefs and the like, printed or otherwise impressed on paper napkins or boxes or anything that is designed for temporary use and discard'. For good measure cute Betsy Bunnykins violates the rule in the same paragraph to the effect that 'the flag should never touch anything beneath it, such as the ground, the floor, water, or merchandise'. Taken at their strictest, the rules mean that virtually any person using the flag outside its specific function as a normal flag has committed a misdemeanour.

Number 4 governs the familiar 'Pledge of allegiance to the flag', stipulating that the right hand should be placed over the heart when it is delivered. Both the right hand and the heart (as in Chapter 3) carry an obvious symbolic import. Virtually every possible insult and potential threat to the sanctity of the flag is covered, including bad weather: 'the flag should not be displayed on days when the weather is inclement, except when an all-weather flag is displayed.'

It is easy to make fun of such unenforceable earnestness. Even the Stasi in communist East Germany would have been hard pressed to cover the range of violations. But behind the rules there lies a big belief system, what I am calling the metaphysics of the flag. This decrees that the flag is not simply a piece of symbolic cloth that signals an identity but that it somehow embodies a 'real presence'—some kind of spiritual essence of the USA as a God-given entity. In a way it is the blood and body of holy America just as the wine and bread are the body of Christ. Attempting to destroy the wafer of the Host is a heinous crime of which Jews were accused in the Middle Ages and thereafter as a way of whipping up anti-Semitic feeling. In an equivalent way, to besmirch the flag or even to try to destroy it is seen as representing an evil assault on the deepest values of America itself.

In March 1989 a student at the School of the Art Institute in Chicago, Scott Tyler (subsequently re-styled as 'Dread Scott'), mounted a small display entitled *What is the Proper Way to Display a U.S. Flag?* Below a collaged image of the flag, used and abused, was a comment book on a wall-mounted shelf. The Stars and Stripes was placed on the floor in such a way as to act as a potential mat for those who wished to write a comment. It looks quite tame and orderly to a European. But the comments of the 'Veterans' were vituperative. They protested loudly, removing the flag from the floor and forcing the exhibition to close. The charismatic Director of the School, the Welshman Tony Jones, was on the horns of a dilemma. The exhibition reopened a few days later with restricted access. The Veterans sought an injunction against the reopening and what they termed the 'deliberate soiling of the flag'. One of the Veterans' statements is particularly telling: 'it would be different if it was his own rendering of the flag. But it was a real flag. And it belongs to the American people.' The 'real' thing embodies a 'real' presence that a mere representation does not.

In November, inevitably some time after the dust had settled, Judge Kenneth Gillis ruled that artists could not be prosecuted, because 'when the flag is displayed in a way to convey ideas, such display is protected by the First Amendment'. This was consistent with an earlier ruling of the Supreme Court, which decided narrowly that Gregory Lee Johnson had exercised his constitutional freedom of speech when he burnt the flag of the United States outside the 1984 Republican National Convention in Dallas. Scott himself later provocatively took part in a flag burning in Washington. If torching eludes definitive punishment, Bunnykins should be safe.

In a dissenting minority opinion in 1984, William Rehnquist expressed the view that 'millions and millions of Americans regard it [the flag] with an almost mystical reverence', which does indeed seem to be the case. The issue was not dead and refuses to die. A Flag Desecration Amendment has been proposed on a number of occasions but has so far foundered in the face of the First Amendment, which guarantees freedom of speech, to say nothing of difficulties in defining what is a flag and what is not. If Tyler had painted a flag on the floor, would this have been the same as placing a 'real' flag there?

All this elaborate legalism stands in the sharpest possible contrast to the constitutional and legal position of the British Union Jack—or rather

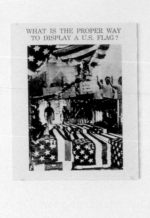

WHAT IS THE PROPER WAY
TO DISPLAY A U.S. FLAG?

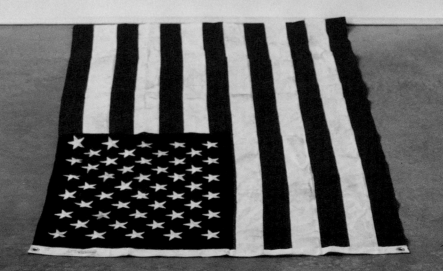

its lack of definable position. On 15 July 2002 the relevant minister, Ms Rosie Winterton, was asked in a written question about the need for legislation about the display of the flag. She replied,

> There are no restrictions under the general law on the display of the Union Flag on land in England and Wales other than those imposed by the provisions of the Trade Descriptions Act 1968 and the Trade Marks Act 1994, which relate to the reproduction of flags in trade marks. The Department for Culture, Media and Sport issues guidance, in consultation with the Lord Chamberlain's Office, as to the days The Queen has approved for flags to be flown from Government buildings.

Hotter issues such as desecration are similarly devoid of rules comparable to those in the Flag Code of the USA. This is partly a reflection of the British tendency to develop loose coalitions of rules by custom and use rather than constitutional imperative, but it also reflects a huge and generally unrecognized cultural gulf that has opened up between the 'New' and 'Old Worlds' when it comes to the primary symbol of the nation.

Iwo Jima

The island of Iwo Jima ('Sulphur Island') is a notably uninviting squashed slug of land, 5 miles long and irregular in shape, with a crusty volcanic lump, Mount Suribachi, at the end of a south-west protrusion. It is 750 miles south of the Japanese mainland. Looking at a satellite image of it today we can gain a clue as to why this inhumane place hosted one of the most bitterly contested and bloody battles of the Second World War. It has an airstrip (or rather two at the time), which made it of particular strategic significance. It was claimed that if the Americans could capture it from the formidable Japanese defenders their goal of achieving air dominance would be hugely advanced.

The defenders had transformed the island into a geological fortress, with a vast complex of underground bunkers, gun placements, and tunnels, far more formidable than any castle contrived by unaided human hand. A remorseless pounding from the air proved to have little effect, other than on vegetation. On 19 February 1945 waves of landing craft scurried to the shore, like swarming water beetles, disgorging adrenalin-fuelled hordes of marines onto the hostile beaches. Some 110,000

eventually made landfall. What follows, more than vividly documented by videos on the internet and in the account by Bradley and Powers, is enough to make someone stronger than me weep. Ferocious fusillades of gunfire; machine guns scything through advancing ranks of attackers; artillery blasting rocks and limbs into the smoke-filled air; shuddering bombs digging instant graves; lobbed grenades shattering the underground lives of unseen adversaries; and, perhaps most brutally, tongues of immolating fire from flame throwers spewing into the mouths of the Japanese bunkers. At the end of thirty-six days of indescribable savagery and mutual bravery, 18,000 or more Japanese were dead (precise figures are elusive), and almost 7,000 Americans.

A key focus of the battle was the volcanic lump, only 550 feet high but looming far higher for the assaulting marines. The ironically named Easy Company, already decimated by 40 per cent casualties, made it to the top of the symbolic peak on 23 February. There they erected a flag, not a large one but enough to be seen from the flat ground below. The raised flag was photographed by Staff Sergeant Louis Lowery, a professional marine photographer. The subsequent events, leading to Joe Rosenthal's truly iconic photograph, are inevitably subject to our proportional law of mythical accretion, but over the years a common core of narrative has been extracted from the overlapping and sometimes contradictory testimony of witnesses. Typically, the photographs taken to and on the summit are not enough to tell the story or even to identify the participants decisively. What follows is that core as it has emerged. (Inevitably any compact summary does less than full justice to some of the key participants.)

Joe Rosenthal and two marine photographers set out for the summit. They encountered Lowery on his way down and were assured that they could get some good pictures from the top. The three climbers reached the peak as a group of 6 marines were preparing to erect a second, larger flag, using a very heavy length of Japanese piping as a pole. Rosenthal, a man of diminutive stature, built a small podium of rocks on which to stand. As he turned, he was only just in time to catch and immortalize the wedge of marines forcing the pole towards the vertical and embedding it in the shattered ground (Fig. 8.5). The flag raisers are now identified with some security as Ira Hayes, Franklin Sousley, John Bradley, and Harlon Block in the front, and Michael Strank and Rene Gagnon at the back. Only Bradley, Hayes, and Gagnon were to leave Iwo Jima alive.

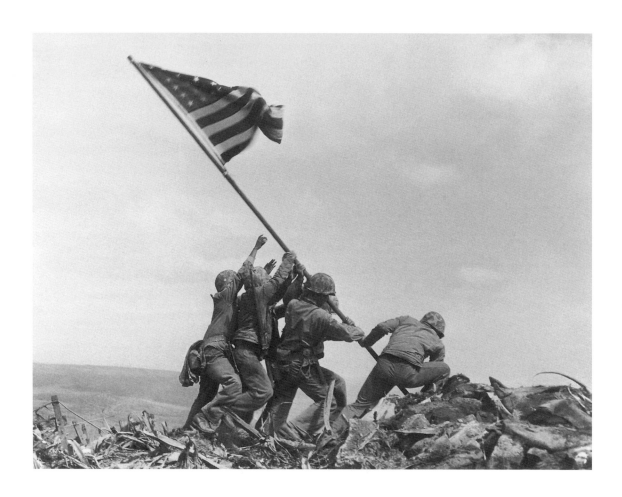

Fig. 8.5

Joe Rosenthal, *Flag Raising on Mount Suribachi on Iwo Jima*, 1945.

Rosenthal knew the event was worth photographing, but it was one important shot amongst many that he took on Iwo Jima and during his career. As he said, 'when you take a picture like that, you don't come away saying you got a great shot. You don't know.' There is a picture by Bob Campbell that shows the moment when the second flag replaced the smaller one, together with a clutch of other photographs and a short film, including an image of Rosenthal standing on his rocky dais, and a posed cluster of cheering marines. Only one photograph became instantly and enduringly famous, both in its cropped and uncropped versions. It was awarded the Pulitzer Prize in the same year.

I think we can see why. It achieves, in that instant of semi-chance, what great artists of heroic narrative images have always sought. The main group of five is compacted into a cohesive unit and conforms to the

pyramidal ideal beloved of old-style formal analysis. The marines' echoing right legs imply a cinematographic sequence of powerfully concerted actions. The marine guiding the pole into the ground adopts a torsioned pose worthy of one of Michelangelo's soldiers, stirring from their bathing before the *Battle of Cascina*. The lurching diagonal of the flag pole, animated by the fluttering flag, emphasizes the dynamism of the action, as do the turbulent waves of the fractured earth below.

What we are describing is a distant cousin of Théodore Géricault's famous *Raft of the Medusa* in the Louvre. In some ways the comparison is wildly improbable. Géricault's masterpiece is a huge and complex oil painting, depicting the desperate plight of victims of the shipwreck of the *Medusa*, cast adrift on a ramshackle raft by callous officers. Those able to do so are reacting with concerted hope to the glimpse of a ship on the horizon. The differences are clear. The time taken to produce the two images could hardly be more different. The elements of creative control and chance are very differently compounded. One image is predominantly

Fig. 8.6

Théodore Géricault, *Raft of the Medusa*, 1819, Paris, Musée du Louvre.

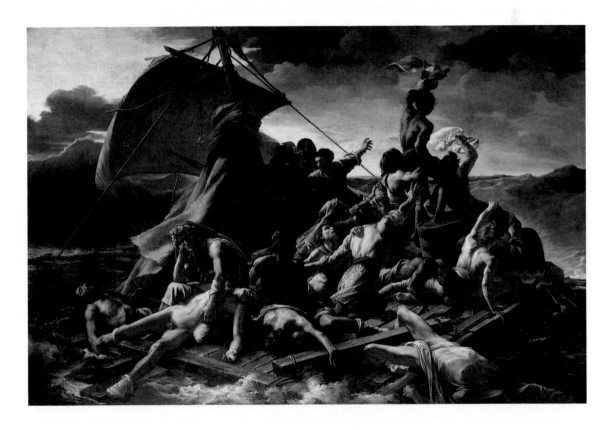

planar, the other deeply spacious. And so on. But the principles of compositional effect are shared across their different levels of visual complexity, not least their diagonal dynamism. They share a quality that all great art has, however variously it is generated. It is that sense of enduring rightness that never loses its ability to surprise.

It was precisely this classical quality that has allowed its transcription and translation into other media. The most famous of these transcriptions is the massive bronze group created by Felix de Weldon and his team of assistants for the Iwo Jima memorial at the Arlington National Cemetery on an elevated site looking over the capital. The Austrian sculptor operated for some years out of London, becoming known as an effective official portraitist in a traditional mode. In 1938 he moved to America. Fired by Rosenthal's photograph, he initially developed a small model of his own volition. This was translated into a 9-foot plaster that toured to support the promotion of war bonds. Its highly favourable reception was followed by a Congressional commission for the 48-foot high monument. After more than nine years of intense effort, the monument was dedicated on 10 November 1954 (Fig. 8.7).

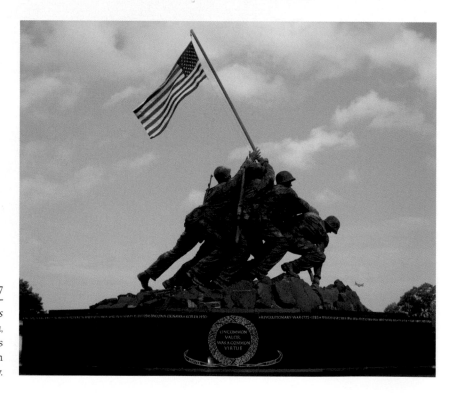

Fig. 8.7

Felix de Weldon, *Marines Raising the Flag at Iwo Jima*, Virginia, Marine Corps War Memorial, Arlington National Cemetery.

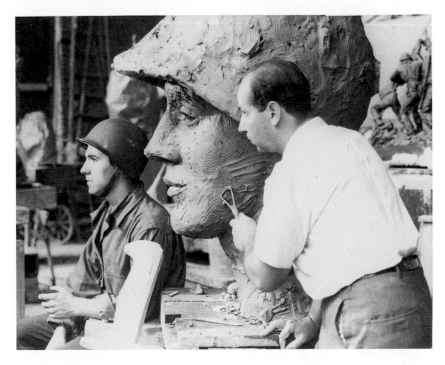

Fig. 8.8

Felix de Weldon working on the clay model for the head of Rene Gagnon.

In creating the massive bronze tableau, the sculptor garnered as much physical data as he could. The survivors were modelled from life, and he researched the stature and appearance those who had not survived (Fig. 8.8). The sculpture serves as a kind of 3-D photograph, set up in such a way as to convince the viewer of its gritty veracity.

In fact the realism, like all realisms, is full of artifice and rhetoric. The young marines all come from the same heroic mould, clean featured and strong jawed (Fig. 8.9). Their close relatives can be found on many Soviet war memorials. The surface has been raked with a series of coarse 'comb marks', like those made by a claw chisel in marble, which provide an overall texture that serves simultaneously as a kind of sign of abrasive reality and as a mark that this is real art. De Weldon has reorganized the group so that the bodies are more densely packed—to an improbable degree. The marines' legs are more closely parallel; all can still reach the ascending pole; and the figure planting the shaft in the ground has been fused into the main group. The expressive tensions in Rosenthal's incomplete and ragged pyramid have been replaced by a more academic compositional geometry.

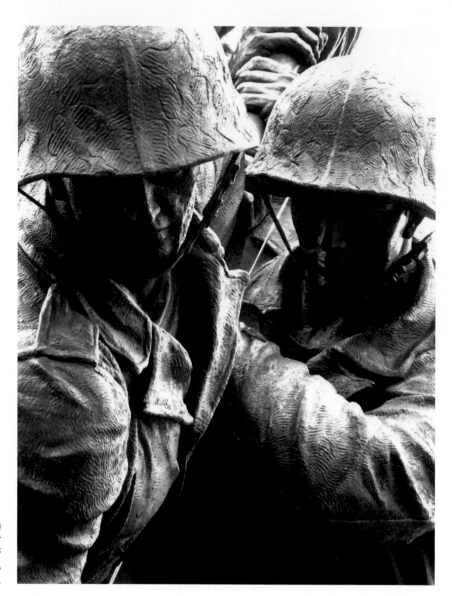

Fig. 8.9

Felix de Weldon, *Marines
Raising the Flag at Iwo Jima*,
detail.

The official website dedicated to de Weldon, who died in 2003, confidently declares that he 'is internationally recognized as the foremost American sculptor of the 20th century'. So much for Alexander Calder, David Smith, Richard Serra, and other heroes of the art world. The fact is that de Weldon's kind of realistic 'public' sculpture and avant-garde sculpture operate in very different worlds. De Weldon's style is best identified

with a range of 'realistic' public media, including photography and film—most specifically the Hollywood war film—rather than the 'Fine Art' of specialist art galleries. The Memorial does not comfortably belong in the same category as a mobile by Calder, a contemporary of de Weldon.

This proposed reassigning of 'photographic' sculpture to a different category of public media is not *necessarily* linked to value, since the Iwo Jima Memorial clearly does its job supremely well, and has become something of an icon in its own right. It has a brief that is quite different from that of the work produced by Calder, which is to be appreciated by viewers attuned to the specialist criteria of 'Art'. The difference is not *necessarily* a question of popularity, since Calder's mobiles have gained a huge following. I personally find Calder far more rewarding than de Weldon. With the latter, what you see is what you get; Calder invites the spectator do more work on his or her own behalf. His creations exist at a higher level of imagination. But in the context of narrative flag waving, de Weldon does something that Calder cannot.

The flag raising was re-enacted on the basis of Rosenthal's photograph for the 1949 John Wayne film *Sands of Iwo Jima*. It has more recently featured prominently in Clint Eastwood's film of the bloody battle and its aftermath, *Flags of our Fathers*, and provided the image for the poster, set against a threatening sky. The memorial and its photographic source have subsequently served inseparably as the basis for multiple re-stagings, including a real-life tableau enacted by the marines, which was in its turn photographed and displayed in the newsletter of their Heritage Centre. Signed posters were produced and are still being marketed. Rosenthal's image featured on a postage stamp in the same year as it was taken, and has been widely exploited by the military in publicity images and recruiting posters. Then, following the destruction of the World Trade Center in 2001, firefighters were photographed by Thomas Franklin of the *Bergen Record* in New Jersey raising an American flag in a way that cannot but carry echoes of Iwo Jima (Fig. 8.10). As Franklin later said, 'as soon as I shot it, I realized the similarity to the famous image of the Marines raising the flag at Iwo Jima'. An iconic image is shaping what is seen and selected. Franklin's image was on its own account transformed into a monumental bronze group at the National Fallen Firefighters Memorial Park in Emmitsburg. It also featured on a special kind of postage stamp. The price of what was called a 'semi-postal stamp' carried an 11-cent premium as a donation to the Federal Emergency Management Agency.

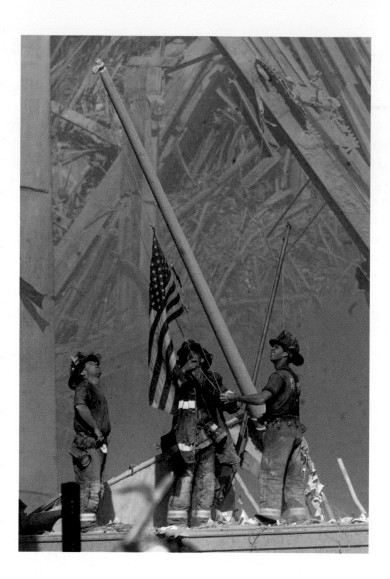

Fig. 8.10

Thomas Franklin,
*Flag Raising at Ground Zero
(Ground Zero Spirit), New
York*, 11 September 2001.

Wax and Skin

Finally, the flag has become art—not included or represented in art but effectively becoming the work itself. This first famously happened when Jasper Johns completed his inaugural flag painting in 1955, the work that really made his name and still serves as his signal image (Fig. 8.11). *Flag* was produced in many variant forms. In May 2010 a Johns *Flag* purchased directly from the artist by Michael Crichton, author of techno-thrillers and film magnate, was sold in New York for $25,500,000. It is an

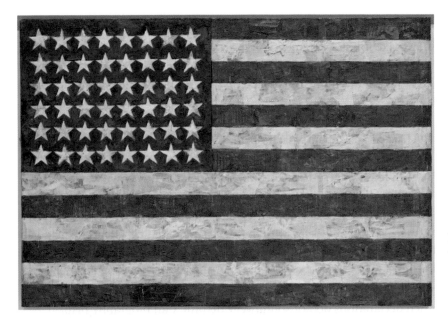

Fig. 8.11

Jasper Johns, *Flag*, encaustic, oil, and collage on fabric mounted on plywood, 1954–5, New York, Museum of Modern Art.

image that invites and has attracted torrents of writing about art and the nature of depiction, and about meaning and non-meaning. It is one of those artworks on which it would be good to call a moratorium on further commentary for at least a decade. However, in the present context it simply cannot be avoided. Let me begin with some facts and words from the horse's mouth.

It is painted on fabric mounted on three joined plywood boards. The first pictorial layer consists of a collage of bits from newspapers. On top is thickly applied coloured wax, layered and drippy—a glutinous version of the encaustic technique, which had been known since ancient Egypt but was largely unfamiliar in modern art. The print on the papers can be glimpsed but not coherently read. What are we to make of it? Do the painter's statements help? Johns tells us how it came about:

> One night I dreamed I painted a large American flag, and the next morning I got up and I went out and bought the materials to begin it. And I did. I worked on that painting a long time. It's a very rotten painting—physically rotten—because I began it in house enamel paint, which you paint furniture with, and it wouldn't dry quickly enough. Then I had in my head this idea of something I had read or heard about: wax encaustic.

Krasnow is working with a medium that is as complex in potential meanings and emotional reactions as any art medium could be. Flaying is full of traditional resonances. In ancient mythology, Marsyas was notoriously skinned for the temerity of his musical challenge to Apollo. St Bartholomew was excruciatingly martyred by flaying. In Michelangelo's *Last Judgement* in the Sistine Chapel in Rome, the knife-wielding saint, fully intact in heaven, holds his own earthly hide, which bears a distorted imprint of the artist's own face.

Closer to home, Krasnow is inviting us to think about 'the skin history . . . of the Americas, from the scalping of Native Americans on the frontier to the branding of slaves in the South to the dropping of the A-bomb on Japan to the use of napalm in Vietnam and phosphor bombs in Central America'. He also tells us that his sister 'suffered severe burns', from which she died in spite of extensive skin grafts from their parents. However, he resists the idea that there is a dominant 'defining experience', either for him or for us. Like Johns he is not making a 'statement'. He shares John's awareness that their kind of images do not work that way.

Flags are not the most benign of human inventions. At their best they identify cohesive communities that support meaningful human lives. At their worst they are waved aggressively in the faces of outsiders. The schematic heraldry of flags is both primitive and enduringly potent. At one level flags are robustly unambiguous, but in the emotional domain they are open to various and even polarized readings. It is this openness that Johns and Krasnow exploit.

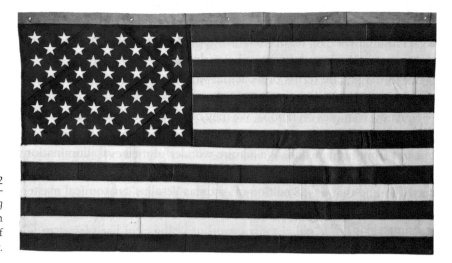

Fig. 8.12

Andrew Krasnow, *The Flag from Flag Poll*, 1990, human skin and dye, collection of the artist.

For patriotic Americans, the Stars and Stripes embodies American values in a 'sacred' manner and evokes everything that is good about living in one of the fifty states. For those who see America in an opposite light, the flag looks very different.

Reading

http://en.wikipedia.org/wiki/Battle_of_Iwo_Jima.

http://www.felixdeweldon.com/.

http://www.usflag.org/uscode36.html.

J. Bradley and R. Powers, *Flags of our Fathers*, New York, 2000.

H. Buell, *Uncommon Valor, Common Virtue: Iwo Jima and the Photograph that Captured America*, Berkeley, 2006.

R. Burrell, *The Ghosts of Iwo Jima*, College Station, Tex., 2006.

W. Furlong, B. McCandless, and H. Langley, *So Proudly We Hail: The History of the United States Flag*, Washington, 1981.

G. Gentile, *History of the Iwo Jima Survivors Association & the National Iwo Jima Memorial*, Iwo Jima Survivors Association, 1997.

S. M. Guenter, *The American Flag, 1777–1924: Cultural Shifts from Creation to Codification*, Madison, 1990.

F. Hopkinson, *Miscellaneous Essays and Occasional Writings*, 3 vols., Dobson, Pa., 1792.

K. Kakehashi, *So Sad to Fall in Battle: An Account of War Based on General Tadamichi Kuribayashi's Letters from Iwo Jima*, New York, 2007.

M. Kemp, 'More than Skin Deep', *Nature*, 457, 5 February 2009, 665.

F. Orton. *Figuring Jasper Johns*, Chicago, 2004.

L. T. Ulrich, 'How Betsy Ross Became Famous: Oral Tradition, Nationalism, and the Invention of History', http://common-place.org/vol-08/no-01/ulrich/.

J. Weiss. *Jasper Johns: An Allegory of Painting, 1955–1965*, London, 2007.

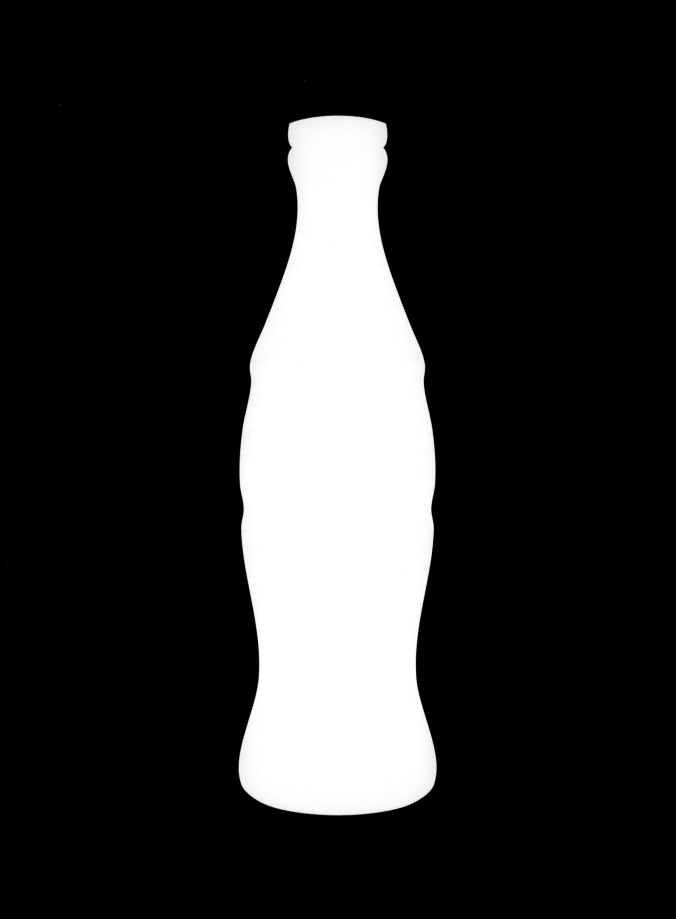

COKE

THE BOTTLE

'I'D LIKE TO BUILD the world a home and furnish it with love . . .' A sweet-faced teenage girl mouths the words in close-up, her hair caressed by a soft breeze. The delights of this utopian home are intoned melodiously by a chorus, while the camera pans in little skips across a multiracial spectrum of youths, viewed from the waist up. They are arrayed in neat lines. Their skins are of varied colours and their faces belong to different 'racial types'. Their dress elusively hints at national costumes. 'I'd like to teach the world to sing in perfect harmony . . .' We become aware that those in front, and by implication those further back, are clutching bottles of COCA-COLA, gripping them firmly around the waist of the bottle in the

- Contours of the COCA-COLA bottle designed by Earl Dean et al. (photograph by the author).

authorized manner. 'I'd like to buy the world a COKE and keep it company . . . It's the real thing . . . It's the real thing.'

Like a baroque *da capo* aria the verse is repeated with slight variations. '. . . It's the real thing, what the world wants today.' The camera slowly draws back to show a fan-shaped cluster of international youths standing on a green hilltop. Finally, a centrally inset bottle of COKE appears. It is all over in a second under a minute.

This is the famous 1971 *Hilltop* commercial for COCA-COLA, one of the all-time classics of advertising. It is sentimental and sugary in flavour, yet I confess that it is oddly affecting in its spirit of youthful hope. Perhaps it means more to someone who was a young person in the 1960s than to a later generation, but I would not count on it.

Like many company outputs, the song and film were the result of team-work, in a way that frustrates any search for the author or even a presiding genius. Bill Backer of the advertising Agency McCann-Erickson originated the line 'I'd like to buy the world a COKE'. Roger Cook and Roger Greenway, the British songwriters with a track record for producing hits, including the Beatles' lyrical *Michelle*, reworked an earlier song of theirs. The successful group The New Seekers were recruited to lead the singing. The director Haskell Wexler devised the visuals, assembling young people from some twenty countries on what proved to be an unexpectedly weather-prone hill outside Rome. The total bill ran to an unprecedented $250,000. The melody and its vocal harmonization struck a public chord, and The New Seekers recorded a three-verse expansion that dropped the commercial references. The song was a worldwide hit.

The *Hilltop* commercial is openly political with a small p. But it is also political in a more pointed sense. COCA-COLA's traditional and often bitter adversary in the 'Cola Wars', Pepsi-Cola, had stolen a march on the COCA-COLA Company in the niche market for black consumers in the USA, with implications that carried over into the world market. In the 1940s Pepsi had taken a lead in hiring a black sales team, and identified the company with progressive causes. Although by 1970 the racial and commercial climate was much changed, both companies strove to remain attuned to anything that would affect their image in the multi-ethnic markets with which they engaged at home and increasingly abroad. The cosy racial harmony of the advert, like that later evoked by Benetton in the 'United Colours' campaign, brought highly desirable associations for a global brand. A company that markets worldwide cannot but be politically aware. The

commercial was also, of course, pitched at an age group that any soft drink company would hope to capture as loyal long-term customers. Above all, the climactic moment at which the single bottle moved into view was part of a long campaign to inculcate the idea that the international attribute held by the young is a COKE bottle, with its instantly recognizable shape.

When Andy Warhol, that greatest of all spotters of icons and the author of multiple images of COCA-COLA bottles, wanted to emphasize his notion of the democracy of consumption in the USA, it was COKE that immediately came to mind:

> What's great about this country is that America started the tradition where the richest consumers buy essentially the same things as the poorest. You can be watching TV and see COCA-COLA, and you know that the President drinks COKE, Liz Taylor drinks COKE, and just think, you can drink COKE, too. A COKE is a COKE and no amount of money can get you a better COKE than the one the bum on the corner is drinking. All the COKES are the same and all the COKES are good. Liz Taylor knows it, the President knows it, the bum knows it, and you know it.

He could easily have extended the quotation to include the world. However, the democracy hardly extends to his own artworks incorporating COKE bottles, which now sell for huge prices. His very large 1962 black-and-white painting of a COKE bottle sold for more than $22 million at Sotheby's New York in 2010.

Alcohol, Cocaine, and Other Addictive Things

Artificially carbonated drink has been around since the late eighteenth century. Joseph Priestley, renowned experimenter with what became known as oxygen, published an instructional pamphlet in 1772 entitled *Impregnating Water with Fixed Air in Order to Communicate to it the Peculiar Spirit and Virtues of Pyrmont Water and Other Mineral Waters of Similar Nature*. Citric acid was added as flavouring shortly after. A succession of fizzy concoctions followed in the nineteenth century, such as lemonade, ginger beer, and root beer. The background was almost always pharmaceutical. Bubbly water was identified with the health springs, baths, and spas that had become such a big social and financial business during the eighteenth century. In the early days, fizzy drinks were sold over the counters of

pharmacies. On the face of it, COCA-COLA—as yet another contender in a crowded market in the late nineteenth century—seemed unremarkable.

In fact, COCA-COLA has a messy and rather inglorious prehistory. It was initially concocted by an entrepreneurial and well-regarded pharmacist from Georgia, John Stith Pemberton, who had marshalled his own cavalry troop to serve on the Confederate side in the Civil War. To reduce the pain of wounds he suffered in battle, he administered to himself morphine, to which he developed an addition. Moving to Atlanta in 1869 to seek a bigger arena for his public health activities and a wider market for his potions, he invented a 'French Wine Coca', which, as its name suggested, contained a modest amount of alcohol. For good measure Pemberton added an extract from the coca leaf, which was then used quite widely in popular medicines that claimed to treat an improbably wide range of complaints. The active ingredient extracted from the plant *Erythroxylum coca* was cocaine (*benzoylmethyl ecgonine*), long known as a potent stimulant for brain activity to the native peoples of the Americas. Now classified as a dangerous drug and the subject of huge criminal trade, its actions were then little understood, and various beneficial effects were claimed. At the start of Conan Doyle's *The Sign of Four* (1890), Sherlock Holmes is scolded by Dr Watson for his cocaine habit. Holmes replies, 'Perhaps you are right, Watson . . . I suppose that its influence is physically a bad one. I find it, however, so transcendently stimulating and clarifying to the mind that its secondary action is a matter of small moment.'

Over the years, the more dubious ingredients were dropped. The first to go was alcohol, in the face of local moves in 1885 to introduce prohibition. To replace alcohol (a depressant), Pemberton added an extract from Kola nuts, rich in caffeine, together with sugar syrup. By 1886 his radically revised drink was ready to be launched. Its new name, comprising Coca from the source of the cocaine and Cola, from *Cola acuminata*, the tree that bears the Kola nuts, seems to have been devised by Frank Robinson, Pemberton's commercial partner and dexterous bookkeeper. It was Robinson who drafted the logo in an accomplished version of the Spencerian script that was standard for formal handwriting in America in the later nineteenth century. Devised by Platt Rogers Spencer, the cursive hand was enshrined in a posthumous publication, the *Spencerian Key to Practical Penmanship*, in 1886. Robinson's sprightly logo was immediately striking, in red on a white background or vice versa. It has, like the Ford Motor Company logo in a similar Spencerian script within an oval frame,

introduced in 1912, become increasingly distinctive as the general use of such cursive writing styles has faded away (Fig. 9.1). Such incredibly enduring logos reach points at which they cannot readily be changed. The COCA-COLA logo had gained trademark status as early as 1887. It has been re-used, adapted, and parodied in diverse contexts around the world, exhibiting extraordinary geographical penetration and historical stamina. A nice instance is when a Han dynasty urn was adorned with the red script by the contemporary Chinese artist Ai Weiwei (Fig. 9.2).

Fig. 9.1.

Logo of the Ford Motor Company

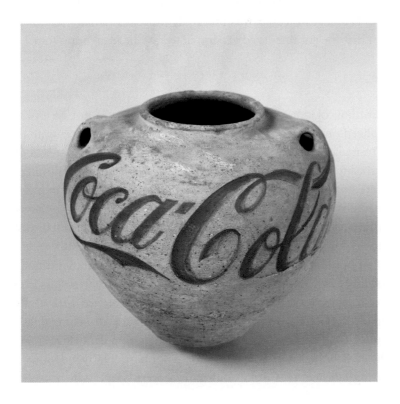

Fig. 9.2

Ai Weiwei, *Han Dynasty Urn with* COCA-COLA *Logo*, 1994.

The new drink was sold with growing success, initially by the glass from soda fountains, accompanied by promises that it was widely beneficial and curative. It was not sold in bottles until 1894, by which time the ailing Pemberton had lost sole control over his own product, confusingly assigning production rights to two businesses as well as to his own son. One of the businesses, led by Asa Candler, rapidly emerged as dominant, successfully claiming exclusive rights in a way that may have been less than entirely justified. In 1882 Candler registered The COCA-COLA Company, which has a continuous history with the present corporation of the same name. Candler proved to be spectacularly effective, leaving a host of rival soda pops trailing in COCA-COLA's wake, and leading the drink to a remarkable position of market dominance. Candler made his fortune and became a major benefactor of Emory University in Atlanta.

Somewhat surprisingly the cocaine was still there in 1882, and was not dropped until 1905, as increasing moves were made by legislatures to regulate and ban what could no longer be regarded as a drug that could be safely available to the public. The 1905 slogan, 'COCA-COLA revives and sustains' had at least some justification, given its rapid sugar 'hit' and its dose of caffeine. At least it was markedly more restrained than the claim in 1891 that the cocaine-laced version acted as 'the ideal brain tonic'.

Nuts

The bottling of COCA-COLA from an early stage was not an operation centralized on the company that produced the syrup concentrate that is used to make the carbonated drink. The business model that was developed meant that the central company sold the concentrate, granting each separate bottler a franchise to produce and sell COCA-COLA in a defined geographical area. The precise combination of ingredients in the syrup, most notably the blend of 'natural flavourings' that give COKE its distinctive taste, is a secret guarded in a manner that is now the stuff of legend. The first bottling was undertaken by the Biedenham Candy Company in Vicksburg, Mississippi, in 1894, using a standard bottle. Five years later the first of a major series of bottling agreements was signed with a nascent company in Chattanooga. Within another ten years, 400 companies were manufacturing bottles of Candler's increasingly popular drink.

The early bottles were neither uniform nor particularly individual, save for being labelled with Robinson's curvaceous script, which was doing

sterling service in banners, on hoardings, and in all kinds of advertising. Producers progressively learnt that arrays of bottles placed in vats of ice to cool them in summer rapidly lost their stuck-on labels, and it became increasingly common for the bottles to be embossed prominently with the COCA-COLA logo (Fig. 9.3). A bottle produced by the Birmingham Bottling company recently sold for $2,420, without any COKE in it.

In 1915 (or, according to another account, in 1913), the COCA-COLA Company resolved to bring some order into the design chaos that had resulted from the otherwise successful franchise model. They wanted a bottle design that was notably distinctive, so that the identity of their product would immediately be recognized wherever it was bottled, wherever it was sold—and wherever it was held in a customer's hand. In keeping with their unusually decentralized approach, the Company circulated a message to its bottling plants, inviting them to compete for the new universal design.

What we now know as the key response to the challenge came from the Root Glass Company in Terre Haute, Indiana, a town in which a number of glass companies were located. Chapman Root, founder of the company in 1901, is a perfect model of the American entrepreneur, and it was typical that he pursued the task with vigour. Again, teamwork was involved, and has resulted in inevitable disputes over priority. However, the key step in moving from vague idea to drawn design is securely attributable to Earl Dean, a machinist in the bottling plant, who was responsible for bottle design at the Root factory. The story is best told in Dean's own words—and is likely to be reasonably reliable, given its lack of obvious over-claiming, and in spite of its being written many years after the events. The account comes from a letter from Dean to the Florida COCA-COLA Bottling Company on 9 April 1971.

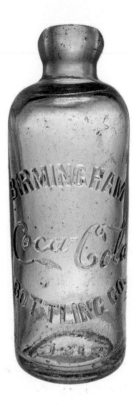

Fig. 9.3

Bottle from the Birmingham COCA-COLA Bottling Company, Alabama (bottle designer unknown).

> The question came up as to what COCA-COLA was made of. Mr. Root had his chauffeur, Roy Grimsly, take T. C. Edwards and me to the Fairbanks Library to see what we could find. It so happened we found in a book of reference, an article and a very good illustration of a pod that contributes to the flavor of COCA-COLA.
>
> I was very much interested in the shape of the pod. It had a very short neck at the stem end and the body had four different diameters and vertical ribs which I incorporated into my first drawing to show Mr. Root the next morning. Mr. Root was well pleased and asked me if I could get a mold made

in time to get a few sample bottles made before the fire went out, which would be 12:00 noon on the last working day of June. I told him that I would do the best I could.

It turned out to be a very close schedule and it was necessary to work on the mold the second day starting at 4:00 am till 2:00 am the next morning which added up to twenty-two hours. I could then see that I could complete the lettering and design cutting within the four hours. I would have the next morning to get it in the machine in time to be heated up and get the sample bottles made.

The COCA-COLA Company accepted this new designed bottle at once, but we could see there would have to be alterations on the lower and middle diameters in order to make the bottle practical. Mr. Root advised the COCA-COLA Company why it was necessary to make these alterations and that sample bottles would be made for their approval.

About a year or so after alterations were made on the first bottle, I came across two of the first samples that I had placed in my locker. I took one of them into the main office and it was agreeable that I keep the other one. The patent attorney came to Terre Haute from Indianapolis. He was handed a drawing showing the front and back view of the COCA-COLA bottle. He cut them apart and handed one to me saying he needed only one to send to Washington. I kept the bottle and drawing for many years and as I was getting up in years I gave them to my son in California and he valued them highly.

The pencil drawing that remained in Dean's possession is in a small archive devoted to him in the Vigo County Public Library in Terre Haute, and shows the front of the bottle (Fig. 9.4), while two prototype bottles are in the hands of the Company and Dean's heirs (Fig. 9.5). The drawing that was filed for the patent on 18 August 1915, which it was granted on 16 November 1915, is indeed of the rear of the bottle, corroborating Dean's account (Fig. 9.6). Any remaining doubts about his role in the conception of the bottle should be laid to rest by the documentation in the recent book *The Man Behind the Bottle*, by Norman Dean, Earl's surviving son.

Dean's narrative is not without apparent problems, however. What was the role of Alexander Samuelson, the Swedish plant superintendent, in whose name the patent was actually granted? The application declares that 'I, ALEXANDER SAMUELSON ... have invented a new, original and

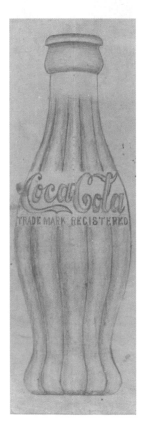

Fig. 9.4

Earl Dean, drawing for the coca-cola bottle, 1915, Terre Haute, Indiana, Vigo County Public Library Sm. D.C. 37B, courtesy of Norman and Linda Dean.

ornamental Design for Bottles or Similar Articles.' This should not be taken to mean that Samuelson was the author of the design, but he had been put forward by the Company to front the application. In the patent application for a revised design in 1922, Chapman Root himself is named as the 'inventor', which he clearly was not in the literal sense. But Samuelson was obviously an active player in the process. The precise role of T. Clyde Edwards, the auditor in the Company, is also unclear, though he was Dean's partner in the trip to the library. But the biggest conundrum is the identity of the nut or pod.

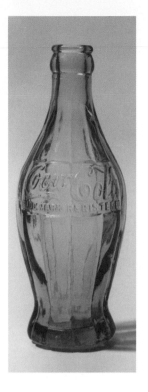

Fig. 9.5 (*above*)

Earl Dean, COCA-COLA bottle prototype, 1915.

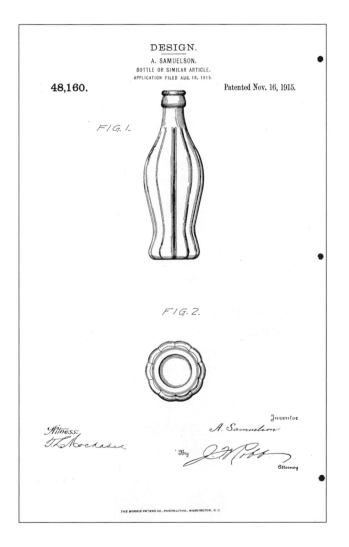

Fig. 9.6

COCA-COLA bottle patent, named 'inventor' Alexander Samuelson, 16 November 1915.

In their search for what should have been the coca leaf (the cocaine-bearing ingredient) or the kola nut, Dean and Edwards alighted on the cocoa nut, or rather the cocoa pod. The geographical origins of cocoa are much the same as for coca, but the pod yields the nuts from which chocolate is made. The plant is *Theobroma cacao*, literally the 'food of the gods', and had been revered by the Aztecs and Mayans long before Columbus arrived to sample its delights. Its Maya name was *kakaw*, and it is splendidly portrayed in a compact Aztec stone sculpture (Fig. 9.7). The bulbous pod with its longitudinal ridges is readily recognizable as belonging to the variety of cocoa plant that had been avidly cultivated by the great Mesoamerican civilizations in the pre-Columbian era.

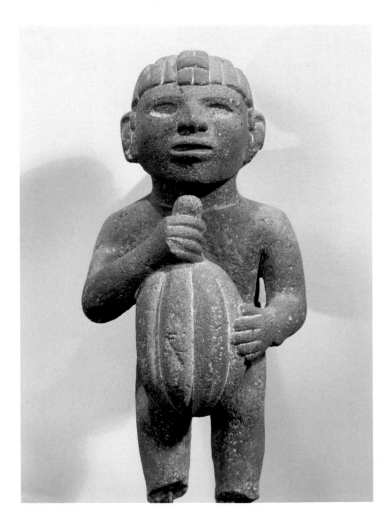

Fig. 9.7

Man with cocoa pod, *c.*1440–1521, Brooklyn Museum, Museum Collection Fund, 40.16.

Cocoa not Coca! Perhaps an understandable mistake for bottlers from Terre Haute to make when rushing against a deadline. In fact, if we go to the classic eleventh edition of the *Encyclopaedia Britannica*, to which they almost certainly had recourse, we can more or less trace their steps. Volume vi will yield an entry on 'COCA or CUCA (*Erythroxolan coca*)'. We are given a botanical account and a brief discussion of the stimulant that the leaf contains. It is noted that excessive chewing of the leaf induces 'great bodily wasting and mental failure', but what effect the active ingredient might have in moderation is unclear 'in the absence of extended experiments in psychological laboratories, such as have been conducted with alcohol'. The coca entry is immediately followed by a short rather technical account of cocaine. There is no illustration of the plant. There is no separate entry for Kola (nut), but it appears briefly in the general entry on nuts, where it is recorded that it contains a stimulant (i.e. caffeine). The Kola-nut also features in entries on Africa and the Gold Coast under discussions of trade. If this is the route pursued by Dean and Edwards, we might imagine that they were becoming dispirited.

What they found in the entry for 'COCOA more properly CACAO' is quite another matter—regardless of how they made their way to the authoritative three-page account. The tone is busily informative and positive, pointing to the popular uses of the seed to produce cocoa drinks and chocolate. At an early stage in the entry it is noted that the Aztecs accorded the seeds such value as to use them as currency. An early footnote warns about the 'unfortunate confusion with coco-nut (*q.v.*)'. Most importantly, for Dean, there is an illustration (Fig. 9.8).

Cocoa pods, even of the Mesoamerican varieties, vary a good deal in appearance, as noted in the encyclopedia, and the ridges are often not clearly defined. However, the tradition in botanical illustrations had been to show a neatly sculpted pod, with ten ridges around the central core of five rows of beans. This is what Dean and Edwards saw on their brief period of research in the local library, and it does indeed work well as a source of inspiration for Dean's design. The 'short neck at the stem end' is readily visible, and it is possible to see what he meant about 'four diameters'. The image of the 'bottom plan' in the patent drawing also clearly shows the ten lobes of the canonical bean shape. We can confirm, therefore, that the cocoa nut was indeed the source of the bottle's ten flutes and its curving sides.

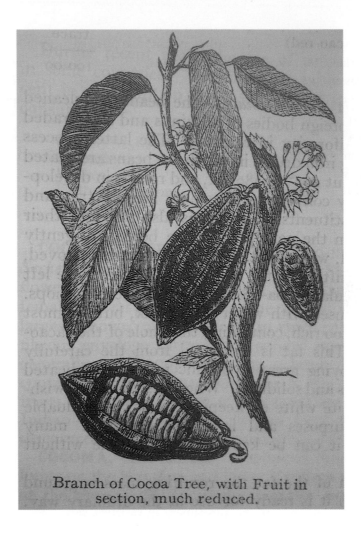

Branch of Cocoa Tree, with Fruit in section, much reduced.

Fig. 9.8

The cocoa pod, from volume vi of the 11th edition of the *Encyclopaedia Britannica*, 1911.

The use of such botanical sources of inspiration was common in avant-garde design of the period. The era of Art Nouveau and Arts and Crafts saw an upsurge in the use of organic forms as a prime source for shapes and decorative motifs in the applied arts. In America, companies such as Rockwood, Teco, and the more down-market Platzgraff adopted the Arts and Crafts principle of 'natural design', in contrast to the classical and Gothic modes widely favoured in the mid-nineteenth century. A green ceramic vase produced by William Gates' Teco company in the town of Terra Cotta, Illinois (TErra COtta), provides an apt point of comparison, with its swelling, seed-like contours and vertical clefts (Fig. 9.9). The style is very much in tune with the 'prairie architecture' being pioneered in

nearby Chicago, most famously by Frank Lloyd Wright, and Gates called on the services of leading Chicago designers.

We need not assume that Dean was a keen student of design magazines to recognize that he was following what was the latest trend. Indeed it may have been Root himself who had given Dean and Edwards instructions to look for a relevant source in nature. It probably lay more within Root's budget to purchase the latest Arts and Crafts ceramics than within those of his employees. On the other hand, Dean's pencil drawing is decently effective and shows some gifts as a draughtsman. The flutes fade into the neck very nicely—the transition has been made more obvious in the lithographed version in the patent document—and they grip the base in an effective manner. However, the portrayal of the neck as if seen slightly from below does not suggest that he had been instructed in the art of technical draughtsmanship—a fault that was rectified in the printed patent design. The swelling outline continuously changes its curvature in a way that retains our interest and corresponds to his appreciation of the cocoa pod's contours. It meets the legendary demand, recorded as a refrain in the literature on the bottle, that it should be recognizable in the dark and even when broken.

The COKE bottle also feels good in the hand, not least because its waist makes it easier to hold than a straight-sided glass bottle (particularly when wet from a vat of ice). It is also far easier to drink directly from the bottle because of the smooth transition of the body of the bottle to its neck, being less prone to sudden surges than the more common bottle shape with its domed body and chimney-like neck. This smooth neck was, however, shared with other fizzy drink bottles and with those used for distributing milk.

It is not clear when drinking directly from the bottle, which my parents viewed as a 'vulgar habit', became a serious factor in the success of the bottle. It may have been there from the first with bottles sold by street vendors. Drinking directly from the bottle conveys an air of informality, even of a daring neglect of conventional manners. Certainly before the Second World War, advertisements presented bottles to the viewer as open and ready to put to one's lips. Most notably, the famous and skilfully painted Santa Claus advertisements by Haddon Sundblom from the 1930s onwards show a more than ample and irrepressibly cheery Father Christmas quaffing directly from the bottle. This is conspicuously the case with Fig. 9.10. Such an image of an exaggeratedly fat man, with round cheeks polished like an apple in a

Fig. 9.9

Green vase by the Teco Company, c.1910.

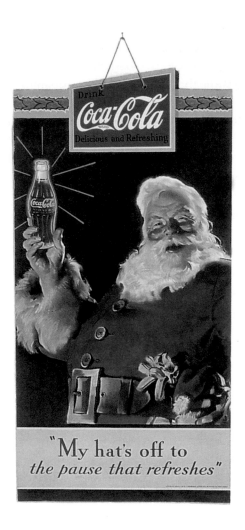

Fig. 9.10

Haddon Sundblom,
My Hat's Off, 1944

child's school bag, has less wholly positive connotations in our era, when such sugary drinks have been allegedly linked with childhood obesity.

Santa's hand is of such dimensions that he often adopts the second mode of authorized gripping, that is to say with his little finger crooked under the foot of the bottle. He only need tilt the bottle a little to achieve his first sip of the restorative liquid without a messy airlock. There is an urban myth that 'Santa' wears red and white because of COKE. Not true: he had been dressed in this way for a long time.

Before moving into production with what became known as the 'contour bottle', the design was adjusted, as Dean's account noted. It proved impractical to have the middle wider than the base, for reasons

of production and packing, and the bottle's curvaceousness was therefore reduced a little. It remained, however, an individual and evocative design. There are the embedded references to natural form of course, extending from the cocoa pod to more generic analogies with the human body, particularly the female one. As it happened, it chimed so well with the contemporary fashion for the hobble skirt that fashion rather than nature has been seen as its source. The hobble skirt, typically gathered tightly at or below the knee, became popular on both sides of the Atlantic, but was not renowned for its practicality (Fig. 9.11). In its constraint of female mobility, it reflected the influence of Japanese fashion on

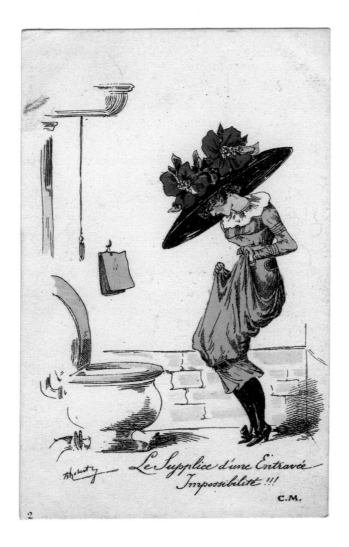

Fig. 9.11

L. Roberty, *Hobbled by the Hobble Skirt*, postcard from the series 'Les Entravées', c.1910.

European designers. Japanism had become something of a rage. Gilbert and Sullivan's *Mikado* of 1885 saw the stereotypical 'Three Little Maids' in pencil skirts shuffling on stage with skittering steps and fluttering fans, looking more like trainee Geishas than schoolgirls. The fashion for hobble skirts waxed and waned, but the bottle's more generic associations with natural and artificial forms endowed it with a remarkably enduring life. As the great designer Raymond Loewy pungently wrote, after he had become involved with COCA-COLA design in 1939: 'its shape is aggressively female—a quality that in merchandise, as in life, sometime transcends functionalism.'

Subsequent patent applications reflect some of the fine tuning that the contour bottle has undergone over the years, not least in relation to techniques of bottle production and labelling. The 1922–3 design, which Root himself 'invented' according to the language of the formal application, excises the ribs around the bottle's belly to make a flatter surface for the lettering (Fig. 9.12), which results in shallow scallops above and below the flattened band. This had already been done to some extent in the bottles as produced, but was now formalized. Now a proper cross-section is provided in the application, rather than illustration of the base. Then in 1937 the central band is divided into two panels by shallow ridges, while the original ribs fade much earlier into the curved cylinders of the neck and base (Fig. 9.13). The 'inventor' is now Eugene Kelly, one-time head of Canadian operations, and again not the author of the design as such. Further subtle changes have been made, but the name of the game is to make sure that the bottle always looks the same—'it's the real thing', as The New Seekers sang. Even in vending machines which only clatter forth chilled red cans, the bottle is likely to feature—as a handle or elsewhere—as a visual certifier of authenticity.

The later designs are tidied-up and 'designerized' versions of the Root–Dean original, in which the characteristics of the design remain recognizable while the pod-like features tend to atrophy. The later COKE bottles essentially refer to themselves rather than anything else. They have in effect become a genus (with a good number of local species) in their own right rather than needing to masquerade as an evolved form of *Theobrona cacoa*. They do retain however a certain kind of abstracted sexiness that obviously plays an important part in their enduring appeal.

It is not my intention here to tell, even in brief, the story of COKE's extraordinary commercial success and the Company's notable shrewdness

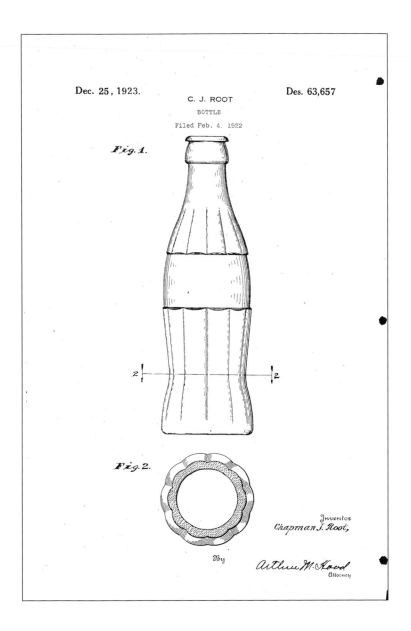

Dec. 25, 1923.

C. J. ROOT

BOTTLE

Filed Feb. 4, 1922

Des. 63,657

Fig. 1.

2

2

Fig. 2.

Inventor
Chapman J. Root,

By

Arthur M. Hood
Attorney

Fig. 9.12

Second COCA-COLA bottle
patent, 25 December 1923,
named 'inventor' Chapman
Root.

in social and political realms in America and far beyond. That narrative
has been told effectively elsewhere, as a striking story of extreme business
potency and as a model of American commercial imperialism in mass
markets across the world. The figures for production, consumption, sales,
and profits exist in realms of such size that they can be read without being readily grasped. We are talking about many billions of dollars. I am

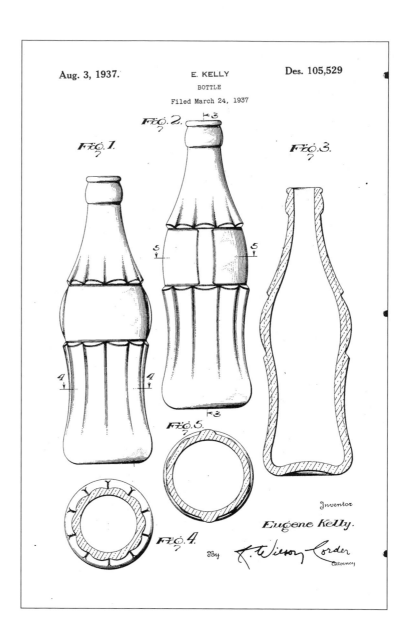

Fig. 9.13

Third COCA-COLA bottle patent, 3 August 1937, named 'inventor' Eugene Kelley.

not going to examine the claims and counter-claims about COCA-COLA in relation to medical matters such as obesity and athletic performance, or with respect to the behaviour of the COKE and Pepsi companies in the 'Third World'—two big issues which have been much debated. The company has attracted such multi-faceted criticism that there is even a specific entry in Wikipedia on 'Criticism of COCA-COLA'.

Rather, my concern here has been to look at how the visual icon of the contour bottle came into being and at some of the special characteristics that have given it staying power. In the final section, I would like to try to get a handle on the role that the visual icon of the bottle has played by looking at an aspect of COCA-COLA's rivalry with Pepsi-Cola. In particular we will see how important visual identity and name are to how something actually tastes in our mouths and in our brains.

The Pepsi Challenge

COKE and Pepsi are on the face of it bitter rivals, yet to an extent they need each other. The battle for markets, both general and niche, has served to increase total world consumption enormously.

Pepsi is no newcomer. It was devised by another pharmacist, Caleb Bradham, in Bern, North Carolina, and introduced as *Brad's Drink* in 1898 before acquiring its present name. We are familiar with the Cola from the Kola nut; Pepsi comes from pepsin, the digestive enzyme, which in turn comes from the Greek word for digestion, *pepsis*. If something went wrong with a client's digestion, Bradham would diagnose that person as suffering from 'dyspepsia'. Not only would their tummies hurt, but they would also become irritable. Body and mind were linked. As with COKE, the pharmacological background is crucial to the drink's invention. The 1903 Pepsi slogan strikes entirely expected notes: 'exhilarating, invigorating, aids digestion'. Pepsi-Cola's initially smooth trajectory of success was abruptly halted by two bankruptcies during the 1930s. During the later part of the decade the company was booming again, to become COKE's great rival, albeit with a lesser market share overall. Loyalties to each brand are fierce, but in Pepsi's case consumer loyalty has needed to stretch across a patchy visual history of recurrent logo change and bottle redesign. The story of Pepsi designs speaks of continuing anxiety in the face of COKE's visual consistency.

The Pepsi logo has undergone radical changes, at increasing frequency. The first trademark filed by Bradham in 1902 used a rather fussy version of the Spencerian script exploited by COKE. It was replaced three years later by a tidied-up version very much in the style of the COKE logo. In the 1950s the now familiar wavy red, white, and blue bands crossing a circle were introduced, exuding a generalized American aura. During the 1990s the circle mutated (aspirationally) into a globe. In the second half of the

twentieth century the fonts changed regularly in accordance with fashions in graphic design.

The bottles plotted a comparable course. A bottle with a curved waist appeared in 1923, and the 'swirl bottle' made its debut in 1958, endowed with flutes in a steep spiral (Fig. 9.14). This latter is the most elegant of the Pepsi bottles, and had a good run, but it did not last. There were many others. There is a sense that the designers and the company were always looking over their shoulder at the COKE bottle. That Pepsi should have achieved the success it has over the years suggests that while a powerfully consistent visual identity is good to have, it is not wholly decisive in commercial success. Since both drinks are marketed heavily at a young generation (increasingly young I suspect), cultural memory is less important than it is for more mature consumers, and may even be a disadvantage. The 'real thing' may be less potent than the 'new thing'. The same applies to the newer markets that are being targeted in former communist countries and in what is often called the developing world, where the two companies are more likely to start on an equal footing.

Perhaps the image issue helped keep Pepsi advertising on its toes, and it may have lain in part behind the role of aggressor that they often assumed in what have become known as the 'Cola Wars'. There probably has been nothing really equivalent to the head-on rivalry of these two companies on such a scale and over such a period. It is inevitable that their advertising and general marketing strategies will always be directed to some extent against each other, even when the rival is not overtly addressed. COKE's 'the real thing' only makes sense if there is something that is by implication 'not the real thing'. A number of other drinks could be implicated, but we know which one they really mean. On occasions the attack on the other product has been explicit to a degree exceptional in the commercial world. The most sustained example was the 'Pepsi Challenge' initiated in 1975. It was set up as a kind of 'scientific' test, involving the technique of blind tasting. 'Ordinary' Americans visiting public places were presented with unlabelled samples of Pepsi and COKE, and asked which they preferred. Triumphantly Pepsi announced in the resulting commercials that 'fifty percent of the participants who said they preferred COKE *actually* chose the Pepsi'. The matching question—asking people who preferred Pepsi which they favoured—was either not asked or the results not revealed. If people simply could not tell the difference under the odd

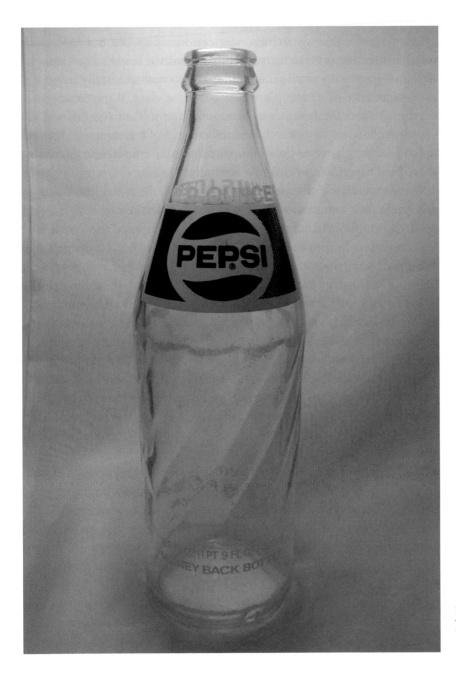

Fig. 9.14

Pepsi-Cola 'swirl bottle',
1970s.

their taste preferences than devotees of COKE. Something very odd is going on—as yet unexplained and difficult to grasp. Might the extraordinary stability of the brand identity of COKE have something to do with it? Yet, as with the case of the constant versus inconstant bottle and logo design, the commercial effects do not seem to align in a straightforward manner with factors that we might regard as important. At present the sciences that are beginning to grapple with such questions are at a very early stage of development.

Whatever the answer to the new questions posed by the brain sciences with respect to branding, the classic nature of the COKE bottle design is not in question. It is instantly recognizable around the world, even for those who encounter COKE in cans. It is a great masterpiece of design (originally generated by people who were not professional 'designers'). Whether it actually helps to sell more of the drink is, as we have seen, another matter.

For me, can I tell the difference between COKE and Pepsi? The answer is that I dislike the taste of both of them equally. But I seem to be in a tiny minority.

Reading

In general, the literature on the bottle is less reliable than we might hope. The internet, which contains a great deal of unreliable material on COCA-COLA, is nevertheless a ready source for the images that I have been unable to include.

http://www.thecoca-colacompany.com/heritage/chronicle_birth_refreshing_idea.html

Anon, 'Little Bottle—Big Business', *Indiana Historian*, September 1995, pp. 2–16.

E. R. Dean documents, Vigo County Library, Terre Haute, Indiana, Sm. D.C. 37B.

N. Dean. *The Man Behind the Bottle*, Bloomington, Ind., Xlibris, 2010.

J. A. Gottfried and R. J. Dolan 'The Nose Smells what the Eye Sees: Crossmodal Visual Facilitation of Human Olfactory Perception', *Neuron*, 39, 2003, pp. 375–86.

C. Hays, *The Real Thing: Truth and Power at the COCA-COLA Company*, New York, 2004.

J. C. Louis and Harvey Z. Yazijian, *The Cola Wars: The Story of the Global Battle between the COCA-COLA Company and PepsiCo, Inc.*, New York, 1980.

S. M. McClure, Jian Li, D. Tomlin, K. S. Cypert, L. M. Montague, and P. Read Montague, 'Neural Correlates of Behavioral Preference for Culturally Familiar Drinks', *Neuron*, 44, 2004, pp. 379–87.

C. Munsey, *The Illustrated Guide to the Collectibles of* COCA-COLA, New York, 1972.

M. Pendergrast, *For God, Country and* COCA-COLA, New York, 2000.

R. Schaeffer and W. Bateman, 'A Bottle You Can Recognise in the Dark', *Cola Call*, March 1985, pp. 4–8.

C. Spence, and J. Driver (eds), *Crossmodal Space and Crossmodal Attention*, Oxford, 2004.

B. E. Stein, N. London, L. K. Wilkinson, and D. D. Price, 'Enhancement of Perceived Visual Intensity by Auditory Stimuli: A Psychophysical Analysis', *Journal of Cognitive Neuroscience*, 8, 1996, pp. 497–506.

Andy Warhol, *The Philosophy of Andy Warhol (from A to B and Back Again)*, New York, 1975, ch. 6.

M. Zampini and C. Spence, 'The Role of Auditory Cues in Modulating the Perceived Crispness and Staleness of Potato Chips', *Journal of Sensory Science*, 19, 2004, pp. 347–63.

15 February 2001

nature

$10.00

www.nature.com

the
human
genome

Nuclear fission
Five-dimensional
energy landscapes

Seafloor spreading
The view from under
the Arctic ice

Career prospects
Sequence creates new
opportunities

naturejobs
genomics special

10

DNA

It was one of the greatest moments in the history of science and humanity, but not even the people involved knew for sure just how momentous it was, and the rest of the world was oblivious.

PHILIP CAMPBELL, CURRENT EDITOR of *Nature*, is writing in *50 Years of DNA*, issued to commemorate the anniversary of the publication on 25 April 1953 of a brief 'letter' entitled 'Molecular Structure of Nucleic Acids: A Structure for Deoxyribose Nucleic Acid'. The authors were J. D. Watson and F. H. C. Crick. The paper occupied in total little more than a two-column page and contained one schematic line illustration, by Odile

■ Eric Lander and Darryl Lea, cover for *Nature*, 15 February 2001.

Fig. 10.1

Odile Crick, diagram of the proposed structure of DNA, from James Watson and Francis Crick, 'Molecular Structure of Nucleic Acids: A Structure for Deoxyribose Nucleic Acid', *Nature*, 25 April 1953, p. 737.

Crick (Mrs F. Crick) that is rightly described as 'purely diagrammatic' (Fig. 10.1). There are only six footnotes.

The momentous piece opens, 'We wish to suggest a structure for the salt of deoxyribose nucleic acid (D. N. A.). This structure has novel features which are of considerable biological interest.' There follows a compressed technical outline of their proposed structure. At the end, before an announcement that 'the full details . . . will be published elsewhere' and a short paragraph of acknowledgements, Watson and Crick write, 'It has not escaped our notice that the specific pairing [of the nucleotide bases] we have postulated immediately suggests a possible copying mechanism for the genetic material.' It seems that Crick himself had favoured more explicit and developed discussion of the genetic implications in their *Nature* paper.

Such is the apparently modest, technical, and laconic debut of the double helix, now the most reproduced image from any science at any period. Normally, James Watson and Francis Crick were not subject to undue attacks of modesty or lack of ambition. So excited were they by their discovery that they were described as acting 'like mad hatters' (at the tea party in Lewis Carroll's *Alice's Adventures in Wonderland*). Crick lost no time in proclaiming to habitués of their favourite Cambridge pub, the Eagle, that they had 'found the secret of life'.

Fifty years later, Watson saw no reason to temper their enthusiasm: 'it's the biggest thing of the [twentieth] century.' This is a big claim, implicitly echoed by Campbell, who speaks not only for science but also for 'humanity'. In the same commemorative publication issued by *Nature*, my essay on the visual legacy of DNA was entitled 'The *Mona Lisa* of Modern Science'. The description seems to have caught on. The initials DNA have, like $E = mc^2$ in the next chapter, become part of public commerce, recognized by people who do not know what the letters stand for. We say 'it's in her [or his] DNA' when we want to say that a certain proclivity is built in the very nature of a person at the deepest genetic level. The format of the double helix has come to be used and misused in a wide variety of elite and popular cultures. It features in an extraordinary range of product design, often with no obvious relevance to the item in question.

The voyage of DNA from a page in *Nature* to such a universal position has been told a good number of times, both by participants and by more detached historians, as has the story of its brilliant discovery, involving

egos, rivalries, collaboration, and intense competition, with a least some hints of less than proper behaviour and of sexist attitudes. Here I will be concentrating on the visual dimensions to its discovery and ascent to fame, before looking at a few of its more unusual cultural manifestations.

As a preliminary it will be helpful to provide a compact outline of the basic *structure* of DNA as now understood, so that we can be alert to the key steps. The intricacy of how DNA actually *operates* in the context of the cells and the organism as a whole—an incredibly complex matter that is still far from resolved—is not our concern here.

DNA consists of two long chains, called polymers, comprised of nucleotides (Fig. 10.2). Each nucleotide has three molecular components (reading from the outside towards the centre): a phosphate, a deoxyribose sugar, and a nitrogenous base. The chains are arranged in the famously beautiful double helix, supported by a scaffolding (or 'backbone') of phosphates and sugars. The bonding scheme in the two chains runs in opposite directions and is therefore termed 'anti-parallel'. The gaps between the two helical chains are not equal. There are four types of nucleotide, each with its own nitrogenous base, cytosine, adenine, thymine, and guanine. The bases are always paired, adenine with thymine and guanine with cytosine. It is, rather improbably, the four paired bases, or rather the sequence of them, that comprise the key to the complex genetic information in each chromosome. When we realize that the forty-six chromosomes in the nucleus of a human cell contain some 3 billion base pairs, their encoding of genetic information seems less unlikely. Sequences of DNA with their varied pairings comprise the genes, which are the key units of genetic inheritance. They are arranged in the nucleus of the cells in long structures as chromosomes.

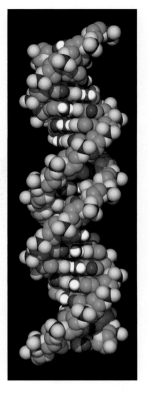

Fig. 10.2

The structure of DNA rendered as a space-filling molecular model.

Base Pairs and Other Players

The rise of DNA to iconic status obviously only really begins in April 1953, but the dramatic story of the race to discover its structure is wholly integral to its fame, and the pre-publication narrative deserves to be outlined in some detail.

Watson and Crick emerge from the story of DNA as the most strongly etched public personalities amongst the notable group of characters who acted as the pioneers in the DNA story. This is not just because they are seen in retrospect as the pair who made the key discovery, but their

prominence is an accurate reflection of the amount of intellectual, verbal, and visual noise they created, both individually and as collaborators. Watson emerges as unspeakably smart and Crick as unspeakably clever. Only Linus Pauling in the USA stands in the same personality league amongst the pioneers. Rosalind Franklin has come to be seen as at least as fascinating as either Watson or Crick, but has only fully emerged as a personality after her early death of ovarian cancer in 1958 at the age of 37. She was not a public figure in her own lifetime.

Before we look at the narrative that led to Watson and Crick's breakthrough, it will be useful to gain some idea of the main actors in our drama, centred on Cambridge, and about the scientific background to DNA research.

Francis Crick had studied physics before the Second World War, working as a scientist for the Admiralty, but moved after the war into the study of X-ray diffraction in large organic molecules. In 1939 he joined the Medical Research Council 'Unit for the Study of Molecular Structure of Biological Systems' in the Cavendish Laboratory (the Department of Physics) in Cambridge. Crick eventually received his doctorate in the year following his 1953 publication in *Nature*. In 1951 the considerably younger James Watson arrived in the Unit via Copenhagen and Indiana. He had been trained in the USA as a zoologist and had developed an intense interest in genetics and in the potential of DNA as the bearer of genetic information.

Crick's background in physics and the location of the Unit in a renowned physics laboratory is highly significant. Biology was being transformed by the importation of new techniques from the physical sciences, which were producing novel information about the structure of the large and highly complex molecules that stood at the centre of life. There is a strong parallel with Gregor Mendel's revolutionizing of genetics in 1865–6. The Moravian monk had trained with the physicist Doppler in Vienna and was a pioneer meteorologist. By the time he undertook his famous experiments on peas in Brno, he was by habit a counter and an analyser of statistics. As it happens, it took biology over three decades to catch up with his then unfamiliar numerical methods.

X-ray diffraction, the technique that served to unlock a key aspect of the puzzle for Watson and Crick, involves striking a crystalline substance with a beam of X-rays that are diffracted within the crystal. The diffracted rays are then intercepted on a sensitive surface, on which the position and

intensities of the resulting marks convey information about the density of the electrons in the crystal. This two-dimensional 'map' can, using sophisticated analysis, be translated into various kinds of representations and models of the actual three-dimensional structures within the crystal. The pioneering work was conduced by the physicists William Henry Bragg and his son, William Lawrence, who shared the 1915 Nobel Prize for Physics. The younger Bragg, Lawrence, still Director of the Cavendish in 1953, will feature later in our story.

The founding head of the MRC Unit in the Cavendish was the urbane and cultured Austrian Max Perutz, who undertook renowned work on the structure of the haemoglobin molecule, using a refined X-ray diffraction technique he had devised. His colleague John Kendrew worked in parallel on myoglobin. They both developed a novel range of techniques for visualization and modelling, and Kendrew pioneered the new power of computers for handling data. The two masters of the molecule were photographed holding the remarkable models of 'their' proteins in 1962, the year they won their Nobel Prizes for Chemistry (Fig. 10.3).

The other central players in the British drama were the New Zealand biophysicist Maurice Wilkins and the English chemist and expert in X-ray

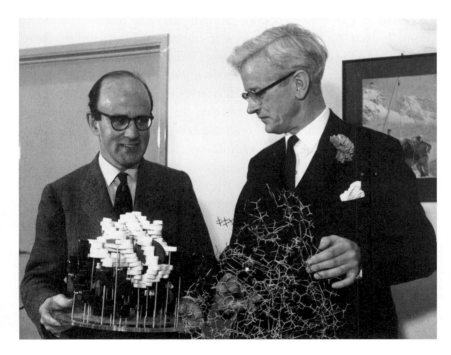

Fig. 10.3

Max Perutz with his model of haemoglobin and John Kendrew with his model of myoglobin, 1962.

diffraction Rosalind Franklin, both working in the Medical Research Council Biophysics Unit at King's College London, which was headed by the physicist Sir John Randall. The crucial activities of the King's unit will emerge shortly.

The major participant in the USA was the remarkable Linus Pauling. Of the actors, Pauling has the clearest claim to be a truly great person and not just a magnificent scientist and striking character. He remains unique in having won two individual Nobel Prizes, the first in 1954 for the nature of the chemical bond, and the second in 1962 for Peace, in acknowledgement of his campaigning against nuclear weapons and his opposition to the McCarthy witch-hunts in America during the 1950s. As we will see, his role as a humanitarian campaigner, which resulted in his being refused a passport to visit Britain in 1952, may in some small measure have hindered his arriving at the correct structure of DNA before or in collaboration with the Cambridge pair.

The other bit of background we need at this point concerns the history of the discovery of DNA. The key moments are fifty years apart. In 1869 Friedrich Meischer, the Swiss biologist, isolated what he called 'nuclein' from the nucleus of white blood cells contained in the pus of wounds. The vital step in showing that what we now know as DNA consists of phosphate, sugar, and four base components was made by Phoebus Levene in New York in 1919. Interest in nucleic acids was limited, however, because the complexity of proteins indicated that they were more likely to be carriers of intricate genetic information. That this was not the case was first shown by Oswald Avery, Colin MacLeod, and Maclyn McCarty in 1944, who demonstrated that the genetic transformation of the pneumococcus bacterium could be accomplished by the transfer of DNA material. But again most attention was focused elsewhere, because, as McCarty recalled, 'the work on the composition of DNA, dating back to its first identification 75 years earlier, had concluded that DNA was too limited in diversity to carry genetic information'. Complex proteins still seemed much better candidates. This common view was only to be decisively overthrown in the aftermath of the discovery by Watson and Crick.

A vital step had been taken in the 1940s by the Austrian Erwin Chagraff, who formulated rules about the bases in DNA: adenine and thymine appeared to be present in the same amounts, as were guanine and cytosine. The pairs each consisted of a larger purine and smaller pyrimidine.

These rules proved vital when Watson and Crick developed their successful model. The abrasive Chagraff has also left the most vivid if prejudiced picture of the Cambridge pair: 'the impression, one [Crick] 35 years old, the looks of a fading racing tout, something out of Hogarth's *The Rake's Progress*, Cruickshank, Daumier; an incessant falsetto with occasional nuggets glittering in the turbid stream of prattle. The other, quite undeveloped at twenty-three, a grin more sly than sheepish; saying little, nothing of consequence.'

Neither of the odd couple was 'contracted' to work on DNA, but Watson's obsession with the nucleic acid and Crick's brilliant apprehension of the theory of crystallography and X-ray diffraction interacted in the most spectacular and dynamic way. They shared a central interest in how understanding the physical and chemical properties of molecules and the nature of living things could be integrated in a new manner. In this they had both been encouraged by Erwin Schrödinger's 1944 book *What Is Life?* in which he argued for the role of physics in biology and more specifically for a molecular explanation for heredity. The exchanges of ideas between Watson and Crick should not be simply characterized as a dialogue between a zoologist and a physicist. They mutually intuited where the key questions lay in the new science of biophysics.

Their first foray into the field of DNA modelling was, however, not crowned in glory. In November 1951 Watson had attended a presentation in London by Rosalind Franklin of her X-ray diffraction results to date. To understand what happened then and thereafter, we now need to introduce Franklin, who is a key actor in our drama.

Rosalind Franklin, an English Jew from a wealthy family, had been working in the Laboratoire Centrale des Services Chimiques de l'État in Paris, and was establishing a high reputation in crystallography, not least for her work on carbons, including coal. When Sir John Randall, the distinguished physicist who was head of the Biophysics Unit at King's, wrote to her on 4 December 1950 before her arrival, he signalled that her work was to be redirected towards 'the structure of certain biological fibres in which we are interested, both by low and high angle diffraction'. Randall assured her that 'as far as the experimental X-ray effort is concerned there will be at the moment only yourself and Gosling [Ray Gosling a research student], together with the temporary assistance of a graduate from Syracuse, Mrs. Heller'. Given that Maurice Wilkins, the most senior researcher in the Unit, was deeply engaged in this work and had already

gathered some striking data, Randall's assurance could not realistically be delivered, and Wilkins knew nothing of it until many years later. Not a good start to their relationship, and it never gelled. Franklin felt alienated by the culture in biophysics at King's, but this did not prevent her from considerable achievements during her stay of less than a year and a half, when she left for Birkbeck College with another 'agreement' imposed by Randall that she would 'cease to work on the nucleic acid problem and take up something else'.

What Franklin achieved depended crucially on the famed ability of her 'golden hands' to coax superb X-ray diffraction pictures from the equipment she set up. DNA fibres readily take up water and at lower humidities they adopt a regular, crystalline form. Franklin noted that at high humidities the arrangement became looser and the fibres could be pulled out more thinly. It was this looser and less ordered array that actually gave the clearest indication in the X-ray diffraction photographs of the cross-shaped pattern that is suggestive of a helical structure. She referred to the more crystalline array as the A-form and the looser arrangement as the B-form. The more compressed and crystalline A-form provides a more complex diffraction picture. Franklin was inclined to focus on the crystallography of the A-form, but in May 1952 she took the key X-ray photograph of the B-form (Fig. 10.4). She clearly delighted in the images of elegant clarity that resulted from her experimental skills, and, like the pictures taken by a great photographer in any medium, her photographs have a special 'look'.

In 1951 Franklin was already arguing that the willingness of DNA to take up water pointed towards phosphates being on the outside of the structure. This was precisely what Watson overlooked in Franklin's presentation in London. Nevertheless he returned to Cambridge in high excitement. Together with Crick he worked impulsively and precipitately to assemble a model with three chains and phosphates at the centre. They were, as Watson said, always on the look-out for a 'short cut'. The resulting model was notably wrong in relation to what was already known by Franklin, and their demonstration to her and Wilkins was a debacle. Bragg instructed them in no uncertain terms to leave DNA to King's.

That they were allowed to return to their cherished topic was largely due to the spectre of Pauling, who had already scooped Bragg in a crucial aspect of protein structure. Pauling had intended to travel to the UK in

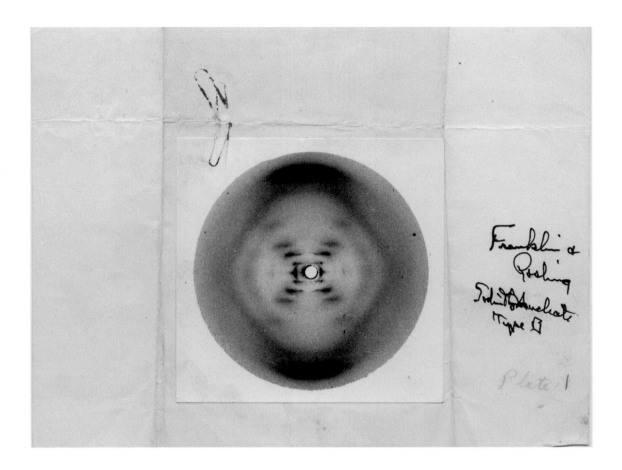

1952, but was prevented by the US authorities from doing so (Fig. 10.5). He missed the presentations of research by both Wilkins and Franklin, and was not able to discuss the latest developments in person until the passport ban was rescinded after international protests some months later. His son Peter, who was in the Cambridge Unit, worked to keep Pauling up to date during the travel ban, and Linus conducted regular correspondence with the researchers in England. Pauling constructed his own model with some haste, and its structure was disclosed to the Cambridge researchers shortly before publication. They were elated to see that he also had got the structure badly wrong, as Franklin also confirmed to Watson. Bragg, smarting from his earlier 'defeat' by Pauling, unleashed his two eager hounds on the structure of DNA to make the scientific killing.

Fig. 10.4

Rosalind Franklin and Raymond Gosling, crystallographic photo of Sodium Thymonucleate, Type B, 'Photo 51', 1–2 May 1952, Ava Helen and Linus Pauling Papers, Oregon State University Library.

PAULING RAPS PASSPORT BAN

Caltech Man Denounces U. S. Refusal of Trip to London

"The damage done to the nation by the refusal to permit me to attend scientific meetings in England must be attributed to the McCarran Act, and is an argument for the repeal of this act."

Dr. Linus Pauling, California Institute of Technology chemistry department head, made this statement yesterday in discussing the State Department's refusal to issue him a passport, as disclosed in yesterday's Examiner.

He had accepted an invitation to speak before the Royal Society of London.

On April 28, despite an earlier appeal by letter to President Truman, officials of the State Department upheld an original refusal to issue him a passport on the ground "that my proposed travel would not be in the best interests of the United States."

Advised on April 21 by a State Department official that the decision was made because he was suspected of being a Communist, Dr. Pauling stated:

"I then submitted to the Department of State my statement, made under oath, that I am not a Communist, never have been a Communist, and never have been involved with the Communist Party, as well as other documents.

SCIENTIST—Dr. Linus Pauling stands beside a model showing protein structure that is the same as that in the horn he holds. He protested U. S. refusal to permit his attendance at London scientists' meeting where he was to explain his theories.
—Los Angeles Examiner photo.

"The action of the State Department in refusing me a passport represents a different way of interfering with the progress of science and restricting the freedom of the individual citizen. In my opinion, it reflects a dangerous trend away from our fundamental democratic principles, upon which our nation is based."

Los Angeles Examiner, Mon., May 12, 1952 Sec. III—2

Fig. 10.5

Linus Pauling's passport ban, *Los Angeles Examiner*, 12 May 1952, showing Pauling with his alpha-helix model of proteins.

As we have seen, Franklin in May 1952 had taken her extraordinary image of the B-form of DNA, known as 'Photo 51'. She was already alert to the possibility of a helical structure with two, three, or four chains in each helical unit. On 23 February 1953 her notebooks record that both A and B forms were probably double helices. It is clear that she was very close to the structure. What was missing was the role of the base pairs in forming the rungs, like the steps in a spiral staircase. Franklin also remained cautious about precisely what the cross-pattern conveyed and reluctant to build a set-piece model when so much was still hypothetical.

Watson became convinced during a fractious discussion that Franklin was committed to resist a helical structure (at least for form A). Unbeknown to her, Wilkins showed Watson Photo 51 of form B in London on 30 January 1953, motivated at least in part by what he perceived to be Franklin's lack of cooperation with him. As Watson later luridly said, there was a feeling that 'Rosy had to go or be put in her place'. (Rosy was not a name that they would use to Franklin's face.) Further information about the King's research became available to Watson and Crick in February when Perutz showed them the MRC's report on the London unit. For Watson, the impulsive visualizer, Photo 51 said unambiguously, 'It's a helix, a perfect helix.'

Batting ideas back and forth with all the concentrated intensity of table tennis players engaged in a match of fierce rallies, James Watson and Francis Crick in Cambridge fought their way towards a conclusion. On 28 February they were sure that they had it. Their rackety model was finished by Crick late on 7 March and confirmed that the structure was 'so perfect that the experimental evidence in its favor from King's seemed an unnecessary accompaniment to a graceful composition put together in heaven'. This statement by Watson is that of a natural modeller and visualizer. At the time of the fiftieth anniversary celebrations, he recalled that 'the model was so pretty that we wanted to believe it whatever the data might say'. It was no doubt personally gratifying and politic for Watson and Crick to play up their roles as visionaries and to downgrade the determining role of Franklin's and Wilkins's experimental data. Their arrogance that it was another 'big Cambridge find' (in Watson's own words) also played a role in their downplaying of the King's work. There was also a strong element of toys for smart boys in their modellers' enterprise.

By 17 March 1953 Franklin had drafted the paper that she and Gosling were intending to submit to *Nature*. Watson and Crick's essay arrived on the desk at *Nature* on 2 April, with Odile Crick's skeletal illustration of the double helix. Wilkins had declined to be named as one of its co-authors. It was published with notable expedition on 25 April with two articles by the King's researchers: 'Molecular Structure of Deoxypentose Nucleic Acids' by Wilkins with Alec Stokes and Herbert Wilson; and Franklin's and Gosling's 'Molecular Configuration in Sodium Thymonucleate', which contained a grainy reproduction of Photo 51. Franklin added a sentence to the effect that 'our general ideas are not inconsistent with the model

proposed by Watson and Crick in the preceding communication'. Wilkins viewed the Watson–Crick structure as a 'magnificent suggestion'. For their part, Watson and Crick were, in spite of their bullish public front, prepared to acknowledge the speculative nature of what they were proposing, in effect exhorting the experimenters to catch up with them:

> The previously published X-ray data on deoxyribose nucleic acid are insufficient for a rigorous test of out structure. So far as we can tell, it is roughly compatible with the experimental data, but it must be regarded as unproved until it has been checked against more exact results. Some of these are given in the following communications. We were not aware of the details of the results presented there when we devised out structure, which rests mainly though not entirely on published experimental data and stereo-chemical arguments.

Was it Franklin's Photo 51 that hid behind the ambiguous phrase 'not entirely'?

In total the three epochal papers occupy less than five pages. They are a dense, technical, and notably unsensational read.

Steps to Fame

The one-page 'letter' to *Nature* was not an overnight sensation. Nor did it disappear in the manner of Mendel's 1866 paper on the hybridization of plants. It was the loquacious Crick rather than the impulsive Watson who led the drive to bring their discovery to public attention. Crick gave an interview to the *Sunday Telegraph* and contacted the BBC. Watson was unusually reticent. As he later explained in *Genes, Girls and Gamow*, 'I was afraid that we might be thought grabby and did not want to stir up more discussion as to whether we had improperly used King's College data.' The tone of their discussions is conveyed in Watson's letter of 16 December 1953.

> Dear Francis,
>
> Received your note, several hours ago. About the Discovery article—O.K. Concerning the Scientific American. I do not want to write another article on DNA. Why not a joint article by Maurice and yourself. I believe Maurice should get as much credit as possible. The pay is 200 dollars per article. I'm still opposed to the BBC . . .

On 21 May Cambridge photographer Antony Barrington-Brown had taken photographs of Watson and Crick in the Cavendish for publication in *Time Magazine*, but the intended feature never transpired. Two of Barrington-Brown's eight shots were to become famous following the publication of Watson's picturesque narrative *The Double Helix* in 1968. They show the Cambridge pair beside a model of DNA, which the photographer did not find to be particularly photogenic, one with Crick pointing in a staged manner with the extruded central shaft of a slide rule (Fig. 10.6) and the other with both of them laughing in a more relaxed manner. The model is not the one on which they were intensively working before the publication but was specially created for subsequent demonstrations. Behind it is a drawing pinned to the wall, presumably by Odile Crick though it does not correspond precisely to the published diagram. This model, overtaken by more definitive ones made by Wilkins in the wake of the discovery, did

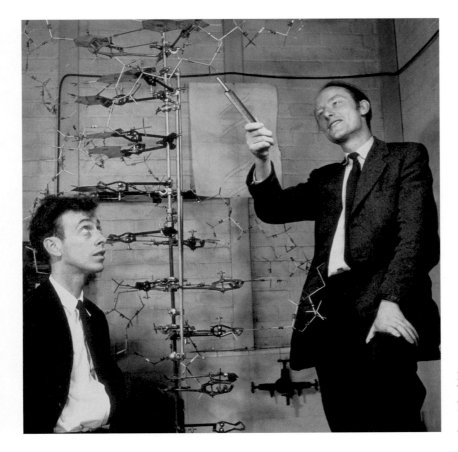

Fig. 10.6

Antony Barrington Brown, *Watson and Crick with their Model of DNA*, 21 May 1953.

not survive, but in 1976 some of the specially cut metal plates of the base pairs were discovered in Bristol and it was reassembled like a cherished Greek vase reconstructed from excavated shards. It is currently on display in the Science Museum, London.

The citation record of the Watson and Crick 'letter' up to 2003 in English language journals (Fig. 10.7) shows that it got off to a relatively slow start in the world of science. Remarkably the majority of papers in the next five years that discussed DNA did not mention the double helix. Interest in DNA was not primarily centred on the implications of its structure for genetics but on medically related issues. There is a notable spike on the tenth anniversary, indicative in part of the award of the 1962 Nobel Prize for Physiology or Medicine, awarded jointly to Francis Harry Compton Crick, James Dewey Watson, and Maurice Hugh Frederick Wilkins 'for their discoveries concerning the molecular structure of nucleic acids and its significance for information transfer in living material'. The 2003 citation take-off occurred at the time of the fiftieth anniversary and in relation to the Human Genome Project.

The public ascent of DNA was given a massive boost by the publication of Watson's *The Double Helix: A Personal Account of the Discovery of the*

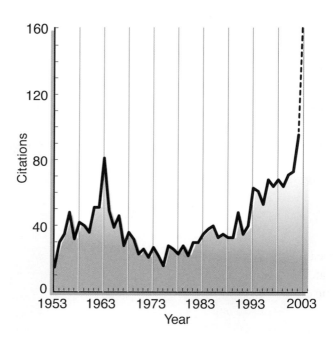

Fig. 10.7

Bruno Strasser, English language citation of record of Watson's and Crick's 1953 paper on DNA to 2003.

Structure of DNA with a foreword by Lawrence Bragg in 1968. It is an extraordinary and vivid book, achieving sales of over a million copies by the time of the fiftieth anniversary of the discovery. Crick and Wilkins were opposed to its publication. Watson openly admits, 'I was writing it as a novel . . . as a "non-fiction" novel.' There is a strong sense that Watson sees himself as an actor playing himself under his own direction in a dramatic narrative of pre-destiny, with a supporting cast in which Crick richly deserves an Oscar for the best supporting role. 'Rosy' Franklin is little more than a characterful bit-player, who is seen as Wilkins's assistant. Watson was thinking at the time that 'the best home for a feminist was in another person's lab'. *The Double Helix* shows that a devotion to frankness and the open parading of a highly personal standpoint do not make for historical accuracy. On the other hand, no book had ever presented such an incisive picture of the erratic untidiness of a major scientific discovery, intellectually and socially. At the end of the book as published, after its rejection by Harvard University Press, is an Epilogue that acknowledges the very partial nature of the truths 'in the early pages of this book'. It seems that Watson wanted to retain the literary vitality of the book rather than deadening it by rewriting for the sake of historical balance. Fittingly, it provided the basis for the TV programme *Life Story* by the BBC in 1987.

Essential to the technical rise of DNA within science was the progressive revelation of the mechanisms by which it transmitted genetic instructions and replicated itself. The problems of 'unwinding' and 'unzipping' were particularly acute if DNA was to be seen as a self-replicator. What we witness, over the years following 1953, is a series of research findings that cumulatively begin to overcome the doubts and difficulties, although often shifting the problems into other areas of explanation.

Key steps were Crick's own advocacy in 1957 of his 'central dogma' that information flowed from DNA to proteins but not vice versa. Then in 1958 Matthew Meselson and Franklin Stahl actually demonstrated DNA replication in the bacterium *E. coli*. Watson himself was involved in the 1961 discovery of 'messenger RNA', which plays a key role in the transmission of genetic instructions into the cell. But it was not until the 1970s that the complex matter of the operation of DNA in the context of the cell was demonstrated with some general degree of conviction, even if there is still much to be discovered.

The scientific rise of a given paper as charted by citation history is a complicated matter, involving a series of intellectual, institutional, and

social factors, with aspects of individual charisma thrown into the equation. Once a publication has reached a certain status, its citation is used to validate the citer's own enterprise. This is a rare occurrence outside the locality of each specific research area. The Watson and Crick paper has crossed disciplinary boundaries in a way that is probably unrivalled in any science. It became a standard-bearer of the new discipline of molecular biology, whose practitioners were struggling for increasing levels of institutional prominence. Eventually, we see a situation in which the citers of Watson and Crick were happily building themselves into a history that was becoming legendary.

DNA has invaded a wide variety of disciplines, including genomics, evolution, population genetics, medicine, forensics, and nanotechnology. On the fiftieth anniversary, Francis Collins and others writing in *Nature* in a promotional mode on behalf of the US National Human Genome Research Institute graphically illustrated the complex structures of research, education, and practical applications that they see as being erected on the foundations the genomic project (Fig. 10.8).

The massive project to unravel the 'code' of the complete human genome—that is to say to map the total genetic array of all the 3 billion base pairs of CGATs in the genes of human chromosomes—seems first to have been proposed by Robert Sinsheimer at the University of California Santa Cruz. In 1986 it was taken up by Human Genome Initiative of the US Department of Energy, initially to study its feasibility. A goal was formulated, which seemed highly ambitious at the time, to complete the sequencing by 2005. In 1990 the Human Genome Project was established at the US National Institutes for Health under the scientific leadership of Watson. Unlike most government projects, the timetable actually accelerated, courtesy of automated sequencing machines that could handle up to 1.5 million base pairs a day. Not least, the official international project faced the threat of a commercial rival which was intending to patent genes.

The initial threat came from Celera genomics in 1998, which was working to a three-year schedule. The driving force behind the private programme was Craig Venter, previously the founder of the Centre for the Advancement of Genomics. An accomplished scientist and aggressive entrepreneur with a massive ego, Venter progressively escalated Celera's aspiration from an initial intention to patent 'only 200–300 genes' to planned applications for 6,500 genetic components. The management of the National Institutes for Health in the USA also controversially

Fig. 10.8

Francis Collins, Eric Green, Alan Guttmacher, and Mark Guyer, 'The Future of Genomics Rests on the Foundation of the Human Genome Project', *Nature*, 422, 2003, p. 836.

announced its intention to patent genes connected with the brain, leading to Watson's resignation from the project in April 1992. He objected strongly to the concept of any ownership of the 'laws of nature', declaring that 'the nations of the world must see that the human genome belongs to the world's people, as opposed to its nations'. He was supported by Sir John Sulston, Director of the Sanger Centre in Cambridge and leader of the project in Britain, who was appalled by Venter's actions: 'If global capitalism gets complete control of the human genome, that is very bad news indeed. I do not believe it should be under the control of one person. But that is what Celera are trying to do as far as they can.' Sulston believed that Venter had 'gone morally wrong'. The principle of public access was endorsed by President Bill Clinton and Prime Minister Tony Blair in 2000. However, the issue is still being disputed. Only in March 2010 did a New York court strike down a patent on two genes held by Myriad Genetics.

In 1998, the new Director of the Human Genome Project, Francis Collins, declared its intention to 'finish the complete human genome sequence by the end of 2003. The year 2003 is the 50th anniversary of the discovery of the double helix structure of DNA by James Watson and Francis Crick. There could hardly be a more fitting tribute to this momentous event in biology.' The first to go public was the Santa Cruz Bioinformatics Group, which had flirted with Celera but could not accept the company's private and commercial terms. It published a rough and incomplete draft on the web on 7 July 2000, effectively pre-empting Celera's patenting initiative. A year later the Project led by Collins published a working draft in *Nature* (Fig. 10.9), accompanied by two fat fold-out pages of the 'bar codes' of the sequences on the chromosomes, with the biggest author list ever published—incomplete but occupying a full page. The 15 February issue of *Nature* ran to 154 pages. Amongst the faces in the mosaic on the cover are Mendel, Watson, and Crick. An advertisement for Integrated DNA Technologies Inc. inside the issue depicts the double helix overlaid on the *Mona Lisa*. A day later Venter and his extensive team published 'The Sequence of the Human Genome' in *Science*, over the course of forty-seven pages. But the whole cat was not and still is not out of the bag, since both sequences were 'drafts', and much still remains to be clarified. Not least, the popular assumption that the 'code' can simply be read off like the bar code in a supermarket is wrong. This or that gene cannot automatically be taken as simply standing for this or that characteristic in the individual. The code does not explain how we have become who we are. There are many epigenetic issues of timing, expression, inhibition, and cellular context that involve processes of enormous complexity.

A good number of the more inflated of the early claims for medical and other benefits that would result from knowing the genetic composition of human chromosomes have not yet been realized. Modern science, given the dynamics of funding in the public and private sectors and the increasing tendency of prominent scientists to promote their careers in the media, is all too readily subject to over-claiming. The Human Genome Project can be justified as one of the greatest human quests of all, like the desire to unravel the mysteries of the cosmos or of the atom. There will be material benefits, to be sure, as regularly happens with basic research, but they should flow from rather than direct and restrict the enterprise of discovery.

Even if potential 'benefits' do accrue, we cannot automatically assume they will be beneficial or ethical. Do we, for example, want to engineer

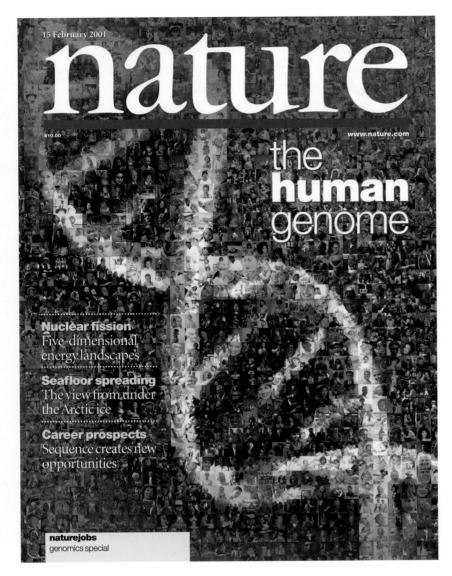

15 February 2001

nature

$10.00

www.nature.com

the **human** genome

Nuclear fission
Five-dimensional
energy landscapes

Seafloor spreading
The view from under
the Arctic ice

Career prospects
Sequence creates new
opportunities

naturejobs
genomics special

Fig. 10.9

Eric Lander and Darryl Lea, cover of *Nature*, 15 February 2001.

more intelligent people? Watson is inclined to think so. He envisages a situation in which 'you can genetically enhance people', and asks, 'if you could make your children more intelligent wouldn't you want to do it?' Not only is the ethical morass here deep and treacherous, but the notion of intelligence is predicated on the prioritizing of the kind of brilliance that Watson and his peers manifest, which is certainly not identical with human worth.

Such is the journey of the apparently humble base pairs—from roughly cut hexagons of metal in a Cambridge lab to some of the biggest issues facing humankind. We can see this clearly now. Such is the benefit of historical hindsight.

Some New Twists

Organic and inorganic sciences have presented us with a remarkable array of molecular structures. Proteins are perhaps the most wondrous, often qualifying for the epithet 'beautiful' (Max Perutz), but they are too various and complicated to engrave themselves readily in public visual consciousness. Proteins might be compared to the total *œuvre* of Henry Moore, one of the greatest of twentieth-century sculptors, who has created many memorable works but none that is unquestionably iconic.

The nearest rival to DNA is the undeniably attractive inorganic molecule C_{60}, in which sixty carbon atoms are arranged in the form of a semi-regular polygon, the faces of which are composed of hexagons and pentagons (Fig. 10.10). It came to international prominence in 1985, when it was published by a research team at Rice University in Texas. Harry Kroto (then of the University of Sussex), Robert Curl, and Richard Smalley were awarded the 1996 Nobel Prize in Chemistry for its discovery. Kroto played a crucial role in envisaging its three-dimensional structure, inspired not least by having seen the geodesic dome by Buckminster Fuller in Expo 69 at Montreal—hence the name of the molecule, Buckminster fullerene. However, compared to DNA as the 'molecule of life' it has less potential to lead the kind of legendary existence that is essential for fully iconic status.

As with other of our images, there are so many visual manifestations of the double helix in so many guises and in so many media that a small selection of some of the more notable and curious will have to stand for them all. There is also already a very substantial history of DNA in fiction and in film. Its potential is obvious. It can be used to bring long dead organisms to life. Aliens can insinuate their DNA into an earthly context (but why should aliens possess DNA rather than alternative genetic material?). And it readily serves the needs of some monstrous piece of genetic engineering by a crazed scientist. The most famous examples of DNA monsters are the rampaging dinosaurs in *Jurassic Park*, the 1990 novel by Michael Crichton and the Steven Spielberg film three years later.

Fig. 10.10

Buckminster fullerene (Carbon$_{60}$).

One of the nicest appearances of DNA in a sculptural mode is in the Royal Society in London, the venerable scientific academy, where it appealingly features in the translucent door handles (Fig. 10.11). But in this case, the story is not as straightforward as we might expect.

The Royal Society's premises in the historic Carlton House Terrace in London completed its much needed refurbishment in 2003—again the fiftieth anniversary of DNA. Burrell Foley Fischer, the architects responsible, had the neat idea to produce translucent handles containing the double helix for the new glass doors. The specialist architectural hardware company Izé was commissioned to manufacture the pull handles, the basic form of which is close to one devised by Walter Gropius, the pioneer modernist architect. Within the toughened glass tube of each handle, we can see a helix that is formed from rectangular sections of white Perspex held in place by translucent pins. So far so good. But, as Stefanie Fischer explains,

Fig. 10.11

BFF Architects and Izé, DNA door handles, London, Royal Society, 2003.

the model was signed off by the Royal Society, but somehow the double helix on the front door handles ended up the wrong way round and this was pointed out to the then President Lord May by an eminent visitor and the story made it onto the pages of The Independent. They were hastily replaced.

The eminent 'visitor' was Sir Aaron Klug, past President of the Royal Society (1995–2000), who had worked at Birkbeck College, where he was greatly affected by Rosalind Franklin's 'beautiful X-ray photographs'. Klug followed her into the investigation of the structures of viruses, her main focus on moving from King's. In 1962 he moved to the newly built MRC Laboratory of Molecular Biology at Cambridge, the successor to the unit founded by Perutz. Twenty years later he also was to be awarded the Nobel Prize for Chemistry 'for his development of crystallographic electron microscopy and his structural elucidation of biologically important nucleic acid-protein complexes'. Klug was highly unlikely not to notice the aberrant helices of the handles.

The helices in the rectified door handles, necessarily schematic in their geometry, bear a strong resemblance to images of DNA created by Mark Curtis, the British sculptor and graphic artist. Curtis is one of a growing number of artists who have created works centred upon DNA in one way or other, beginning in 1957 with Salvador Dali's typically enigmatic painting *Butterfly Landscape: The Great Masturbator in a Surrealistic Landscape with DNA*, a title that ostensibly describes the content but leaves much to be explained. Of the many 'DNA artists', I have chosen only to look at Curtis, because his desire to make sculptures based on DNA exceptionally led him to propose a revised structure for the famed base pairs.

Curtis is uncompromisingly committed to geometrical logic and symmetries in their ideal, even Platonic forms, and was disconcerted by the less than ideal geometry of the base pairs. He accordingly strove to devise a structure that would meet his demands. He tells us that

> Without compromising the essence of [the Watson–Crick] structure, I propose a resolution of the geometrical inconsistencies by means of a simple change in the position of alignment between the purines and pyrimidines. This realignment is founded entirely upon geometric principles.

Rather than using the outer frame of the sugar phosphates to shape the helices, Curtis proposed that stacked base pairs, coupled in an opposite

Fig. 10.12

Mark Curtis, *The Double Helix Unzipping*, collection of the artist.

orientation from the accepted bonding, comprise a helix of pentagonal plates around a central void of decagonal cross-section (Fig. 10.12). The rung-like disposition of the base pairs, a key feature of Odile Crick's diagram, is no more. This hollow spiral has featured in a number of his sculptures, including one that shows how it unzips. Three of the graphic representations of his revised structure appeared on the British Millennium Stamp, with the caption, 'Decoding DNA', which is hardly an accurate description of what he is doing.

Curtis's new kind of double helix has not achieved any serious penetration into biological or genetic science, and it seems at this point unlikely to do so. This is not to say that his endeavour does not deserve our respect—or of course that the qualities of his art as art should be dismissed. Science has over the ages been marked by tensions between the mathematical modellers and the dogmatic empiricists. Mendeleev's periodic table of the elements (1869) is perhaps the extreme example of a highly theoretical structure that has subsequently been vindicated. These tensions, albeit in a less than extreme form, can be witnessed in the divergence between the empirical experimentalist, Franklin, and the more speculative modellers,

Watson and Crick. The polarities are too crudely drawn here, but they contain an element of truth about modes of scientific thinking.

Curtis seems to stand in a position comparable to Galileo, when the great astronomer was faced with Kepler's proposal that the actual physical orbits of the planets are elliptical not circular. Galileo could not believe that the heavens were set up in a less than ideal form. But, of course, Kepler was right to apply the laws of the physical behaviour of moving bodies as material objects rather than to retain obstinately the ideal geometry that he revered no less than Galileo.

To move from the heavenly and molecular sublime to something that verges on the ridiculous, I have selected as my example of DNA from the world of popular images 'the 1950s' Golly brooch issued by James Robertson & Sons, the famous jam makers (Fig. 10.13). The golly (an abbreviation of golliwog) had served as Robertson's trademark since 1910, and the company produced series of promotional badges, largely aimed at children. The badges were obtained by redeeming gollies collected from the labels on the back of the jars. I recall doing so myself, having developed a fondness for Robertson's Bramble Jelly. A golly with the double helix featured in a set issued in 2001 to celebrate major events in the twentieth century

Fig. 10.13

Robertson's DNA golly brooch, the 1950s, 2001.

(Fig. 10.13). A year later the golly trademark was abandoned, and sadly the Robertson brand itself was to disappear in 2008 following a takeover.

Introduced as a character in children's books by Florence Upton in 1894, the golliwog became a very popular doll, enjoyed innocently in the company of such favourites as teddy bears. It became a fairly standard member in an infant's entourage of cuddly toys. We know that such innocence was not to endure as society became more sensitized to implicit racism—or even explicit racism in the case of the term 'wog'. Robertson's cited a decline in popularity for their abandoning of the trademark.

Racing to Conclusions

It would be good to think that our understanding of DNA has laid to rest the beliefs that lie behind crude concepts of race and racial discrimination. However, this seems not be the case.

I will close this chapter by looking at an unhappy episode that involves James Watson himself. What it illustrates, amongst other things, is that racing to conclusions in an instinctive and impulsive way might work well in positing a structure for DNA but is fraught with danger when dealing with corrosive social issues. Making a mistake in theoretical modelling within the scientific community generally has limited consequences, other than for the esteem of the scientist(s) involved. Pauling's stellar reputation has undoubtedly suffered as the result of his incorrect model of DNA, but there was little collateral damage. In the socio-political domain the stakes are quite different. The personal qualities that acted as such powerful drivers for Watson in 1953 can all too readily become incendiary when deployed in other areas of human controversy.

The episode involves some offhand remarks made by James Watson in 2007. On the eve of a speaking tour of Britain, Watson commented on the policies of Western countries towards those in Africa. He expressed his view that 'all our social policies are based on the fact that their [Africans'] intelligence is the same as ours—whereas all the testing says not really'. He found few willing to defend him, and rapidly issued an apology:

> To those who have drawn the inference from my words that Africa, as a continent, is somehow genetically inferior, I can only apologise unreservedly. That is not what I meant. More importantly from my point of view, there is no scientific basis for such a belief.

Watson diverted the issue from one of inferiority and into one of difference:

> We do not yet adequately understand the way in which the different environ-ments in the world have selected over time the genes which determine our ca-pacity to do different things. The overwhelming desire of society today is to as-sume that equal powers of reason are a universal heritage of humanity. It may well be. But simply wanting this to be the case is not enough. This is not science. To question this is not to give in to racism. This is not a discussion about supe-riority or inferiority, it is about seeking to understand differences, about why some of us are great musicians and others great engineers. It is very likely that at least some 10 to 15 years will pass before we get an adequate understanding for the relative importance of nature versus nurture in the achievement of im-portant human objectives.

This, as he suggests, leaves open the question that one of the genetic dif-ferences might be greater of lesser intelligence or what he calls 'powers of reason'.

There is a real difficulty here. Should we give science and scientists the lib-erty to think and express the socially unthinkable? Even if the answer is yes, as it seems to me it must be, the Watson incident shows that what precisely is said to whom and in what context must be considered with supreme care, and only on the basis of secure facts that have not been obtained with any taint of bias and are not expressed in a slanted manner. Sticking your controversial neck out about the structure of DNA in 1953, when the facts were not wholly secure, is a very different business from expressing views about race when the full facts are equally elusive. It is my personal view that a proper understanding of human sameness and our extremely marginal differences in the longer term in the light of DNA and genetic science will progressively leave conventional views of race and nation in tatters. Either way, Philip Campbell's emphasis on the human consequences of the discov-ery of the structure of DNA , with which we started, is entirely vindicated.

Reading

There is a burgeoning volume of literature on the discovery of DNA, in-cluding accounts of varying reliability by the main actors in the drama and some careful historical accounts. Only a small selection is given here.

http://www.curtisdna.com.

Mark Curtis on DNA and his DNA artworks.

http://www.gollycorner.co.uk/.

http://www.nature.com/nature/dna50/.

http://www.ncbe.reading.ac.uk/dna50/timeline.html.

A detailed timeline.

http://www.ncbe.reading.ac.uk/dna50/ephemera1.html.

Some jolly DNA artefacts.

http://osulibrary.oregonstate.edu/specialcollections/coll/pauling/dna/index.html.

Containing a wealth of important and in part unresearched documents relating to
 Pauling and his contacts.

http://www.youtube.com/watch?v=2HgL5OFip-0.

An account by Watson in 2007.

Suzanne Anker and Dorothy Nelkin, *The Molecular Gaze: Art in the Genetic Age*, New
 York, 2004.

J. Clayton and C. Dennis, *50 Years of DNA* (Nature Publishing Group), Basingstoke,
 2003.

F. Collins, E. Green, A. Guttmacher, and M. Guyer, 'A Vision for the Future of
 Genomics Research', *Nature*, 422, 24 April 2003, pp. 835–47.

F. Crick, *What Mad Pursuit*, New York, 1988.

S. de Chadarevian, *Designs for Life: Molecular Biology after World War II*, Cambridge,
 2002.

S. de Chadarevian and N. Hopwood (eds), *Models: The Third Dimension of Science*,
 Stanford, Calif., 2004.

A. Gunn and J. Witkowski, 'The Lost Correspondence of Francis Crick', *Nature*,
 467, 30 Sept 2010, pp. 519–25.

B. Maddox, *Rosalind Franklin: The Dark Lady of DNA*, New York, 2002.

R. Olby, *The Path to the Double Helix: The Discovery of DNA*, Seattle, 1994.

M. Ridley, *Francis Crick: Discoverer of the Genetic Code*, New York, 2006.

B. Strasser, 'Who Cares about the Double Helix', *Nature*, 422, 24 April 2003, pp.
 803–4.

J. Watson, *The Double Helix: A Personal Account of the Discovery of the Structure of DNA*
 (1968), New York, 1998.

M. Wilkins, *The Third Man of the Double Helix: The Autobiography of Maurice Wilkins*,
 Oxford, 2003.

"You think you're pretty
smart, don't you?"

$$E = mc^2$$

SEARCHING ON THE WEB for photographs of Einstein, we find that his rights are handled for the Hebrew University of Jerusalem by a major Los Angeles agency that specializes in celebrity images. We are informed that

> GreenLight is a leading global consultancy, providing corporate, advertising, and media clients access to iconic music, film, celebrities, and entertainment content. We are experts at resolving the legal and logistical hassles our clients wrestle with, relieving them of stress and saving both time and money. Our team conducts thousands of clearances every year for various assets and properties worldwide. We have patience so you don't have to. Our rights representation group manages the personality rights of iconic estates, including

■ Baloo (Rex F. May), 'You think you're pretty smart, don't you?'

Albert Einstein, Bruce Lee, Steve McQueen, and Johnny Cash. GreenLight is based in Los Angeles and serves clients in more than 50 countries . . .

GreenLight LLC and its affiliates exclusively represent publicity, trademark, and related rights of Albert Einstein on behalf of The Hebrew University of Jerusalem. 'Albert Einstein' and 'Einstein' are trademarks and/or registered trademarks of The Hebrew University of Jerusalem. . . .

All visual media © by Corbis Corporation and/or its media providers. All Rights Reserved.

Another of GreenLight's posthumous clients is Mae West, the famously provocative and pneumatic film star, renowned for her bawdy one-liners. A later film star, Bruce Lee, displays his famous martial arts torso beaded with sweat—the very definition of sinew and muscle. Lee is quoted as saying, 'The key to immortality is first living a life worth remembering.' On the home page of GreenLight Albert Einstein stares out at us in the famous Oren Turner photograph (Fig. 11.1), which happens to be out of copyright. The venerable sage of relativity tells us that 'Imagination is more important than knowledge. Knowledge is limited. Imagination encircles the world.'

A table denotes the main licensees who have the rights to use the Einstein image/trademark.

Fig. 11.1

Oren Turner,
Albert Einstein, 1947.

Licensee	Details	Territory	Contact
All U, Inc.	apparel, accessories, mousepads, mugs, throws	North America	9 Interstate Ave. Albany, NY tel: 518-438-2558
Avenue de Jeux SAS	Einstein limited edition jigsaw puzzles	worldwide	Eric Lathiere Lavergne 56 Avenue de Nantes 44116 Vieillevigne, France tel: +33 2 51 11 86 52
Baby Einstein Company, LLC	Disney's Baby Einstein line of educational DVDs, videos, CDs, books, toys and discovery geared towards infants, toddlers, babies and young children	worldwide	9220 Kimmer Drive, Ste 200 Lone Tree, CO 80124-2884 retailer@babyeinstein.com tel: 1-800-793-1454
Coin Invest Trust AG	commemorative Albert Einstein gold coins	worldwide	Riestr. 7, PO BOX 47 9496 Balzer Principality of Liechtenstein Germany
Customworks	magnets, mousepads, notebooks	worldwide	1/3 Bowmains Industrial Estate Linlithgow Road Bo'ness, West Lothian EH51 0QG info@customworks.co.uk tel: +44 (0) 1506 821910
Eurographics	line of gifts and collectibles	US and Canada only	9105 Salley Street Montreal, Quebec H8R 2C8 CANADA fax : 514-939-0341
Excalibur Electronics	handheld electronic games, smart puzzles, brain games and science kits	North America, EU, Australia	18001 Old Cutler Road Suite 556 Miami, FL 33157 tel: 305.477.8080 fax: 305.477.9516 licensing@ebexcalibur.com
Impulse Imports Inc. DBA Import Images	posters	US and Canada	1903 West Main St Stroudsburg, PA 18360 tel:1-877-687-2579
Legoland California, Llc	Einstein Lego statue for public display within its theme park	California, US	1 Legoland Drive Carlsbad, CA 92008-4620 tel: 760-918-5322

Licensee	Details	Territory	Contact
Luminary Graphics	line of greeting cards and collectibles	US and Canada only	19080 Lincoln Road Purcellville, VA 20132 tel: 540-338-4586 888-295-3159 fax: 540-338-4587 fax: 888-290-1421
Optiq Ltd	eyewear for men, women, and teens	US and Canada only	2-344 North Rivermede Road Concord, Ontario Canada L4K 3N2 tel: 905-669-6251
Pomegranate Comm.	AE inspired calendars	worldwide	P.O.BOX 808022 Petaluma, CA 94975 (800) 227-1428, extension No. 104
Posterservice, Inc.	Einstein posters	US and Canada	Posterservice, Inc. 225 Northland Blvd Cincinnati, OH 45240 tel: 513-577-7100 (x 134)
Pyramid Posters	Einstein posters, magnets, and wall art	worldwide	The Works Park Road, Blaby Leicester UK LE8 4EF tel: 01162642630 fax: 0116 2642630
Walt Disney Internet Group	Einstein Brain Games for Mobile	worldwide—excluding North America	Walt Disney Internet Group 3 Queen Caroline Street Hammersmith London W6 9PE wdig.communications@dig.com tel: +44 (0) 208 222 1954

I am surprised to discover that Oxford University Press, publisher of this book, is a client, though not for Einstein images. The project involves Joseph Conrad's novel *The Secret Agent*.

Oxford University Press was interested in using 30 to 40 stills from the movie *The Secret Agent* in its educational books. They tasked GreenLight with attaining the appropriate clearances for a print run of 18,000 books in multiple languages. Because of our long-standing relationships with major Hollywood studios, GreenLight was able to clear the rights to these stills.

Celebrity images are big business, involving such mighty and profitable players as Corbis, Bill Gates's company, and Getty images. Einstein is a celebrity and, as we learn, is now a 'trademark'. And $E = mc^2$ is *the* celebrity equation above all others. The equation has become an icon of science and famed as a visual image. If it could have been copyrighted by the Hebrew University, it would have been. It has come to be used by people who have no clue as to what it means.

The singer Maria Carey, of the flashing smile and flowing locks, named her 2008 album $E = MC2$. The second track seductively invites the listener to 'Touch my Body'. The public explanation of her use of the formula is that is signifies 'the emancipation of Mimi to the second power'. Three years earlier she had issued an album entitled, 'The Emancipation of Mimi'. Questioned about the connection with Einstein, Carey answered, 'Einstein's theory? Physics? *Me? Hello!* I even failed remedial math. I could not pass seventh grade math even in the lowest class with the worst kids.' Interviewed by the BBC, Dr David Leslie of the Department of Mathematics in Bristol gnomically explained, 'the "two" in the equation means C squared, not MC multiplied by two ... the correct reading of the equation is $E = MCC$, so perhaps Mariah's re-interpretation should have been "emancipation equals Mariah Carey Carey"?'

There are other famous equations of course. Many will remember chanting at school, 'the square of the hypotenuse equals the sum of the square of the two opposite sides', Pythagoras's theorem for a right-angled triangle. It has a certain magic. The sides can be simple whole numbers, 3, 4, and 5 ($9 + 16 = 25$), but the length of the hypotenuse can also be an irrational number that cannot be resolved however many decimal points we use. Thus if the shorter sides are both one unit long, the hypotenuse

is the square root of 2 (or 'root 2'), which, to 55 decimal points, is 1.41421 35623 73095 04880 16887 24209 69807 85696 71875 37694 80731.

The formula for water, H_2O, is probably the only one for a chemical compound known to almost everyone who has been through school—though CO_2 for carbon dioxide is also very familiar, not least in this era of global warming. Almost as famous is Pi (π), the ratio of the circumference of a circle to its diameter, which we now know is also an irrational number. Finding a precise value for the squaring of a circle—finding a square that is precisely equal in area to a given circle—had been a long-standing problem, causing sleepless nights to Leonardo da Vinci amongst others.

It is in the nature of things that more recent formulas tend to become more complicated, and therefore less iconic when they leave the realms of mathematics and physics. By the time of Newton's law of gravity in 1687, things were becoming somewhat tricky: 'every particle of matter in the universe attracts every other particle with a force that is directly proportional to the product of the masses of the particles and inversely proportional to the square of the distance between them.' When we come to Euler's formula, named after Leonhard Euler the Swiss eighteenth-century mathematician and greatly revered within mathematics and physics, we enter a territory which is beyond those of us who struggle with trigonometry and exponential functions. The formula states that, for any real number x, $e^{ix} = \cos x + i \sin x$, where e is the base of the natural logarithm, i is the imaginary unit, and cos and sin are the trigonometric functions cosine and sine respectively, with x given in radians. I would prefer not to have to explain this at the drop of a hat—or even not all.

As we move into twentieth-century physics, specialist knowledge is generally required to untangle even the most basic formulas. The grave of Erwin Schrödinger, in the achingly picturesque Tyrolean village of Alpach, is adorned with one of the simpler expressions of his famous equation, which describes how the quantum state of a physical system changes in time (Fig. 11.2). Originally the circular plaque just contained the symbol for the wave function. The equation was added after the death of his wife Annemarie in 1965. It is utterly fundamental to quantum mechanics at all scales, applicable to molecular, atomic, subatomic, and macroscopic systems.

(For those who wish to know, Ψ is the wave function, the probability amplitude for different configurations of the system at different times; i is the imaginary unit and \hbar (h-bar) is the reduced Planck constant; and H is the Hamiltonian operator.)

Schrödinger is perhaps most famous for his imaginary cat, which like
$E = mc^2$, is cheerfully cited by people who have little grasp of its implica-
tions. The physicist envisaged a thought experiment in which

> A cat is penned up in a steel chamber, along with the following device (which
> must be secured against direct interference by the cat): in a Geiger counter,
> there is a tiny bit of radioactive substance, so small that perhaps in the course
> of the hour, one of the atoms decays, but also, with equal probability, perhaps
> none. If it happens, the counter tube discharges, and through a relay releases a
> hammer that shatters a small flask of hydrocyanic acid [which will kill the cat].

The observer outside the chamber cannot know if the cat is alive or dead after the designated hour. The probability is fifty–fifty. The cat may be considered, conceptually, as simultaneously alive and dead, a paradox that is only resolved when the observer opens the chamber. For Schrödinger, this strange 'experiment' revealed the bizarre nature of the 'Copenhagen interpretation' of quantum mechanics, in which it was accepted, amongst other things, that matter can be observed either to consist of particles or waves, depending on the act of observation.

None of these equations or others of note comes close to rivalling E = mc², which spectacularly bucks the trend of fundamental formulas to become more complex after the age of the great classical mathematicians. This relative simplicity, as we will see, is integral to its significance. It means that energy equals mass multiplied by the speed of light squared. It arose from a series of remarkable papers published by Einstein in 1905 and it derived from what became known as his theory of special relativity. It is not my intention here to explain relativity in detail—something that others are far better equipped to do—since my main focus is on the formula's voyage into fame, but some basic understanding of the equivalence of energy and mass is necessary. As Einstein said, 'mass and energy are both but different manifestations of the same thing—a somewhat unfamiliar concept for the average mind'. It is customary to frame an explanation mathematically in relation to the papers published in his *annus mirabilis*. I will for my part prefer to enter via physical experiences to which we can relate through standard experience.

Our Own Experience and Einstein's Theory

We are all familiar with phenomena that involve the conversion of mass into energy, or more specifically, the emission of photons that we detect in the form of light and heat, with an accompanying loss of mass in the body that emits the photons.

Any material that burns—say, a flaming piece of coal in an open fire or the match that is struck to light the fire—involves an atomic reaction that arises from chemical processes. During the process of combustion the molecules that comprise the coal are rearranged in a reaction with oxygen in the air, and a very small quotient of the energy that is potentially convertible in the mass of coal is emitted in the form of thermal

energy. The burning of carbon fuels also produces carbon dioxide (resulting from the combining of oxygen in the air with the carbon in the coal), along with methane—with consequences that are now alarmingly familiar to us from environmental science. The loss of mass involved in the production of the energy is so small as to be immeasurable in practice. To restate Einstein's equation, mass equals energy divided by the speed of light squared. The speed of light (or other electromagnetic radiation) is approximately 186,282 miles per second, and the speed of light squared is therefore a massive 35,700,983,524 miles per second. Thus a noticeable amount of energy can be produced from the conversion of a very very tiny amount of mass.

Let us look at another familiar example. In the glowing tungsten filament in a conventional light bulb, an electric current stimulates the metal to radiate incandescently at a temperature up to 3,000 °C. In this case the chemical decomposition of the substance that is emitting the light—the metal filament—is reduced to a minimum by the creation of a near-vacuum within the bulb or by its filling with inert gases that do not react with the metal. An electric current comprises a mass movement of those electrons that are least tightly bound to an atom. As the electrons pass along through the filament, they collide with the tungsten atoms. The collision vibrates each impacted atom, effectively heating it. The more tightly bound electrons in the vibrating atoms temporarily acquire an enhanced energy level, and release the extra energy in the form of photons. Again a negligible amount of mass is lost in the production of what is for us a bright and hot radiation. The light bulb was of course invented long before this atomic explanation was known.

A more direct and spontaneous manifestation of the conversion of mass into energy occurs with the rare, naturally occurring unstable elements, such as uranium, which on its own account emits energetic particles as its atomic nuclei disintegrate. As Marie Curie demonstrated, an ounce of radium continuously emits 4,000 calories of heat per hour. In Einstein's first statement in 1905 of the equivalence of mass and energy, he speculated that 'it is not impossible that with bodies whose energy-content is variable to a high degree (e.g. with radium salts) the theory [of the relationship of energy to mass] may be successfully put to the test'. When eventually put to the precise test, Einstein's formulation proved to hold good.

The spontaneous decaying of matter into energy is vital to our life on earth. The earth's crust is warmed by nuclear reactions deep within, while the heat of the sun results from the energy released when hydrogen continuously fuses to form helium within the great crucible of the sun's interior. And of course there are the atomic reactions that result in nuclear power and 'The Bomb' (about which more later).

Art history and archaeology now exploit one small part of the phenomenon of the spontaneous decay of radioisotopes, in this case that of carbon-14 or ^{14}C. The unstable isotope of carbon is taken up by living things from the atmosphere during the course of their lives. Once the plant or animal dies, this take-up ceases, and the amount of carbon-14 gradually decreases through radioactive decay. This decay is expressed in terms of a 'half life'; that is to say that the amount of carbon-14 in a given sample is halved over the course of 5,730 years. Comparing the remaining amount of carbon-14 in a sample to that expected from the carbon-14 in atmosphere allows the likely age of the sample to be estimated according to a band of probabilities. This band becomes more of a problem with samples of a relatively recent date, such as the wooden panel on which a Leonardo portrait has been painted. Carbon dating will not tell us precisely in what years Leonardo painted the picture. But it will indicate that the period of the wooden support is right and that the portrait is unlikely to be a modern forgery (unless a forger is alert to carbon dating and uses an old panel).

Fortified with the knowledge that we can draw upon our experience to understand how mass can be converted into energy, let us look at the key publications of 1905, submitted in remarkably short order to the prestigious German publication *Annalen der Physik*. Particularly important amongst the four articles from our point of view is the one published on 30 June, 'On the Electrodynamics of Moving Bodies', which introduced the concept that was later termed the Special Theory of Relativity. The key idea, building upon the pioneering work of James Clerk Maxwell, the Scottish physicist, is that the speed of light (or other electromagnetic radiation) is constant in all circumstances, even if the source of the emission and/or its receiver is in motion. All the other variables of space and time are relative to each other and to the speed of light.

It had long been recognized that the measurement of speed was relative to the speed of the observer. For example, the speed of a passenger in an aircraft and of the plane in which he or she is seated will be the same, and they will be stationary to each other as far as the passenger in concerned,

while both the passenger and the plane will be moving at say 500 miles per hour relative to an observer watching from the ground, who will himself or herself be moving though space at the speed of the rotating earth racing through the heavens. Einstein abandons the notion that all these motions can be plotted in relation to an invariable framework 'out there' consisting of three-dimensional space and regular time. For him, the speed of electromagnetic radiation, such as the photons of light, is the only constant. In his own words (translated from the original German),

> the same laws of electrodynamics and optics will be valid for all frames of reference for which the equations of mechanics hold good. We will raise this conjecture (the purport of which will hereafter be called the 'Principle of Relativity') to the status of a postulate, and also introduce another postulate, which is only apparently irreconcilable with the former, namely, that light is always propagated in empty space with a definite velocity c which is independent of the state of motion of the emitting body. These two postulates suffice for the attainment of a simple and consistent theory of the electrodynamics of moving bodies based on Maxwell's theory for stationary bodies.

Einstein came to regret the term 'relativity' as too slippery, thinking that 'co-variance' or 'invariance' (with respect to the speed of light) would have been better. But 'relativity' is the term that has stuck—to be used and even more misused.

Without exploring the technicalities of the relativity paper, we can see how Einstein follows it up in the fourth and very short essay on 27 September, 'Does the Inertia of a Body Depend Upon its Energy Content?' As he declares at the outset, 'the results of the previous investigation lead to a very interesting conclusion, which is here to be deduced . . .'. The conclusion that he rapidly reaches is that

> if a body gives off the energy L in the form of radiation, its mass diminishes by L/c^2. The fact that the energy withdrawn from the body becomes energy of radiation evidently makes no difference, so that we are led to the more general conclusion that the mass of a body is a measure of its energy-content.

But where is $E = mc^2$? The answer is that it does not appear in this exact and absolute form in the 1905 paper nor in his follow-up papers in the next two years, in spite of common assumptions to the contrary. The final

paragraph of a paper 'On the Relativity Principle and the Conclusions Drawn from It' in the *Jahrbuch der Radioaktivät und Electronic* in 1907 comes closest: 'the proposition . . . that to an amount of energy E there also corresponds to a mass of magnitude E/c^2, holds not only for *inertial* but also for *gravitational* mass', providing, as he admits, his starting assumptions are correct. It seems likely that a rather free translation of the 1905 paper into English put the classic form into general circulation.

Seven years later Einstein wrote a substantial overview of his ideas written in response to a request to contribute to a comprehensive book on radiology (Fig. 11.3). Due to a number of factors, including the intervention of the war and the substantial changes in Einstein's professional circumstances, the account was never published. Here the equation appears in its more complex form as applicable to a moving body. The reformulation occurs in a section of the manuscript entitled 'Equations of Motion of the Material Point'. Einstein has crossed out L, replacing it with E for energy, while q represents the 'instantaneous velocity of the moving point'. Later in the same section, he says that he is 'inclined . . . to grant a real significance to this term mc^2, to view it as the expression for the energy of the point at rest. According to this conception, we would have to view a body with an inertial mass m as an energy store of magnitude mc^2 ("rest-energy of the body").' He notes that the 'most important of all the consequences of the theory of relativity, which unites the principle of the conservation of mass and the energy principle into *one* principle, is extremely difficult to test experimentally'. But we still do not quite have $E = mc^2$. For a physicist, insistence on the canonical form is of little or no consequence, but since we are dealing with it as an iconic *image*, that is to say with its visual life, its absence is surprising.

Remarkably, the stock form of the equation, where E is the total energy, m is the 'relativistic mass', and c is the vacuum speed of light, does not seem to appear in any of Einstein's key papers. To state the issue in its technical terms, he always preferred to relate the rest-energy of a system to its invariant inertial mass. The formula for the static system was first clarified by Max von Laue in 1911, who was critical of the way that Einstein had formulated his argument. Von Laue derived the mass–energy relation for an arbitrary, closed static system in uniform motion. This gives the formula $m^0 = E^0/c^2$, where o signifies the lack of relative motion.

It seems in effect that the stock, unqualified formula in its familiar graphic form became identified with him as the scientific debate gathered

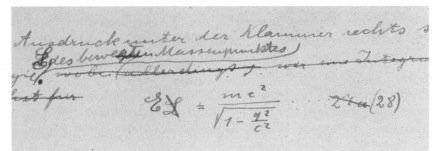

Fig. 11.3

The energy/mass/light equation in Einstein's manuscript on relativity, 1912, Jerusalem, Israel Museum.

momentum, not least during the translation of his ideas into a wider public forum. When it actually first appeared has remained elusive to me. As Einstein said, somewhat warily, in 1976, 'It is customary to express the equivalence of mass and energy (though somewhat inexactly) by the formula $E = mc^2$'.

In spite of this 'inexactitude' Einstein did embrace $E = mc^2$ in the public domain. We can hear him intoning it on YouTube:

> It followed from the special theory of relativity that mass and energy are both but different manifestations of the same thing—a somewhat unfamiliar conception for the average mind. Furthermore, the equation E is equal to mc-squared, in which energy is put equal to mass, multiplied by the square of the velocity of light, showed that very small amounts of mass may be converted into a very large amount of energy and vice versa. The mass and energy were in fact equivalent, according to the formula mentioned above. This was demonstrated by Cockcroft and Walton in 1932, experimentally.

The reference is to the 'splitting of the atom' by John Cockcroft and Ernest Walton in Cambridge in 1932. They succeeded in accelerating protons and smashing them into lithium atoms, producing alpha-particles and energy. The resulting fragments of the atom exhibited slightly less mass but flew apart with great vigour. Mass had been transformed into energy.

In historical retrospect, the 1905 papers have been widely criticized for Einstein's very limited acknowledgement of the theories of predecessors, such as Poincaré, Lorentz, Hilbert, and Hasenöhrl, who had proposed ideas close in whole or part to those of Einstein. His more severe critics have even accused him of plagiarism. It is true that his sparse references to the large body of work that was relevant to his postulates falls below

what we would now regard as acceptable in a fully referenced research paper. And he continued to be rather slippery when asked later about his relationship to earlier published theories. But we can take into account both circumstances and style.

The circumstance is that the 25/6-year-old Einstein, whose academic career had stalled, was working as a patent officer in the Federal Office for Intellectual Property in Bern. He was not isolated from people engaged with advanced physics, but neither was he locked into the kind of complex network that he would have enjoyed if he had occupied a post in a major university. His time and access to sources were also limited by his full-time post in the Patents Office. As it happens, when he emerged to become a public figure, the 'humble' background of the 'neglected' genius contributed to the romance of his story and became an integral part of his myth. It is one of the factors that have led him to become a household name, whereas Henri Poincaré, whose achievements were of an extraordinary magnitude, is little known outside specialist circles.

The issue of style is probably more significant, and does much to explain his rather cavalier attitude. The tone of the papers is of cutting back to basics—or rather to a new set of basics—on a compact set of foundations laid down by a few predecessors, amongst whom Maxwell was the most revered. The extensive citing of more or less close precedents in the writings of his predecessors did not fit with this focused mission. What Einstein was knowingly setting out to achieve was one of the great acts of crystalline clarification. Such acts were typically preceded and followed by long periods of complication. I am thinking of the radical clarifications, often of a counter-intuitive kind, wrought by Copernicus in astronomy, Newton in physics, Darwin in biology, and Mendeleev in chemistry, all of whom extracted a newly simplified order from existing theories and data by recasting the central premisses of their science.

To take just the first example, Copernicus was able to eliminate the complications of epicycles and eccentrics that had proved necessary to reconcile astronomers' observations with the conviction that the earth was at the centre of the celestial system. Followers of Copernicus, not least Galileo, saw his new, simple, heliocentric system as consigning the complicated 'ugliness' of the Ptolemaic universe to the waste bin of history. Copernicus relied on his own kind of relativity; that is to say the relativity of the motion of the earth in relation to the sun and planets.

We intuitively feel ourselves to be standing on a static body, with the sun passing in a great arc overhead, but we have no reason (other than theology and commonsense) for believing that we are not ourselves on a planet moving past a static sun. As Copernicus pointed out, citing Virgil, when we are on a boat we see the coast as 'slipping backwards'. By inverting the common sense intuition, Copernicus literally made fresh sense of the planetary system from a new perspective—the perspective of an observer on a moving heavenly body. In due course, the observational data caught up with his theory.

In much the same way, Einstein was aspiring to invert our standard assumptions about energy, mass, motion, space and time, so that our commonsense view of the coordinates can be seen as no longer functioning at the extreme scales of the atom and the cosmos. Like Mendeleev, who proposed his periodic table for the elements as a fundamental theoretic construction, leaving gaps where unknown elements were presumed to be, Einstein was proposing a basic schema that openly awaited future empirical verification. His theories were a priori constructions, based upon logical deduction and thought experiments, rather than drawn out of new physical experiments set up by himself. He did however fully recognize the ultimate need for his postulates to be verified by strictly empirical investigations that would confirm the predictions that followed from his theories. Einstein was no follower of Kant; he did not believe that the order we see in nature was essentially a mental construct. There was real order out there, and it originated with God. In his unshakeable faith in a central set of intelligible rules behind the manifest of natural appearance at every scale, he stands in the tradition of great generalizers and synthesizers like Goethe.

Validation and Fame

The key moment in the fame of Einstein came with one of those rare but dramatic astronomical events that attract public attention. On 29 May 1919 there was to be a total eclipse of the sun across a path in the southern hemisphere. A total eclipse is an act of high cosmic drama. The disk of the sun is masked blackly by the silhouette of the moon. All that remains is an explosive aura of radiance.

The eclipse was predicted to last for almost seven minutes, an unusually long duration. Arthur Eddington, the leading British astrophysicist,

realized that this presented a special opportunity to test the 'bending of space' by gravitation, as required by Einstein's general theory of relativity. The general theory, which Einstein had announced in 1915, had built gravity in the relativistic framework first outlined in the 1905 paper. The massive body of the sun should distort space close to it in such a way that distant stars seen in the background fringing the sun should be seen as displaced to some degree, compared with standard observations made without the sun's intervention. Normally the glare of the sun prevents any stars (in this case those in the Hyades constellation) being observable when they are visually located just outside the borders of the disc of the sun. Eddington, with the support of Frank Dyson, Astronomer Royal, led an expedition to the island of Príncipe, in the Gulf of Guinea off the West African coast, while another was dispatched to Sobral in Brazil, to make the necessary observations and take a series of photographs (Fig 11.4).

Things on Príncipe did not go as planned. The weather was foul, and for interminable minutes no observations could be made. Suddenly, with

a bare ten seconds remaining, the skies cleared enough for observations to be made and photographs taken. Eddington bore his spoils home and undertook detailed analyses. He deduced that the gravitational field of the sun caused a deflection of approximately 1.61 seconds of arc, relying largely on his Príncipe observations, though the actual photographs from Sobral were more striking. The results were announced or rather trumpeted at a joint meeting of the Royal Society and the Royal Astronomical Society on 6 November 1919. Alfred North Whitehead, the mathematician, compared the highly charged atmosphere to a 'Greek drama'. Joseph Thompson, President of the Royal Society, hailed the revelation of Eddington's results as 'one of the momentous, if not the most momentous pronouncements in the history of human thought'. Understatement was not the order of the day.

The press, initially in England and then in the USA, picked up on the story in a hyperbolic way. *The Times* headline exalted in the 'Revolution in Science—new Theory of the Universe—Newtonian Ideas overthrown'. The *New York Times* quoted Thompson's huge claim, while the *Washington Post* speculated that this was 'the most portentous scientific discovery in the history of the world'. The stories under the headlines were generally more nuanced in their assessments, but headlines did the important public work.

It is always difficult to say precisely why a story takes on a huge scale at a particular time. The link with the drama of the eclipse certainly helped. Eddington's own evangelical mission to prove Einstein right played a large role, though his evidence was thinner and more open to alternative interpretation than his public stance allowed. There was also a more general if nebulous sense that the existing world orders were being overthrown, not only by war but also in broad swathes of culture. Relativity became integral to what we now call Modernism, above all in its public reception. It came to be seen in an inchoate way as the equivalent of Cubism in art, of 12-tone serialism in music, of the disorderly modern novel as forged by James Joyce, and other cultural revolutions. And of course there was the Russian Revolution. All very threatening and potentially dangerous.

Old rules of commonsense and customary perception were seen as being overthrown, often much to the distaste of the bewildered public. Relativity dropped into a revolutionary environment in which it was well adapted to receive robust attention. There is of course an element of gross generalization in all this, of the kind to make a responsible historian wince, but we are talking about the kind of perceptions retailed in the

popular media rather than about any tangible links between the events and cultural trends in the years around 1919. 'Einstein had destroyed space and time', lamented the *New York Times* in an editorial on 7 December 1919. The former Swiss patent assessor had become a world star, a hero of the modern age or a dangerous advocate of scientific anarchy, depending on taste. As he said in the following year, 'Just as with the man in the fairy tale who turned whatever he touched into gold, with me everything is turned into newspaper clamor.' He was on his way to becoming the archetypal genius, accountable only to his own superhuman brain.

It is possible for responsible historians to posit plausible links between Einstein's 1905 theories and subsequent visual culture. It seems likely that Cubism in the pioneering hands of Picasso and Braque drew in part from the new sciences of geometry and physics that were transmitted via non-specialist and publicly oriented journals. One pioneering building, the Einstein Tower in Potsdam (Fig. 11.5), was a direct and early attempt to express the new physics in architectural form. Eric Mendelsohn was commissioned in 1917 by the astronomer Erwin Finlay-Freundlich to design an observatory specifically constructed to address Einstein's relativity. Its extraordinary form, realized after the First World War, presents a highly original and dynamic medley of organic curves and rising verticals. It was specifically conceived by Mendelsohn as a piece of revolutionary architecture fit for the visionary new world inaugurated by Einstein.

The next key public step (and I am narrating highlights from the main public story here rather than exploring the history of the scientific or artistic *fortuna* of his theories) came on Einstein's visit to America in April 1921 as part of the Zionist delegation lead by Chaim Weizmann. The delegation initially attracted greatest notice from the Yiddish press and Jewish commentators for its advocacy of the Jewish state. But Einstein progressively took over as the main focus of attention. His amiable and dishevelled eccentricity helped, as did his photogenic physiognomy, which always emerged as unmistakably individual, even before his full mane of white hair became apparent in all its later glory. He was also very good at giving the press headline quotes. His initial reaction to the eager attention of reporters and photographers seems to have been not a little distrustful, but he found that he possessed an inadvertent ability to play the fame game.

Fame brings adulation, but also notoriety and antagonism. There were, and still are, suspicions that the legendary 'twelve men' who were claimed to understand the new cosmology to the fullest extent were basking in

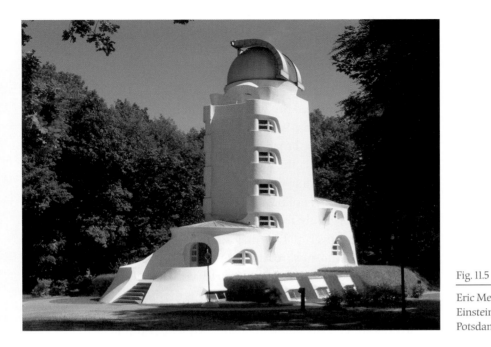

their elite intellectual superiority, and perhaps pulling the wool over our eyes. The *New York Times* picked up on this distrust in a particularly American manner.

> As professor Einstein remarks, the 'man in the street' has felt the foundations of belief in upheaval. He has an explanation of the fact, regarding it as 'psychopathological'. It is an interesting theory; but to those who know our man in the street, it is not plausible. The true answer is democracy. The Declaration of Independence itself is outraged by the assertion that there is anything on earth, or in interstellar space that can be understood by only the chosen few.

The whole ethos of the counter-intuitive theories was 'basically un-American'.

Generations of physicists from Richard Feynman to Stephen Hawking, John Barrow, and the notably young Brian Cox have worked hard in the domain of popular science to ensure that most of us can now join the twelve men. I suspect the best that can be expected is that those of us outside the field can grasp what kind of thing is being advocated rather

than feeling it instinctively in terms of our deeply embedded concepts of time and space and being able to operate its mathematical formulas on our own account.

By the time of Einstein's settling in America as a faculty member of the Institute of Advanced Study in Princeton in 1933, a move precipitated by the advent of the anti-Semitic Nazi government in Germany, his scientific status was more broadly recognized. What threw him back into the public limelight was the atomic bomb, though his engagement with the science of its production—even as its intellectual progenitor—was peripheral. But public, political, and journalistic perception is very much another thing. On 1 July 1946 a tousle-haired and wry portrait by Baker appeared on the cover of *Time* magazine. Rising above his shoulder is a representation of the mushroom cloud of the Nagasaki bomb, on which is inscribed, like the biblical writing on Belshazzar's wall, '$E = mc^2$' (Fig. 11.6).

Inside we learn that this 'modern Merlin' is the 'father of the bomb'. The characterization is uncompromising, and, in the wake of the dropping of the two bombs and surrender of Japan, distinctly triumphalist.

> The Genius. Through the incomparable blast and flame that will follow, there will be dimly discernible, to those who are interested in cause & effect in history, the features of a shy, almost saintly, childlike little man with the soft brown eyes, the drooping facial lines of a world-weary hound, and hair like an aurora borealis. He is Professor Albert Einstein, author of the Theory of Special Relativity, the Unified Field Theory, and a decisive expansion of Max Planck's Quantum Theory, onetime director of Berlin's Kaiser Wilhelm Institute, Professor Emeritus at Princeton's Institute for Advanced Study, onetime Swiss citizen, onetime Enemy No. 1 of Hitler's Third Reich, now a U.S. citizen.

The identity of Einstein with the bomb was recognized, albeit more circumspectly, in the remarkably open government report by Professor Henry Smyth of Princeton University on *Atomic Energy for Military Purposes*, published in 1945 only a few days after the explosions of the two bombs in the cities of Hiroshima and Nagasaki. Close to the start of the report, which provides a basic, lay education of nuclear physics, Smyth notes that

> As early as 1905, he [Einstein] did clearly state that mass and energy were equivalent and suggested that proof of this equivalence might be found by

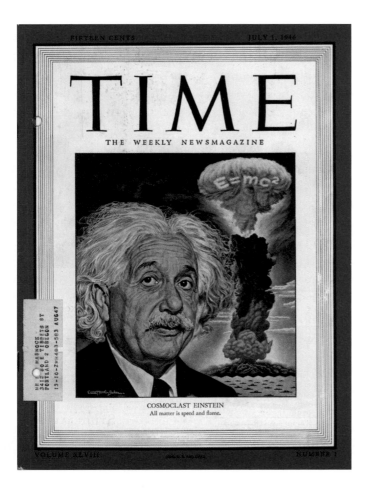

Fig. 11.6

Ernest Hamlin Baker,
Cosmoclast Einstein, cover of
Time magazine, 1 July 1946.

the study of radioactive substances. He concluded that the amount of energy, E, equivalent to mass, m, was given by the equation

$$E = mc^2$$

Where c is the velocity of light. If this is stated in numbers its startling character is apparent. It shows that one kilogram (2.2 pounds) of matter, if converted entirely into energy, would give 25 billion kilowatts of energy. This is equal to the energy that would be generated by the total electric power industry in the United States (as of 1939) running for approximately two months.

This close linkage requires a lot of hindsight and a distinctly schematic view of the history of science.

The report, surprisingly, shares something of *Time*'s relish for the nuclear sublime. An appendix contains the account of General Thomas Farrell, who had been a witness at the inaugural test of the bomb in New Mexico on 16 July 1945. Not only does Farrell note that the bomb represented 'the means to insure its [the war's] speedy conclusion and save thousands of American lives' and that atomic power might 'prove to be immeasurably more important than the discovery of electricity', but he also provides a poetic description of the awesome nature of the explosion itself.

> The effects could well be called unprecedented, magnificent, beautiful, stupendous and terrifying. No man-made phenomenon of such tremendous power had ever occurred before. The lighting effects beggared description. The whole country was lighted by a searing light with the intensity many times that of the midday sun. It was golden, purple, violet, gray and blue. It lighted every peak, crevasse and ridge of the nearby mountain range with a clarity and beauty that cannot be described but must be seen to be imagined. It was that beauty the great poets dream about but describe most poorly and inadequately. Thirty seconds after the explosion came first, the air blast pressing hard against the people and things, to be followed almost immediately by the strong, sustained, awesome roar which warned of doomsday and made us feel that we puny things were blasphemous to dare tamper with the forces heretofore reserved to The Almighty. Words are inadequate tools for the job of acquainting those not present with the physical, mental and psychological effects. It had to be witnessed to be realized.

Einstein's direct role in the bomb was limited, and tempered by his pacifism. In close collaboration with the Hungarian physicist Leó Szilard, Einstein addressed a letter to President Roosevelt on 2 August 1939. It is excerpted here.

> Sir: Some recent work by E. Fermi and L. Szilard, which has been communicated to me in manuscript, leads me to expect that the element uranium may be turned into a new and important source of energy in the immediate future. Certain aspects of the situation which has arisen seem to call for watchfulness and, if necessary, quick action on the part of the administration . . . It may become possible to set up a nuclear chain reaction in a large mass

of uranium, by which vast amounts of power and large quantities of new radium like elements would be generated. Now it appears almost certain that this could be achieved in the immediate future.

This new phenomenon would also lead to the construction of bombs, and it is conceivable—though much less certain—that extremely powerful bombs of a new type may thus be constructed. A single bomb of this type, carried by boat and exploded in a port, might very well destroy the whole port together with some of the surrounding territory. However, such bombs might very well prove to be too heavy for transportation by air. . . .

In view of this situation you may think it desirable to have some permanent contact maintained between the Administration and the group of physicists working on chain reactions in America.

Einstein and Szilard exhort the President

To speed up the experimental work, which is at present being carried on within the limits of the budgets of University laboratories, by providing funds, if such funds be required, through his contacts with private persons who are willing to make a contribution for this cause, and perhaps also by obtaining the co-operation of industrial laboratories which have the necessary equipment.

The needs of the war machine had long provided a major source of funding for scientists, including Galileo. As a final warning, Einstein and Szilard note that 'Germany has actually stopped the sale of uranium from the Czechoslovakian mines, which she has taken over.'

Then on 25 March, towards the end of the war and in the fateful year of the dropping of the bombs, Einstein wrote again, stressing that

Dr. Szilard . . . is greatly concerned about the lack of adequate contact between scientists who are doing this work and members of your Cabinet who are responsible for formulating policy. In the circumstances I consider it my duty to give Dr. Szilard this introduction and I wish to express the hope that you will be able to give his presentation of the case your personal attention.

As an ardent pacifist, Einstein faced a terrible dilemma. The death and destruction of war were repulsive to him but could he stand aside while Nazi

Germany beat America to the production of the most decisive weapon of all? He did not of course say that America should manufacture and deploy atomic bombs. But he was obviously aware of the potential outcome of the research he was promoting in the political arena. In the event, Germany was not the target of the actual bombs.

The Image of Genius

Like Picasso, his revolutionary counterpart in the visual arts, Einstein became the very face of genius. Even if he did not court photographic exposure in the way that Picasso did—often professing a reluctance to be photographed—he was certainly alert to its potential and understandably flattered by the way that his image came to signify the transcendent genius on the worldwide scale.

The Einstein of his most productive years hardly looked the part (Fig. 11.7). Indeed, he could well be a minor civil servant. By the time he first visited America, his visual character was being forged. The halo of negligent hair was beginning to grey and the outer corners of the 'hound-like' eyes had started to sag. Even when dressed smartly, he looked only a step away from being dishevelled—whether or not we actually noticed that he preferred not to wear socks. And he puffed cosily on a pipe. He was well aware of his image. As early as 1913, he wrote, 'If I were to start taking care of my grooming, I would no longer be my own self.' He was taking care to show that he did not care.

By the time of the 1946 *Time* cover, the image was fully formed. The Oren Turner photograph one year later is lit to highlight the wispy energy of Einstein's white hair—a graphic transformation of a linear substance into intellectual radiance—and openly invites comparison with historic portrayals of other seers. The closest comparison is with Julia Margaret Cameron's compelling photographs of Sir John Hershel in 1867 (Fig. 11.8). As a truly great astronomer and giant figure in the science of his day, Herschel was a worthy comparator. It is notable that the defining images of great men, particularly those renowned for their brain power, often show them as venerable sages, even when, as in Einstein's case, his defining work was undertaken in his youthful years. The gravitational pull in images of famous women is, by contrast, in a youthful direction.

In all, Einstein was to be portrayed on five *Time* covers. We have already seen the one from 1946. The first was on 18 February 1929, in which he is

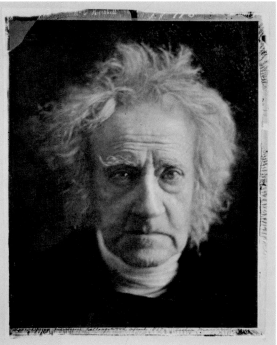

wearing a richly patterned robe. On 4 April 1938 he was shown informally and pensively in a crumpled jacket, apparently in his study. In the centenary year of his birth (19 February 1979) a painted image based closely on a photograph showed the dynamic vortices of his white hair entangled with cosmic bodies, including a spiral nebula and Saturn. The superb photograph was taken by Philippe Halsman (Fig. 11.9), whose immigration to America Einstein helped to facilitate, and it has on its own account achieved something of an iconic status. Einstein stares at us in that intensely complicated manner with which we have become familiar . His untidy neckline has been replaced on the cover by a neatly anonymous collar and tie. The fourth image appeared when he was named as 'PERSON OF THE CENTURY' on 31 December 1999. On this occasion, Halsman's photograph was reproduced rather than redrawn. The story begins, 'he was the embodiment of pure intellect, the bumbling professor with the German accent, a comic cliché in a thousand films. Instantly recognizable, like Charlie Chaplin's Little Tramp, Albert Einstein's shaggy-haired visage was as familiar to ordinary people as to the matrons who fluttered about him in salons from Berlin to Hollywood.'

Fig. 11.7 (*left*)

Lucien Chavan,
Einstein, 1906–7.

Fig. 11.8 (*right*)

Julia Margaret Cameron,
Sir John Herschel, 1867.

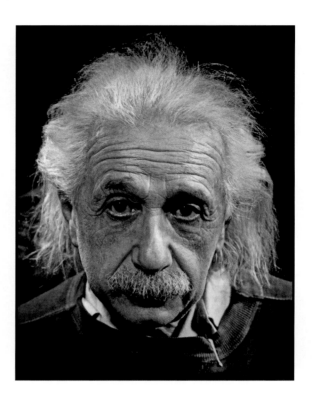

Fig. 11.9

Philippe Halsman,
Einstein, 1947.

There are many photographs and numerous caricatures in the same vein, appearing on billboards, T-shirts, mugs, and every kind of merchandise. But one stands out for its startling irreverence and has become duly famous. In 1951 a celebration was organized at Princeton to mark Einstein's 72nd birthday. His reaction to the intrusive and persistent efforts of press photographers to take some pictures was to stick his tongue out—further than most of us can do. Arthur Sasse, a photographer from United Press International, managed to take a snapshot, which originally included two of Einstein's companions. The physicist was delighted with the result, and cropped out the other heads from the photograph (Fig. 11.10). He ordered prints for his personal use, inscribing in German the one he gave to the radio reporter and anchorman Howard Smith: 'this gesture you will like, because it is aimed at all of humanity. A civilian can afford to do what no diplomat would dare. Your loyal and grateful listener, A. Einstein '53.' It would be totally out of character for Einstein to be bluntly dismissive of *all* humanity. Most immediately he may be inviting us to see him as sticking his tongue out at the communist and anti-American witch-hunt

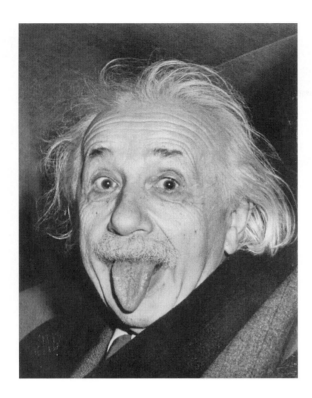

that was at its height at the time. He also seems to be mocking the whole public business of genius, fame, press intrusion, conformity to norms, and, perhaps even more profoundly, the extreme hubris of human aspirations to double-guess the creator's most elusive secrets. In the event, a wide swathe of humanity have taken the image to their hearts. The version dedicated to Walker was sold for $74,000 in 2009.

A number of well-known photographs show Einstein at work on blackboards, scrawled with sense aggregations of formulas. The attraction is obvious; the blackboards give us a sense of him actually thinking, literally on his feet. There is an obvious analogy with the many blackboards generated by the German artist Joseph Beuys during his performance-lectures, in which he diagrammatically demonstrated his theories of civilization. But Beuys always intended that his blackboards should remain as enduring traces of his thought and actions. As it happens, a number of actual blackboards graced by Einstein's 'divine' touch were retained rather than erased. The one in the Museum of the History of Science in Oxford (Fig. 11.11) dates from Einstein's 1931 visit, when he had been elected to a 'Research Studentship' at Christ

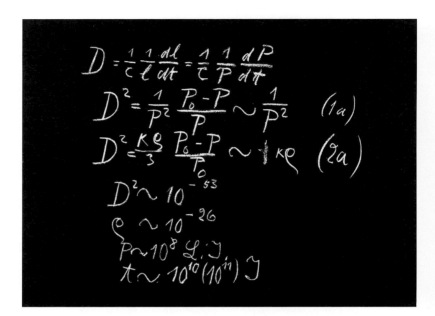

Church. It is of unimpeachable authenticity. The last three lines give numerical values for the density (ρ), radius (P), and age of the universe, T.

$E = mc^2$ is quite often illustrated as if written with white chalk on a blackboard—although written not by Einstein himself. The informal look of the formula written in chalk, as a trace of momentarily realized thought, is far more evocative than when it is set in formal type. The whole of the 1912 manuscript has been published in facsimile so that we feel as if we can see the great man thinking. But if the formula is printed, what type face should we use? Those in *Annalen der Physik* were conservative. It is truer to Einstein's 'modernity' to us a *sans serif* font, like the bold face designed by Eric Gill, which first appeared in 1926?

$$\mathbf{E = mc^2}$$

Or we should use the font called chalkboard?

$$E = mc^2$$

My point is not that one font is necessarily better than another, but that once the formula becomes a visual image the issue of graphic style becomes of some consequence.

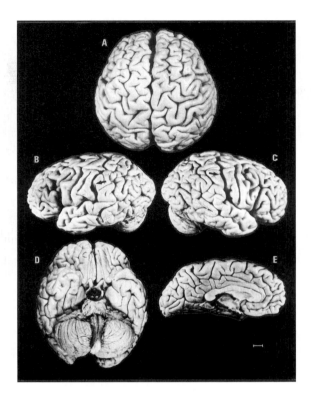

Fig. 11.12

Photographs of Einstein's brain, as published by Sandra Witelson et al., *The Lancet* in 1999.

A Gory Postscript: The Not So-Big Brain

The autopsy undertaken on Einstein's death in Princeton on 18 April 1955 was performed by the pathologist Thomas Stoltz Harvey, who decided unilaterally to remove Einstein's brain. Formalin was injected into blood vessels of the brain, which Harvey then surveyed photographically (Fig. 11.12). He later sectioned it into centimetre cubes, which were set in collodion. He also removed Einstein's eyes and presented them to Henry Abrahams, Einstein's eye doctor. It is not hard to imagine why Harvey did what he did—in spite of its Frankensteinian echoes. He said himself that 'I assumed that we were going to study the brain.' No such scheme had been authorized, although it may have been retrospectively endorsed by Einstein's son. Harvey was removed from his post in Princeton Hospital for refusing to hand over his neurological prize. The pathologist himself possessed none of the knowledge or skills to undertake a full-scale investigation. He limited himself to noting that he could see nothing unusual about the brain, and that it was a perhaps a bit smaller than average.

No research was undertaken on the cubed and pickled brain in the years immediately following Einstein's death. It travelled with Harvey as he moved from post to post. It had by default become a relic of the genius than the subject of scientific investigation. Einstein was not the first scientist to be so relic-ized. In 1737 when Galileo's remains were disinterred for reburial in the tomb being built for him in Sta. Croce in Florence, three fingers and a tooth were removed. One finger has long been displayed in an ornate jar in the Museo di Storia della Scienza in Florence, and recently the three other relics have come to light. Galileo may be a fitting patron saint for scientists, but the preservation of shrivelled bits of his body tells us more about us than him.

Over the years, interest waned in Einstein's cubed brain and the trail went cold, but in 1978 Steven Levy of the *New Jersey Monthly* was asked by his editor to research a piece on the lost brain. Levy traced Harvey to Wichita, Kansas, and the genie was soon out of the bottle. The journal had a scoop on its hands, and Harvey was besieged by the media. He was given a rough ride—heavily criticized and savagely lampooned. He could only mount the defence that he 'kept it to find out, if possible, what was the source of his [Einstein's] intelligence, of his genius'. That nothing had been achieved for twenty-three years did not help his case.

The first detailed study of blocks selected from areas in Einstein's brain was undertaken by Marion Diamond and published in 1985 in *Experimental Neurology* as 'On the Brain of a Scientist: Albert Einstein'. The study was, by general consent, not wholly convincing and does not provide a really secure basis for any enduring conclusions. Unsurprisingly others have subsequently tried to define what was physically special about Einstein's brain. Even as a non-specialist, my sense is that none has any claim to be better than speculative. The study in *The Lancet* in 1999, from which the illustration is taken, was justifiably cautious in its conclusions. The whole enterprise seems to be founded on insecure assumptions about how we can read the nature of Einstein's mind from anatomical observations of a brain that has hardly been treated with exemplary care. Had Einstein lived in the era of fMRI scans the situation might have been more promising.

For now the remaining brain cubes remain in a strange and unedifying limbo in Princeton Hospital. Presumably no one (and no committee) would want to be responsible for disposing of them in whatever way might be deemed appropriate. To be billed as 'The Man [or Woman] who Destroyed Einstein's Brain' is not an appealing way to stake a claim to posterity. Perhaps we should wait until its total mass can be converted into energy.

Reading

Given my uncertainties about the emergence of the famous formula, I am including the main primary sources and editions of Einstein's writings.

http://www.albert-einstein.org/.

http://einstein-annalen.mpiwg-berlin.mpg.de/annalen.

http://einstein.biz/links.

http://www.newhorizons.org/neuro/diamond_einstein.htm (M. Diamond, 'Why Einstein's Brain?').

M. Beller, R. Cohen, and J. Renn (eds), *Einstein in Context*, Cambridge, 1993.

C. Cattani and M. De Maria, 'Max Abraham and the Reception of Relativity in Italy: His 1912 and 1914 Controversies with Einstein', in *Einstein and the History of General Relativity*, Boston, 1989, pp. 160–74.

A. Einstein, 'Ist die Trägheit eines Körpers van seinem Energiehalt abhängig?', *Annalen der Physik*, 18, 1905, pp. 569–74.

A. Einstein, 'Die Realivitäts-Theorie', *Naturoschende Gesellschaft in Zurich. Vierteljahrsschrift*, 56, 1911, pp. 1–14.

Einstein's 1912 Manuscript on the Special Theory of Relativity, a facsimile with essays by H Gutfreund et al., New York, 1996.

The Collected Papers of Albert Einstein, 12 vols., Princeton, 1987–2009.

P. Galison, G. Holton, and S. Schweber (eds). *Einstein for the Twenty-First Century*, Princeton, 2008.

E. Hecht, 'Einstein on Mass and Energy', *American Journal of Physics*, 77, 9, 2009, pp. 799–806.

M. von Laue, 'Zur Dynamik der Relativitätstheorie', *Annalen der Physik*, 35, 1911, pp. 524–42.

M. von Laue, *Die Relativitätstheorie*, Braunschweig, 1911.

A. I. Miller, *Albert Einstein's Special Theory of Relativity: Emergence (1905) and Early Interpretation (1905–1911)*, Reading, Mass., 1981.

H. Ohanian, 'Did Einstein Prove $E = mc^2$?', *Studies in History and Philosophy of Modern Physics*, 40, 2009, pp. 167–73.

J. Renn (ed.), *Einstein's Annalen Papers: The Complete Collection 1901–22*, Weinheim, 2005.

H. Smyth, *Atomic Energy for Military Purposes*, Princeton, 1945.

S. Witelson, D. Kigar, and T. Harvey, 'The Exceptional Brain of Albert Einstein', *Lancet*, 19 June 1999, 353, pp. 2149–53.

12

Fuzzy Formulas

THIS WAS TO BE A CONCLUSION, and it still is to a degree. However, for reasons that will become clear, it is very much not conclusive, and I am therefore finishing with a concluding chapter rather than a conclusion as such.

Do iconic images have anything in common? This is the question I posed and partly dismissed in the Introduction. We can now rephrase the question more specifically in relation to what has come in between. If the eleven examples are a reasonably representative selection of types of iconic image, what do they share in common? Again I would say it rests on a false or at least unproven premiss, that is to say it assumes that one iconic image *necessarily* has anything in common at all with another. Or we can refine the premiss to read: iconic images necessarily share a certain set of key or essential features if they are to achieve the highest status.

As will become clear later, I still think this premiss, even in its refined form, is untenable.

There are two main dimensions to the achieving of iconic status; the fame of the subject or content of the thing represented or signified; and the memorable look of the image or sign. It must be the case that these two factors act in total concert with the most enduring visual icons, but for the purpose of an analysis it will be useful to separate them out. The issue of content is somewhat easier, at least in terms of the kind of arguments we can use. Let us begin with this.

Celebrity and Presence

Only two of our icons are predominantly religious, Christ and the cross. The heart also has a conspicuous religious dimension. Does this mean that the other eight are secular? If by secular we mean not specifically attached to an organized body of beliefs and practices in a particular religion, the answer is fairly obviously yes. But if we extend our notion of the religious to embrace devotion that accords a value to something that transcends all its apparent physical existence, then the other eight all exhibit either religious or quasi-religious dimensions.

The Stars and Stripes, so linked to the Christian foundations of America, probably is the most religious of the apparently secular images. It has become a kind of sacramental object through both law and custom. However, none of the others lacks a strong devotional component that expresses itself through acts of worship of one kind or another. The lion, for instance, often stands for the divine attribute of majesty, as accorded to absolute rulers, heroes who have been immortalized, or state entities that aspire to transcend the individual. No one who has witnessed the elbowing crowds in the front of the *Mona Lisa* can doubt that 'she' is the subject of cultural worship and journeys of pilgrimage (Fig. 12.1).

Merely having been in the presence of the original has a special value, almost independently of the viewing conditions that do not provide a close visual experience of the painting as a physical reality. The fusion of Che and Christ is readily apparent. The naked Kim Phuc is an innocent massacred or at least tortured, like the infants slaughtered on the order of Herod, and her pose carries echoes of the scourged Christ. The age-old quest for the 'secret' of life is embodied by DNA, a special kind of scientific icon that has in some minds supplanted God as the origin of life.

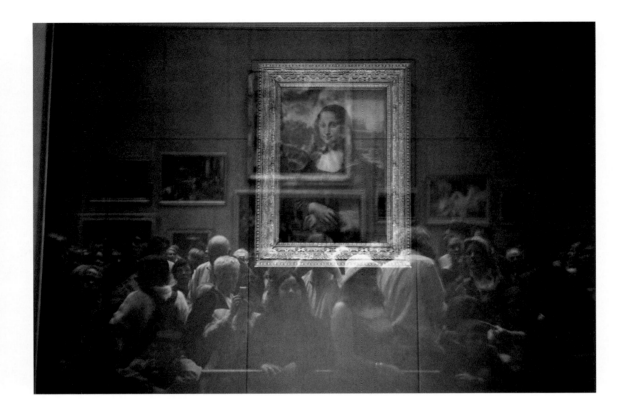

Fig. 12.1

Matthew Landrus, *Mona Lisa under Siege*, 2001.

$E = mc^2$ pays a comparable role at a cosmic rather than human scale, and is locked into both the greatest things that human genius can achieve (in the person of Einstein) and the greatest destructive evils it can perpetrate (in terms of the bomb). The COCA-COLA bottle is perhaps the least easy to characterize in religious terms, without debasing the term 'religious' to embrace such things as the worship of material consumption, an Americanized lifestyle, and the cult of youth—coupled with a fierce devotion to a particular brand as a form of individual and collective identity. However, The New Seekers did provide a hymn to COKE: 'I'd like to teach the world to sing | In perfect harmony . . .'

We all tend to accord value to things that transcend any kind of financial and utilitarian worth. Recently my fountain pen was severely chewed by a seat in the lecture theatre at St John's College in Oxford. It fell into the hinge and when the seat was pressed down to see if it had dropped onto the floor the mechanism crushed its stout steel barrel. It has been resuscitated, albeit with some residual scarring, by a local jeweller, Julia Beusch.

Why all this trouble for a pen of the kind that can still be purchased quite readily? The answer is that it was given to me by my son Jonathan, inscribed with my name. I have used it for many years and renewed its innards. It has what is called 'sentimental value'—a rather unsatisfactory phrase that glosses over the kinds of identity involved in something like my pen. It has a kind of presence—something I am saying as someone not generally prone to mystical and religious beliefs.

All the iconic images are endowed with a special presence, as if some quality of the original is embedded in them. Looking is only part of it. When the image is realized in a physical form that we can possess, the artefact in its own right assumes some kind of status that goes beyond it being a representation. I think we would be worried to find that we had accidentally creased a page in a well-illustrated book in such a way that it 'defaced' the *Mona Lisa*. Duchamp understood exactly this when he added the moustache and beard. Perhaps a narrative image, like the photograph of the running Kim, least readily turns into an icon that embeds presence. However, Leonardo's *Last Supper*, Michelangelo's *Creation of Adam*, and Picasso's *Guernica* show that narratives are not entirely resistant to assuming the status of revered images rather than remaining illustrations. The dividing line is not absolute. An *Annunciation* can be a devotional image on an altar and a narrative in a fresco cycle of the Virgin's life, but Fra Angelico can paint the Angel greeting Mary in a monk's cell in S. Marco in Florence in a way that both tells the story and functions as a contemplative image of the Virgin Annunciate, embodying the essence of her immaculate nature. It is precisely this transfer of the real presence from the subject of devotion to the representation that has raised the ire of iconoclasts in all those religions that have always or for a time rejected figurative images of deities and revered followers.

In the more modern period the concept of icon has become entangled in the cult of celebrity, which tends to be characterized as a shallow replacement of spiritual values by a superficial worship of transitory qualities via the media. Again I do not think there is a sharp division. All iconic images must acquire the property of celebrity, but not all celebrities are icons, above all in the longer term.

There have been a number of attempts to define the beginning of celebrity culture. The rise of mass popular entertainment in Britain in the later eighteenth century, the advent of photography on a mass scale, the rise of film and then television, and the internet have all been seen as marking

special beginnings. Historians like breaks, changes, and beginnings, but I tend to see basic human continuities as predominantly at work in the arena of enduring celebrity.

The specific subject here, the icon, certainly is not subject to any definable starting point. It is difficult to argue that the Willendorf 'Venus', the limestone statuette in which a woman's naked body is composed primarily from the more bulbous parts of her physique, is not an icon of some kind, along with a number of such figures (Fig. 12.2). It is generally seen having originated some 25,000 years ago. Although there is no independent evidence of its role, beyond the appearance of the statuette itself, we can sense that it always was intended as an iconic object, and it has now achieved a high level of worldwide fame. If it was in the Kunsthistorisches Museum rather than that devoted to Natural History, on the other side of the grand avenue in Vienna, it might well be even more iconic. Images of the human body, or the divine in human-like form, have been central to

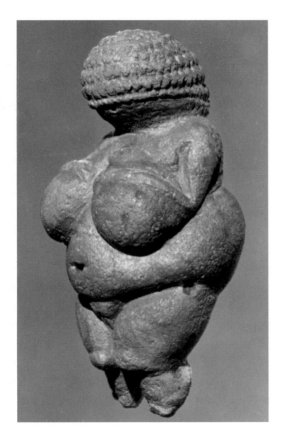

Fig. 12.2

The 'Venus' of Willendorf, c.23,000 BC, Vienna, Naturhistorisches Museum.

many religions, and the emphasis in the 'Venus' upon those anatomical features in which women most differ from men feeds our alertness to primary sexual characteristics. It clearly plugs into some pretty basic visual and conceptual instincts.

There are undeniable signs that the celebrity of some modern celebrities is surviving beyond their apparently passing prominence in the media of mass consumption. In 2005 the National Portrait Gallery in London launched an exhibition on *The World's Most Photographed*. Ten subjects (not eleven!) were identified: Muhammad Ali, James Dean, Mahatma Gandhi, Greta Garbo, Audrey Hepburn, Adolf Hitler, John F. Kennedy, Marilyn Monroe, Elvis Presley, and Queen Victoria. The show of 100 or so photographs was coupled with a television series. It is notable that only one is still alive, the boxer Muhammad Ali, who sadly is in little state to promote his own cult. It is clear that to move from being a celebrity for the time (enjoying Andy Warhol's 15 minutes of fame) into the realm of a more enduring fame requires the attraction of a cult following on a widespread basis that outlives the subject themselves. They need in some way to embody something greater than their individual characteristics. They need to become representative, in a way comparable to deities or saints who have become associated with particular facets of life, redemption, and eternity. Ali is a kind of Hercules, Dean a youthful martyr like St Sebastian, Gandhi a Christ-like saint of non-violent action, Garbo, Hepburn, and Monroe are Juno, Pallas, and Venus, awaiting the Judgement of Paris, and Presley is the Joshua whose trumpeting voice tumbled the walls of adulthood, while the assassinated Kennedy is a modern King Arthur ruling over his court of Camelot, and Hitler is an obvious Satan. Queen Victoria would probably not feature on any list outside England. There is obviously an element of overstatement in my identifications, but the analogies do have a certain level of validity in terms of the archetypes involved.

The serial reproduction of images of the saints and celebrities, ancient and modern, has been characterized by Walter Benjamin as diminishing their 'aura'. The reverse is true. Any widespread broadcasting of fame ensures that the embodying of a special presence in the original is enormously enhanced. The democratizing of images has resulted in the canonical subjects and their images becoming ever more exclusive from and elevated above the common herd. We are all familiar with images of teenagers' bedrooms adorned with posters and pages cut roughly from magazines. The bedrooms become, as has often been remarked, shrines

to the teenagers' personal saints. Adults may be less blatant, but I suspect we all create spaces or arrays of cherished possessions that share something of the quality of shrines.

The biologist Richard Dawkins and his followers have claimed that we can characterize the survival of something iconic in Darwinian terms—as a 'survival of the fittest' in the jungle of cultural competition. Dawkins has even applied a specific name, the 'meme', to the unit involved in the genetics of culture. Inasmuch as an iconic image has manifestly demonstrated its fitness for survival in changing contexts over time, we can affirm that the biological analogy works well enough. However, the analogy does not go all that far once we realize that we are dealing with active and purposeful agents rather than chance mutations and an environment of physical causes and effects. For example, those involved with the design of the Stars and Stripes did so according to a series of clearly defined ends in an environment that they were themselves actively shaping. Even the most teleological form of Darwin's natural selection cannot be seen as analogous to such processes. There is also another important difference. Icons transgress original form, function, and context so that some or most of the original fitness criteria no longer apply. It is like putting a polar bear in the tropics and finding that its white coat helps to insulate from the rays of the sun. Nonetheless, the bear is unlikely to be viable in searing heat. The 'commie' Che somehow needs to survive in posh Sloane Square. His 'fitness for survival' is clearly of a very elastic and even paradoxical kind.

In the chapter on Che we encountered the cultural theorist Régis Debray in his Bolivian prison, and noted how he came to emphasize 'transmission' rather than just the thing in itself. I described his cultural analysis of images as embracing all the media, mechanisms, technologies, institutions, materials, rituals, conventions, and the circumstances of transmission in and across time. There is nothing very biological in the varied material mechanisms and transformations of form that are involved. However, there are clearly some central perceptual and cognitive mechanisms at work in a way that transcends the particularities of the media of transmission. The medium is not the whole message, as Debray thought. Rather the message somehow seeps through its media transformations in such a way that some aspects of a recognizable core still survive, however much subverted. This core obviously survives in visual form in our eleven examples, and it is to the visual characteristics that we now turn.

Visual Cores

We might hope or even expect that such iconic images as we have described here would share some memorable visual features in common. Some common features are evident, and can indeed be observed commonly if not uniformly. They are a strong element of symmetry and the kind of simplicity that allows us to seize upon the key identifiers. In the case of human heads, the eyes and mouth are in the lead, as Dante recognized, while in the case of some icons, such as the heart, the images have been reduced to these minimal identifying features already. Iconic images often exhibit extraordinary robustness however inadequately they are transmitted or however they are traduced during transcription. This robustness is something that Warhol infallibly identified (Fig. 12.3). His *Twelve White Mona Lisas* demonstrates how far the process of reduction can go without losing the essential signs of resemblance. Not only is the image reduced to a few basics, it has been rendered as a negative, reversing the darks and lights. Warhol was also very alert to the way in which some famous images make superb repeats, that is to say they can be laid out effectively like a repeating wallpaper pattern.

Warhol remained a pious Catholic in the Polish tradition, even during the years of his apparent excesses, and was brought up with popular images of Christ, the Virgin, and saints, and with devotional paintings and sculptures in church. Having grown accustomed to traditional religious icons as a child, the adult Warhol became the genie of a new set of modern popular icons. He shaped himself into a manufacturer of iconic images in serial repetitions, whether he is capturing the brittle glamour of Marilyn Monroe or the sinister darkness of the electric chair. The icons are being iconized. It is entirely in keeping with this creation of images in the devotional style that he should have turned late in his life to serial versions of Leonardo's *Last Supper*.

Amongst the so-called Pop Artists of Warhol's generation, Jim Dine has performed this role for the heart shape, in an extended series of graphic works, paintings, and sculptures since the mid-1960s. More generally Pop Art has been heavily engaged with sets of basic images in the public domain that retain their visual potency, however much they are bowdlerized and traduced.

We have, then, some reasonably promising criteria, which involve some measures of symmetry, simplicity, basic recognizability, resistance to poor replication, and the making of good repeats. However, not all the

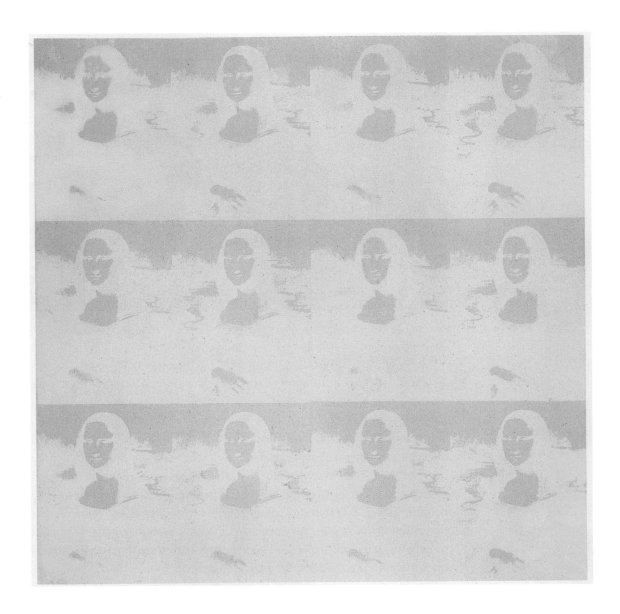

images are symmetrical and simple. Nick Ut's photograph, even if we analyse it according to the Renaissance rules described by Alberti, presents a complex and not very symmetrical pictorial field with a number of centres of interest. Lions do of course have certain bilateral symmetries and exhibit a simple set of identifiers, but they can be portrayed from the side (as is common) and without obvious pictorial symmetries. And $E = mc^2$ doesn't work at all according to symmetry or the making of good repeats.

Fig. 12.3.

Andy Warhol, *Twelve White Mona Lisas*, 1980, private collection.

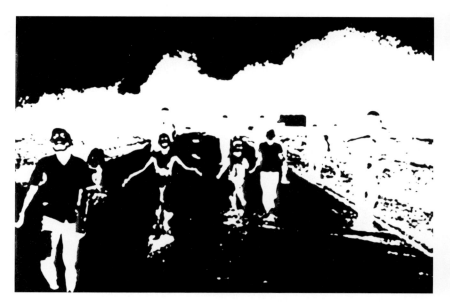

Fig. 12.4

Nick Ut's photograph of the napalmed girl, transformed by the Stamp feature in Adobe Photoshop.

Thinking that the Vietnam photograph is the most complex of the images and least likely to survive severe degradation, I subjected it to the 'stamp' feature in Adobe Photoshop. This reduces the image so that it becomes simplified like a rubber stamp with darks and lights inverted, across a potential range from moderate to extreme. I found that it resisted degeneration surprisingly well (Fig. 12.4). The strongly silhouetted contours of the figures in the original—Kim herself is picked out in dark and light tones against a pale grey background—are clearly important. The running girl in the 'stamped' version remains very striking, reduced to a trembling cross-shape. Her brother and the two children hand in hand remain surprisingly legible. However, it is her body-form that attracts our curiosity. It remains supremely eloquent of something out of the ordinary, as the cropped version shows (Fig. 12.5). Indeed, we refer to Nick Ut's image as the photograph of a napalmed girl, rather than of a fleeing family. It is a photograph of her.

To test how another moderately complex but non-iconic image in a semi-symmetrical photograph would react to the 'stamping' process, I chose a quite casually taken snapshot by my son from May 2008 of my daughter's sons Etienne and Louis, and my son's daughter Alice (Figs 12.6 and 12.7). There is some composition involved, but nothing sophisticated.

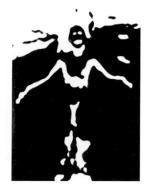

Fig. 12.5

Kim Phuc in the Stamp version, cropped.

Fig. 12. 6

Jonathan Kemp, *Etienne,
Louis, and Alice*, May 2008.

Fig. 12.7

The Stamp version of
Etienne, Louis, and Alice,
May 2010.

It is immediately apparent that the complex pose of Etienne, as he reaches down to play with a rubber octopus, does not transmit legibly. Indeed, something like a cat has emerged, pawing at Louis's right leg. Alice remains discernible as a little girl, courtesy of her skirt and hair. Louis remains the closest to the original, with even a trace of his infant stare (Fig. 12.8). It takes a lot of effort to unravel the man's disembodied legs originally visible to the right of Alice. Perhaps the image of Louis would have become iconic if he had written *War and Peace* as an infant.

Fig. 12.8

Louis in the Stamp version,
cropped, 2010.

Some common threads are emerging, not least the robustness of the images when severely transformed, but I still think they are well short of becoming defining characteristics. I think we are dealing with helpful tendencies in the more pictorial of the items rather than a fixed set of necessary properties that covers all of them. Can we go beyond this rather feeble conclusion?

Fuzzy Categories

I should like to propose that we can, using an odd variant of fuzzy group theory that I have developed to handle clusters of visual and social features in images. It is probably best called fuzzy category theory. The notion of fuzziness in set and group theory has been developed to cope with situations in which absolute definitions, inclusions, and exclusions cannot be made. Fuzziness can handle categories that are identifiable and have broadly agreed characteristics but whose boundaries and membership are open to dispute. It can also embrace looser associations that lie outside strict membership conditions. Let us take a simple example. One of my grandsons rejects food as 'too hot' if it is above room temperature to a discernible degree. He is told that is not too hot—to no avail. I like my food much hotter than that, but not as hot as some people like it. Their food is 'too hot' for me. Thus, if we have a category of 'too hot', the definition of what belongs in that category is untidy, even though we know what it means. If we apply the category 'too hot' to how hot the plate is to touch, the untidiness is even more pronounced. Even more so with 'the weather is too hot'. We have no difficulty in practice navigating through all the kinds and degrees of 'too hot' and it is a useful category, but it is difficult to deal with it in a clear-cut and systematic manner. There is no thermometer with the reading 'too hot' on it. It seems to me that the definition of 'Art' is essentially like this. What is and what is not 'Art' is neither tidily agreed nor subject to any neatly definable rules, but we generally know it when we see it in a given context.

In the case of iconic images, let us imagine a field in which we distribute those factors that we deem to be effective in promoting the various kinds of images to the top status (Fig. 12.9). In my diagrammatic field, there is no spatial separation between historical-cum-social factors, such as political significance and worldwide fame, and the kind of visual characteristics we have outlined, since they interact in complex and dynamic

ways. It is easy to imagine an image of something extremely famous that is ineffective, while Lisa Gherardini was not famous at all, though Leonardo was and is. Sometimes the interactions will be most powerful with adjacent factors; sometimes the linking factors will just happen to be situated in remote parts of the field. Nor is there any strict ranking, though factors that we feel to be more significant, such as visual robustness, will be deliberately clustered towards the centre. I am not attempting here to identify the actual factor denoted by each of the twenty letters distributed erratically across the field. Rather I am demonstrating a mode of thinking about the category 'iconic image'. The proposal I am making is that it is possible to have three or more things that belong more or less indisputably in the category but do not necessarily share any particular factor or set of factors in common.

There are three groups of letters (or factors), eleven enclosed by the green border, ten by the blue, and nine by the red. There is no letter that appears in all three, which means that no factor can be deemed to be absolutely necessary. Poor P, in the bottom right corner, is not in any group, but it must be there because it has been identified as a common factor in other iconic images, outside the given three. K, for instance, features in

12.9

Fuzzy category field, with green, blue, and red groups, 2010.

only the green, while J is shared with red. E and H look a bit marginal, included only once and located at the edge of the field, but they could potentially figure powerfully with other marginal factors in conjunction with a very few of the more central factors in another iconic set. The red group includes less than half of the letters, but is strongly represented by the central factors. It would be possible to undertake a precise analysis of the various combinations of nine, ten, and eleven letters, but I want to retain a central element of subjective perception rather than resorting to mathematical theory.

I am envisaging a situation in which we instinctively recognize that the green, blue, and red groups are all readily identifiable as being members of the category of iconic images, without having any *necessarily* shared factors or critical number of factors. I also envisage that each group itself, with its defined factors, might well be associated more loosely with other factors outside its boundaries, but without these other factors being drawn decisively within the boundaries of the group. What looks like a relatively weak set might be given a great boost from powerful associated factors outside the category. For instance, it is clearly not necessary for an image to be considered an artistic masterpiece (only the *Mona Lisa* obviously qualifies amongst our eleven) but it can be a hugely significant factor for an image that also belongs in the category 'Work of Art'. The chapters, we may recall, were chosen in relation to different types or categories, and each of these brings its own particular set of associations. We are dealing with a complex interweaving and permutation of major and secondary factors, with associated tertiary ones, without a single formula being operative in defining which factors infallibly make an iconic image.

Thus we can argue that symmetry is a very common property, but it is not apparent in the Stars and Stripes. Robustness is however a powerful factor with the American flag, even to the point that a fragment including a star and stripe or two would be unmistakable. A fragment of the heart would need to contain enough hints about the shape, such as the central dip, to tell us what it is. But the broad expanse of sky in Nick Ut's photograph would not speak of the whole to a useful degree.

It is certainly possible to extract a list of factors from the above discussions. It runs something like this (not excluding the possibility that I have missed something important); a famous subject; a link to powerful factions; a broad, rich, and flexible set of associations; a broadly representative function; personal and even emotional engagement; human

significance; the focus of a cult; a sense of presence that goes beyond its material existence; a measure of symmetry; simplicity of the main subject; tonal and colouristic clarity; robustness in the face of degraded reproduction; making good repeats; recognizable in fragmentary form.

However, the reader might guess that I am rather resistant to such listing, not least because such a list can too easily congeal into an explanatory formula. I do not think that an image consciously composed to embody all the factors would necessarily become iconic. There is no absolute predictability—just a series of extraordinary stories about images that exhibit varied kinds of shared and individual characteristics.

And Finally

On 8 April 2007 Reuters News Agency reported:

> An Italian film '7 km from Jerusalem' about an advertising executive who is soul searching after losing his job and marriage and runs into Jesus in Jerusalem sparked protest from the Coca-Cola Company. As a result, the film could not premier over Easter weekend as the film maker had planned. The movie showed Jesus drinking a can of COCA-COLA. The Italian division of the Coca-Cola Company demanded that the scene be edited out stating that the use of its brand was unacceptable.

I wonder whose image is being protected here? Christ or COKE? Neither seems to need it.

Reading

R. Dyer, *Heavenly Bodies: Film Stars and Society*, London, 2004.

R. Howells, 'Heroes, Saints and Celebrities: The Photograph as Holy Relic', *Celebrity Studies*, 2/2, July 2011: 112–30.

F. Inglis, *A Short History of Celebrity*, Princeton, 2010.

J. Mordenson, K Butani, and A. Rosenfeld, *Fuzzy Group Theory*, New York, 2005.

R. Muir (ed.), *The World's Most Photographed*, London, National Portrait Gallery Publications, 2005.

M. Smithson and J. Verkuilen, *Fuzzy Set Theory: Applications in the Social Sciences*, London, 2006.

PICTURE ACKNOWLEDGEMENTS

Pʜᴏᴛᴏɢʀᴀᴘʜs ᴀɴᴅ ɪʟʟᴜsᴛʀᴀᴛɪᴏɴs were supplied by, or reproduced by kind permission of, the following: © ADAGP, Paris, and DACS, London 2011/image © ADAGP, Banque d'Images, Paris 2011: 6.1, 6.2, 6.4; Aderans Hair Goods, Inc.: 5.5; © The Heartfield Community of Heirs/VG Bild-Kunst, Bonn and DACS, London 2011/akg-images: 2.17; Interfoto/ Hermann Historica GmbH/akg-images: 2.15; Robert Harding Picture Library/Alamy: 2.7; Imagestate Media Partners/Impact Photos/Alamy: Chapter 4 opener, 4.4; Moviestore Collection/Alamy: 4.1; Photo12/Alamy: 4.2; Sergey Skleznev/Alamy: 4.3; American Bottle Auctions: 9.3; Jean Vigne/Kharbine-Tapabor/The Art Archive: 9.11; V & A Images/The Art Archive: 3.9; Rainer Arlt, Astrophysikalisches Institut Potsdam: 11.5; the Author: Chapter 2 opener, 2.6, 3.2, 4.11, 4.12, 6.13, 6.14, 8.1, 8.7, 8.9, Chapter 9 opener, 9.8, 10.11, 11.2; Bibliothèques, Médiathèques de Metz, Département patrimoine: 3.12; The Bodleian Library, University of Oxford (D.1.21(3) Art. Seld, fo. A5v): 4.7; The Bodleian Library, University of Oxford (Douce R.534): 3.10; The Bodleian Library, University of Oxford (N2289 d 10 Cover): 1.1; The Bodleian Library, University of Oxford/Taylorian Institution Library (Arch.fol.it.1552): 4.8; Ai Weiwei, Han Dynasty Urn with COCA-COLA Logo, 10" × 11" × 11" (25.5 cm × 28 cm × 28 cm), paint/Han dynasty urn (206 BC to 24 AD), 1994, courtesy of Mary Boone Gallery, New York:

9.2; The British Museum, London/The Bridgeman Art Library: 7.6; © Succession Marcel Duchamp/ADAGP, Paris, and DACS, London 2011/Cameraphoto Arte Venezia/The Bridgeman Art Library: 5.8; Giraudon/The Bridgeman Art Library: 4.5; Louvre, Paris/The Bridgeman Art Library: 8.6; Musée du Petit-Palais, Paris/The Bridgeman Art Library: 5.3; Naturhistorisches Museum, Vienna/Ali Meyer/The Bridgeman Art Library: 12.2; The Royal Collection © 2010 Her Majesty Queen Elizabeth II/The Bridgeman Art Library: 3.3, 5.2; © The Trustees of the British Museum: 1.2, 1.3; The British Postal Museum & Archive, 2011: Chapter 3 opener, 3.16; Man Carrying a Cacao Pod; culture: Aztec, 1440–1521, volcanic stone, traces of red pigment, 14 1/4 × 7 × 7 1/2 in. (36.2 × 17.8 × 19.1 cm), Brooklyn Museum 40.16, Museum Collection Fund: 9.7; Frémez (José Gómez Fresquet), *Hasta La Victoria Siempre*, photographer Alberto Korda, offset, 1967, Cuba, courtesy of the Center for the Study of Political Graphics, Los Angeles/© ADAVIS: 6.6; © The Andy Warhol Foundation for the Visual Arts/Artists Rights Society (ARS), New York/DACS, London 2011/Christie's Images Ltd. 1994: 12.3; Churches Advertising Network: 6.12; Georges Roualt (French 1871–1958), *Head of Christ*, *c*.1937, oil on canvas, 104.8 × 75.0 cm, © ADAGP, Paris, and DACS, London 2011/The Cleveland Museum of Art, Gift of the Hanna Fund 1950.399: 1.14; Bettmann/Corbis: 2.12; Tim Page/Corbis: 7.9; © Claudio Papi/Reuters/Corbis: 1.13; The Master and Fellows of Corpus Christi College, Cambridge (Ms 26 f VII): 1.6; Pascal Cotte: Chapter 5 opener, 5.1; Couturier Gallery, Los Angeles: 6.3; Mark Curtis: 10.12; courtesy of Norman and Linda Dean: 9.5; courtesy of Norman and Linda Dean; image from the Community Archives, Vigo County Public Library, Terre Haute, Indiana: 9.4; Mary Evans Picture Library: 5.4; Jim Fitzpatrick: Chapter 6 opener, 6.8; www.flagguys.com: 6.3; Ford Motor Company: 9.1; Getty Images: 10.3, 11.10; Apic/Getty Images: 9.10; Kaveh Kazemi/Getty Images: 6.9; Alan Oxley/Getty Images: 6.5; Freddy Alborta/Popperfoto/Getty Images: 6.10; Roger-Viollet/Getty Images: 2.16; Bob Thomas/Getty Images: 2.1; Ghilardi, Lucca: 2.8; www.gollycorner.co.uk: 10.13; www.GoneCountryAntiques.com: 9.14; GV Art, London: Chapter 8 opener, 8.12; Hebrew University of Jerusalem, Albert Einstein Archives, courtesy of AIP Emilio Segrè Visual Archives: 11.7; Index, Florence: 1.5; The Israel Museum, Jerusalem: 11.3; Jonathan Kemp: 12.6, 12.7, 12.8; Robert Knudsen, White House/John F Kennedy Presidential Library and Museum, Boston: 5.11; Matthew Landrus: 12.1; Karin Leonhard: 2.9; Library of Congress: 11.1; reprinted by permission from Macmillan Publishers Ltd.: 10.1 (Nature, 25

April 1953, copyright 2011), Chapter 10 opener, 10.9 (Nature, 409, 6822, 15 February 2001, cover, copyright 2011), 10.8 (Nature 422, p. 836, 14 April 2003, copyright 2011), 10.7 (Nature, 422, 6934, 24 April 2003, copyright 2011); Robert Capa/Magnum Photos: 7.10; Philippe Halsman/Magnum Photos: 11.9; Rex F. May, www.baloocartoons.com: Chapter 11 opener; www.megamonalisa.com: 5.9; Merton College, Oxford (MS 249, fo. 2v), Warden and Fellows of Merton College, Oxford: 4.6; Lectern of Sainte Radegonde: collection Musée de la Ville de Poitiers et de la Société des Antiquaires de l'Ouest, © Musée de Poitiers/Christian Vignaud: 2.5; Museum of the History of Science, Oxford/Einstein Archive, Jerusalem: 11.11; ® I LOVE NEW YORK logo is a registered trademark/service mark of the NYS Dept. of Economic Development, used with permission: 3.17; The Ava Helen and Linus Pauling Papers, Special Collections, Oregon State University: 10.4, 10.5; Peace of Concrete Company: 3.15; Press Association Images: Chapter 7 opener, 7.1, 7.2, 7.4, 7.5, 7.8, 8.5, 12.4, 12.5; Private collection: 1.7, 1.12; © 2001 The Record (Bergen County, N.J.)/photo by Thomas E. Franklin: 8.10; © RMN (Domaine de Chantilly)/Gérard Blot: 5.6; © 2011 Scala, Florence: 1.4, 1.11, 2.10, 2.11, 3.1; Museo Nacional Centro de Arte Reina Sofia, Madrid, © Succession Picasso/DACS, London 2011. Image © 2011 Art Resource/Scala, Florence/John Bigelow Taylor: 7.7; Bargello, Florence/© 2011 Scala, Florence, courtesy of the Ministero Beni e Att. Culturali: 4.10; Basilica of Il Santo, Padua/© 2011 Scala, Florence: 3.6, 3.7; © 2011 Scala, Florence/BPK, Bildagentur für Kunst, Kultur und Geschichte, Berlin: 1.9; Metropolitan Museum of Art, New York. Oak, inlay, and tempera; wrought-iron mounts; overall: 4 3/4 × 10 3/4 × 6 1/2" (12.1 × 27.3 × 16.5 cm). Rogers Fund and The Cloisters Collection, by exchange, 1950 (50.141). BW photo.© 2011. Image copyright The Metropolitan Museum of Art/Art Resource/Scala,Florence: 3.8; Metropolitan Museum of Art, New York. Brass; h × w × d: 12 3/4 × 7 1/4 × 1" (32.4 × 18.4 × 2.5 cm). Gift of Ernst Anspach, 1999 (1999.295.14). © 2011, image copyright The Metropolitan Museum of Art/ Art Resource/Scala, Florence: 2.14; © 2011 Scala, Florence, courtesy of the Ministero Beni e Att. Culturali: 2.2, 2.3, 6.11; Johns, Jasper (b. 1930): Flag, 1954 (dated on the reverse). Museum of Modern Art (MoMA), New York. Encaustic, oil and collage on fabric mounted on plywood, 42 1/4 × 60 5/8" (107.3 × 153.8 cm). Gift of Philip Johnson in honor of Alfred H. Barr, Jr. 106.1973. © 2011, digital image, The Museum of Modern Art, New York/ Scala, Florence; © Jasper Johns/VAGA, New York/DACS, London 2011: 8.11; © 2011 The National Gallery, London/Scala, Florence: 1.8, 1.10;

Pierpont Morgan Library (MS M.7, fo. 24r)/Art Resource/Scala, Florence: 3.13; Museo Pio Cristiano, Vatican/© 2011 Scala, Florence: 2.4; A. Barrington Brown/Science Photo Library: 10.6; Dr. Tim Evans/Science Photo Library: 10.2; J. Bernholc et al., North Carolina State University/Science Photo Library: 10.10; Dread Scott: 8.4; Jeff Whyte/Shutterstock: 6.7; SLUB Dresden/Deutsche Fotothek/Richard Peter Sen: 7.3; National Media Museum/SSPL: 11.8; Science Museum/SSPL: 11.4; St Catherine's Monastery, Mount Sinai: Chapter 1 opener; © The State Hermitage Museum (photo by Vladimir Terebenin, Leonard Kheifets, Yuri Molodkovets): 5.7; Robert Farris Thompson from R. F. Thompson and J. Cornet, The Four Moments of the Sun: Kongo Art in Two Worlds, Washington, National Gallery of Art, 1981: 2.13; from Time magazine (July 1, 1946), © 2011 Time Inc., used under licence: 11.6; Hans-Peter Töller: 4.9; Fortean/Topfoto: 3.11; Treadway Toomey Galleries: 9.9; Official US Marine Corps Photo # 313579: 8.8; United States Patent and Trademark Office: 9.6, 9.12, 9.13; © The Andy Warhol Foundation for the Visual Arts/Artists Rights Society (ARS), New York/ DACS, London 2011; image © The Andy Warhol Foundation for the Visual Arts, Inc.: 5.10; Wellcome Library, London: 3.4, 3.5, 3.14; reprinted from Witelson et al., Lancet (1999), with permission of S. Witelson: 11.12; WWRD UK Ltd.: 8.2

The publisher and the author apologize for any errors or omissions in the above list. If contacted they will be pleased to rectify these at the earliest opportunity.

Index

Bold numbers denote references to illustrations.

7 km from Jerusalem 353

abacus 123–4
acheiropoietos 20–21
Adams, Eddie 204–9
 General Nguyen Ngoc Loan Executing a
 Viet Cong Prisoner in Saigon **208**
adenine 281, 284
Aesop 125, 128
Agbar, King of Edessa 21
Alacoque, Marguerite Marie 102–3
Alberti, Leon Battista 210–212, 347

Alborta, Freddy 188
 Che Guevara Dead **188**
Alexander, Pope 34
Alpach 312,
 Churchyard of St Oswald **313**
Amenhotep III 118
amplavit 30
Anothomia 88
anatomy 88, 90, 92–3, 137
Anatomy of a Pregnant Woman,
 Johannes de Ketham's
 Fasciculus medicinae **89**
Andrew, St 67
angel **22**, 29, 48–9, 52, 56, 133, 342
Anghiari 147

Anglo-Norman 128
Angola 71
Annalen der Physik 316, 334
Anne, St 147
Anthony, St 65–7, 73, 92, **94**
anti-parallel 281
Antwerp 104
aorta 84–5, 93, 104
Apelles (Apelles) 146–7
aplevit 30
Apocalypse 30, **33**, 215
Apollinaire, Guillaume 156
Apollo 19, 250
Archbishop of Genoa 27
architecture 59, 264, 324

d'Arcis, Pierre 38
Arezzo 48–50, 150
Argentina 46–7,171
Aristotle 85–7, 91, 126, 132, 176
Arlington National cemetery 227,
 228, 242, **242**
Arnolfini Wedding 2
ARS GRATIA ARTIS 114
Art of Chiromancy 130
Art Nouveau 184, 264
Arts and Crafts 264–5
Aryan 74, 76
*As in the Middle Ages . . . so in the
 Third Reich* **78**
Ashoka 122–4
Asia Minor 21, 23
Aslan 138
Assisi 65
 church of S. Francesco 63
astrology 116, 124, 130
Atlanta 256
 Emory University 258
atom 296, 315, 319, 321
auricle 85
Avedon, Richard 173
Avery, Oswald 284
Avignon 38

Backer, Bill 254
Bakongo 71
Baloo (Rex F May)
 *'You think you're pretty smart, don't
 you?'* **307**
Baptist 65, 70
Bardi Chapel 63
Barnard, Christiaan 92
Barrington-Brown, Antony 291
 *Watson and Crick with their Model
 of DNA* **291**
Barrow, John 325
Barthélemy d'Eyck
 'Contrition and Fear of God Return
 a Purified Heart to Soul', from
 René d'Anjou, *Le Mortifiement of
 vaine plaisance* **104**

Bartholomew, St 250
base pairs 281, 288, 292, 294, 298,
 300–301
Basel 188
Battle of Cascina 241
battle of the Milvian Bridge 47
Baum, L. Frank 110
Bavaria 16
Bayfield, Chas 190 *see also Meek Mild
 As If* 191
The Beatles 254
Beatrice 34
de Beauvoir, Simone 173, 176
Beijing, Royal Palace (Forbidden
 City) **113**, 120, **121**
Belfast 186
Belgium 172
Bellini, Giovanni
 Doge Leonardo Loredan 143
Beloved-of-the-Gods 122–3
Benetton 254
beret 174, 179, 191, 193
Bergen Record 245
Berman, Paul 170
Bernard, St 19, 34, 101
Bernini 142
Bestiary 128
Beusch, Julia 341
Bidloo, Govard
 'The Heart, whole and dissected',
 from *Anatomia Humani
 Corporis* **90**
Biedenham Candy Company 258
Biophysics Unit at King's College,
 London 284, 285
Birkbeck College 286, 300
Birmingham Bottling company 259
Birth of a Nation (or *The Clansman*) 68
blackboard 334, **334**
Blair, Tony 295
Boccaccio, Giovanni 95
Bolivia 168, 183, 187, 190, 194
Bolivian Diary 183
bomb 170, 212, 214, 239, 328–9
 A-bomb 250, 326, 330, 341

Dresden Bombed **203**
fire-bombing 202
Nagasaki 326
nuclear 173, 316, 326
phosphor 250
Bonaventure, St 101
Book of Complexions 130
Book of Hours 103, **104**
Book of the Dead 83
*Book of Physiognomics*128
Book of Revelation 19, 133
Borgo San Sepolchro 60
Boston Celtics 110
Bradham, Caleb 271
Brad's Drink 271
Bragg, Lawrence 293
brain *see* Einstein
branding 250, 276
Brews, Margery 107
Brown University 249
Buckminster fullerene 298, **298**
Buddha 8, 119, 123–4
Buddhist 122, 124
Buell, Hal 204, 219
bull 52, 123, 212
Burrell Foley Fischer architects
 299
Bush, George 226
Byzantine 17, 22–4, 33, 39–40, 47

de Cabestan, Guillem 94
Caesar 98
Cain's Murder of Abel 54
Calamatta, Luigi 154
Calder, Alexander 244–5
Cameron, Julia 330,
 Sir John Herschel **331**
Campbell, Bob 240
Campbell, Philip 304
Canby, William 230–31
Candler, Asa 258
Canto XXXI 34
Cape Town, Groote Schuur
 Hospital 92
Cappa, Robert 209, 217–18

Loyalist Militiaman at the Moment of Death **217**
Caprotti, Giangiacomo (Salai) 147
card
 games 99
 L.H.O.O.Q. 160
 maker 99
 playing 97, 99
 postcard 186, 191, **192**, **267**
 Valentine **80,** 107–8, **109** *see also*
 St Valentine
Carey, Maria 311
Carroll, Lewis
 Alice's Adventures in Wonderland
 280
cart 56, 125, 128, **129**
casket 96–7, 102, 108
 Casket with Armorial Shield **97**
Cassius Clay *see* Muhammad Ali
Casson, Martin 190
 Meek Mild As If **191**
Castro, Fidel 167, 171–2, 176, 179, 206
Castro, Raúl 172, 194
Catherine, St
 of Siena 101–102
 monastery of in Sinai 17
The Cavalry **175**
Caxton, William 27
Cefalù Cathedral, Sicily 22
 apse mosaic **22**
celebrity / celebrities 59, 161, 307,
 311, 340–4
Celera 294–6
Celtic cross 54, 56
cemetery 72, 172–3, 175, 227 *see also*
 Arlington National…
Cerro Muriano 217
CGATs *see* DNA
Chagraff, Erwin 284–5
Charlemagne 98
Charles I 35, 154
Charles, Prince 91
Chattanooga 258
Chaucer, Geoffrey 107
 Parliament of Foules (or Fowls) 107

Che Guevara 167–73, 175–80, 182–88,
 193–95
Che Guevara **166, 185**
Che Guevara Dead **188**
Enrique Avila González, Che
 Guevara, Havana **183**
Che Guevara Helping Workers on a
 Government Housing **180**
Christ/Che Crucified postcard **192**
Guerillo heroico **169**
Hasta la victoria sempre **182**
Republican mural painted with a
 portrait of … **186**
(*see also* González, Enrique Avila)
(*see also* Fitzpatrick, Jim)
Chicago
 School of the Art Institute 236
chi ro 19, 48, 51
China 8–9, 119
chiromancy 130
choleric 129–30
Crichton, Michael 246, 298
Christ (Numerous mentions
 throughout) 12–**103**, 235, 340
see also Jesus, St Veronica and
 Sudarium
 and Che 179–94
 and Coca-Cola 353
 and the lion 133–4
 Dead Christ **189**
 Lion of Judah 133
 Christ as Pantokrator **12**
 Christ Mocked 55
 Christ with the Virgin and Angels **22**
Christian 19, 20, 30, 47–8, 50–52, 54,
 67, 68, 72, 77, 85, 99, 105, 107,
 189, 230, 340
Christie's 31
christograms 19
Christus, Petrus 32
 Young Man with a Book **33**
Christus Rex 20
chromosomes 281, 294, 296
Chronica Major (Great Chronicle) 25, **26**
Cicero 99, 146

Cimabue, Crucifixion by 65
Civitali, Matteo 57
 Tempietto to House the Volto Santo
 58
St Clare of the Cross 102
 Heart of St Clare of the Cross with
 the Symbols of the Passion,
 woodcut **102**
Clement VII, Pope 38
Clerk Maxwell, James 316
Clinton, Bill 295
Clos Lucé 147
Clunas, Craig 9
Coca-Cola 253–274, 341, 353
Coca-Cola bottle **252**
Coca-Cola bottle patent and prototype
 261, 269–70
Coca-Cola bottle **252**
 Dean, Earl *Drawing for the* Coca-
 Cola *Bottle* **260**
 Han Dynasty Urn with … Logo **257**
Coca Nuts 258
cocaine 255–8, 262–3
Cockcroft, John 319
cockerel 113, 125, **129**
Cocoa Pod 262, **264**, 262–7
Codex Leicester 150
coin 19, 34
Collins, Francis 294–296
Colmar 65–6
colobium sindonis (shroud robe) 59
de la Colombière, Father 103
Colón Cemetery 172
Columbus, Christopher 172, 262
complevit 30
Congo 71, 187
Conrad, Joseph 311
Constantine 19, **47–50**, 68, 226
Constantinople 18, 21, 23, 54
Convivio 149, 152
Cook, Roger 254
Copernicus 320
Corbis Corporation 308, 311
corpus Christi 188
corpus domini 25, 65

Corrales (Raúl Corral Fornos) 174–5, 180
The Cavalry **175**
Cotte, Pascal 143–4
Cox, Brian 325
Crick, Francis 279–86, 289–94, 296
Crick, Odile 301
Diagram of the Proposed Structure of DNA **280**
Cross *see also* rood 45–78, 95, 102–103, 118, 340
Ankh 67, 118
Celtic 54, 56
Cross of Muiredach 54–5, **55**
Crusaders' (or Jerusalem) 67
Hakenkreuz (hooked cross) 71, 74, 76–7
Kongo 71, 74
Ku Klux Clan (fiery) 68
Lorraine, cross of 67
Maltese 67
Papal 67
Red Cross 67
tau 65, 67
crown of thorns 29, 51, 54, 64, 102–3, 179
crucifix *see* cross
crystallography 285–6
Cuba / Cuban 167–8, 173–194, 206
Cubism 323–4
Curie, Marie 315
Curl, Robert 298
Curtis, Mark 300–1
The Double Helix Unzipping 301
Cusanus 16–18, 32, 37
cytosine 281, 284

The Da Vinci Code 158
dais 119, 240
Dali, Salvador
Butterfly Landscape, The Great Masturbator in a Surrealistic Landscape with DNA 300
Dante 34, 148–9, 152, 164, 346
Darvall, Denise 92

David 54, 133, 135,
David and Goliath 54
De visione Dei (On the Vision of God) 16
Dean, Earl 253, 259, 260, 261
Dean, James 168, 344
Dean, Norman
The Man Behind the Bottle 260
Debray, Regis 183, 194, 345
Transmitting Culture 183
Decameron 95
Declaration of Independence 231, 325
deoxypentose nucleic acids 289
deoxyribose nucleic acid 279, 280, 290; *see also* DNA
Descanso **44**
devotion 18–34, 56–63, 72–3, 85, 99–100, 102–5, 124, 179, 340–42, 346
Dharmachakra (or Dharma Chakra) 122–3
Diamond, Marion 336
Diane de Poitiers 160
Dietz, Howard 114
Dine, Jim 346
dissection 87, 93
Divina commedia 34
DNA 279–**88**, 290–304
CGATs 294
Citation of Record of Watson's and Crick's 1953 paper on DNA to 2003 292
Cover for Nature **278**
Structure of DNA rendered as a molecular model **281**
DNA Door Handles, Royal Society **299**
DNA Golly Brooch **302**
Molecular Structure of Nucleic acids. A Structure for Deoxyribose Nucleic Acid 280
Domitilla, St 51
Don Juan 81
Donatello 92–3, 135–6, 142, 145

Detail showing *St Anthony with the Miser's Heart* 94
Mary Magdalene 65
Marzocco 135, 136
Miracle of the Miser's Heart 93
Dong Latch, Vietnam 216
double helix 280, 281, 289, 291–293, 296, 298,299–300, 301, 302
Double Helix Unzipping 301
Dow Chemical Company 202
Doyle, Conan 256
Dracula 68–9
dragon 119, 120
Drawing Water from the Rock 54
Dread Scott (Scott Tyler) 236
What is the Proper Way to Display a U.S. Flag? **237**
Dresden 202, 213
Dresden Bombed, viewed from the Tower of the Town Hall **203**
Duchamp, Marcel 160, 342
L.H.O.O.Q. 160, **161**
Duke Ludovico 149
Duveen, Sir Joseph 157
Dyson, Frank 322

E. coli 293
eagle 116
The Eagle pub, Cambridge 280
St John's 52
Eastern Orthodox 17, 18
Easy Company 239
Eddington, Arthur 321, 323
Edessa 21–2, 23, 27
Edwards, T. Clyde 261
Egypt 67, 83, 117–8
Eikon 5, 17
Einstein, Albert **308**, **327**, **331–333**
Albert Einstein Sticking his Tongue Out **333**
brain **335**, 335–6
Blackboard **334**
Cosmoclast Einstein, cover of Time magazine **327**

Energy / Mass / Light Equation
 $E = mc^2$ 307–37
 manuscript on relativity **319**
Einstein Tower **325**
Eisenhower, Dwight 201
Electa Publishers 142
electric current 315
electrodynamics 316–7
electrons 283, 315
electron density map 283
elements (scientific) 301, 315, 321, 329
 also see humours
elephant 123, 125
Emperor Hongwu 120 (Zhu
 Yuanzhang)
Emperor Maximilan 99
Encyclopaedia Britannica 263–4
energy 317–9, 321, 326–30, 337
Entry into Jerusalem 55
Erythroxylum coca 256
d'Este Isabella 146
Eucharist 17, 25, 54, 124
Euler, Leonhard 312
Evagrius, Bishop of Edessa 21
Evangelists, symbols of 52 (St John's
 eagle, St Luke's bull, St Mark's
 lion & St Matthew's angel)
exile 18, 168
d'Eyck, Barthélemy
 Contrition and Fear of God Return a
 Purified Heart to Soul **104**
van Eyck, Jan 17, 30, 36
van Eyck, Jan (after), *Christ* 31

Faas, Horst 200, 204, 209, 215, 219
 Why? **205**
fables 124, 125, 128
Fabrica 89, 249
Fall of Adam and Eve 54
Farrell, Thomas 328
Fasciculus medicinae 88, **89**
Feltrinelli, Giangiacomo 183–4, 194
Feynman, Richard 325
Fioretti di San Francisco 60 (The Little
 Flowers of St Francis)

Fitzpatrick, Jim 184–6, 190–1
 Che Guevara **166–185**
flag
 Russian 227
 Stars and Stripes 76, 224–51, 345,
 352
 Star-Spangled Banner 209, 226
 Union Jack 226–7, 236
*Flag Raising on Mount Suribachi, Iwo
 Jima* **240**
Fleming, Victor 110
Fontainebleau 148
Fontova, Humberto 168–70
football 45–7, 70, 226
fountain pen 341
fovea 85, 88
Fra Angelico 342
Fragonard, Jean-Honoré 154
Francesca of Foligno, Sister 102
Francesco Melzi 159
Francis I 147, 154, **155**
Francis, St 60–3, **62**
Franklin, Rosalind 282–300
Franklin, Thomas 245–6
Frémez (José Gómez Fresquet) 181–2
 Hasta la Victoria Sempre **182**
Fuller, Buckminster 298
Funerary Jar **72**, 72–3
fuzzy category theory 350–1

Galen 85–7, 128
Galileo 302, 320, 329, 336
Gallerani, Cecilia 148–9
Gates, Bill 150
Gates, William 264–5
de Gaulle, Charles 137, 162
genetics 282, 292–6, 345
George III 231, 233
Gregory Melissenos 18, 32
George, St 67, **78**
Geri, Alfredo 157
Géricault, Théodore 241
 Raft of the Medusa **241**
Gessner, Conrad *History of the
 Animals* 124

Gherardini, Antonmaria di Noldo
 146
Gherardini, Lisa *see* Mona Lisa
Giambattista della Porta, *Heads of
 Lion and Leonine man* **132**
Gillis, Kenneth (Judge) 236
Gioconda see Mona Lisa
del Giocondo, Francesco 146
Giotto di Bondone 84
 Charity **84**
 OPUS IOCTI FLORENTINI 61
 *Stigmatisation of St. Francis with
 Scenes from his Life* **62**
Giovanni di Paolo 102
Glaser, Milton 109–10
 I ♥ NY **110**
God(s) 16, 19, 70–1, 82, 107, 122–34,
 190, 321
 as the origin of life 340
 Egyptian 117–8
 fear of, 103
 food of the Gods 262
 hand of 46–7, 55
 Maat 83
van Gogh, Vincent 135
Golden Legend 27, 29, 58, 107
Goldin, Nan 204
golliwog **302**, 302–3
González, Enrique Avila 182–3
Gosling, Raymond 285–9
Gott, Richard 187–90
Goya, *Nude Maja* 160
grave marker for Erwin Schrödinger,
 Churchyard of St Oswald
 312, **313**
graven images 19, 24, 50
gravity 312, 322
Great Sphinx of Giza 117
GreenLight 307–8
Green Vase **265**
Gregory (from Constantinople) 18
Griffith, D.W. 68
Grünewald, Matthias (Matthis
 Neithardt?) 65, **66**
guanine 281, 284

Guernica 212, **212**, 214, 342
Guardastagno, Guiglielmo 95–6
Guardian Lions at the Gate of Heavenly Purity **112**, **121**
Guevara, Che *see* Che Guevara
Guevara, Ernesto 169–71
Guido da Vigevano, *Anothomia* 88
Guillem de Cabestan 94–5
Gutierrez, Alberto Diaz *see* Korda

Hakenkreuz (hooked cross) 71, 74–77
Handbook of Medicine 131, **131**
Harvey, Thomas 335–6
Harvey, William 91
Hasta la Victoria Sempre **182**
Havana 170–9, 183, 206
Hawking, Stephen 325
heart 80–**111**
 Heart of a Pig 86
 Heart of St Clare of the Cross with the Symbols of the Passion **102**
 I ♥ NY 108, 110
 Sacred Heart 99, 103–7, 107
 Sacred Heart from a Book of Hours **105**
Heartfield, John (Helmut Herzfeld) 77
 As in the Middle Ages . . . so in the Third Reich **78**
Hebrew University in Jerusalem 307–11
Helen, Ava 9
Hendrix, Jimi 209
Henri II 160
Henrietta Maria 35, 154
Hercules 134
Hermitage, St Petersburg 159, 160
Herod, King 211, 340
heraldry 96, 119, 136–7
Herschel, Sir John 330, **331**
herzzerreißend (heart-rending) 82
Hilltop commercial 254
Hitler 74, 76–7, 114
hobble skirt 267–8

Hobbled by the Hobble Skirt **267**
Holbein, Hans 154, 188
Holmes, Sherlock, *The Sign of Four* 256
Holy Face 16, 23–26, **24**, 32, 56 (*Volto Santo*)
Holy Land 54, 56
Holy Vine 104
Hopper, Dennis 215
Hopkinson, Francis 231–3
 Stars and Stripes **232**
Human Genome Project 292–6
humours, four 86, 128–9

Ichthys or 'fish' 19
iconoclast 24, 342
Illumination of a Lion with a Cart and Cockerel **129**
imagery 52, 83, 104, 117, 137, 148, 149
Ingres, Jean-Auguste-Dominique 154
 Leonardo Dying in the Arms of Francis I **156**
in hoc signo vinces (in this sign you will conquer) 47
I(nitium) and *F(inis)* 30
Innocent III 25, 61
Internet 40, 70, 160, 219, 230, 239, 342
Italian Communist Party 181, 183
Introduction to Horoscopic Matters 130
Iran 123
Isenheim Altarpiece Closed **66**
Isidore, St, of Seville 128
Islam 67
Iwo Jima 201, 202, 204, 227, 238, 239–40, 242, 245
Izé 299

Jackson, Ishizaki 204
Jacobus da Voragine 27, 48, 107
Jasper, William 248
Jeremiah 82–3
Jerusalem 27, 63–4, 353
 church of the Holy Sepulchre 64
 Entry into Jerusalem and Pilate

Washing his Hands 55
Hebrew University 307–8
Jesus 16–42, 59– 65, 101–5, 353
see also Christ
La Joconde see Mona Lisa
Johannes, Bishop 56
Johannes de Ketham 88,
 Zodiac Man **131**
 Anatomy of a Pregnant Woman **89**
 Fasciculus medicinae 131
John V Palaeologus 23
John VIII Palaeologus 49
Johns, Jasper 227, 246
 Flag **247**
Johnson, Gregory Lee 236
Johnson, President **163**
Johnston, Robert 56
Jones, Tony 236
journalist 187, 200, 204, 215, 220, 326
 photo... 206, 219
Judith (David and ...) 98
jungle 202, 221–2, 345
Jupiter 19
Justinian 19–20, **21**

Kalinga (Orissa) 122–3
Kelly, Eugene 268, 270
Kemp, Jonathan
 Etienne, Louis, and Alice **349**
Kempe, Margery 63–4
Kendrew, John 283, **283**
Kennedy, Jacqueline 162, **163**
Kennedy, President **163**
King's Lynn 63
Kitchener, Lord 14
Klara and Edda Belly-Dancing 204
Klug, Sir Aaron 300
Knave 97–9
 Knave of Hearts and Diamonds 98
Kola nuts 256, 262–3, 271
Kongo 71–3 *see also* cross
Korda, Alberto 168–9, 173–84, 186, 189–90
 Contact Sheet of 28 Frames **177**
 Guerillo Heroico **169**

Norka Modelling a Hat **174**
Korea 206
Kossinna, Gustav 74
Krasnow, Andrew 227, 249–50
 Flag from Flag Poll **224**, **250**
Kroto, Harry 298
Ku Klux Klan 68
 *Family Assembly of the Ku Klux
 Klan at Macon, Georgia* **69**

Labarum logo 48
Laboratoire Centrale des Services
 Chimiques de l'Etat, Paris 285
Lamba Teye 72
lance wound 54, 61, 188
Lander, Eric *see* DNA
Landseer, Sir Edwin 137
 *Lion from the Base of Nelson's
 Column* **138**
Last Judgement 34, 250
Last Supper 47, 342, 346
Lateran 34
Latin Apocalypse 30
Latin America 171, 187
von Laue, Max 318
Lea, Darryl *see* DNA
Leboino, Deacon 56
Lee, Bruce 308
Leete, Alfred 14
 Your Country Needs You **15**
Leo
 128 (king in Latin)
 130 (astrological)
Leo XIII 103
Leonardo 15, 32–8, 47, 87–91,
 141–65, 312, 316, 342–51
 Battle of Anghiari 147
 Cecilia Gallerani (*Lady with the
 Ermine*) 148–9
 Codex Leicester 150
 Ginevra de' Benci 145
 *Leonardo Dying in the Arms of
 Francis I* **155**
 Lucrezia Crivelli 149
 Maddalena Doni 152

Madonna Vanna **158**–60
*Map of the Arno Valley West of
 Florence showing his Protected
 Canal* **151**
*Mona Lisa; Portrait of Lisa
 Gherardini* **144**, **168**
St John the Baptist 154
Salvator Mundi **36**
vene d'acqua (veins of water) 150
Virgin of the Rocks 154
*Vessels of the Thorax and Upper
 Abdomen with Demonstration of
 the Heart as Seed* **88**
Salvator Mundi 35, **36**, 40, 154
leonine 117–21, 130, **132**, 133–8
Leslie, David 311
Levy, Steven (journalist of *New Jersey
 Monthly*) 336
L.H.O.O.Q. 160, **161**
Libreria Feltrinelli 183
Lineker, Gary 47
Lion Capital of Ashoka 122, **123**
Lion King 138
Lisa del Giocondo *see* Mona Lisa
Lisa Gherardini *see* Mona Lisa
liver 86–7, 92
Lloyd Wright, Frank 265
Loewy, Raymond 268
Longfellow, Henry Wadsworth 34
Longinus 101
Los Angeles 225, 307–8
Louis XIII 154
Lucca 56–60
 cathedral of S. Martino 57, **57**–8
Luke, St 34
Lumière Technology 143

Macbeth 218
McCarty, Maclyn 284
MacLeod, Colin 284
Madonna (Monna) Vanna **158–60**
Mandylion 21–3, 27, 38
Mantegna, Andrea
 Dead Christ **189**
Maradona, Diego **45**–7, 192

Marani, Pietro 142
Margarita philosophica 99
Marine Committee 227, 230, 233
Marines Raising the Flag at Iwo Jima
 228, **239–45**
Mark, St 119, 133–36
Marmite 40–2
Marochetti, (Baron) Carlo 137
Marsyas 250
Mary Magdalene 65, 145
Marzooco **135–6**
matrix 181–3, 192–5
Matthew, St 37, 52, 212
Matthias Grünewald (Matthis
 Neithardt)
 The Isenheim Altarpiece Closed 65,
 66
Medical Research Council 282, 284
de'Medici, Guiliano 148
mediology 183, 194
Meek Mild As If 190, **191**
Meischer, Friedrich 284
Melissenos, Gregory 'the Confessor'
 18, 32
meme 345
Mendel, Gregor 282, 290, 296
Mendeleev, Dmitri 301, 320–1
Mendelsohn, Eric 324
 The Einstein Tower **325**
Menendez, Natalia *see* Norka
Meselson, Matthew 293
messenger RNA 293
Metro Goldwyn Meyer (MGM) 114
 Metro Goldwyn Meyer Logo **114**
Mexico, New 45, 52, 70, 172, 328
Michael, St 54
Michelangelo 35, 135, 241, 250, 342
Ming dynasty 119
Mistress of Dread 117
Modernism 323
Mona Lisa **140–52**, 160, 351
 La Gioconda 145, 160
 La Joconde 141, 145, 152
 Lisa Gherardini **140**, 145, 351
 Lisa del Giocondo 145–8

Mona an Icon **161**
Mona Lisa Digitally Restored **144**
Mona Lisa Vanished **156**
Unveiling of, the 161–3
Monroe, Marilyn 185, 344, 346
Moore, Henry 298
mosaic 19, 22, 48
 Mosaic Floor with Roundel of Christ **20**
Moser, Brian 190
Motorcycle Diaries 170
Mount Suribachi 238, **240**
Magnetic Resonance Imaging 275, 336
Muhammad Ali (Cassius Clay) 344

napalm 197–214
Napalm Sticks to Kids 197–8, 208
Nature journal **278–297**
Nelson's Column, London 137–8
New Seekers 254, 268, 341
Newton's law 312
Nguyen Ngoc Loan, General 207, **208**
Nicholas of Cusa (Cusanus) 16–18, 32, 37
Nicodemus 56
Nixon Tapes 202
Nobel Prize 283–4, 292, 298, 300
non manufactum 20
Norka 173, **174**
Nucleotides 281
Nun and Corpse **216**

Old Glory 226
Old Testament 19, 82, 134
omnium gatherum 125
On Etymology 128
On the Parts of Animals 87
Oxley, Alan 180–1
 Che Guevara Helping Workers on a Government Housing Project **65**

Padua 63, 93
 S. Antonio 92
 Scrovegni Chapel 84
Page, Tim 209, 214

Nun and Corpse **216**
Page after Page 215
Pantokrator **12**, 17, 37, 40
Paris 23, 137, 143, 157, 161, 179, 285, 344
 Exposition 74
 Paris Match 184
 Musée du Louvre 141
 Sacre Coeur 100
Paris, Matthew 25
Passion 25, 91
 insignia of 61
 Passion Sarcophagus 48, 51, **51**
 symbols of 102
passport ban 284, 287–**8**
Pater, Walter 154–5, 164
Pathé 113
Paul, St 33, 54, 134, 217
Pauling, Linus 282–7, **288**,
Peace of Concrete Company 105
 The Sacred Heart **107**
Pearl and Dean 113
Pepsi 254, 270, 274–6
 Pepsi Cola 'swirl bottle' 273
 Challenge 271, 272
Perutz, Max 283–300
 with his model of Haemoglobin and John Kendrew with his Model of Myoglobin **283**
Peter, Richard 202, 209
 Dresden Bombed, viewed from the Tower of the Town Hall **203**
Peter, St 67, 134
Petrarch 148
Petrus Christus 32
 Young Man with a Book **33**
Petrus Mallus 25
Phuc, Kim **196**, **201**, 200–207, 340, 348, **348**
Physiognomics 126–8
Physiologus (The Bestiary) 128
Picasso, Pablo 156, 212, 214, 330
 Guernica **212**
pictogram 84, 99
Piero della Francesca 48–50
 Constantine's Dream of the Cross **49**

Constantine's Victory over Maxentius **50**
Pilate, Pontius 27, 51, 55
pilgrim / pilgrimage 25–6, 34, 63–4, 92, 102, 124, 134
Pliny the Elder 125
Poincaré, Henri 319–20
de Poitiers
 Diane 160
 Henri 38
Polenton (or Polentone), Sicco *Life of St. Anthony* 92
Presley, Elvis 344
Prior Analytics 126
Principe, Gulf of Guinea 322–3
Purgatory 25–6, 32
Puzzle Valentine Card **80**, **109**

Qingming shanghe tu 8
quasi-religious 190, 340

Raft of the Medusa 241, **241**
Raimon of Castel Rossillon 95
Raimondi, Marcantonio 211
Randall, Sir John 284–6
Raphael 152–3, 160, 211
 Massacre of the Innocents **211**
Red Brigade 181
Red Crescent 67–8
Redford, Robert 170–1
Rehnquist, William 236
Reisch, Gregor 99–100
Rembrandt 142–3
Riefenstahl, Leni 76–7
 The Sea of Flags, still **77**
Roberty, L.
 Hobbled by the Hobble Skirt **267**
Robertson's 302–303
 DNA Golly Brooch **302**
Roman catacombs 51
Romanesque 59, 134,
rood (*rode*) 54–5
Root, Chapman **259–69**
Rosenbach, James (Johannes da Indagine or John the Hunter) 130

Rosenberg, Pierre 141
Rosenthal, Joe **201–45**
 Flag Raising on Mount Suribachi,
 Iwo Jima **240**
Ross, Betsy **227–49**
Rouault, Georges 40
Royal Astronomical Society 323
Royal Society **299**, 299–300, 323
Rubens 153, 218
Rublev, Andrei 34–**5**

SS. Annunziata, Florence 146
St Anthony's fire 65
St Clare of the Cross 102
Sta. Croce, Florence 336
St John the Baptist 65
St John the Evangelist 65
S. Lorenzo, Rome, chapel of 34
S. Marco, Florence 342
St Mark the Evangelist 133
St Trophime Cathedral, Arles 134–5

Sacred Heart **99–107**
Saigon 200–8
Salaí (Giangiacomo Caprotti) 147–8,
 152, 160
Salvator mundi 35–6, **36**, 40, 104, 154
Samson 134
Samuelson, Alexander 260–61
Sanger Centre, Cambridge 295
Santa Claus 265–6, **266**
Sarcophagus 48, 51
Sarcophagus with the Cross and Scenes
 from the Passion **51**
Sarnath 122–4,
Sarnath column **123**
Sartre, Jean Paul 167–8, 173, 176
Sasse, Arthur 332–3
Schliemann, Heinrich 74
Schreitmüller, August 202
Schrödinger, Erwin 285, 312–14
Scot, Michael
 Book of Physiognomics 128
Scrovegni Chapel, Padua 84
Sebastian, St 57, 65, 344

The Secret Agent 311
Sekhmet (or Sakhmet) 117–18, 120
Senatus Populusque Romanorum
 (SPQR) 6, 19
Ser Piero da Vinci 146
Seraph 60–1, 63
Seremonda 95
Serra, Richard 244
Seward, Dr 69
Shilton, Peter 45–6
Shrady, Henry Merwin 137–8
 Grant on Horseback and Lion **138**
shrine 37, 53, 344–5
silphium plant 85
Slats (the lion) 115–116, **115**
Smalley, Richard 298
soccer *see* football
Sodium Thymonucleate **287**, 289
Solidus of Justinian **21**
spada (sword) 98
speculatio (meditation) 16
speed of light 314–18 (or other
 electromagnetic radiation)
Speer, Albert 76
SPQR 19
Stars and Stripes *see* flag
Star-Spangled Banner *see* flag
stigmata 60–1
Stigmatisation of St. Francis with Scenes
 from his Life 62
Stith Pemberton, John 256
Sudarium (of St Veronica) 21, **25–30**, 34
Sulston, Sir John 295
Sundblom, Haddon 265
 For Santa **266**
survival of the fittest 345
swastika 71, **74–8**, 226
Szilard, Leó 328–9

Tancred, Prince of Salerno 95
tau *see* cross
Teco Company 264
 Green Vase **265**
Tegernsee 16
Tempietto 57–9

Tempietto to House the Volto Santo **58**
Templars, knights 48
Terre Haute (Indiana) 259, 260, 263
tetragrammaton 19
Theobrona cacao 268
Theophrastus 127, 132
Theory of Relativity 316–22
Thompson, Joseph 323
Three Little Maids (*Mikado*) 268
Three Statues of the Goddess Sekhmet **118**
thorax 87, **88**, 93
thymine 281, 284
Time Magazine 207, 291, 326
 Einstein cover **327**
Tin Man 110
Titian 153–4, 160
Topcroft Hall 108
trademark 257, 271, 302–3, 308, 311
Trafalgar Square, London 137
Transmitting Culture 183
Turner, Oren 308, 330
 Albert Einstein **308**
Turin Shroud 38, **39**
Tyler, Scott 236

Ulysses S. Grant Memorial 137, **138**
Union Jack flag 226–7, 233, 236
Upton, Florence 303
uranium 328–9
Urn, Han dynasty, with COCA-COLA
 logo **257**
Urban VIII, Pope 37
Ut, Nick 199–205, 209, 213, 217–19,
 347–8, 352
 Grandmother Flees with Dying
 Grandson **199**
 Kim's Aunt Carrying a Baby **213**
 Photograph of the Napalmed Girl,
 transformed by the Stamp feature
 in Adobe Photoshop **348**
 Villagers Fleeing along Route I **196**, **201**

Valentine, St 107
Valentine Card, British Postal
 Museum **80**

Vallegrande 187
Vasari, Giorgio 148, 153, 154
Vatican, Rome 37, 38, 103
Velázquez, Diego *Las Meninas* 212
vellum 32, 249
Venter, Craig 294–6
Venus 343–4, 146
 Venus of Willendorf 343
ver icon (veram iconam) 25
Vermeer, Jan 14
Veronica 21, 25–6, 34, 37–8, 59, 249
Veronica, St 21, 25, 27, 29, 32
 St Veronica with the Sudarium 29
 The Sudarium of St Veronica 28
Vesalius, Andreas 89
 De humani coporis fabrica 249
Vespucci, Agostino 146–7
Via Dolorosa 21, 27
Vienna 282, 343
Vietnam 168, 198–202, 204, 207,
 213–5, 220, 250, 348 *see also*
 war, Vietnamese
Virgil 321
Virgin 34, 61, 65, 99–100, 147, 342,
 346
 Annunciate 61, 342
 holy virgins 102
 Virgin of the Rocks 154
 Christ with the Virgin and Angels **22**
viscera 83, 102
vision 83, 122, 124, 151, 178, 213, 274
 De visione Dei 16
 sacred 16, 33–4, 47–8, 60–61,
 101–103, 133
 Margery Kempe 63–4
visual culture 117, 119, 324
Vitis Mystica (the *True* or Mystic Vine)
 101
Vitruvian Man 1

Viva Che 184
Volto Santo 23, 56–60
 Il Volto Santo di Lucca **57**

Wain, Christopher 200, 206
Walton, Ernest 319
war 83, 217–20, 226, 233, 242–3, 248,
 323, 329
 Board of, 230
 Cold 194
 Civil 137, 256
 Cuban 175
 Great 14
 Guernica 212
 First World 324
 Gulf 225
 Mars, the God of 129
 religious 68
 Second World 202, 234, 238, 265,
 282
 Vietnamese 168, 198, 201–202,
 206–9, 208 (*see also* Vietnam)
Warhol, Andy 185, 255, 346
 Thirty are Better than One 161, **162**
 Twelve White Mona Lisas **347**
Washington 137, 145, 162, 236, 260
 Ulysses S. Grant Memorial **138**
 Washington Post 323
Washington, George 227, 230–1
Washkansky, Louis 92
Watson, Dr 256
Watson, James 279–82, 284–87,
 289–97, **291** 300, 302–304
Wayne, John 114, 245
Weigl, Bruce 220
Weiwei, Ai
 Han Dynasty Urn with COCA-COLA
 Logo 257
Weizmann, Chain 324

de Weldon, Felix 227, 242–4
 *Felix de Weldon Working on the
 Clay Model for the Head of Rene
 Gagnon* **243**
 Marines Raising the Flag at Iwo Jima
 228, 242, 244
Wells Rich Greene advertising
 agency 108
Wessel, Horst 76
West, Mae 308
Wexler, Haskell 254
Whitehead, Alfred North 323
Wierix, Antonius 104
 'On other side of the door beats the
 heart of JESUS' **106**
Wilkins, Maurice 283, 285, 290, 292
Wilshire Wigs 157
Wilson, Thomas 74
Wizard of Oz 110
Windsor Castle 13–14, 16, 88
Winterton, Rosie 238
World Cup 45–6, **46**
The World's Most Photographed
 exhibition 344
worshipper 18, 40, 54, 134
wreath 51

X-ray 282–3, 285–6, 290, 300

Young Man with a Book **33**
YouTube 220, 329
Yu Shinan, *Ode to the Lions* 122

Zaire 71, 187
Zeduan, Zhang 9
Zeus (Jupiter) 19
Zionist 324
Zmigrodski, Michael 74
Zodiac Man **131**

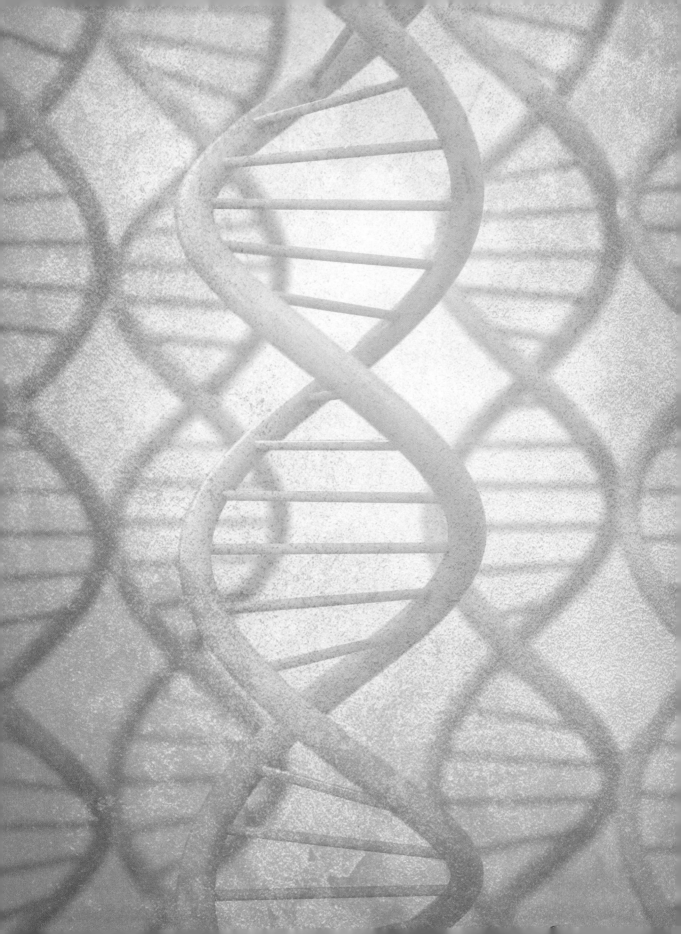